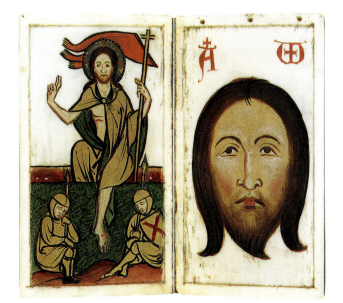

THE ART
OF DEVOTION

1300-1500

THE ART
OF DEVOTION

in the Late Middle Ages in Europe

1300-1500

Henk van Os

With Eugène Honée,
Hans Nieuwdorp,
Bernhard Ridderbos

Translated from the Dutch
by Michael Hoyle

PRINCETON UNIVERSITY PRESS

PRINCETON, NEW JERSEY

This book accompanies the exhibition
'The Art of Devotion 1300–1500'
at the Rijksmuseum, Amsterdam
26 November 1994 – 26 February 1995

All exhibited works are illustrated in colour. The plate numbers correspond
with those of the catalogue beginning on page 175.

The exhibition was made possible thanks to Visa Card Services and the
VSB Fund Foundation

Stichting **VSB** FONDS

Published in 1994 by Princeton University Press, 41 William Street, Princeton,
New Jersey 08540

Library of Congress Cataloging-in-Publication data:
Os, H. W. van.
 The art of devotion 1300–1500 / Henk van Os; with Hans Nieuwdorp,
Bernhard Ridderbos, Eugène Honée
 p. 192 cm.
 Includes bibliographical references and index.
 ISBN 0 691 03793 0
 1. Spirituality in art. 2. Art, Gothic. 3. Christian art and symbolism
– Medieval, 500–1500. I. Title
 N8248.S7708 1994
709'.01'3—dc 20 94–15506 CIP

This book has been composed in Palatino

Princeton University Press books are printed on acid-free paper and meet the
guidelines for permanence and durability of the Committee on Production
Guidelines for Book Longevity of the Council on Library Resources

Printed in Italy

10 9 8 7 6 5 4 3 2 1

Front cover: Master of the Magdalene Legend,
diptych (cat. 36)
Back cover illustration: Master of St Veronica,
triptych (cat. 26)
Endpapers: Geertgen tot Sint Jans, *The Man of
Sorrows* (detail, cat. 41)
Half-title illustration: Lower Rhine/Westphalia
master,
devotional booklet, fol. 4v. and 5r. (cat. 35)
Frontispiece: Gelderland (?) master, *St Christopher*
(detail, cat. 43f)

Produced by Merrell Holberton Publishers,
Axe & Bottle Court, 70 Newcomen Street, London SE1 1YT
in association with Rijksmuseum, Amsterdam
Designed by Karin Dunbar Design, London
Typeset by August Filmsetting, St Helens
Printed and bound by Graphicom, Vicenza

CONTENTS

This book is dedicated to my friends at Smith College
and St John's Episcopal Church, Northampton (Mass.)

Henk van Os

Opposite: Back of left panel of cat. 32

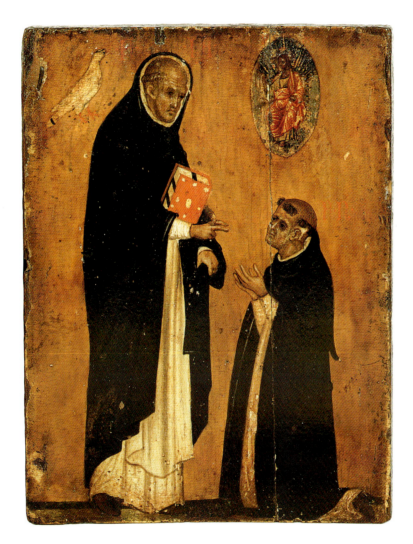

THE ART
OF DEVOTION

FOREWORD

In recent years the functional aspect of art has become an increasingly important area of study. The intentions of patrons, the purpose of a work of art in the location for which it was made, the relationship between art and its architectural setting, the reconstruction of larger works from their surviving fragments — all these are now major issues in art historical research, whereas previously the focus was mainly on style and iconography. Moving beyond the monograph, is it possible to write a history of art by adopting the functional approach? I have tried to show that it is, in two books on the history of the altarpiece in Sienese art.

When I came to the Rijksmuseum in 1989 my new colleagues eagerly took up the discussion of new challenges for art history. They asked if it was possible to write a history of Late Medieval art for private devotion along the lines of the one on Sienese altarpieces. This was followed by the even more exciting question: "Could we make an exhibition on the subject?" After a lot of thought and lively discussion we came to several conclusions, covering the parameters for such an exhibition:

1. In the interests of clarity we would have to restrict ourselves to works of art the size and provenance of which clearly demonstrated that they had been made for a private room, be it a nun's cell or a layman's bedroom.

2. Notwithstanding this self-imposed limitation, it would be fascinating to make the geographical spread as wide as possible, for then we would be dealing not with local schools but with the cultural heritage of Europe as a whole. This would allow us to illustrate the impressive diversity of Late Medieval devotional art. In Italy, the practice of prayer prompted the creation of objects that differed from those produced in France, England, Germany and the Burgundian realm, but there are striking instances of cross-fertilization which can easily be overlooked.

3. This panoramic approach would be completely unworkable unless we somehow narrowed the field, so we decided to concentrate on the very best objects from Dutch collections, supplemented with choice pieces from foreign collections. I am most grateful to the lenders for enabling us to bring together so many of the most beautiful and precious objects from the Waning of the Middle Ages. Our aim was not to give the fullest possible picture of a historical phenomenon, but to gather together a small group of superb pieces in order to evoke an image of the culture of prayer of that period.

We were also provided with a unique opportunity to reunite several of the most important painted ensembles — diptychs and polyptychs — that have come down to us from the Middle Ages, separated or dismembered. For the first time in the written history of art, it is now possible to see as a whole one of the incunables of Netherlandish painting, the magnificent early fifteenth-century polyptych that once belonged to Philip the Bold, Duke of Burgundy, otherwise divided between two museums.

4. One subject that came up during our discussions was the phenomenon of the 'exhibition catalogue'. Annemarie Vels Heijn, the Rijksmuseum's Director of Exhibitions, did not want the show to be accompanied by a hefty tome containing profound scholarly analyses of each work of art. Most of those exhibited are anyway so famous that they have already been discussed at length elsewhere. The question was, could we use the objects in the exhibition as the framework for a straightforward narrative aimed at the general public? This would enable us to discuss the main themes of the Late Medieval culture of prayer systematically.

I will always be grateful to my two fellow directors at the Rijksmuseum for giving me the opportunity to write this book. That task, though, would never have been brought to a successful conclusion without the assistance, inquiring spirit and tireless enthusiasm of Norbert Middelkoop.

A book like this can only be written on the foundation of work by other scholars, and with the encouragement of colleagues and friends. Here I would particularly like to single out Hans Belting, Henning Bock, Anton Boschloo, Ton Brandenbarg, Carolyne Bynum, the late Mieke Caron, Henri Defoer, Jan Piet Filedt Kok, Rona Goffen, Mark Gudwin, John Hand, Jan Jessurun, Anne Korteweg, Jan Rudolph de Lorm, Marianne Maaskant-Kleibrink, James Marrow, Virgina Reinburg, Viktor Schmidt, Jacques Toussaint and Caroline Villers.

I am especially grateful to Eugène Honée, Hans Nieuwdorp and Bernhard Ridderbos, whose individual contributions have considerably improved the book. The translation is by Michael Hoyle. We were fortunate in being able to call on the expertise of Lambertus Okken, Dieuwke van der Poel and Sabine Rieger for the transcription and interpretation of passages in Middle Dutch and Middle German. Arpad Orbán kindly allowed me to consult him on the Latin quotations.

This book is dedicated to my friends in Northampton (Mass.). I could not imagine a more ideal setting for writing *The Art of Devotion* than the Hillyer Art Library of Smith College.

Henk van Os
17 April 1994

A TREASURY OF STORIES

Henk van Os

PLATE 1
**Anonymous
(France/Meuse Valley)**
Diptych, mid-14th century

Bottom: *The Nativity* and *The Adoration of the Magi*
Top: *The Crucifixion* and *The Last Judgment*
Ivory; wings 20.3 × 9.5 cm

Amsterdam, Rijksmuseum, inv. no. BK 1992–28

A NEW GOSPEL

In 1992 a superb and very well preserved example of Late Medieval ivory-carving was donated to the Rijksmuseum in Amsterdam (PLATE 1). It is a small diptych, and given its size must have been intended for private devotion, presenting an individual worshipper with illustrations of stories from the Bible as an aid to meditation. Its provenance can be traced back some way, for on the reverse of the right wing are the words *"verus Possessor Albergatus Ehlen Prior Cartusie Trevirensis 1781"* (The true owner [is] Albergatus Ehlen, prior of the Charterhouse at Trier, 1781). It is not clear why Ehlen calls himself the "true" owner, but what is important is that the diptych was still being used in a monastery in the eighteenth century, and probably the monastery for which it had originally been made. In an inscription on the back of the left wing, the prior refers to "four ivory representations" (*Quatuor eburnae Imagines*) supposedly dating from the eighth century. The inscription and the bizarre early date show that Ehlen was convinced that he was the true owner of a very special object. He was absolutely right. The exquisite scenes and the lovingly decorated Gothic arches are carved with great feeling for spatial organization and for the sculptural effect of the figures.

The "four representations" are as one might expect. In the two lower fields are the *Nativity* and the *Adoration of the Magi*, with the *Crucifixion* and the *Last Judgment* above them. The way in which the stories are depicted is also conventional for the thirteenth and fourteenth centuries. The *Nativity*, however, at bottom left, merits a closer look. The Virgin is stretched out on a bed, resting her head on her right hand. She is gazing at her Child and playing with its arm. The expressions of the ox and the ass suggest that they, too, have realised that Jesus is a very special baby. In the arches on the left behind the Virgin, angels are announcing the birth of the Saviour to distinctly rustic shepherds in the fields. The most striking aspect of the scene is the prominence given to Joseph, who appears twice. As usual he is attending behind the Virgin, but the same figure is seen again in the right-hand arch in the background. It was customary in medieval art to portray Joseph as an old man, to make it clear to the faithful that he could not possibly have been responsible for the conception of this Child. St Matthew's Gospel relates that an angel appeared to Joseph to calm his misgivings about the unusual birth, and this is what is depicted in the right-hand arch. The angel is pointing to Heaven with his right hand as if to say, "That is where it comes from". In the Gospel, Joseph naturally accepts the angel's explanation. The outcome is expressed in the ivory by his loving devotion to Mary. The fact that Joseph is depicted twice, in two very different states of mind, gives the scene a remarkable visual rhythm. A specific instance of this kind demonstrates that the ivory-carver treated traditional scenes with insight and a close attention to detail.

In the case of a diptych like this, however, simply analysing the individual scenes would miss an important point. Ivory-carvers, like the illuminators of manuscripts, brought into the private domain images that a century earlier had been restricted to public locations. Although the image remained the same, its function was now radically different. For example, when looking at a series of church murals illustrating the life of Christ, one might wonder why some scenes were included and others not.

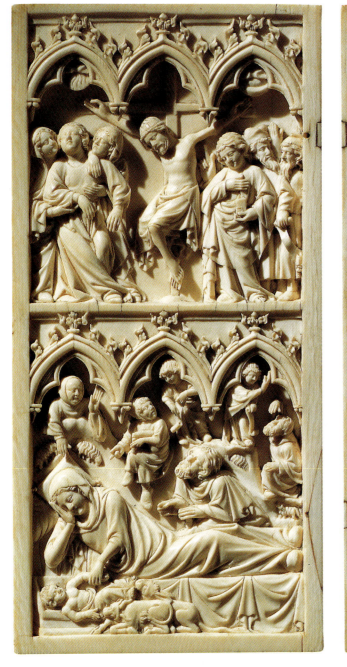

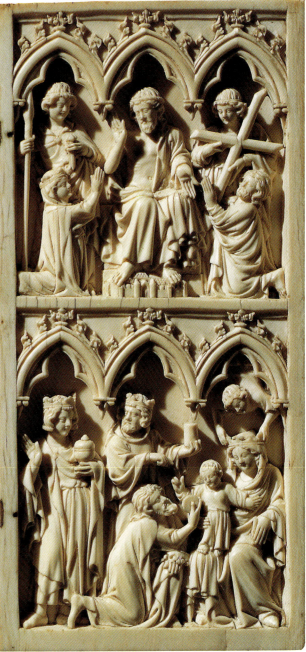

Fig. 1. Anonymous, Tuscany, 14th century, *The Virgin giving the gifts of the Magi to the poor,* from *Meditationes Vitae Christi,* Ms. Ital. 115, fol. 30v. Paris, Bibliothèque Nationale

The answer is to be found in theological ideas and didactic intentions. In the case of an ivory, it is a question instead of the scenes that the patron wanted to have before him during his meditations. They were not Christ's exciting, miraculous deeds – healings, raisings from the dead – such as were depicted extensively elsewhere, but four scenes of adoration and redemption. In the first, God becomes man at the birth of Jesus. The beholder can, as it were, join the procession of the Magi in the second to adore Him. In the third, Jesus dies for him on the Cross, and in the fourth He will come again to pass judgment, not so much on the general mass of the living and the dead, but on the viewer alone. The Virgin and St John will plead his cause. Behind them, angels bear attributes of Christ's Passion, the cross and the lance. They have become the weapons that gained Him His unique victory. The four scenes depict what the pious patron had learned to regard as the most important moments of God's redemptive relationship with him.

As traditional doctrines were translated to a new setting, not only their representation changed over the course of time, but the stories themselves. The same narrative was related differently, depending whether it was for a public or a private audience. The *Meditationes Vitae Christi,* written ca. 1300 by a Franciscan friar for a nun of the female branch of the order the Poor Clares, was a widely read new version of the story told in the Gospels. The Franciscan is at great pains to explain to the nun how she must assimilate the scenes from Jesus's life if she is fully to profit from them. Since he had evidently made a close study of visual images, his advice is of great importance for our knowledge of art made for private devotion in this period. The author deploys all his narrative skills in the stories of the Nativity and the Crucifixion, which take up more than half the book. The text also includes exhortations, consisting of extracts from the sermons of St Bernard of Clairvaux (1090–1153). This leavens the narrative with a fair amount of theology written by the man who, above all others, determined the direction of Late Medieval spirituality. The author also urges the Poor Clare to experience the events while she meditates, to transport herself into the story, as it were.

One may read the friar's comments about the *Adoration of the Magi* with the representation in the Rijksmuseum ivory in mind. He states that he does not intend to dwell on the Magi's wanderings before they finally found Christ. The nun must read that elsewhere. What he will do, though, is "recount a few meditations according to imagined representations, which the soul can comprehend differently, according to how they happened and how they can be credible in a holy manner". See how they kneel before Mary. They speak to her, and ask how the Child fares. Look at them, and look at the Virgin, "as, with great modesty in speech, her eyes always turned to the ground, she finds no pleasure in speaking much". The Franciscan evidently could not resist the temptation to weave in some rules of behaviour here, by making Mary the model for the humility required of conventuals. He has Mary worry about the fact that the Magi have brought such expensive presents. The accompanying miniature shows Mary giving them away to the poor, because she and her Child long to continue in their state of poverty (*fig. 1*).

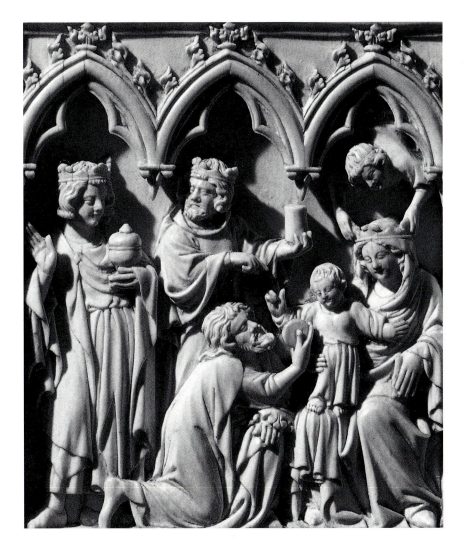

Detail of PLATE 1

All the urgings of the author of the *Meditationes* have a common thread, which is, "Go and stand beside them". Step into the story and look closely at each of the main actors, and above all kneel with the shepherds and the three kings. When the shepherds depart, the exhortations continue: "You, too, who lingered so long, kneel and adore your Lord God, and then His mother, and reverently greet the saintly old Joseph. Kiss the beautiful little feet of the infant Jesus who lies in the manger and beg His mother to offer to let you hold Him a while. Pick Him up and hold Him in your arms. Gaze on His face with devotion and reverently kiss Him and delight in Him. Then return Him to the mother and watch her attentively as she cares for Him assiduously and wisely, nursing Him and rendering all services, and remain to help her if you can."

PLATE 2
Jean le Tavernier (active in Oudenaarde ca. 1434–69)
The Adoration of the Magi, fol. 143v. from the Book of Hours of Philip of Burgundy, 1454
Vellum; 268 × 187 mm; late 15th-century binding

The Hague, Koninklijke Bibliotheek, Ms. 76 F 2

This urge to participate becomes almost obsessive in one of the finest illuminated manuscripts in the libraries of the Netherlands, the Book of Hours of Philip of Burgundy. Many of the drawings in the book feature the duke himself (PLATE 2). Beneath the Cross, by the altar, at the Virgin's feet – the donor is everywhere (*fig. 2*). In the case of the *Adoration of the Magi* it was simplicity itself to make the scene contemporary: just have yourself portrayed as one of them, or dress them in the costume of your own day. Both solutions were adopted by Jean le Tavernier, to whose workshop the miniatures are attributed. He also treated the setting as if there were no difference between a Bethlehem inn and one at Oudenaarde, where he worked. Joseph appears to have taken on the rôle of innkeeper. The result is a domestication of the traditional image of the *Adoration of the Magi*. The arrival of the three kings is shown at top left. In the foreground they are adoring the Christ Child, with their gold, frankincense and myrrh: the aged Melchior, kneeling before Mary, Balthasar behind him and on the left the young Caspar, in the guise of Philip, Duke of Burgundy.

The main reason for writing new versions of the Gospels was to meet the growing desire to give the Virgin greater prominence in the story of Christ's life. In the apocryphal gospels she occupies a central position between God and mankind. God chose her to be the mother of His Son, so the faithful ask her to represent them before God. But the same believers also share in all the emotions that Jesus's presence on earth aroused in her. Not only are her feelings theirs, but as the first person present at His Incarnation, she also becomes the vehicle for all the human emotions that He awakens. More than any other image, depictions of the Annunciation testify to the Mariological slant in the retelling of the Gospel story.

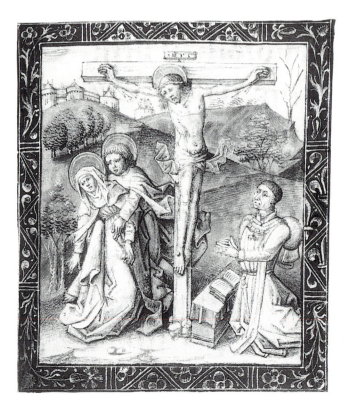

Fig. 2. Jean le Tavernier, *Philip of Burgundy kneeling beside the Cross*, from the Book of Hours of Philip of Burgundy, fol. 20r. The Hague, Koninklijke Bibliotheek

PLATE **3**

Master of the Modena Book of Hours (active in Lombardy ca. 1390–1400)

The Annunciation and *The Visitation*, fols. 13v.–14r. from the Book of Hours of Gian Galeazzo Visconti, also known as the Book of Hours of Isabella of Castile, Milan ca. 1400, completed in Spain ca. 1500

Vellum; 89 × 67 mm; 18th-century binding

The Hague, Koninklijke Bibliotheek, Ms. 76 F 6

One of the finest achievements of Late Medieval North Italian book illumination is an *Annunciation* datable ca. 1400 that occupies a full page in a Book of Hours commissioned by Gian Galeazzo Visconti (1351–1402), the powerful and expansionist Duke of Milan (PLATE 3). The manuscript was later taken to Spain and completed there, probably for Isabella of Castile (1451–1504). Despite its small size, the *Annunciation* is as impressive as it is ingenious. But is it an Annunciation? Surrounded by a mandorla of angels, God looks down on His handmaid. When Gabriel tells Mary that God will be sending His Son, it is as if Heaven is already present on earth. This is precisely in accordance with the version given in the *Meditationes*. Gabriel has to kneel before the Virgin, for through her exceptional virtue she has already summoned up the presence of the Holy Ghost on earth. Here Mary is not just God's instrument for the Incarnation; for anyone reading the *Meditationes* she is almost its cause. The dove of the Holy Ghost descends to overshadow the Virgin, which is how St Luke refers to her miraculous conception. But now that God has found the vessel through which He can send His Son down to earth, Heaven itself is once again in order, so the angels also have every reason to celebrate the reversal of the untold damage caused by the Fall of Man.

In this way, in the Late Middle Ages, the fairly straightforward story of the angel Gabriel bringing a message to Mary was transformed into a scene illustrating her central rôle in God's arrival on earth. When he entered, the angel spoke the words, "Hail Mary, full of grace". Originally that was a greeting, but now it had become the respectful confirmation of a fact. In the story told by the author of the *Meditationes*, Gabriel hurtled down to earth, "but his flight was not so swift that God did not enter before him, and thus the Holy Trinity was present, entering before His messenger". Gabriel kneels and utters the *Ave Maria* as a prayer. Countless worshippers have knelt to repeat it after him.

Scenes of the Annunciation created before ca. 1300 look extremely simple compared to the more complex and detailed representations made after that date. An early composition can be seen on the left shutter of the '*Vierge ouvrante*' in New York (PLATE 16), and in the ivory *Madonna* in Berlin (PLATE 23). It has the form of two figures standing side by side, one usually holding a banderole with the words "*Ave Maria*", and the other possibly with one reading "*Ecce Ancilla Domini*" (Behold the handmaid of the Lord). Here the Annunciation is still just one of the many scenes of Mary's motherhood. In later periods the angel kneels, the Virgin responds to him, and room is made for the Holy Ghost. The Nativity may have illustrated God's arrival on earth, but in time the Annunciation, too, became a scene of the Incarnation, with emphasis being placed on the conception, and hence on Mary herself. Eventually the Annunciation became the scene from the Gospels most often associated with the Madonna. In a triptych from Sassetta's workshop (PLATE 22), the kneeling angel and the humble Virgin are specifically related to her motherhood: the angel and she have become mandatory attendants to the central panel with the *Virgin and Child*.

To return to the Book of Hours of Gian Galeazzo Visconti: the *Annunciation* is depicted at the beginning of the Hours of the Virgin. God's mandorla of seraphim forms the initial D of "*Domine*", which is followed by the words "*labia mea apperies et*

PLATE **4**

Anonymous (Southern Netherlands)
Retable with *The Annunciation*,
ca. 1480–90

Oak and walnut, polychromed; centre
41.5 × 23.5 × 9.5 cm, wings 41.5 × 11.1 cm

Antwerp, Museum Mayer van den Bergh, cat. 2,
no. 2227

os meum annuntiabit laudem tuam". This is the text of Psalm 51,15: "O Lord, open thou mine lips; and my mouth shall shew forth thy praise". The first two Hours of the day, Matins and Lauds, deal with the Annunciation and the Visitation, both of which are depicted here. The Annunciation fills the entire folio, the Visitation the initial D of *Deus in adiutorium meum intende*. To the illuminator the "*Domine*" evidently evoked the majestic presence of God the Father at the Annunciation. He then gave his imagination free rein in the margin around the main image by presenting a visual narrative of all that befell the Virgin between the Annunciation and the Visitation. She went to visit her cousin Elizabeth, who despite her advanced age was pregnant with the future John the Baptist. The illuminator could not have taken the story of the journey from Nazareth to Jerusalem from the author of the *Meditationes*, for he relates that "she walked rapidly because she did not want to be long in the public view", let alone pause to rest beside a stream with two female companions. They do not feature in the *Meditationes* either, but are found in earlier versions of the story of Mary's motherhood. Joseph, here, is a bewildered old man who witnesses everything from a distance. The radiant Elizabeth welcomes Mary at the gate, and the cousins then, in the initial, fall into each other's arms. It is a moving and enchanting start to the Hours, lending substance and structure to the devotions to the Virgin.

Charged with so many new meanings, the Annunciation became eminently suitable for devotional purposes. One can join the angel in kneeling before Mary, full of grace. A small South Netherlandish retable from the end of the fifteenth century is a remarkable example of the way in which an artist could stage such a scene for the individual worshipper (PLATE 4). The retable is really nothing more than a small cabinet, and can be opened and closed like a diptych or triptych. As such, it formed part of the religious rhythm of everyday life: sometimes it was open, sometimes closed, depending on the times when prayers were said to the Virgin. This kind of small oak cabinet with sculptures turned the story into theatre. First one unveils the scene by opening the shutters. That task is then taken over by angels, who pull back the costly curtains around the tent in which the event is taking place. Winged figures opening the flaps of tents, pulling back curtains, or generally revealing something are common in antiquity. They create the impression that what they are disclosing is not always readily accessible, but is only revealed for a short time. Here the angels have flown down from Heaven to a clearly demarcated earthly setting, which looks like the choir screen in a church. They have come to display a sacred event. The person who opened the cabinet did not just witness the Annunciation by the angel, but experienced it personally.

Art history has paid little attention to dynamic elements like these angels, who greatly intensify the relationship between the image and the viewer. There has always been far more interest in static motifs that might have symbolic connotations. That is why we now know that the prominent, made-up bed in the background is a reference to the virgin birth of Jesus. The beautiful vase on the small table in the centre probably alludes to Mary, who is regularly likened to a vase in hymns and prayers. Gabriel's staff of lilies is a reference to Mary's purity. The locks of his hair streaming backwards show the speed with which he came flying in. Mary had been reading when he entered. The original purpose of including her book was to recall the prophecy of

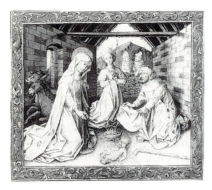

Fig. 3. Jean le Tavernier, *The Nativity*, from the Book of Hours of Philip of Burgundy, fol. 12r. The Hague, Koninklijke Bibliotheek

Isaiah, "Behold, a virgin shall conceive", but the author of the *Meditationes* suggests another meaning. On the authority of none other than St Jerome, one of the Fathers of the Church, he states that Mary had spent much of her life in prayer, and that she was holding a prayer-book. As the author intended, this interpretation made the Virgin a very suitable rôle-model for nuns. Some of the books that Mary holds in Annunciation scenes accordingly display the opening words of the Hours of the Virgin, which could be repeated by the worshipper 'off stage'.

According to the Gospels, Gabriel reassured Mary with the words, "Fear not". Medieval theologians concluded from this that she had been frightened, but needlessly so, for had her piety not brought her into frequent contact with angels? Thus her fear became yet another token of her humility. The maker of the retable did not follow the customary programme of showing Mary with her back to the angel when the angel appears. Her fright is expressed by the sudden twist of her body, which is accentuated by the folds of her cloak, and by the gesture she makes with her right arm. This pose turns her far more towards the viewer than was previously the case, when both she and the angel were seen in profile. The owner of this retable could project himself on to the figure of Gabriel uttering the words "Hail Mary", but could also follow the path of 'imitation' and become inwardly absorbed in Mary, to whom an angel appeared after long and intense prayer.

The artist also did his best to make the retable look as expensive as possible. Although there is no gold to gleam, since the cabinet is made of oak and the figures of walnut, the wood has a golden patina that suggests the use of the costliest materials. The unique pearl shape of the relief eyeballs was also undoubtedly inspired by the desire to make this *Annunciation* appear an extremely precious object. That, too, is the sole purpose of the opened shutters. Instead of the figures one would expect to find on them, there is ornate decoration in the form of a tissue of foliate patterns on a radiant gold ground. The ground is a little worn, revealing the underlying red bole that gave the gold leaf its warm sheen. The outside of the cabinet is painted with this red layer alone, with a stencilled floral motif on the shutters. It is almost inevitable that fragments are now missing from such a delicate object. The wings of three of the angels are missing, as is Gabriel's right hand. Originally, too, the Gothic trefoil arch above the tent probably contained the figure of God the Father. Nevertheless, this small retable is quite exceptional in that the original polychromy has survived almost intact. It reflects the golden glow of worship more strikingly than any other South Netherlandish figure group.

Depictions of the Nativity illustrate the way in which elementary scenes could be modified to give them a higher devotional content. In the Book of Hours of Philip of Burgundy (see p. 14) there is a *Nativity* in which all the main figures have been given new rôles (*fig. 3*). The props, too, have been changed: the bed has gone, making way for the detailed rendering of a stable. This forms the backdrop for the Virgin, who is adoring the Child. The ox and the ass have been moved aside. The shepherds remain in the background, but have been told the news by the angel, and participate in the Adoration at a respectful distance. Mary is the most important figure in the composition, and the Christ Child, naked and radiant at the lower edge of the picture,

is the central motif. Joseph also kneels, but he is too busy to adore the Child as fervently as Mary does. Joseph fans a fire with a lappet of his cloak in order to keep Jesus warm. There is more to this motif than meets the eye, for the flames of a fire signify purity, a key element of the virgin birth, so it is very fitting that Joseph should be the one to fan the fire.

In the centre, just behind Mary and Joseph, a young woman has joined in the Adoration. She is undoubtedly one of the two midwives who figure in apocryphal stories of the Nativity – probably Salome, who adores the infant Jesus after confirming that Mary is indeed a virgin. Here she is wearing contemporary dress from the region where the presumed illuminator, Jean le Tavernier, worked. This shows yet again how traditional scenes were updated in the Middle Ages by placing them in a contemporary setting. Joseph and Salome in jeans would nowadays give a very different look to a Christmas crib with figures in timeless dress.

The point about this scene is that the central fact of the Adoration is really the sole subject. The presence of Salome, not as a companion but as a fellow-worshipper, gave the owner of this Book of Hours a recognisable model for his own behaviour. He kneels facing her, and recites the prayer to which the scene is a visual accompaniment: "*Sancta Maria mater domini nostri Jesu Christi dulcissima in manus eiusdem filii tui dulcissimi et in tuas commendo hodie et in omni tempore animam meam*" (Holy Mary, most sweet mother of Our Lord Jesus Christ, I commend my soul into the hands of your most sweet Son, and into yours, now and forever). The reiterated "*dulcissimus*" indicates how sugary private worship could often be.

In the stories in the *Meditationes*, too, Mary is the first of the believers to worship the Christ Child. This is one of the scenes the Franciscan author added to the canon in order to increase the amount of prayer in the story. Even in the early fourteenth century there were scenes of the Nativity in which Mary's veneration of the Child had become the central theme. The best known and most influential story of Mary adoring the naked Child takes the form of a vision. In her *Revelations* of the third quarter of the fourteenth century St Bridget of Sweden (1303–1373), foundress of the Bridgettine Order, describes at length how she witnessed the Nativity. She saw "the glorious Child lying on the ground, naked and dazzling, His body free of all blemish or impurity" (fig. 4). It is generally assumed that the scene of Mary worshipping her child is due to these *Revelations*, which had a vast readership. In fact, that is unlikely. The interaction between text and image in that period is too complex for us to say that a text 'gave rise to' an image. Does the author of the *Meditationes* not refer explicitly to depictions as the source for his story? In a vision, in particular, one generally sees something 'really' happen which had already been illustrated elsewhere. Whatever the truth of the matter, St Bridget's vision was undoubtedly crucial for the popularity of this way of depicting the Nativity.

From the crib to the Cross, from the Low Countries to Italy. In Florence, at the beginning of the fourteenth century, there was a workshop that specialised in paintings for private devotion. The master, Bernardo Daddi, came from the *bottega* of

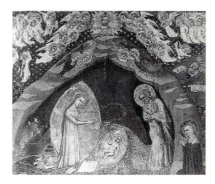

Fig. 4. Sano di Pietro (1406–1481), *The vision of St Bridget,* panel, ca. 1450. Rome, Musei Vaticani, Pinacoteca

PLATE 5
Bernardo Daddi (active in Florence ca. 1312–48)
Triptych, 1338

Centre: *The Crucifixion* and *Christ Logos*
Left wing: *The Nativity* and *The crucifixion of St Peter* (top)
Right wing: *The Madonna enthroned* and *The miracle of St Nicholas* (top)
Panel; centre 90 × 43.5 cm, wings 63.5 × 19 cm

Edinburgh, National Galleries of Scotland, inv. no. 1904

Giotto (ca. 1266/67–1337), where he had learned a new vocabulary of forms. One of the most beautiful and best preserved triptychs from his studio is now in the National Galleries of Scotland (PLATE 5). Its central scene is the *Crucifixion*. Although probably too large for the purposes of private devotion, it is too small to have been an altarpiece in a Florentine church. It seems likely that it was intended for the 'collective private devotions' of a confraternity, and that it stood on the altar in the brothers' chapel. One such triptych by Bernardo Daddi, of roughly the same size, still adorns the altar of the Bigallo Chapel in the very centre of Florence.

The left wing contains a touching scene of the *Nativity*, with Mary very tenderly laying her swaddled Child in a bed of straw as angels look on. This provides a good illustration of how much Daddi had profited from Giotto's manner of spatial composition. By structuring the scene in depth he has given all the main actors independent life and meaning. The viewer is led to Mary and Jesus by way of Joseph and the shepherds. The scene on the right wing is very different, but the same principle applies. The eye is guided by the foreground figures, Sts Peter and Paul, to the Virgin and Child on a throne flanked by St John the Evangelist on her right and St Nicholas on her left. In the upper register of the left wing is the martyrdom of St Peter, who is being crucified upside down. At the top of the right wing St Nicholas is performing the miracle of the three golden balls: an impoverished butcher has decided to chop up his three daughters in order to save his business, but one night, while the butcher and his daughters are asleep, St Nicholas throws three balls of gold through the open window, thus saving the girls from their dreadful fate.

In the pinnacle above the central panel Christ is giving the blessing with a book in His hand. Here He is the Logos, the Word made flesh as described by St John. Below Him is a *Crucifixion* in an elegant Gothic trefoil minutely outlined by the delicately ornamented surround. On the cross is the provocative inscription: "This is Jesus, King of the Jews". The presence of Christ Logos in the medallion gives the crucified Christ His theological and liturgical significance: He is offering Himself up as a sacrifice. The height of the cross removes Him from all the human turmoil taking place below. Emotional reactions like the Virgin's swooning and the apostle's upraised hands remain isolated; Christ is too distant. The only way of making contact is by looking up at the Redeemer on the cross, and it is here that Bernardo Daddi demonstrates his mastery of figures gazing upwards: Mary Magdalene at the foot of the cross, to the right of her Stephaton, the young man with a sponge soaked in vinegar attached to a cane, in the left background two remarkably individualised horsemen, and on the right the centurion, with outstretched arm, who is proclaiming, "Truly this was the Son of God".

The most extraordinary figure is the unidentifiable man standing beside the centurion. Craning his neck and shading his eyes he gazes up at the cross, bridging the distance between himself and Christ. There is probably no *Crucifixion* in which so many people are staring upwards. This could mean that the two standing figures indicate the way in which the fourteenth-century viewer of the triptych could enter into a visual relationship with his Saviour. The compositions of the *Nativity* and the *Madonna enthroned* on the wings also suggest that the triptych stood on a small altar, with the

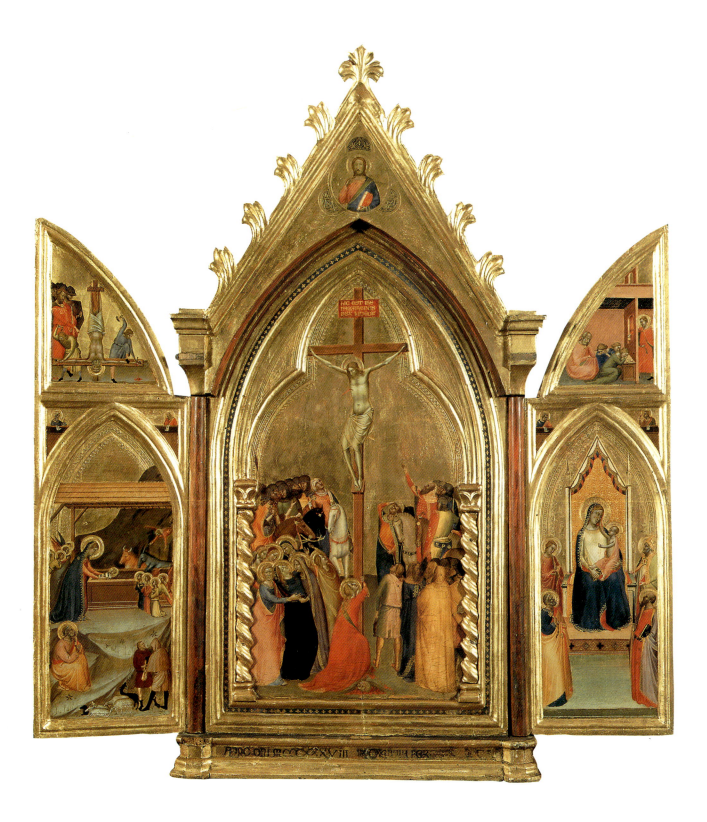

Fig. 5. Workshop of Duccio di Buoninsegna
(ca. 1255–1318/19), triptych, ca. 1310–15.
Boston, Museum of Fine Arts, Grant Walker and
Charles Potter Kling funds

beholder kneeling and looking up at it. Giotto and his pupils, in particular, took the
viewer's position into account in their new ideas on figures within a picture space.

This *Crucifixion* is not only interesting for the figures gazing up at a distant Redeemer,
but also for their spatial arrangement. For comparison we can turn to a triptych of
roughly the same size from the workshop of the great Sienese artist Duccio, which
dates from the beginning of the fourteenth century (*fig. 5*). Here Christ is closer to the
people, who are packed close together on either side of the cross, in the Byzantine
fashion. Individuals stand out from the mass by colour and gesture, not by their
position. Although Bernardo Daddi took a close interest in Sienese painting, he is a
totally different artist in his handling of crowds. Instead of a flat composition, he
creates depth by placing the figures all around the cross. He clearly seized on the
opportunity to demonstrate his skill in this respect, showing people from the back, and
foreshortening horses. The result is that each figure or group takes on its own
significance. It is as if Daddi had designed a Calvary where the figures could be
arranged around the Cross one by one and in small groups.

This new arrangement of the figures below the cross also has a conceptual significance,
transforming a general scene of redemption into an event that the viewer experiences
by sharing the reactions of the onlookers. In the account of the Crucifixion in the
Meditationes, the spotlight falls on each one in turn, and on the Virgin no fewer than
three times, for her heart was thrice pierced by a sword for the tortures inflicted on her
Son. These inner torments won her the martyr's palm, despite the fact that she was
physically unharmed. The reader of the *Meditationes* and the viewer of Daddi's
Crucifixion experience the event through the intense emotional response of Mary
Magdalene, and feel with the centurion as faith dawns. The two crowds at the foot of

the cross, which Italian artists adopted from Byzantine art, were personalised by Bernardo Daddi, who gave them individual reactions. However, the most striking feature of this Mount Calvary is the way in which everyone is staring up at the crucified Christ, pinned against the ornate gold background.

The fourth scene in the Rijksmuseum's ivory diptych (see PLATE 1) is a *Last Judgment*, which catches the eye because Christ is seated on the citadel of Paradise, celestial Jerusalem. The Resurrection, Ascension and Descent of the Holy Ghost have been omitted. However often they were depicted in the Late Middle Ages, they were not stories that played a great rôle in private devotion. By far the most beautiful of the many ivory diptychs of the Last Judgment is a thirteenth-century example in The Cloisters in New York (PLATE 6). Few deep-cut ivories with this degree of refinement have come down to us. The figures are separate little sculptures set in deep recesses, with angels swinging censers in the spandrels above the Gothic arches. That detail alone shows that the artist was familiar with Victories from classical sculpture. On the right is the *Last Judgment*, with the 'arma Christi' (the instruments of Christ's Passion), the Virgin and St John, who intercede with Christ on his Judgment seat. Below Him, angels are blowing trumpets to raise the dead, and on the right the damned are being forced into the jaws of Hell. At the bottom of the left panel, the redeemed souls are being guided to the ladder leading to Heaven. The monk takes precedence over the monarch, for that was the order prevailing in the kingdom of God. Above is the *Coronation of the Virgin*.

Of all images, the Last Judgment was the one that underwent the greatest transformation when transferred to the private domain. Christians originally lived in expectation of their Lord, who could return at any moment. Life here on earth, and in particular the community of the faithful, could only be ordered on a provisional basis, otherwise it would impede the prospect of the Second Coming. But Christ did not come, and that in itself allowed the Church to become increasingly institutionalised. The process was completed by the beginning of the thirteenth century, by which time the Church had become the channel to salvation by virtue of its ability to make Christ available, as it were, in the sacrament of the Eucharist. The Church, as an institution, had taken charge of the future of the faithful. Monumental sculpted scenes of the *Last Judgment* and the *Coronation of the Virgin* adorned the portals of cathedrals. All entering the consecrated building knew that they were being given a foretaste of the kingdom of Heaven in the most literal sense of the word.

The person who commissioned The Cloisters' ivory around 1260, probably a French monk, brought the monumental scenes from cathedral doors into the privacy of his own living-quarters. This instantly transformed their nature. Scenes that had initially had a general significance, even if they undoubtedly reminded worshippers of the salvation of their own souls, were now being made to accompany the prayers of a single individual. That change of function is also reflected in the scene itself. Christ is no impassive judge: His raised hands denote compassion. He breaks free of His rigid frontal pose, and leans towards the Virgin, as if responding to her mediation. In the *Coronation*, the Virgin is no longer the symbol of the Church, of which the glory is

PLATE **6**
Anonymous (France)
Diptych, ca. 1260–70

Top: *The Coronation of the Virgin* and *The Last Judgment*
Bottom: *The Ladder to Heaven* and *The Raising of the dead and the Jaws of Hell*
Ivory; wings 12.4 × 7 cm

New York, The Metropolitan Museum of Art,
The Cloisters Collection, inv. no. 1970.324.7a-b

affirmed in Heaven, as in monumental medieval art; she is now the bride of Christ. At her glorification it is the lovers' language of the Song of Songs that is used to indicate the relationship between Jesus and Mary. She is the symbol of the soul that partakes of heavenly bliss. Despite the fact that she is being crowned by an angel, she has no regal air about her. Even now, she remains sunk in prayer before her groom.

The monk heading the procession up the ladder to Heaven tells us something about the life of prayer in monasteries that is too often forgotten in romanticised descriptions of conventual life: even in the spiritual world people were working to earn their place in Heaven. The great preachers of the thirteenth-century mendicant orders, the Dominicans and Franciscans, used the Last Judgment to remarkable effect in the sermons they gave for the moral instruction of the citizenry in the churches and on the squares of the new cities. Those delivered in the vernacular on the Campo in Siena by St Bernardino (1380–1444), the great Franciscan preacher, were jotted down in shorthand on a wax tablet by a loyal supporter. "You there", he would call out across the crowded square, "If you don't mend your ways it will be the worse for you." The Apocalypse, the visions of St John on Patmos, was comminatory, spurring people on to acts of charity, penitence and prayer. This ivory diptych did the same, as well as holding out the promise that prayers would be said for you at the Last Judgment and in Heaven.

Much later, in the fifteenth century, the idea of death came to dominate the religious atmosphere entirely. Among the brothers of the Common Life, devotionalist followers of Geert Grote (1340–1384), the preferred readings were about death, Hell, Heaven and damnation. The writings of Thomas à Kempis (1379/80–1471) are imbued with a melancholy that is sometimes well nigh unbearable. He only needs to look up at God to realise that life here on earth is worthless, and will never amount to anything. And when he looks about him he comes to the same conclusion: death and misery are all around us. We hear of a brother of the Common Life in Zwolle who desecrated a grave in order to obtain the skin of another brother who had recently died. He planned to make it into a shirt so that it would constantly remind him of death. The diptych in The Cloisters did not originate in that all-pervasive atmosphere of outright contempt for the world. But by exposing the viewer to judgment and death, Heaven and Hell, it undoubtedly encouraged the original owner to address prayers to the Virgin, asking her to intercede to ensure that he did not disappear into the maw of Hell, but would instead be quite near the head of the queue to mount the ladder.

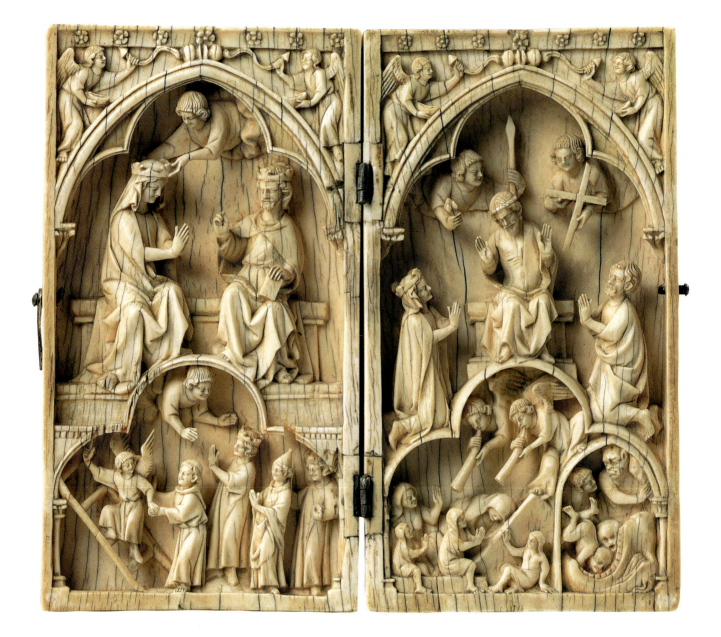

PLATE **7**
Attributed to Hans Paur
(documented in Nuremberg
1445–72)
The Martyrdom of St Sebastian,
ca. 1472
Woodcut, hand-coloured; 255 × 182 mm

Munich, Staatliche Graphische Sammlung,
inv. no. 118258

Saints are the heroes of the Middle Ages, but they cannot be regarded as the natural descendants of the classical heroes. Most were historical figures – martyrs and ascetics – and it was historical fantasy that turned their lives into hagiographies. Saints lead to God. Classical heroes, on the other hand, are mythical and thus unhistorical. They often fought with their gods, and gained their own identities through their struggles. Criteria evolved in the Middle Ages to enable the Church to decide, in a canonisation process, who qualified as a saint and who did not. In the fourteenth and fifteenth centuries the Church authorities were overwhelmed with petitions for canonisation. A city gained considerable prestige if it had native-born saints, and advocates were set to work extolling the religious virtues of local holy men and women with the aim of having them canonised. Even if that failed, many were beatified, placing them just one rung lower on the ladder to God. Leading families became embroiled in the most byzantine intrigues in order to have a pious relative admitted to the Christian pantheon. Monastic orders suffered identity crises if they failed to produce enough saints from their own ranks as advertisements for the quality of religious life they offered.

Saints were venerated in the first place by the pilgrimages made in order to view their relics. The medieval worship of relics stimulated tourism, and the travellers brought back images as souvenirs of their journey. The depiction of a saint also enabled those who had not been on a pilgrimage to feel that the saint was nevertheless close at hand. Images of saints were produced in every sort and size, and in order to meet the growing demand numerous impressions were made from the same wood-block. The lives of most of the saints were related in the Late Medieval 'bible of saints', the *Legenda Aurea* or *Golden Legend*, which was written around 1280 by the Archbishop of Genoa, Jacopo da Varazze (otherwise known as Jacobus de Voragine, ca. 1228–1298), who relates the lives in the order of the liturgical calendar.

One of the most venerated saints was Sebastian, an officer in the bodyguard of the Roman emperor Diocletian (245–313). One day the emperor discovered that Sebastian was a Christian, and demanded that he abjure his faith. When Sebastian refused he was condemned to death and taken to the Colosseum, where his body was riddled with arrows. According to one version of the legend, he was still alive when he was untied from the stake. He was nursed back to health, and when he next saw the emperor he upbraided him for his cruelty. Again he was seized, and this time he was clubbed to death. This kind of accretion is typical of the way in which stories of martyrs were embroidered throughout the Middle Ages. With God's help martyrs withstood the most terrible tortures, enabling the hagiographer to dwell lovingly on the mounting sadism of the heathen executioners. It should be remembered, though, that torment was the crown of a martyr's life, the climax of his or her 'imitation of Christ'. St Lawrence, for instance, when he was being roasted alive (see PLATE 35), politely asked if he could be turned over, so as to cook his other side. That too, of course, is a later addition to the original text of the martyrology.

Around 1475 the Nuremberg map-maker Hans Paur made a woodcut of St Sebastian, with two prayers at the bottom that reveal why the saint was so popular (PLATE 7). The first reads: "O blessed Sebastian, how great is thy faith. Pray for me, thy servant, to Our Lord Jesus Christ, that I may be spared the malady [of the] ravages of the plague.

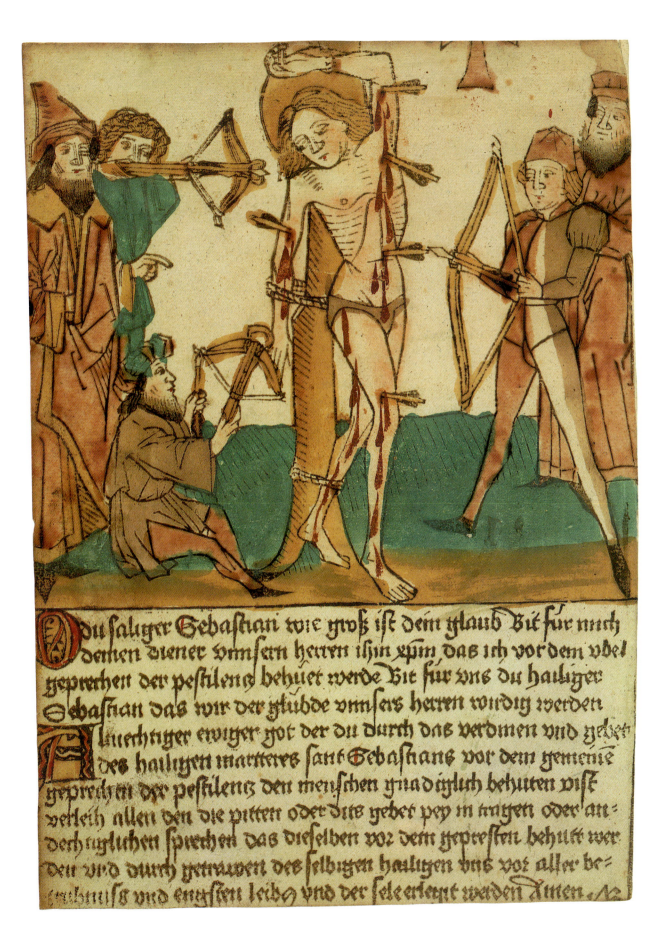

Odu saliger Gebastian wie groß ist dein glaub Bit für mich
deinen diener unsern herren ihin xpm das ich vor dem vbel
geprechen der pestilentz behuet werde Bit für uns du hailiger
Gebastian das wir der gnade unsers herren wirdig werden
Almechtiger ewiger got der du durch das verdinen und gebet
des hailigen marteres sant Gebastians vor dem gemeine
geprechen der pestilentz den menschen gnadiglich behuten vist
verleih allen den die pitten oder dis gebet pey in tragen oder an
dern taglichen sprechen das dieselben vor dem gepresten behuett wer
den und durch getrauwen des selbigen hailigen uns vor aller be
rubnuß und engsten leichs und der sele erlest werden Amen

29

PLATE 8
Master of the Amsterdam Cabinet (active Upper Rhine ca. 1470–1500)
St Sebastian with archers,
ca. 1475–80

Drypoint (unique impression); 129 × 192 mm

Amsterdam, Rijksmuseum, Rijksprentenkabinet, inv. no. RP-P-OB–904

*O du saliger Sebastian, wie groß ist dein glaub. Bit für mich deinen diener unsern herren Jesum Christum, daß ich vor dem ubel [des] geprechen[s] der pestilencz behüet werde. Bit für uns, du hailiger Sebastian, daß wir der glübde unsers herren wirdig werden.

Pray for us, holy Sebastian, that we may be worthy of the vow to Our Lord."* St Sebastian's remarkable recovery from the wounds left by the arrows had made him a patron saint of those menaced by the plague. If one remembers that outbreaks of plague often wiped out more than half the population of a city, one can well imagine the intensity and frequency of prayers to the saint. The believer used St Sebastian as a conduit to God, whose protection he sought. That is also the saint's rôle in prayers in Books of Hours.

In addition to woodcuts there were images of saints of a very high artistic quality, such as the rare drypoint prints by the Master of the Amsterdam Cabinet (also generally known as the Housebook Master), active in the Rhineland. Interestingly, the master depicts Sebastian's body free of arrows (PLATE 8), despite the aggressive posture of the two executioners. Italian painters had formerly shown Sebastian in the same way, because he gave them a good excuse to portray the beauty of the male nude. Another northern example of Sebastian depicted as a beautiful, naked young man is in an engraving by Martin Schongauer (*fig. 6*), and it is quite possible that the Master of the Amsterdam Cabinet was familiar with Schongauer's print when he made his own drypoint.

A saint possibly even more popular than Sebastian was St Christopher, the patron of pilgrims and travellers. He was a giant, and the *Golden Legend* tells how he wished to put his strength at the service of the most powerful king on earth. A hermit advised him to serve Christ by carrying pilgrims on his back across a swift-running river, which he could ford easily, thanks to his size. One night a child appeared and asked Christopher to carry him to the far bank. The giant set out surely enough, but only reached the other side with the greatest difficulty, for the child, "who bore the weight of the whole world upon his shoulders", grew heavier and heavier with each step. It

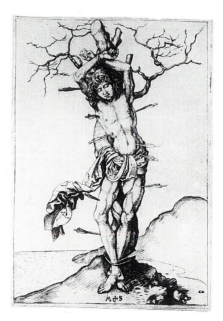

Fig. 6. Martin Schongauer (active 1465–91), *St Sebastian*, engraving, ca. 1475. Amsterdam, Rijksmuseum, Rijksprentenkabinet

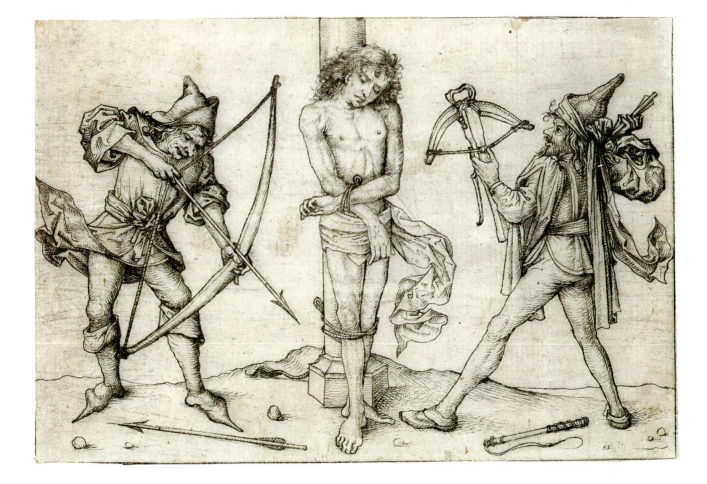

PLATE 9

Anonymous (Lake Constance region?)

St Christopher with the Christ Child, ca. 1430–40

Woodcut (unique impression), hand-coloured; 283 × 201 mm

Berlin, Staatliche Museen zu Berlin, Preußischer Kulturbesitz, Kupferstichkabinett, inv. no. 120–1908

was only the following morning that Christopher realised who his passenger had been, when from his staff, which the child had told him to plant in the ground, a date palm blossomed. In a fourteenth-century rhyming German version of the saint's life, green leaves start sprouting from his staff even while he is crossing the river. A Bavarian woodcut of ca. 1430/40 accentuates the rugged muscularity of this gigantic saint (PLATE 9; see also PLATE 43f).

There is a great difference between Sebastian and Christopher. The first was a real person, an early Christian martyr whose relics are preserved in Rome and Soissons, whereas the other was a fairy-tale figure who inevitably gave rise to superstitions, one of which impinged directly on the function of images of him. Not only was Christopher the patron saint of pilgrims and travellers, he also protected people from dying suddenly without receiving the last rites. This was known as the *mala mors* or 'bad death', for without the sacrament it was impossible to enter Heaven. It was believed, though, that you would safely reach the other side if you had looked on an image of the Christian Hercules that day.

One thing that Sebastian and Christopher have in common is that their popularity was waning by around 1500; Sebastian because improvements in hygiene made outbreaks of the plague less frequent, and Christopher because he was an easy target for humanists and reformers. In addition, when archery was reduced to a recreational activity, Sebastian ceased to be a patron of the civic guard guilds. Christopher remained the saint who kept an eye on travellers, particularly car drivers, even after he was removed from the liturgical calendar at the Second Vatican Council in 1963. In Paris, incidentally, there is still a church dedicated to him – near the Citroën plant.

Barbara and Catherine were the most popular of the female saints. The Master of the Amsterdam Cabinet made two small prints of them in which they appear as courtly figures (PLATES 10a and 10b). Both were indeed of gentle birth. Barbara, who lived in the third century, was the beautiful daughter of a rich heathen. In order to protect her from the world he had her locked up in a tower. However, she managed to receive regular visits from a Christian, and after some time was baptized. Her father discovered this when she insisted that the tower should have three windows in honour of the Trinity. Enraged by her refusal to recant, he seized his sword and struck off her head, thus gaining her the palm of martyrdom. In the print she is shown with her attribute of the tower with three windows. Above the door is a chalice, for like St Christopher she was invoked as a protectress against a 'bad death'.

The print of St Catherine was certainly intended as the companion to that of St Barbara, although the consoles on which they are standing are not seen from the same vantage-point. They were often depicted in tandem, with Barbara representing the active life and Catherine the contemplative. According to tradition, Catherine was a princess living in Alexandria in Egypt at the beginning of the fourth century who converted to Christianity. The emperor Maxentius (ca. 280–312) fell in love with her, but was enraged when she told him that she considered herself the bride of Christ. He gathered together fifty heathen philosophers to persuade her to renounce her faith. Catherine, however, combined brains with beauty, and she converted them all. The

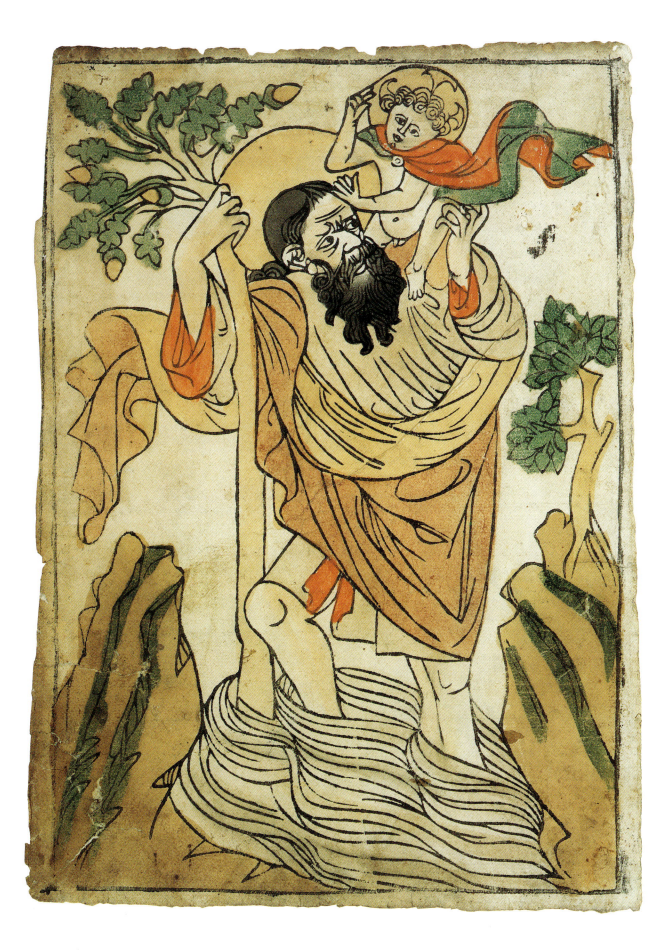

PLATE **10a**

Master of the Amsterdam Cabinet (active Upper Rhine ca. 1470–1500)

St Barbara, ca. 1485–90

Drypoint (unique impression); 120 × 40 mm

Amsterdam, Rijksmuseum, Rijksprentenkabinet, inv. no. RP-P-OB–907

PLATE **10b**

Master of the Amsterdam Cabinet

St Catherine, ca. 1485–90

Drypoint (unique impression); 119 × 38 mm

Amsterdam, Rijksmuseum, Rijksprentenkabinet, inv. no. RP-P-OB–908

emperor condemned them to the stake, and ordered Catherine to be put to death by wheels studded with sharp blades and teeth. An angel, however, intervened to prevent this, whereupon Catherine was beheaded. That is why, in addition to the palm branch, she has the attributes of a wheel and a sword. This kind of small print of a favourite saint could easily be kept in a prayer-book.

St Dorothy was another of the important female saints, and the three were often shown together. The print of Dorothy that has been chosen here is a large hand-coloured woodcut from Bavaria (PLATE 11). Although this splendid devotional prayer-card must be dated around 1410–25, the saint is almost Art Nouveau in appearance. Dorothy had a particularly poetic legend. Like St Sebastian, she was condemned to death by Emperor Diocletian. On the way to the place of execution, a lawyer called Theophilus mockingly asked her to send him flowers and fruit from Paradise. Dorothy promised that she would. When she knelt to say a final prayer, a little boy suddenly appeared beside her. He offered her a basket with fruit and roses that were already in bloom, even though it was mid-winter. Dorothy asked him to give it to Theophilus, who became a Christian after her execution and was later martyred in his turn. Dorothy, needless to say, became the patron saint of gardeners and flower-sellers, and the woodcut shows her with the flowers that are forever associated with her name.

One of the most interesting saints is Jerome (ca. 342–420), because he led a life that enabled very different groups of believers to venerate him. There are only a few surviving depictions of St Jerome intended for private devotion. The most refined of them is the work by Lorenzo Monaco in the Rijksmuseum, which is datable around 1420 (PLATE 12b). It forms part of a diptych, accompanying a Madonna of Humility (PLATE 12a; see further p. 94). Pietro di Giovanni, as Lorenzo was known in the secular, was born in Siena, and in 1390 entered the Camaldolese monastery of Santa Maria degli Angeli in Florence. At the beginning of the fifteenth century he was regarded as the most important painter in the city. His style is defined in art historical terms as International Gothic, typified by figures delineated by the flowing lines of the draperies. Lorenzo deployed the idiom with extraordinary delicacy. Unlike many other painters of the International Gothic, he had a natural talent for monumental figure compositions. Even on the small scale of this painting he has created a figure that dominates the picture surface. What is even more remarkable is that he succeeded in combining the saint, the lion and the study into a single convincing image.

Jerome was not a great miracle-worker or preacher, nor did he die for his faith after harrowing torments. He earned his saintly status by translating the Bible into Latin from Greek and Hebrew. That is why Lorenzo has portrayed him in a study. The lectern has two shelves, one holding the book to be translated, the other the translation. St Jerome ranks second in the hierarchy of the Fathers of the Church, and as a cardinal, despite the fact that the office of cardinal was unknown in his own day. That is how he is usually depicted, although Lorenzo preferred to show him as a monk. Jerome's red cardinal's hat can be glimpsed hanging behind the right-hand lectern.

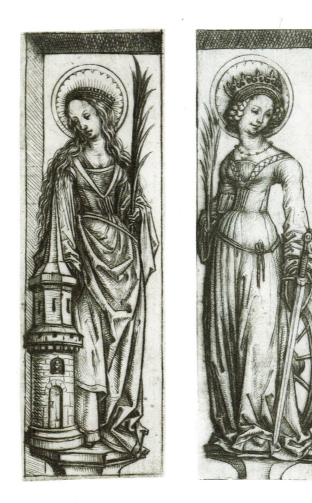

PLATE **11**

Anonymous (Bavaria)

St Dorothy, ca. 1410–25

Woodcut (unique impression), hand-coloured;
271 × 197 mm

Munich, Staatliche Graphische Sammlung,
inv. no. 171506

PLATE **12**

Lorenzo Monaco (Siena ca. 1372 –
Florence 1424)

Diptych, ca. 1420

Left (a): *The Madonna of Humility*
Right (b): *St Jerome*
Panel; wings 22.8 × 17.8 cm (a), 23 × 18 cm (b)

(a) Copenhagen, Thorvaldsens Museum, inv. no.
B 1
(b) Amsterdam, Rijksmuseum, inv. no. SK A 3976

Church dignitaries, of course, could readily identify with St Jerome, so much so that from the mid-fifteenth century they actually had themselves portrayed as him. Here, though, he is shown as an ascetic. Jerome started out as a classical scholar, but when an angel appeared to him in a dream and asked, "Do you belong to God or to Cicero?", he withdrew into the Syrian desert to practise renunciation of the world. Returning to Rome to translate the Bible, he savagely rounded on the clergy there, whom he accused of living in scandalous hypocrisy and luxury. In 385 the authorities found him so troublesome that he was forced to leave the city. He went to the Holy Land, where in 389 he founded a monastery near Bethlehem, for which he drew up a strict rule. It is for that reason that monastic reformers in the Middle Ages regarded St Jerome, rather than St Benedict (ca. 480–ca. 547), as the founder of monastic life in western Europe.

One day, according to Jacobus de Voragine in the *Golden Legend,* a lion walked into the monastery. Wild animals were not uncommon in the desert near Bethlehem, indeed those who truly renounced the world and withdrew into the desert were able to live in harmony with wild beasts, be they snakes, scorpions or lions. But what was true of St Jerome did not apply to his brethren. "One day, as evening was drawing on, and Jerome sat with the brethren to hear the sacred lessons, suddenly a lion came limping into the monastery. At the sight of him all the other monks fled, but Jerome went forward to meet him as a host his guest. The lion then showed him his wounded foot, whereupon he called the brothers and ordered them to wash the lion's feet and to dress his wound with care. When they did this, they found that the lion's pads were wounded by thorns." Jerome healed the paw, and the animal remained in the monastery as a pet. What Jacobus does not point out is that the removal of a thorn from the flesh of a wild animal can also be interpreted in a symbolic sense as a reference to the chastity embraced by Jerome and his followers. The fact that Lorenzo chose not to depict this particular story, but to isolate the removal of the thorn and turn it into a devotional moment, makes the image an emblem of chastity for those praying before it.

More than a century separated Jacobus de Voragine from Don Lorenzo, and in that time there had been a successful campaign to increase the popularity of St Jerome. It was directed from the university city of Bologna, and was masterminded by the lawyer and humanist Giovanni di Andrea (died 1348). Giovanni's intense devotion manifested itself in many ways. He himself celebrated Jerome's feast-day with great pomp. He saw to it that as many children as possible were baptized Gerolamo, which was also the name that he encouraged monks to take on entering a monastery. He composed sermons from the saint's writings, and wrote prayers to Jerome, which he distributed among his friends. He decreed how the saint was to be portrayed: sitting in his study, with his hat or the lion nearby. He had the entire story of Jerome's life depicted in his house. He dedicated a chapel to him in Bologna Cathedral, and set up a fund to pay for regular Masses. He ensured that a new Carthusian monastery near Bologna was named after the saint. He paid for the writing of a special office so that Masses specifically honouring Jerome could be said. Wherever he went he founded altars for his saint, and was constantly on the lookout for relics. No one did more than Giovanni di Andrea to ensure the mass popularity of St Jerome in the fifteenth century. His campaign shows that while public veneration led to individual worship, private devotion could also have a major effect on public worship.

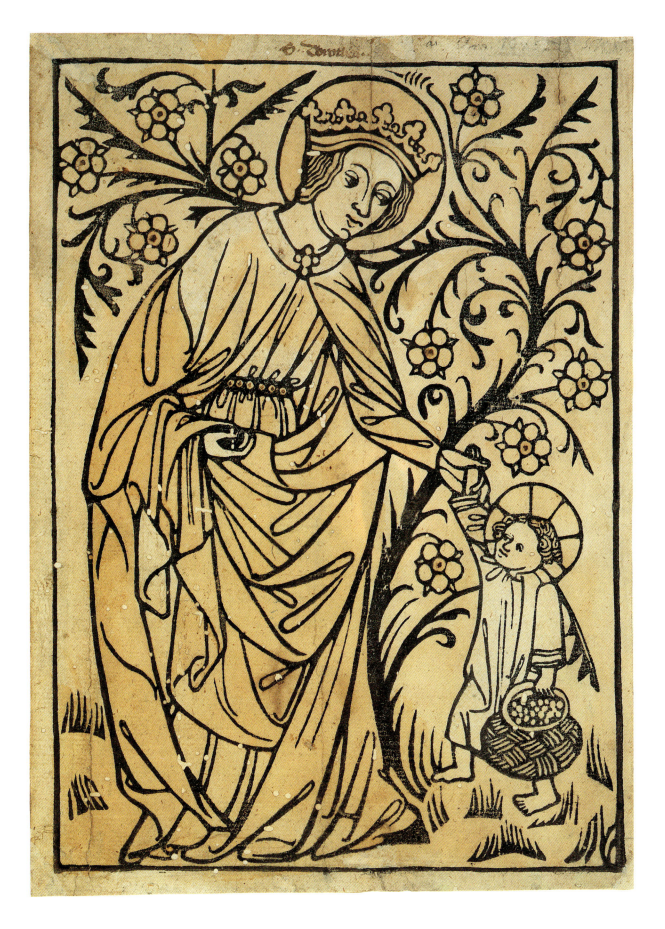

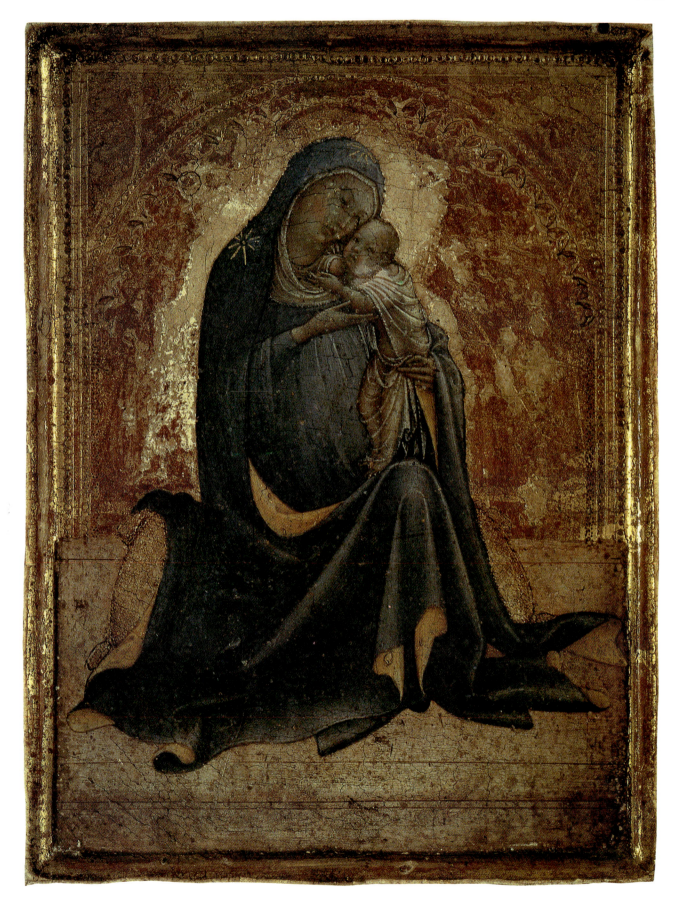

PLATE **12b**

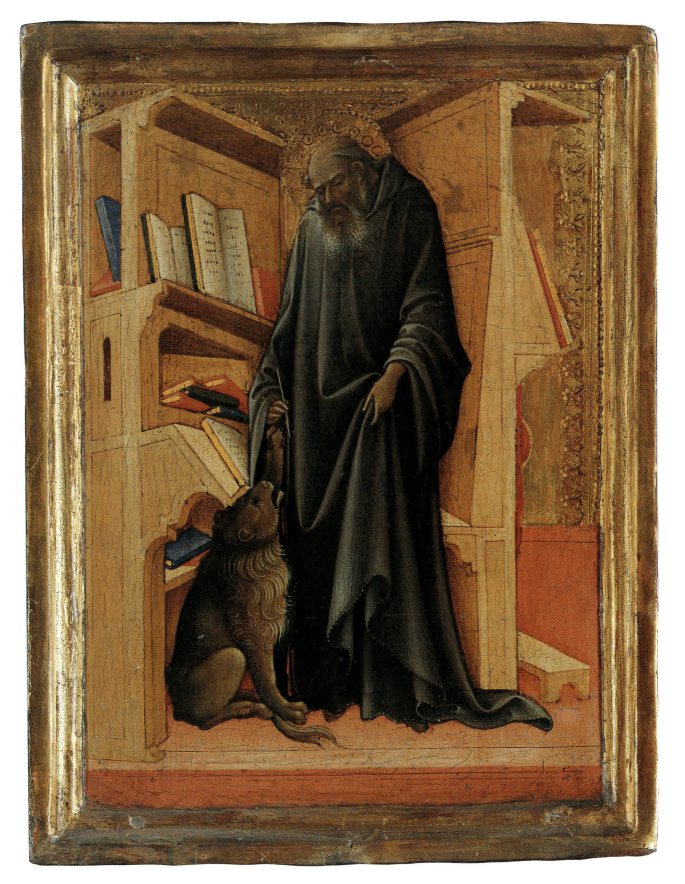

PLATE 13
Dieric Bouts (Haarlem
ca. 1410/20 – Louvain 1475)
Christus Salvator Mundi, ca. 1450
Panel; 36 × 27 cm

Rotterdam, Museum Boymans-van Beuningen,
inv. no. 2442

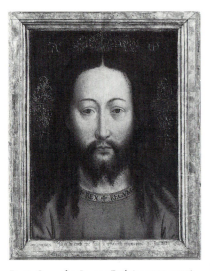

Fig. 7. Copy after Jan van Eyck (ca. 1390–1441),
Vera icon, panel. Berlin, Staatliche Museen zu
Berlin, Preußischer Kulturbesitz, Gemäldegalerie

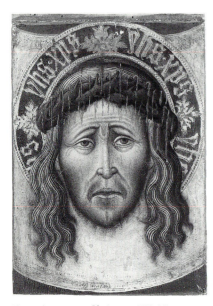

Fig. 8. Anonymous, Venice, ca. 1450–75, *pace*
with the sudarium of St Veronica. Amsterdam,
Rijksmuseum

So far we have considered narrative scenes or depictions of figures that tell their stories by characterization – by the dress, setting and attributes. However, there are also scenes that have no need of these elements in order to fulfil their rôle as devotional images. They are the portraits of Jesus and Mary. Stories are attached to them too, of course, but merely to serve as a guarantee of authenticity. Many of them are the most far-fetched fables imaginable, and there is no space to discuss them all here. Suffice it to relate the tale that is associated with a type of portrait represented in the Boymans-van Beuningen Museum in Rotterdam (PLATE 13). It was painted in the mid-fifteenth century by Dieric Bouts. There is a whole series of small pictures of this kind by Bouts and his pupils, and it is generally assumed that the portrait of Jesus in Rotterdam is the earliest of the group. Some decades before, Jan van Eyck (ca. 1390–1441) had painted exactly the same type of portrait (*fig. 7*). Numerous replicas were made of that painting until into the seventeenth century, and it is now known only from those copies. If there was one area in which the desire for artistic innovation was subordinated to religious function, then it was in the depiction of sacred faces.

The story told by this portrait is found in the *Vita Christi* by Ludolphus of Saxony (ca. 1295–1377). His account of the life of Christ broadly corresponds to that in the *Meditationes Vitae Christi* discussed on p. 12. In northern Europe, Ludolphus's story was by far the most widely read life of Christ in the Middle Ages. His source was a text that was considered highly authoritative at the time, the so called *Letter of Lentulus*, in which one Publius Lentulus gave a description of Christ to the Roman Senate: " . . . having a reverend countenance which they that look upon may love and fear; having hair of the hue of an unripe hazelnut and smooth almost down to his ears . . . waving over his shoulders; having a parting at the middle of the head according to the fashion of the Nazareans; a brow smooth and very calm, with a face without wrinkle or any blemish . . .; having a full beard of the colour of his hair, not long, but a little forked at the chin." It later turned out that the *Letter of Lentulus* was written no earlier than the thirteenth century, which says something about the Late Medieval longing for a description of Christ's actual appearance. The importance that was attached to painted portraits of Christ is demonstrated by the inscriptions on two copies after paintings by Jan van Eyck. The earlier states that the artist "painted and completed me on 31 January 1438". Van Eyck, in other words, was signing as if he had painted the likeness of a living person, which was evidently meant to vouch for the authenticity of the portrait. On the later version Van Eyck describes himself as the "*inventor*", and adds his motto: "*[zo goed] als ikh kan*" (As best I can). Here again he shows himself to be a master in the depiction of reality, in this case the holy face of Jesus.

Portraits of Christ must have hung in countless Flemish homes. It is all the more remarkable that in Italy, which had the greatest output of images for private devotion, there was evidently little demand for this type of picture. There are only a few painted heads of Christ known in Italian art, and most were used as a *pace*, a small dish on which the host was proffered at Communion. So at the most personal moment in the celebration of the Mass, when the worshipper partook of the body of Christ, he was able to look his Saviour in the eye for a moment (*fig. 8*). Italians seem to have been less interested in paintings that looked 'real'.

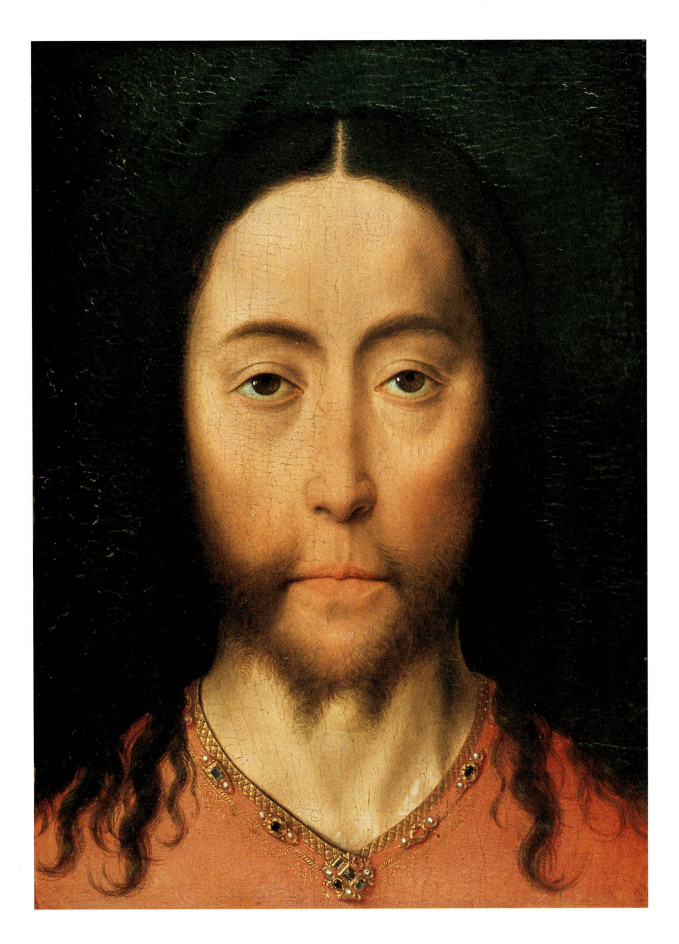

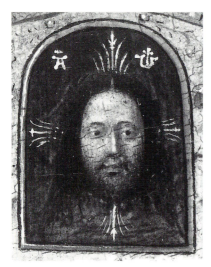

Detail of *fig. 9*

There is abundant documentation on the use of portraits of Christ during prayer. There is even a striking visual document: a portrait of a young man by Petrus Christus, with a devotional print with a portrait of Jesus on the wall behind him (*fig. 9*). The text is an abbreviated version of the familiar prayer, *Salve sancta facies*. Closer examination of the print reveals that this is a different kind of portrait of Christ, without the neck and shoulders. It is an allusion to another type, namely the miraculous impression of Christ's face on St Veronica's cloth (or vernicle). Veronica herself is something of a mystery. She has been identified with the woman whom Christ cured of an issue of blood, who according to an old Greek legend was called Berenike. Others, though, believe that she owes her existence solely to the words *vera icon*, or true image, of Christ. In the *Golden Legend*, Jacobus de Voragine relates that Veronica wanted to have Jesus's portrait painted on a piece of cloth, but on her way to the artist she met Jesus, who took the cloth and pressed it to His face, leaving His image on it.

Fig. 9. Petrus Christus (active 1442?–1472/73), *Young man in an interior,* ca. 1450–60, panel. London, The National Gallery

The story of Veronica's portrait of Jesus became mixed up with yet another tale: of how Christ's face was impressed on the cloth on the road to Calvary. That *sudarium*, the oldest documented portrait of Jesus, was brought to Edessa by the apostle Jude, where it cured King Abgar. In the Middle Ages, cloths bearing various versions of Christ's portrait were venerated in Paris, Rome and Laon. The one in Rome was explicitly known as "the vernicle of Veronica". Amid this plethora of relics and legends, one thing is certain: the *Salve sancta facies* was said before all these relics and the images derived from them, together with the *Ave facies praeclara*. The popularity of devotions before the portrait of Jesus in the Low Countries is attested by the fact that it was here that the earliest surviving vernacular translation of the *Salve sancta facies* was made.

> "God hail Thee, holy face of our Redeemer,
> Radiant the form of the divine demeanour,
> Impressed on a cloth as white as snow
> And given to Veronica as a token of love.
>
> God hail Thee, whole adornment of the world,
> mirror of all sanctity,
> Well-head that the celestial spirits desire to witness,
> Purify and cleanse us of the stain of sin
> And join that band of holy angels.
>
> God hail Thee, our glory in this arduous life,
> So fragile, slippery and fleeting.
> O blessed image, take us to our father's land
> To behold the face, so sweet and pure, of Jesus
> Christ, Our Lord.
>
> O Lord, be our firm assistance,
> A sweet comfort and a sweet refreshment,
> That the enemy's vexations may not harm us,
> That we may delight in eternal rest. Amen."*

At first the main concern was the veneration of the relics themselves, with depictions in paintings and prints for individual devotion in the home being seen as faithful reproductions of them, but towards the end of the fifteenth century the artistic imagination had extended into this area as well. A rare poetic depiction of St Veronica displaying the portrait of Christ for the worshipper's devotion is Hans Memling's painting now in the National Gallery of Art, Washington, which can be dated ca. 1470/75 (PLATE 14b). The natural surroundings define the world in which the saint holds up her precious possession for the viewer's inspection. The point is no longer whether this is the only true portrait. The subjectiveness of the viewer has now become so important that he makes Veronica's portrait his own while praying in front of it. This small painting was originally part of a diptych with *St John the Baptist*, now in Munich, in which John presents a lamb to the viewer (PLATE 14a). These are two tokens of Jesus, one symbolic and the other real, which are explained in the prayer. In the words of the art historian Hans Belting: "The mood is more important than the subject, which is at the viewer's disposal as he wishes."

*God gruet v heylighe aensicht ons verlossers
in welke die ghedaente des godlike schijnsel blencket
in ghedrucket in een laken wit als een snee
ghegheuen was veronica tot enen teyken der minnen.

God gruet v sierheyt alle der werlt, spieghel allre heylicheyt
welle die die hemelsche gheesten begheren te scouwen
puer ende reyn ons van vlecken des sonden
ende toe ghevoecht dat ghesalscap der heylighen enghelen.

God gruet v onse glori in desen harden leuen
welcke broesch is ende glidende ende haestelic verganclic
O salighe figuer brenghe ons tot ons vaderslant
om te sien dat lieue aensicht ende puer ons heren ihu xpi.

O heer wees ons een seker hulpe,
wees ons een zuete troest ende een zuete vercoelen
op dat des vyants beswaernisse ons niet en deer mar
dat wij ghebrucken moghen die ewighe ruste. Amen.

PLATE **14**

Hans Memling (Seligenstadt am Main ca. 1435/40 – Bruges 1494) Diptych, ca. 1470–75

Left (a): *St John the Baptist*; on the back *A skull in a niche*
Right (b): *St Veronica with the sudarium*; on the back *The chalice of John the Evangelist*
Panel; wings 31.6 × 24.4 cm (a), 31.2 × 24.4 cm (b)

(a) Munich, Bayerische Staatsgemäldesammlungen, Alte Pinakothek, inv. no. 652; not exhibited
(b) Washington, National Gallery of Art, Samuel H. Kress collection, inv. no. 1952.5.46 (1125)

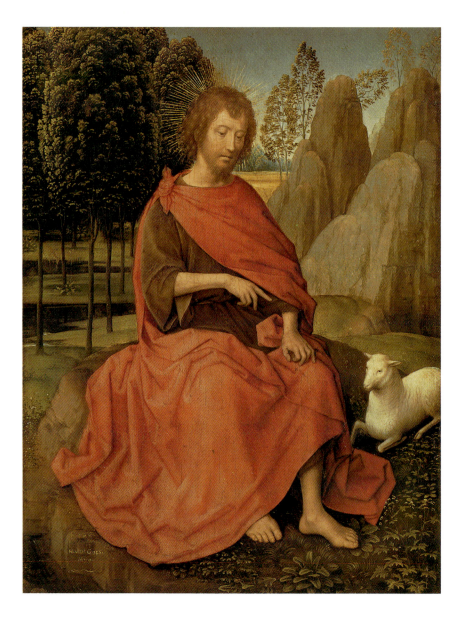

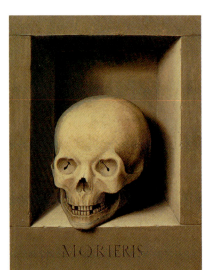

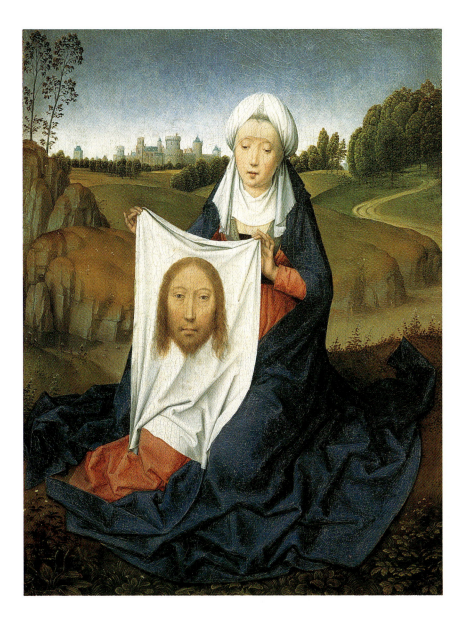

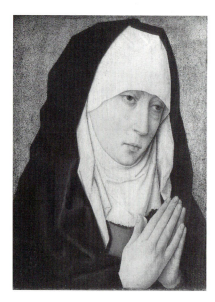

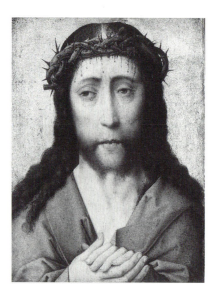

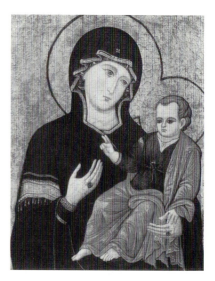

Fig. 10. Follower of Dieric Bouts, diptych, ca. 1475–1500. London, The National Gallery

Fig. 11. Anonymous, Rome (?), ca. 1300, *The Virgin and Child*, panel. Rome, Santa Maria del Popolo

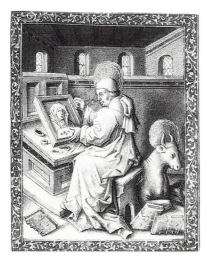

Fig. 13. Jean le Tavernier, *St Luke painting the Virgin*, from the Book of Hours of Philip of Burgundy, fol. 255r. The Hague, Koninklijke Bibliotheek

The Virgin's face was depicted far more infrequently than that of Jesus. Flemish portraits of Christ, however, are often accompanied by her likeness, which is not so much a portrait as a depiction of her with her head bowed towards Christ, her gaze and pose mirroring the emotions expressed in the prayers (*fig. 10*). She is the subjective component, compared to the rigidly frontal pose of Jesus's portrait. There are, though, many depictions of the Virgin and Child that pretend to be authentic. The name generally attached to such scenes is that of St Luke, whose description of Mary's motherhood and Christ's birth is so graphic that he was said to have actually painted them. The most famous of these 'St Luke Madonnas' is in the church of Santa Maria del Popolo in Rome (*fig. 11*). St Luke is seen painting the Virgin in a marginal decoration of the Book of Hours of the Van Lochorst family (*fig. 12*; see further p. 78), and he appears again in a drawing in the Book of Hours of Philip of Burgundy, but this time with only the Virgin's head (*fig. 13*). The artists working in Jean le Tavernier's studio were evidently familiar with this type of Madonna image, which later became much more popular under the name *Mater Dolorosa* or Mother of Sorrows.

Fig. 12. Master of Catherine of Cleves, *St Luke painting the Virgin*, from the Book of Hours of the Van Lochorst family, fol. 43r. The Hague, Rijksmuseum Meermanno-Westreenianum

PLATE 15
Attributed to Lorenzo Monaco
(Siena ca. 1372 – Florence 1424)
Madonna, ca. 1395
Panel; 36 × 29 cm

Amsterdam, Rijksmuseum, inv. no. SK A 4004

One of the earliest examples of a portrait of the Virgin was painted in Florence around 1395 by an artist from the immediate circle of Lorenzo Monaco (PLATE 15). The extreme delicacy of drawing and ornamentation have even suggested the idea that this is a youthful work by Lorenzo himself. The 'close-up' of the Virgin's face, which is exceptional for the period, set against such an ornate gold ground, must have been made as a *vera imago* or 'true portrait' of Mary. The most moving feature of the earliest forms of many devotional images is that so much is expressed with such minimal means. One can hardly speak of specific facial expressions in this work of around 1400. Mary's compassion is registered merely by a slight inclination of the head, but the emotional charge seems to be conveyed all the more intensely by this abstract visual formulation. One would assume that this small panel was part of a diptych, with a portrait of Christ on the left of the Virgin, but for the fact that there are no traces of any attachment for a second panel. The gentle tilting of her head remains an isolated motif, and it is to this that devotion is directed.

This 'true portrait' has its own story to tell, albeit one from three centuries later. Pasted on the back of the panel is a piece of paper relating that this Madonna spent three days floating in the sea before being miraculously rescued by a monk. At the beginning of the present century the Madonna was still in the Carthusian monastery of Galluzzo near Florence. This tale is probably a watered-down version of the celebrated story of another icon of the Virgin, the *Maria portatissa* belonging to the Iviron monastery on Mount Athos, which sailed across the Aegean to escape destruction at the hands of the Iconoclasts in Constantinople. In any event, the piece of paper documents a general phenomenon that applies to paintings of this kind: their exceptional impact often gave rise to remarkable tales.

Further reading:
Belting 1990; Dobschütz 1899; Graesse 1890; Hand 1992; Kaftal 1952–85; Kirschbaum 1968–76; Kleineidam 1950; *Meditationes*, edd. Ragusa, Green, 1961; Van Os 1969; Ridderbos 1984; Ringbom 1984; Timmers 1947; Uden 1986; Utrecht 1984; Weale 1890

Quotations
Meditationes, edd. Ragusa, Green, pp. 49, 51, 38–39, 16, 22; Uden 1986, p. 32; Graesse 1890, pp. 432, 654, 655–56; Dobschütz 1899, pp. 319, 306–09

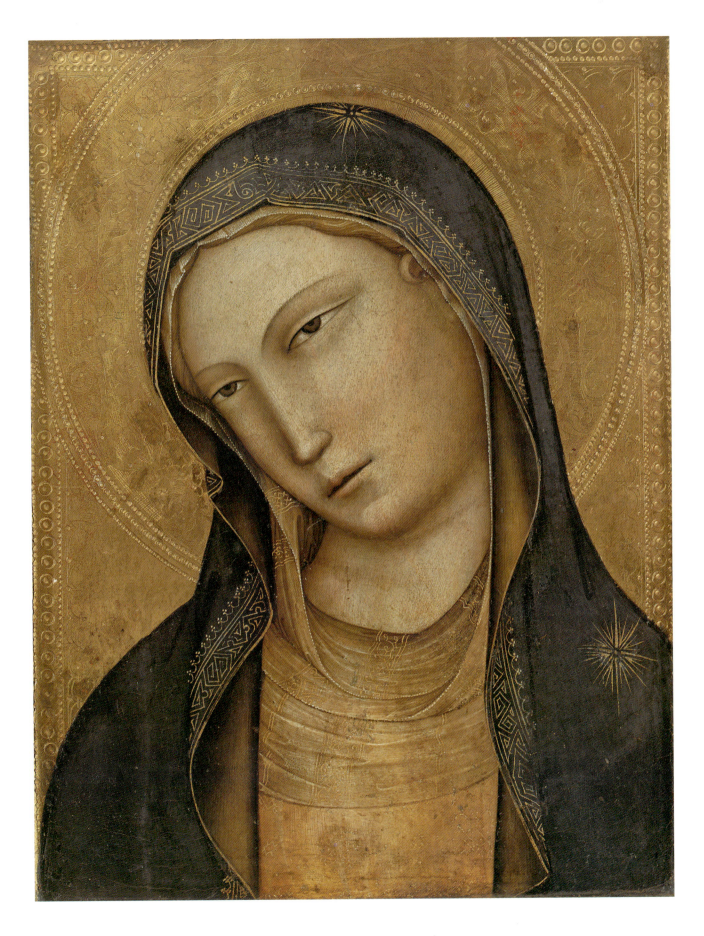

PLATE **16**
Anonymous (Cologne)
Vierge ouvrante, ca. 1300

Oak, polychromed and painted; height 36.8 cm
Closed: *Madonna lactans*
Open: *Mercy-seat Trinity* (incomplete); left wing:
The Annunciation, The Nativity and *The Adoration
of the Magi*; right wing: *The Visitation, The
Presentation in the Temple* and *The Announcement
to the Shepherds*

New York, The Metropolitan Museum of Art,
inv. no. 17.190.185

PLATE **17**
Master IAM van Zwoll (active in Zwolle ca. 1470–1500)
The Lactation of St Bernard,
ca. 1480–85

Engraving; 320 × 241 mm

Amsterdam, Rijksmuseum, Rijksprentenkabinet,
inv. no. RP-P-OB-1093

THE MONASTERY AS A CENTRE OF DEVOTION

One of the jewels in the collection of the Metropolitan Museum of Art is an early fourteenth-century statuette of the Virgin suckling the Child, a so called *Madonna lactans* (PLATE 16). It stands a mere 36.8 cm high. The abundance of ornament and gold conceals the fact that it is actually made of wood, which was covered with cloth to provide a support for the gilding. Nowadays we tend to regard gilding as rather ostentatious, but in the Middle Ages a costly appearance was an additional aid in ascending to the glory of God in one's thoughts. It can be assumed that the statuette came from a cell in a convent near Cologne. This Virgin, then, was the silent witness of a nun's daily prayers.

The Virgin is seated regally on a throne, and is wearing a handsome gown. She has a crown on her head and has lifted her right hand in benediction. The Christ Child on her arm is also elegantly dressed. That bare breast, though, looks as if it has been added as an afterthought. The young Saviour turns a little clumsily towards this attribute of the Virgin's motherhood. He has twisted round to give the blessing with His right hand, but seems not entirely sure what to do with His arm. The statuette as a whole exudes a fascinating tension between the tall queen presenting the Saviour to the world, and the mother caught in the intimate act of feeding her child.

In the Late Middle Ages, images of salvation were brought close to the viewer in order to encourage an emotional response. The nun who owned this statuette prayed before a queen who was also a mother. The contrast between the heavenly and the earthly was put into words by Bernard of Clairvaux when he told his Cistercian monks: "I have simply not been allowed to see or even apprehend Him as the king Who sits in glory above the cherubim, on His lofty, exalted throne. That is how angels wish to venerate Him, as the Father in the glory of the saints".

Bernard wanted God to descend from His throne so that he could hold Him. The best known legend about Bernard of Clairvaux relates that the Virgin and Child appeared to him, and that Mary suckled him, rather than Jesus (PLATE 17). Bernard had evidently come to identify so closely with the Christ Child in his devotions that he now benefited from Mary's nourishing care. This story was held up as an example, and Bernard's emotional spirituality became a source of inspiration for many monastics. He played a crucial rôle in the development of the mystical devotion of women. They eagerly identified with the nourishing Virgin, whereas men felt more affinity with the nourished Child. Lactation, or the miraculous appearance of the Virgin's milk, became a not uncommon event in mystical circles. In a number of churches, including Laon Cathedral, supposed Virgin's milk is preserved in magnificent reliquaries, and testimony to its curative powers can be found throughout Christian Europe.

Today we are no longer familiar with this body language of faith. The exuberant outpourings of love made in the Song of Songs now sound a little embarrassing used as declarations of faith. In the Middle Ages, though, the Song of Songs supplied the vocabulary for expressing one's love of God. Had she lived in those days, the singer Madonna would automatically have made performances out of her expressions of

Fig. 14. Anonymous, Limoges, 13th century, *Eucharistic dove*, copper and enamel. Amsterdam, Rijksmuseum

faith. Professing one's belief in sexual terms was not unusual; indeed it knew no bounds. What we now regard as morbid forms of regression, anorexia, hypochondria, masochism and hysteria are all represented in the religious life of Late Medieval monastics.

Even if, to us, these expressions of faith are unhealthy forms of behaviour, it is nevertheless fascinating to discover that much of our emotional apparatus was developed in Late Medieval religious houses – in the sight of God, as it were. It was there that a 'discovery of man' took place of the kind discerned by the great cultural historian Jakob Burckhardt in the politics and culture of the Renaissance. But it was a different discovery from that of the self-aware individual who breaks free of ecclesiastical and political structures. These monastics were not the forerunners of liberal thinkers. They were individuals who devoted all their energies to discovering the path to God as part of their renunciation of the world. What we today would repress was placed openly on the table, even if that table was designated an altar. Women played an unprecedentedly important part in this process, and it is, perhaps, no coincidence that some of the most engaging studies of medieval spirituality in recent years have been written by female scholars.

Religious communities had a cultural and social significance very different from that which they have today. They were the most important centres of knowledge and civilisation, which was essential in such areas as the development of agriculture, pursued by Bernard's Cistercians. At the same time they were indispensable to the rise of urban culture. Monasteries situated in the towns were treasure-houses preserving the norms and values of this new form of community. Added to this was voluntary poverty: the renunciation of everything that the outside world held dear in order to discover the joys of communing with God in one's own world. Lay people were determined that these seekers of God should remain in their midst, for they marked out a path that would lead the general public to heavenly bliss.

Works of art played a major rôle in this form of spirituality. Not only did medieval artists produce pictures for those who could not read, they also created images for those who wanted above all to touch, who wanted to have the scenes of their salvation tangibly present before them. The miracle of lactation could take place only in a vision, but the vision was more deeply experienced if it occurred before a sculpture, such as a *Madonna lactans*. The fourteenth and fifteenth centuries were imbued with an intense desire to visualise salvation. It is then, to echo St Bernard, that God comes down from His lofty throne. Even if He is depicted as the king of Heaven, He is still among the people, to be touched and adored. From time to time theologians fiercely condemned this function of art, but the frequency and intensity of their denunciations are evidence that this was one of the most important purposes of art in the Late Middle Ages, particularly so in the case of devotional images for private use.

To return to the Madonna in the Metropolitan Museum. In His left hand Christ holds a dove, the symbol of the Holy Ghost. Here, in the hand of the Christ Child, it

reminds us of the statement in the Gospel that Mary conceived Jesus because she had been overshadowed by the Holy Ghost. The dove therefore refers to the miracle of God made man. At that time it undoubtedly evoked another association as well. Such doves often stood on the altar as ciboria – the vessels in which the host was kept. There is an enamel dove of this type in the Rijksmuseum (*fig. 14*). This connection between the Incarnation and the Eucharist was of great importance in the world of medieval spirituality. It had been an official part of Church doctrine since the beginning of the thirteenth century that Christ was physically present in the bread and wine at the sacrifice of the Mass. During the service the priest called the Saviour down from Heaven, bringing Him into the presence of the faithful. They shared in the event, because the priest celebrated the ritual before them, in other words with his back to them, elevating the bread and the wine above his head. In this way, the congregation experienced Christ's presence on earth.

As a woman, the pious owner of this statuette did not have the power of a priest. For that and other reasons she would have travelled the path of mystical identification with the Virgin all the more intensely. She could relive the Incarnation in her contemplation, and *"Christum spiritualiter parturire"* – bring Christ to birth inwardly. The main point, though, is to appreciate just how crucial the act of seeing, the visual aspect, had become as a way of achieving salvation.

The Metropolitan Museum's *Madonna lactans* has a large vertical join running down the centre of the Virgin's gown, from the neck to below her feet. This Madonna can be opened. The dish-shaped wings are attached to the throne with hinges, and when they are folded back to display their narrative treasures we see that this *Madonna lactans* has Salvation in her belly in the most literal sense. For there sits God on His throne, displaying the Cross. This is no ordinary cross, but two crossed tree-trunks, the *lignum vitae* or Tree of Knowledge, on which Christ died. The cross has a hole in which the body of Christ was once attached. A smaller hole in God's chest may have been the attachment for a second dove of the Holy Ghost.

The combination of God with the Holy Ghost and Christ the Saviour on the cross was common in the Middle Ages from the thirteenth century onwards, and is known as the *Mercy-seat Trinity* (*fig. 15*). It is a visual construct providing a theologically approved image of salvation in a single motif of God, Saviour and Holy Ghost. The Virgin displays redemption in the most physical way imaginable: as the "fruit of her womb", to use the words spoken by the angel Gabriel at the Annunciation. By opening the statuette one can re-enact the Incarnation, as it were. The wings consequently depict scenes of Christ's arrival on earth. On the left, from top to bottom, are the *Annunciation*, *Nativity* and *Adoration of the Magi*, and on the right the *Visitation*, the *Presentation in the Temple* and the *Angel appearing to the Shepherds*. These scenes cannot be read in chronological order from top to bottom on each wing separately, nor across both wings from left to right. The order was apparently decided by the artist, who deliberately used the smallest surfaces for scenes with just two figures, and gave the greatest space to the worshippers, Magi and shepherds.

Fig. 15. Jean le Tavernier, *Mercy-seat Trinity*, from the Book of Hours of Philip of Burgundy, fol. 244r. The Hague, Koninklijke Bibliotheek

A Madonna with the redemption is known in French as a *Vierge ouvrante*, and in German as a *Schreinmadonna*. There is no established English term for it. *Vierges ouvrantes* could be found virtually throughout Europe in the Late Middle Ages, but very few have survived. The one in the Metropolitan Museum is among the smallest, and is the only *Madonna lactans*. The few known female owners of them were women of gentle birth who entered a convent or had close ties with one. The larger *Vierges ouvrantes* were generally placed in a church, but some may also have served as small portable altarpieces. Many of the surviving specimens lack the body of Christ, which has led to the suggestion that they were later converted to store the sacrament. Our statuette could have been used to carry the consecrated host to a nun who for some reason, possibly illness, had been unable to attend Mass. This statuette of the Virgin with the redemption would thus have been directly linked to the sacrifice of the Mass, which was the catalyst for private devotion.

Prayer was the most important task that monastics had to perform. They came together in the choir of their church at set times, from early morning to late at night, in order to give each day its distinctive religious stamp through readings from the Bible, stories of the saints, hymns and prayers. They also had their private devotions to make, for God is present everywhere and at all times, and so can be addressed at all times and everywhere. Jesus taught his disciples a special prayer, the Our Father, special because it established a very personal relationship with God. There was certainly private devotion in Early Christian times, but it took the form of contemplation of the nature of the Godhead and of man rather than of intimate converse with God. It was that need for intimacy that led believers to turn to Jesus, Mary and the saints rather than to God himself. In addition to the Our Father, the Bible contains many suitable prayer texts in the Psalms and the Song of Songs.

Private prayer should not necessarily be equated with the individual expression of personal emotions. This did take place when communing with God, but people generally said prayers composed by someone else. Bernard of Clairvaux, in particular, had written emotional and moving prayers that found their way into numerous prayer-books. Prayers sparked off the most diverse emotions. Nowadays one immediately thinks that prayer involves asking for something or giving thanks for favours received. Since time immemorial, though, prayers have involved adoration, with a distinction being made between the adoration of God and Christ, and of the Virgin and saints. During this adoration, the worshipper's emotions could reach such a pitch that he or she lost control of themselves and entered an ecstatic trance. Sins were

confessed in prayers, and penance was done, sometimes accompanied by self-flagellation to underscore one's feelings of penitence. Some prayers were an appeal for intercession. God had interceded between Himself and mankind by sending His Son into the world. The saints mediated between God and the faithful, who in turn interceded for others in their prayers. Some people were guided by an awareness of life's fleeting flame, and called on the saints to help them inherit heavenly bliss: "Pray for us now and in the hour of our death". In the Late Middle Ages there was growing awareness of man's corporeality and mortality.

It is not known what prayers were said by the pious owner of the *Madonna lactans* with salvation in her womb, but she had a large number to choose from. One is the well known sequence *Salve mater salvatoris*, which was in widespread use from the beginning of the thirteenth century. The Latin text is attributed to Adam of St-Victor (ca. 1112–1192), and one passage reads: "*Salve, mater pietatis / Et totius trinitatis / Nobile triclinium ...*". Here the Virgin is hailed as nothing less than a king-size bed for the entire Trinity. In German-speaking countries the prayer was said in a translation ascribed to a monk from Salzburg: "Hail, mother of good counsel, of the threefold Trinity, noble, beautiful, threefold fortress. Greetings, mother most good, since God flowered from you in His threefoldness".* In this rendering Mary is the vessel for the Trinity. It is remarkable how theological concepts and mystical metaphors can merge into a single image.

There are also prayers in which the Virgin is begged to grant the worshipper a vision: "Show us salvation". The most beautiful prayer of this kind is the medieval hymn *Salve Regina*, which has inspired numerous composers down the ages. One English version runs as follows:

> "Hail, Holy Queen, Mother of Mercy;
> Hail, our life, our sweetness, and our hope!
> To thee do we cry, poor banished children of Eve;
> To thee do we send up our sighs,
> Mourning and weeping in this vale of tears.
> Turn then, most gracious advocate,
> Thy merciful eyes towards us,
> And after this our exile, show unto us
> The blessed fruit of thy womb, Jesus.
> O clement, O loving, O sweet Virgin Mary."

*Salve, mueter gueter rete/ der gedreiten trinitete/ edels, schöns, gedreits geslos/ Wis gegrüsset, aller güte/ muter, seit got aus dir blüte,/ in seiner dreivaltichait ...

PLATE 18
Anonymous (Upper Rhine)
Christ and St John, ca. 1330–40
Walnut, polychromed; height 34.5 cm

Frankfurt, Liebieghaus-Museum alter Plastik, inv. no. 1447

The nature of spirituality in German nunneries is illustrated by another devotional image, this one from the beginning of the fourteenth century. It is known under the generic title *Christ with St John*, and one of the finest examples is in the Liebieghaus in Frankfurt (PLATE 18). This small painted sculpture came from the former Dominican convent at Adelhausen in Freiburg im Breisgau (Baden Württemberg), where it doubtless adorned one of the nuns' cells. St John is depicted as the disciple "whom Jesus loved", who leaned on Jesus's bosom at the Last Supper (John 13,23). When Christ told his disciples that one of them would betray him, "John immediately cast himself on Jesus's bosom, weeping". In this sculpture the nuns' devotion has isolated the emotive moment from the story of the Last Supper and turned it into an object inspiring prayer and meditation.

Once more it is likely that the earliest examples of this new devotional theme were depicted on larger altarpieces, whence Christ and His beloved John were later transported to the private domain. There the image satisfied the individual's longing to rest his or her head on Christ's bosom, and to receive the love accorded the youngest disciple. And once again it was the imagery of the Song of Songs that aroused that longing. A woman who wanted to regard herself as a *sponsa Christi*, or bride of Christ, saw that wish visualised in the group of Christ and St John. Given the devotional nature of the theme, it is not Christ who is the principal figure, as in the Last Supper, but John. The nun wanted to identify with him in loving her Lord and being loved by Him in return. Here then, Christ has become the attribute of St John. The emotional force of an image like this is known from stories from the period. One tells how a nun became so enraptured in her meditation before a group of Christ and St John that one of her sisters saw her levitate. Being raised from the ground by one's own spiritual powers was one of the most remarkable capabilities of Late Medieval mystics. Their levitations illustrate how intensely both soul and body were affected by a personal experience of the saint.

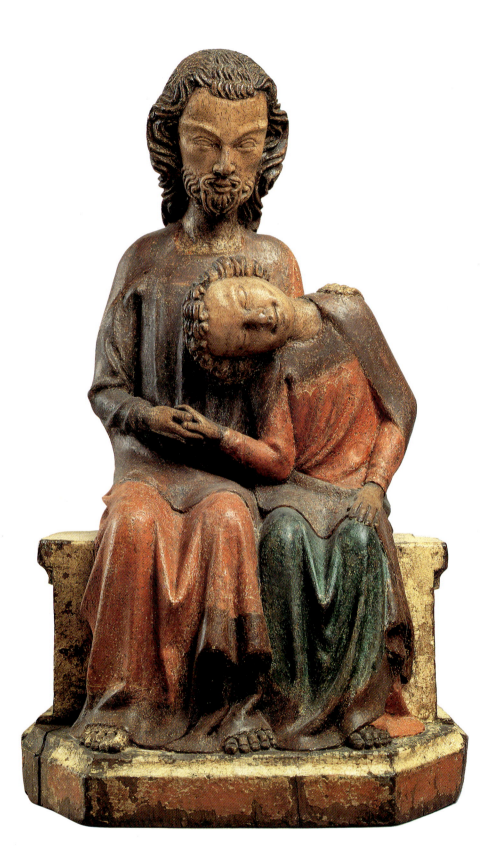

Fig. 16. Sano di Pietro (1406–1481), *St Bernardino preaching on the Campo*, 1427, panel. Siena, Capitolo del Duomo

One of the few large urban centres in Italy which retains the look of a medieval city is Siena. It is dominated by a cathedral, and as one approaches the city one sees, rising in the distance alongside the campanile, the Torre del Mangia of the Palazzo Pubblico. It was on the Campo, the square in front of the seat of the city's government, that the populist Franciscan preacher Bernardino (1380–1444) delivered his sermons. The square was packed on such occasions, as it was for the large annual procession on the feast of the Assumption of Our Lady, Siena's patroness (*fig. 16*). Like a giant insect, Siena perches with its legs stretched out over the Tuscan hills. The city authorities ensured that a religious house was founded on each of those spurs. Franciscans, Dominicans, Augustinians, Carmelites and Servites – each had their own house with a large church which, inconceivable as it may seem, was often too small to accommodate the congregation.

Nowadays the tourist is awakened by bells in the early morning. People find it interesting, charmingly authentic or simply irritating, but few know why the bells are rung. In the Middle Ages, bells imposed a structure on daily life, as well as marking special events. That structure was service to God in the literal sense of the word – *officium divinum*, divine duty. The monasteries, friaries and nunneries brought the claustral life of prayer into the city. Together with the cathedral canons and the parish priests, the friars were an indispensable part of urban life. 'Religious life' is nowadays a category apart, but in the Middle Ages all of life was saturated with the work of conventuals. At first they were the only people with the intellectual ability to rise to the needs of an urban community. They supplied the chief architect for the cathedral, the alderman of finances, the entire infrastructure and staff of the educational system, and they also ran the hospitals and welfare services. So when the bells rang, the authoritative voice of faith sounded. Who would not wish to hearken to it?

Since, in a medieval city, there were few who could read, simple prayers were composed for the faithful to learn by heart. The best known is the Hail Mary, and it is worth taking a brief look at its history by way of example. Fairly soon after it was invented it became the most important part of the Angelus, a short prayer commemorating God's Incarnation in Christ recited in the religious houses. At six in the morning, midday and six in the evening, three Hail Marys were said, together with a few other set prayers. So at an early date the repetition of prayers also became an important factor in religious life. The Hail Mary only took on a wider significance within society when the system of prayer timed by the chiming of bells emerged from the enclosed walls of the monasteries. In 1269 the great Franciscan leader St Bonaventure (1221–1274) gave his brethren the task of encouraging the faithful to say three Hail Marys when the bell was rung for Vespers at six in the evening. Not long afterwards the Angelus bell also rang at six in the morning and at midday, with the result that the city took on the rhythm of monastic life. The final stage in the evolution of the Hail Mary occurred at the beginning of the fourteenth century, when the popes began making indulgences conditional upon its recitation. From then on eternity could be earned by repeating the Hail Mary at fixed times.

The history of the Hail Mary and its overwhelming popularity in the fourteenth and fifteenth centuries is typical of Late Medieval devotion in many respects. It has often been pointed out that much was lost when the culture of prayer became more widespread – theological purity, for example, and with it the respectful distance maintained between worshipper and saint. People were also worried about their own mortality and sinfulness, which led to trafficking in salvation itself. Surely saying the same short prayer over and over again could not create a better chance of eternal life? And then there was all that hysterical behaviour, tasteless self-flagellation, for example.

Even at the time there was an ecclesiastical élite that viewed the exuberant culture of prayer in much this way. It was the inevitable consequence, though, of the spread of religious life throughout the lay community. The Late Middle Ages are often spoken of as a period of secularisation; after the thirteenth century, Europe gradually lost its faith. That idea is largely the result of nineteenth-century liberals going in search of their antecedents. From the perspective of the culture of prayer the reverse is true: monastic life invaded the streets. If 'the spiritual life' initially took place in a world apart, the daily life of lay people in the fourteenth and fifteenth centuries was permeated with religious ritual and pious expectations. The 'third orders' and the confraternities played a key rôle in this sanctification of the daily round. Both were communities of laymen who observed a simple monastic rule and devoted themselves to penitence, prayer and good works. They were, so to speak, 'religious service clubs', membership of which conveyed considerable social status.

Living in Siena in the mid-thirteenth century was one Andrea Gallerani (died 1251). He belonged to the Dominican tertiaries, or 'third order', which had been founded to satisfy the great desire among ordinary citizens for the ascetic life. Their religious fervour was not structured by the spiritual training that the friars had received, and this resulted in the most extreme demonstrations of piety. Andrea had only to kneel before a crucifix and he was transported, praying ceaselessly, day and night. But even spiritual forces have their limits, and Andrea occasionally found himself nodding off. In order to overcome his body's treachery, he tied a rope to a beam in the ceiling and made the other end into a noose, which he slipped over his head. If he fell asleep now he would hang himself.

The clergy were generally worried by this sort of extremism in the lay profession of faith, and tried to curb such excesses. The neighbourhood, though, loved it. Andrea? Now there was a real spiritual athlete. In many cases the laity insisted that the urban orders put up large monuments to these local heroes of the faith, and they were often paid for by the town council. A depiction of Andrea kneeling before a crucifix with a noose around his neck is part of a large memorial, an altarpiece, which was erected immediately after his death in 1251 in the church of San Domenico (*fig. 17*). In his hand he holds a rosary to keep count of the number of Hail Marys he has said.

Fig. 17. Circle of Guido da Siena (active 1260–80?), diptych of Blessed Andrea Gallerani (detail). Siena, Pinacoteca Nazionale

PLATE **19**
Master Caspar (active in
Regensburg ca. 1470–80)
The Stigmatization of St Francis,
ca. 1470–80
Woodcut, hand-coloured; 385 × 252 mm

Munich, Bayerische Staatsbibliothek, Rar. 327

Fig. 18. Giovanni di Paolo (ca. 1403–1482), *The
stigmatization of St Catherine of Siena,* ca. 1461,
panel. New York, The Metropolitan Museum of
Art, Robert Lehman Collection

**Heiliger und wirdiger vatter sandt franciscus ein
diener Jesu Christi und ein trost aller der menschen
die dir hie dienen und dich anruffen und dich eren mit
peiten und vastn, feyeren, almusen geben und ander
gutte werck: Ich pitt dich, das du Got fur mich pittest,
der dich begobet hat mit den heiligen funff wunden,
als er dir erschein. Gyb mir willige armit, keuscheit,
gehorsamkeit, rew und leit meiner sunden und das
ewig leben, Amen.*

The painted wings of that altarpiece also contain a scene of the stigmatization of St
Francis of Assisi (1181–1226). The stigmatization was the most important event in St
Francis's life. In 1224 he retreated to the wild forests of Mount Alverna, and on the
Feast of the Exaltation of the Cross he prayed to the crucified Christ with all the
ardour he could muster. He was granted a vision of a crucifix in the shape of a seraph,
an angel of the highest hierarchy, with six fiery wings. And Francis saw Christ's
wounds appear on his own body. He had become one with the Lord.

There were representations made of St Francis receiving the stigmata in every medium,
and not just in Siena but throughout Europe. One of the most moving is a German
woodcut of ca. 1480 pasted into a book from the Franciscan friary of Ingolstadt (PLATE
19). This prayer-card, made by one Caspar, is hardly a model of artistic refinement. Its
charm lies in its simplicity. St Francis is kneeling on the left, gazing up at the seraphic
cross which is visibly imprinting the seal of the crucified Christ on the saint's body.
Seated beside Francis is his follower, Brother Leo (died 1270), who, like Christ's
disciples on the Mount of Olives, fell asleep at the critical juncture and missed an
important event. What is unusual about this print is that the animals on the mountain
are also witnessing the miracle. The woodcutter was undoubtedly alluding to the
special relationship that Francis, like St Jerome and many other ascetics, enjoyed with
animals. The prayer at the bottom of the print reads: "Holy and worthy father, St
Francis, a servant of Jesus Christ and a consolation for all mankind, who serve you here
and call unto you, and honour you with prayer and fasting, celebrations, alms-giving
and other good deeds. I pray you to pray to God for me, Who bestowed the five
wounds upon you when He appeared to you. Give me voluntary poverty, chastity,
obedience, penitence and sorrow for my sins, and eternal life. Amen."*

The stigmatization was repeated in 1375, the recipient this time being Catherine of
Siena (1347?–1380) (*fig. 18*). In her early years she had become acquainted with Andrea
Gallerani's extreme devotion to prayer, for she lived near the church of San Domenico
where his memorial stood. Her religious life was shaped by that church, and by the
Dominican order. In her mystical experiences she imitated not only the stigmatization
of St Francis, but other mystic events as well, such as betrothal to Christ, following her
namesake Catherine of Alexandria. She became the female counterpart of St Francis, a
sort of Dominican alternative. As in the case of Andrea Gallerani, the clergy were at
some pains to channel Catherine's mystical impulses in the right direction. Time and
again one sees the clergy finding a niche within the Church for even the most
impassioned religious leaders.

Depictions of the stigmatization also reveal that there were various poses for prayer.
God was not addressed with clasped hands alone. A late fourteenth-century
manuscript recently discovered in the library at Siena contains drawings of saints in

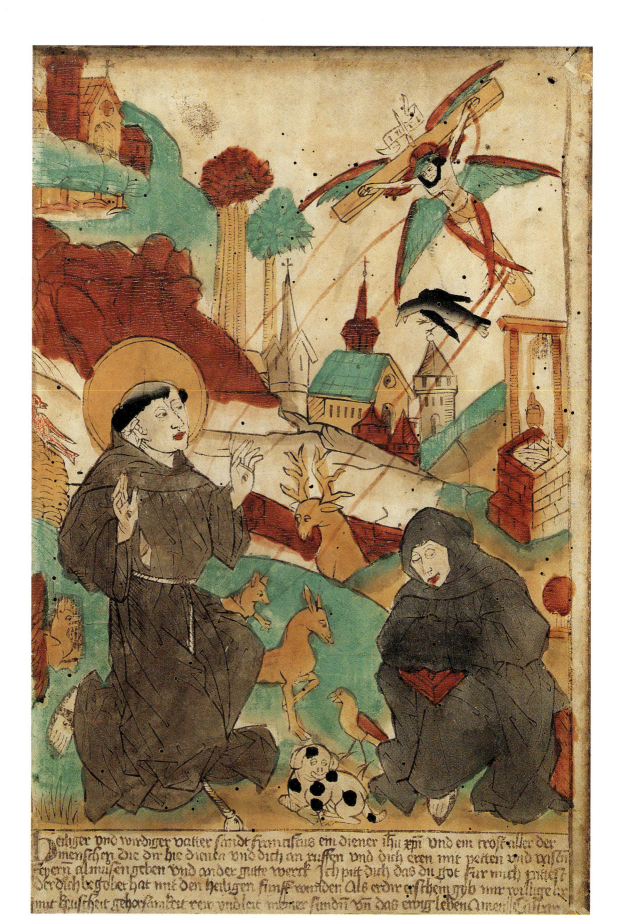

Heiliger vnd windiger vatter sandt Franciscus ein diener ihu xpi vnd ein trost aller der
menschen die dir hie dienen vnd dich an ruffen vnd dich eren mit peten vnd vasten
opern almüsen geben vnd ander gute werck Ich pit dich das du got fur mich pitest
der dich begobet hat mit den heiligen funff wonden Als er dir es them gyb mir willige
mit kuscheit gehorsamkeit rew vnd leit meiner sünden vn das ewig leben Amen Castien

Fig. 19. Cristoforo Cortese (active 1360–71), *Saints in prayer*, Ms. T.I.2, fol. 57r. Siena, Biblioteca Comunale

Fig. 20. Anonymous, Spain (?), 15th century, *Humility*, from *De modo orandi*, Ms. Lat. Rossianus 3, fol. 6v. Rome, Biblioteca Apostolica Vaticana

Fig. 21. Anonymous, Spain (?), 15th century, *Ecstasy*, from *De modo orandi*, Ms. Lat. Rossianus 3, fol. 11r. Rome, Biblioteca Apostolica Vaticana

various attitudes of prayer (*fig. 19*). You could express penitence by using the scourge, or by pounding yourself on the chest with a hard object. Outstretched arms symbolized ecstasy, and lying prostrate instead of kneeling signified utter subjection. A fifteenth-century Dominican manuscript in the Vatican shows the nine modes of prayer used by St Dominic (1170–1221). Compared to the inspired St Francis, Dominic is a systematist, for the precise meaning of each pose is given (*figs. 20, 21*). Lying prostrate, for instance, signified the awareness of humility. All these attitudes of prayer, and above all the stigmatization itself, illustrate the importance that was attached to the body language of prayer.

SUPPLY AND DEMAND

In a manuscript of the *Cántigas* (Canticles of the Virgin) belonging to King Alfonso X of Castile, which was illuminated soon after 1265, there is a scene of a painting being sold from a shop (*fig. 22*). It accompanies the story of a noblewoman who lived in a hermits' colony near Damascus. She asked a monk who was passing through if he could bring her a painting of the Virgin from Jerusalem the next time he came her way. He promised to do so, but it later slipped his mind, until a heavenly voice reminded him. He returned to Jerusalem and bought a Madonna in a picture shop. The monk then discovered that the painting could work miracles, so he decided to keep it for his own order. The Madonna in the painting thereupon took matters into her own hands, demanding that she be brought to the person to whom she rightfully belonged. And so it was that the monk finally brought the picture to the anchoress near Damascus.

Although this tale has certainly been given its place in discussions of miracle-working Madonnas, the fact that this is the earliest known depiction of a commercial picture gallery seems generally to have been overlooked. Even in the thirteenth century, there were evidently shops that sold religious articles from stock. Judging by the miniature, the goods on sale consisted of *Crucifixions* and *Madonnas*. From this it can be deduced just how few paintings of this kind have come down to us from the late thirteenth century. The miniature also intimates that monks were the prime customers, which matches other sources of information on the identity of the earliest owners of art for private devotion.

Siena was one of the first centres where devotional art was produced on a large scale. Andrea Gallerani prayed before a crucifix, and someone must have made it. At the beginning of the fourteenth century, Duccio's workshop was producing not only large altarpieces but also series of smaller-scale *Crucifixions* and *Madonnas*, and an occasional small painting with narrative scenes (*fig. 23*). It is fair to assume that this output was mainly intended to meet demand from monks and nuns, especially those living near

Fig. 22. Anonymous, Spain, 2nd half 13th century, *The sale of a Madonna* (detail), from the *Cántigas de Santa Maria* of King Alfonso X of Castile, Ms. T.I.1, fol. 17. Madrid, Escorial

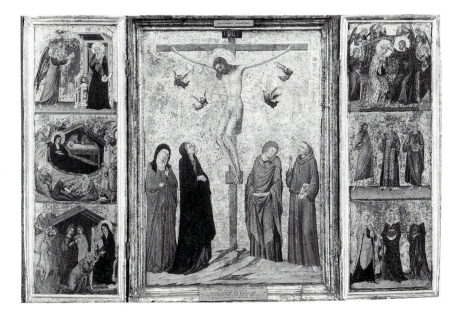

Fig. 23. Workshop of Duccio di Buoninsegna (ca. 1255–1318/19), triptych, ca. 1325. New York, The Metropolitan Museum of Art, bequest of George Blumenthal 1941

PLATE 20
Ambrogio Lorenzetti (active in Siena ca. 1319–48)
The Small *Maestà*, ca. 1335–40

The Virgin enthroned with the Christ Child, six angels flanking the throne at the back; on the left St Elizabeth of Hungary, on the right St Catherine of Alexandria; kneeling on the left St Nicholas(?); in the left foreground Pope Clement I; on the right St Martin(?); in the right foreground Pope Gregory I
Panel; 50.5 × 34.5 cm

Siena, Pinacoteca Nazionale, inv. no. 65

the churches for which Duccio and his pupils made altarpieces. That, though, is no more than a conjecture, for this is an area that has never been researched. There were also specific commissions. A small triptych like the one from the Duccio workshop now in Boston (*fig. 5* on p. 24) could only have been made to order. If nothing else, this is clear from the very specific combination of saints on the wings.

One of the high points of small-scale Sienese painting is the so called Small *Maestà* by Ambrogio Lorenzetti (PLATE 20). Ambrogio, his brother Pietro (active 1306?–1345) and Simone Martini (ca. 1284–1344) were the trio of great painters in Siena after Duccio. This *Maestà*, though small, is breathtakingly beautiful. First of all there is the dazzling gold setting off the Madonna's outline, with angels emerging from it. Then there is the quality of the colour. Rarely in early Italian art does one find such an intense red, and in almost no other work has the costly lapis lazuli of the blue been so well preserved. Each part of the scene demands individual attention: the extremely delicate ornamentation and draughtsmanship of the draperies, the saints' faces, and the magnificent display of colour of the flowers in the golden vase in the foreground.

Of all the features of this unique painting, one does not at first notice its spatial organization. The radiance tends to mask the structure of the composition, yet this is perhaps the most remarkable aspect of the work. Here Ambrogio has resolved an artistic challenge that he also set himself in a large *Maestà*. In Sienese painting the term '*Maestà*' is associated with Duccio's monumental double-sided high altarpiece for the cathedral. The front shows the *Virgin and Child* seated on a large stone throne, flanked by rows of saints and angels (*fig. 24*). Kneeling at the foot of the throne are the four patron saints of Siena. A few decades later Ambrogio Lorenzetti painted a *Maestà* for the Augustinian church in nearby Massa Marittima. It is a *Madonna enthroned*, with heavenly hosts on a large, horizontal picture surface (*fig. 25*). It is as if Ambrogio were deliberately challenging Duccio's composition. His is also a majestic Madonna, but she is shown in a moment of great intimacy, cheek to cheek with the Child in the Byzantine *eleousa* attitude. It is not the throne that defines the space, but the mother and Child. The greatest change is in the organization of the heavenly hosts. Their rows recede into depth, with the *Madonna enthroned* as the three-dimensional subject in the

Fig. 24. Duccio di Buoninsegna (ca. 1255–1318/19), *Maestà*, completed 1311, central part of front (by John White). Siena, Museo dell'Opera del Duomo

Fig. 25. Ambrogio Lorenzetti, *Maestà*, ca. 1330, panel. Massa Marittima, Municipio

centre. At the same time, the two-dimensionality of the gold ground and the haloes heightens the tension between spatial effect and surface decoration. This is undoubtedly the most complex of all the intricate paintings made by that scholarly artist, Ambrogio Lorenzetti.

However complicated the composition of the Small *Maestà*, there is no question of a forced spatial structure. The figures materialise out of the gold background – a device that the great Florentine artist Lorenzo Ghiberti (1378–1455) imitated a century later in his bronze reliefs. Ghiberti also proclaimed his admiration for Ambrogio Lorenzetti in his *Commentarii*. The Madonna creates her own space, not by the three-dimensional modelling but by the asymmetry of her silhouette. She gazes down at her Child, who is playfully turning to the saintly onlookers and holding out a scroll with Mary's reply to Gabriel's "Hail Mary": "Be it unto me according to thy word". All that can now be made out are the letters FIAT V. One of the most notable points about this small painting is not only that the figures have been brought together in a coherent spatial arrangement, but that there is genuine communication between them. The saints really are looking at Mary and the Child, and the Child, in turn, is telling them something. Despite all the decorative beauty, the interpersonal element makes the painting exceptional. It is rare to find the infant Christ drawing the saints' attention to the words spoken by the Virgin, which were crucial for His birth. The presence of no fewer than four church dignitaries kneeling before the Madonna's throne is also unusual. The two saintly popes in the foreground are identified by inscriptions on their robes as Clement (pope from 88 to 97) and Gregory (ca. 540–604). The two bishops behind are unidentifiable.

The two female saints are also of high rank. On the left is Elizabeth (1207–1231), daughter of the King of Hungary, who married the Landgrave of Thuringia in 1221. The crown on her head refers to her royal estate. The flowers gathered in the fold of her gown have often led to her being confused with St Dorothy (see PLATE 11), but in the work of Ambrogio Lorenzetti, who was a stickler for the attributes he gave his saints, Dorothy quite rightly never wears a crown. Elizabeth's flowers refer to a miraculous event. Her husband barely spared a thought for the poor and hungry among his subjects. One day, when Elizabeth set out secretly to visit them with her apron full of bread, she unexpectedly ran into the Landgrave. "What have you got there?" he asked in surprise. "Roses", replied the saint, and lo and behold, God had changed the bread into flowers. Facing Elizabeth is Catherine, the princess from Alexandria, who is instantly recognisable from the wheel on which it was intended she should be martyred (see PLATE 10b).

Both these saints are often found in the Madonna's entourage, but Elizabeth is undoubtedly the most specific saint of the whole company. An exceptional painting like this would not have been supplied from stock. Since Elizabeth entered the Franciscan order as a tertiary, the person who commissioned the Small *Maestà* should probably be sought among the prominent citizens of Siena who had ties with the order. The composition would have been the subject of detailed discussion between Ambrogio and members of this circle.

A second Sienese painting for private devotion was probably not bought from a shop either. It is a diptych; the *Madonna and saints* is in the Rijksmuseum Meermanno-Westreenianum in The Hague, and the *Crucifixion* in the Johnson Collection in Philadelphia (PLATES 21a/b). The *Madonna* has lost her frame, but the *Crucifixion* panel shows how important it was for the overall effect. At least as much care was lavished on the frame and the ornamentation of the gold as on the painting itself. The Philadelphia scene is absolutely standard. The Crucifixion on Golgotha, the place of skulls, with the Virgin and St John flanking the Cross, was the commonest depiction of Christ's Passion in paintings of this size. The angels, too, representing sorrow or adding a sacramental note by catching Christ's blood in a chalice, were common motifs. The *Madonna enthroned* with the seraphim behind her is found in other Sienese works of the period, and St Lawrence with his grid-iron and St Andrew with his cross are regularly in attendance by her throne. Seldom, though, does one see such gold and radiance – all those borders punched into the gold, gesso pillars and vegetative ornaments covered with gold leaf, semi-precious stones sparkling among them. Once again a wooden object has been given the lustrous sheen of gold. It recalls stories of heavenly bliss from the period, which make one feel that one has entered an unusually dazzling jeweller's shop.

Sienese goldsmiths were in demand throughout Europe for their craftsmanship and refinement. They also had a higher status than painters, if only because they dealt in more costly products. Francesco Vannuccio, who painted this diptych, was actually a goldsmith who also painted, and this is quite evident in the development of his figures, whose expressions are frozen, so much so that the figures have turned into decorative motifs themselves. In that respect there could be no greater contrast with Ambrogio's Small *Maestà*, in which, despite the wealth of ornamentation, all the figures are interacting in their poses, gestures and gazes. The Hague *Madonna* has lost much of its gold leaf, especially from St Lawrence. St Andrew, though, shows how carefully and delicately Francesco Vannuccio worked on his figures. Andrew is the focus of the Virgin's and Child's attention, and the latter is handing him a long cross with a short transverse beam. Now Andrew was actually crucified on a cross with beams of equal length – a type that is named after him – but in Sienese art he is often depicted with a normal Latin cross. He was the paragon among those who heeded Christ's call: "If any man will come after Me, let him deny himself, and take up his cross, and follow Me" (Matthew 16,24; Luke 9,23). The long cross with a short beam is the type that members of penitential fraternities carried on their shoulders when they went on procession through Siena, and it is possible that the diptych was painted for a member of one of those brotherhoods. The angel with the chalice in the *Crucifixion* may be an indication that the diptych had a Eucharistic function, and was possibly used as a portable altarpiece by its distinguished owner. He, unfortunately, has been consigned to anonymity, his coat of arms having disappeared from the shield at the bottom of the frame.

PLATE **21**
Francesco Vannuccio (Siena
ca. 1315/16 – Siena ca. 1388)
Diptych, ca. 1380
Left (a): *Virgin enthroned with the Christ Child, Sts Lawrence and Andrew*
Right (b): *Christ on the Cross with the Virgin and St John*
Panel; wings 34.5 × 23.5 cm (a), 43 × 30.5 cm (b, incl. frame)

(a) The Hague, Rijksmuseum Meermanno-Westreenianum, inv. no. 806/60
(b) Philadelphia, Philadelphia Museum of Art, The John G. Johnson collection, inv. no. 94

PLATE **21b**

PLATE 22
Workshop of Sassetta
(Siena 1392 – Siena ca. 1450–51)
Triptych, ca. 1430

Centre: *The Virgin enthroned with the Christ Child, two angels flanking the throne at the back; on the left probably St Catherine of Alexandria; on the right St Lucy; God the Father above*
Left: *St Ansanus, with the angel Gabriel of the Annunciation above*
Right: *St Lawrence, with the Virgin of the Annunciation above*
Panel; 61 × 52.5 cm

The Hague, Rijksmuseum Meermanno-Westreenianum, inv. no. 808/61

Fig. 26. Workshop of Sassetta, *Madonna enthroned with saints*, ca. 1436–45, panel. Siena, Palazzo Salimbeni, Monte dei Paschi di Siena, Chigi Saracini collection

One painting that is known to have been bought from a shop is a triptych, also in the Rijksmuseum Meermanno-Westreenianum, from the *bottega* of the leading Sienese master of the first half of the fifteenth century, Stefano di Giovanni, called Sassetta (PLATE 22). We can be certain about this because four more of these triptychs have survived, all with a virtually identical composition. The one in the Palazzo Salimbeni in Siena still has its base (*fig. 26*), and there are also traces of an attachment at the bottom of the central panel of the Hague triptych. A study of inventories has revealed that less than five per cent of Sienese paintings executed in the first half of the fifteenth century have come down to us, so these five triptychs are all that remain of what must have been a considerable output of small paintings of this type. Stylistic analysis shows that at least four different painters worked on the five triptychs. The Palazzo Salimbeni specimen is by a single artist, but two of the others are the joint work of two painters. The clearest evidence of this is provided by the Hague triptych.

The Virgin is seated in the centre on her throne, the texture of which is softened by a cloth draped over it. Two angels stand behind the throne, to the left of which is St Catherine with her wheel, and to the right St Lucy holding a dish containing her eyes, which were gouged out with a knife during her martyrdom. The group has been placed on a magnificent oriental carpet, of the kind that in those days was already regarded as a highly desirable luxury, and was imported in large numbers. Sassetta evidently had one of these carpets with an abstract bird pattern, for it also appears in the Palazzo Salimbeni triptych, where it serves to heighten the decorative effect. Compared to the central panel of that triptych, the figures in the Hague painting are set much further back in the picture surface. They are small shapes clad in very delicate, elegant draperies.

The two saints on the wings are by no means so small and ethereal. On the left is St Lawrence with his grid-iron, and on the right Ansanus, one of Siena's patron saints. The latter was beheaded in 304, and is identified by his attribute of the city's black and white banner. In marked contrast to the figures in the central panel and to the obligatory Gabriel and the Virgin in the pinnacles, these are true foreground figures, completely filling their ornamented gold niches. Their flat, moon-like faces show that they were painted by the artist responsible for the Palazzo Salimbeni triptych. The central panel and the *Annunciation*, however, are by another of Sassetta's pupils. The work is also interesting from an iconographic point of view. The female saints in the central panel were part of the standard Sienese programme. Catherine and Lucy were depicted endlessly, as was Lawrence. Ansanus, though, very rarely put in an appearance. This suggests that the greater part of a triptych like this was available from stock, but that the lateral saints were executed separately, by another artist in this case, in order to give the triptych a personal touch. Be that as it may, a triptych like this would have been available from the kind of shop depicted in the Spanish miniature (*fig. 22*).

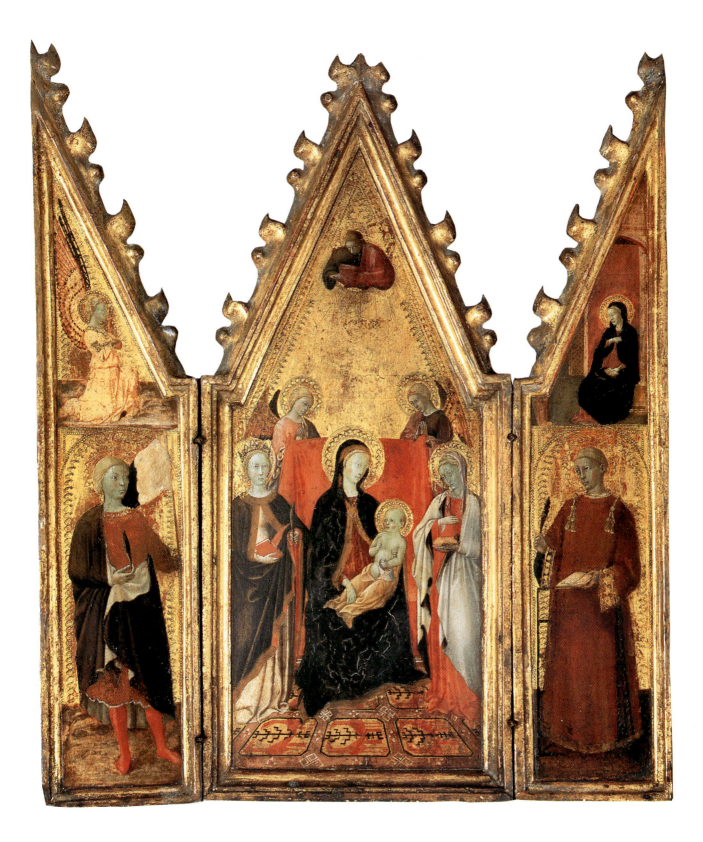

Fig. 27. Andrea di Bartolo (active 1389–1428),
The Virgin and Child, ca. 1415, panel.
Washington, National Gallery of Art, Samuel H.
Kress Collection

That there were commercial picture galleries in Siena is demonstrated by the large surviving groups of stylistically homogeneous paintings for private devotion. At least twenty small Madonnas are known from the studio of Andrea di Bartolo, who was active around 1400 (*fig. 27*), and there are many more from the workshop of Sassetta's pupil Sano di Pietro (1406–1481). Andrea di Bartolo's shop is also known to have produced works for export. On one occasion, Dominican reformers travelled to Venice for the dedication of a house for the tertiaries to which Catherine of Siena had belonged. To mark the event each nun was given a crucifix to hang on the wall of her cell, as well as a Madonna painted by Andrea.

Florence, too, produced a large number of paintings for private devotion in the early fourteenth century. In a shop like Bernardo Daddi's it is possible to trace the same scenes as those in the Edinburgh triptych (see PLATE 5) in series of small triptychs and diptychs (*fig. 28*).

Ivories are perhaps an even more interesting area of study as regards the mass production of images for private devotion. Like miniatures, they are prone to what can be called 'iconographic decay'. An interesting illustration is the repetition of the scene of Joseph's dream on the ivory diptych in the Rijksmuseum (see PLATE 1). In another version of this ivory, in the Suermondt Museum in Aachen (*fig. 29*), the *Last Judgment* has been replaced by the heavenly scene of the *Coronation of the Virgin*. The Nativity scenes in both diptychs are almost identical, although the one in Amsterdam is of slightly better quality. In the background, the angel Gabriel is appearing to Joseph, who can be identified as such because the same figure appears in a parallel pose by the Virgin's bed. Compared to him, the shepherds in the arches on the left have a more rustic look. The point of the angel's gesture is that when Joseph expresses his doubts about the virgin birth he is referred to Heaven. One wonders, though, whether the ivory-cutter of the Suermondt diptych understood the meaning of the motif, for now Joseph is using his right hand to shield his eyes from the light that shone down when the angel appeared to the shepherds. In still later versions of the diptych Joseph's dream has disappeared altogether, leaving just the announcement to the shepherds in the background. The angel, now superfluous, may turn to the shepherds in the other two arches (*fig. 30*). Thus it was that repetition led to the loss not only of aesthetic quality but of narrative subtlety as well.

Fig. 28. Workshop of Bernardo Daddi, triptych, ca. 1320–30. Prague, Narodni Galerie

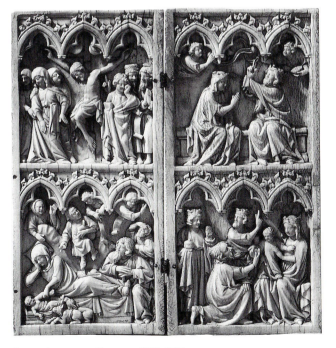

Fig. 29. Anonymous, France, ca. 1375–1400, diptych, ivory. Aachen, Suermondt Museum

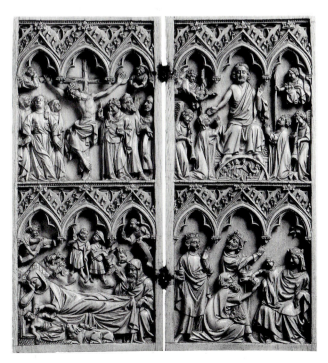

Fig. 30. Anonymous, France, ca. 1375–1400, diptych, ivory. Cologne, Schnütgen Museum

PLATE 23
Anonymous (Paris)
Tabernacle, ca. 1300

Centre: *The Virgin and Child*
Left: *The Annunciation* and *The Adoration of the Magi*
Right: *The Nativity* and *The Presentation in the Temple*
Ivory; 16.8 × 15.1 cm open

Berlin, Staatliche Museen zu Berlin, Preußischer Kulturbesitz, Skulpturensammlung, inv. no. 627

Fig. 31. Anonymous, France, ca. 1330, tabernacle, ivory. London, Victoria and Albert Museum

Fig. 32. Anonymous, France, ca. 1350, tabernacle, ivory. Bologna, Museo Civico Medievale

In the Staatliche Museen in Berlin there is a small ivory polyptych from the first half of the fourteenth century with a standing *Virgin and Child* in the middle, and wings with the *Annunciation, Nativity, Adoration of the Magi* and *Presentation in the Temple* (PLATE 23). It is the earliest in a series of a dozen such ivories. In view of the great delicacy of line and modelling it can be assumed that they were made in a workshop in Paris, the centre of ivory-carving at the time. By dividing each of the narrative scenes over two wings, the innermost of which is considerably narrower than the other, the carver was able to produce some striking iconographic effects. The *Nativity* is particularly interesting in this respect, for the Virgin is allowing Joseph to hold the Child for a moment. The writer of the *Meditationes* describes this event, and adds that we, too, may follow Joseph in longing for this privilege. Joseph is singled out again in the *Presentation*, this time carrying a basket containing the sacrificial offerings. Finally, the three kings, crammed into their niches, appear to be adoring the large Madonna in the centre. She describes the S-shaped curve typical of Gothic sculpture, and it is noteworthy that she is far more involved in the figure of Jesus, perched on her arm and giving the blessing, than is her counterpart in the *Vierge ouvrante* of the same period (see PLATE 16).

An ivory polyptych in the Victoria and Albert Museum in London, of a slightly later date, is one of the rare ivories to retain something of the effect of the original polychromy and gilding (*fig. 31*). The niches are deeper than those of the Berlin polyptych, so there is room for an angel to come flying in to place a crown on the Virgin's head. The depth of the central panel means that the innermost wings, which had to close around it, are wider than those of the Berlin ivory. This led to a slightly different arrangement of the scenes. The *Annunciation* now fits into a single panel, chiefly because the carver decided to show Gabriel flying in from above, which also allowed him to add the Visitation to the programme. The Magi also have room to kneel, and Joseph can sit down at the *Nativity*, no longer serving merely as a space-filler at the *Presentation*.

It is occasionally suggested that polyptychs like these can be regarded as small-scale imitations of much larger tabernacles executed in wood or precious metals. Small ivory tabernacles of this kind may very well have served to adorn a domestic altar, with the pious owner opening them when he wanted to say his prayers. Since they are small and can be closed, they were undoubtedly taken on journeys as religious baggage. That is how one example must have found its way to Bologna (*fig. 32*). There was a busy traffic of professors going to and fro between the universities of Bologna and Paris, as well as regular shipments of manuscripts, so it is not at all surprising to find an ivory domestic altarpiece in the collection of Bologna University, to which it may have been brought by a learned priest from Paris. This polyptych was made a couple of decades after the other two, and is of decidedly inferior quality. Iconographically it borrows something from both. What sets it apart is that it is one of the few ivories to provide evidence of exports from a French workshop.

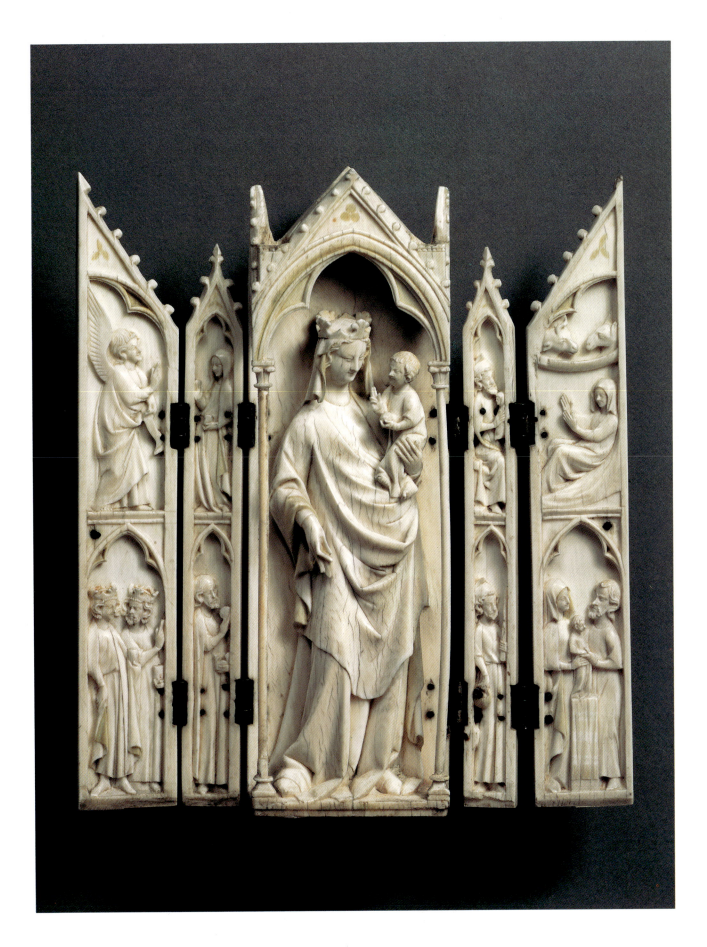

PLATE 24
Master of Catherine of Cleves
(active in Utrecht ca. 1430–60)
The Madonna with donors and
The Nativity, from the Book of
Hours of the Van Lochorst family,
fols. 20v.–21r., ca. 1460

Vellum; 185 × 125 mm; 15th-century binding

The Hague, Rijksmuseum Meermanno-
Westreenianum, Ms. 10 F 50

In 1964, the Meermanno-Westreenianum Museum in The Hague was enriched with a Book of Hours in the vernacular illuminated by an artist known as the Master of Catherine of Cleves (PLATE 24). Its acquisition brought a superb example of the work of the most important Netherlandish workshop for book illumination into a Dutch public collection. At the beginning of the Hours of the Virgin, the text of which has been discussed above (see p. 16), the owners of this precious object kneel on either side of the Virgin. In the initial H the Virgin kneels before the Child as the first of the faithful. As St Bridget had 'seen' in her vision, Joseph enters with a candle, but its light is totally eclipsed by the radiance emanating from the Child. In the border decoration, which is as delicate as it is lavish, there is a sheep-shearer at the bottom of the right-hand page, and on the left, below the kneeling couple, are two putti supporting the arms of Derich van Sevichveld and the Sael family. That shield, though, was applied on top of another with the arms of the Van Lochorst family of Utrecht, which also appears elsewhere in the book.

"At the close of the thirteenth century Italy began to swarm with individuality", wrote Jakob Burckhardt in his *Civilization of the Renaissance in Italy* in connection with the process of individualisation in the Renaissance. He failed to add that almost all of those faces belong to people kneeling and praying. North of the Alps, certainly, the art of portraiture evolved exclusively within the culture of prayer. In a city like Siena, with its large output of images, there are no personalised faces in all those diptychs and triptychs. Very occasionally, a tiny, rich patron appears, but in most cases he is a dignitary from elsewhere who has ordered a special devotional image from one of the leading Sienese painters. A case in point is a cardinal of the Roman Orsini family in a polyptych painted for him by Simone Martini (*fig. 33*). In general, though, the production of devotional art was so standardised that the most a customer might ask was to have his coat of arms depicted on the frame (see PLATE 21b).

In the Low Countries, art for private devotion was to a large extent personalised, with praying donors portrayed prominently in the many Flemish diptychs from the fifteenth century (*fig. 34*). That personal approach applied equally to Books of Hours. In France

Fig. 33. Simone Martini (ca. 1284–1344), *The Descent from the Cross*, ca. 1320, panel. Antwerp, Koninklijk Museum voor Schone Kunsten

Fig. 34. Bruges Master of 1499, diptych of Christiaen de Hondt, 1499. Antwerp, Koninklijk Museum voor Schone Kunsten

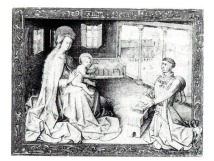

Fig. 35. Jean le Tavernier, *Philip of Burgundy kneeling before the Virgin and Child*, from the Book of Hours of Philip of Burgundy, fol. 299r. The Hague, Koninklijke Bibliotheek

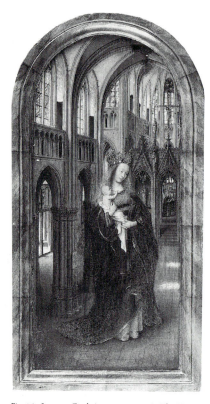

Fig. 36. Jan van Eyck (ca. 1390–1441), *The Virgin in a church*, ca. 1425, panel. Berlin, Staatliche Museen zu Berlin, Preußischer Kulturbesitz, Gemäldegalerie

and the Netherlands such illuminated manuscripts were indispensable status symbols, and they often contain the portrait of the kneeling owner (*figs. 2, 35*). The fact that a subsequent owner of the Van Lochorsts' Book of Hours immediately had his coat of arms painted over theirs shows how much importance was attached to putting one's own stamp on a Book of Hours.

Kneeling is not popular these days, which makes it all the more noticeable that in the Late Middle Ages it was the most elegant pose one could adopt. In a culture of prayer it was the preferred position in which to be immortalised. Kneeling is not a matter of course in religious practice. Free Greeks, for example, did not as a rule like to kneel during religious rituals. In the Early Christian Church kneeling was not the customary attitude for prayer. One stood upright with outstretched arms. In church, people knelt only when doing penance, but from time immemorial it had been the position for praying silently in private. The priest set the example during Mass. From the twelfth century people also knelt to receive Communion, and the posture was construed as an expression of the inner assimilation of the Eucharistic ritual. From the strictly liturgical point of view, kneeling has never been the most appropriate position for receiving the Sacrament. It is often regarded as a pose that can give rise to misplaced adoration and an exaggerated display of humility. In the Late Medieval culture of prayer, however, the élite were only too eager to have themselves portrayed on their knees as a mark of humility and absorption.

Prayer involved reciting and reading. The latter, though, was the preserve of the literate élite, which in practice usually meant the nobility and the patriciate as far as the laity were concerned. The use of a Book of Hours enabled them to approach the monastic ideal, for it imposed a religious framework on daily life. The Book of Hours was the commonest type of book produced in France and the Low Countries in the Late Middle Ages. One famous example, now in New York, may have been a gift from Catherine, Duchess of Cleves (1417–1476), to Ermengaard van Lochorst (died 1517), whose family coat of arms appears in this book as well. In Münster there is another Book of Hours that was made in the same workshop for Catharina van Lochorst, a member of the Utrecht family who had moved to Leyden. The original coat of arms in the Hague Book of Hours probably belonged to Ermengaard's parents, Willem van Lochorst (died 1494) and his wife Moreel.

Anyone who counted for anything had more than one Book of Hours, which is why Van Lochorst's wife has a satchel of books beside the cushion on which she is kneeling. She has just taken a manuscript from it and is demonstratively reading a prayer. Books of Hours were also taken to church, which explains the inclusion of Eucharistic texts. Owners of Books of Hours often collected unusual prayers, and ladies such as Blanche of Burgundy (ca. 1296–1326) even commissioned priests to write special ones for them. Prayers that were out of the ordinary were eagerly collected, just as cooks collect recipes today. There were also evergreens, like the many psalms that found their way into Books of Hours from psalters. Most prayers, though, were to the Virgin.

The Van Lochorsts are kneeling before a church in which the Virgin stands with the Christ Child in her arms. It is worth noting how careful the illuminator was to make a distinction between the space containing the praying couple and that occupied by the objects of their veneration. First we are led outdoors, then back indoors again. The Virgin standing in a church is a common motif in Netherlandish art. The sacral nature of the architecture is emphasized in the miniature by the statuettes of the priests Simeon and Moses. Temple, hall, church and house of God were derived from the Song of Songs in these architectural metaphors for venerating the Virgin. The model for most of those scenes may well have been a painting by Jan van Eyck now in Berlin (*fig. 36*). It is generally assumed that all these *Madonnas* were accompanied by a portrait of the donor praying (see *fig. 34*). The Virgin in the church evidently could not do without the prayers of the faithful. This recalls the formulation used by Ambrose (ca. 334/40–397), one of the Church Fathers. Christ comes into Mary, entering into the virgin womb of his bride, who is simultaneously the Church, which gives birth to the people of God. These metaphors found a place in the liturgy at an early date. The miniature uniting the Virgin and Child in a church with two kneeling worshippers in a scene divided into two distinct spaces can be regarded as the ideal visual representation of such writings. Mary gives birth to the Christ Child and, as the Church, to the faithful.

Kneeling in front of rather than inside a church can be seen simply as a normal, reverential act. Here, though, the tension between the two spaces is so deliberate that there must be a deeper significance. One immediately thinks of the corresponding page in the New York Book of Hours of Catherine of Cleves (*fig. 37*). Once again the Virgin appears to the faithful, but now the vision-like nature of the scene is more obvious, because this is not the Virgin in a church but Mary as the Woman of the Apocalypse from the Revelation of St John, who appeared to him robed with the sun (see PLATE 44b). Although the Hague scene is more static, it nevertheless appears that the Van Lochorsts, through their prayers, have unveiled another space, in which the Virgin stands. In general, the viewer would not have regarded the relationship between depictive image and prayer as merely that of someone kneeling in front of an illustration. Prayer can evoke images, in the most literal sense of the word, just as St Francis's prayer conjured up the image of Christ on the cross. There is a fascinating painting attributed to the Flemish painter Adriaen Ysenbrandt in which Mary Magdalene, with the jar of ointment with which she anointed the dead Christ, is depicted twice with a Book of Hours (*fig. 38*). In the open book in the foreground one can even see fragments of illuminations. The intensity of the Magdalene's prayer conjures up an angel, who brings her a crucifix. Prayer creates images. Looking within from without, this is exactly what is happening on the first page of the Hours of the Virgin in the Hague manuscript.

Fig. 37. Master of Catherine of Cleves, *Catherine of Cleves kneeling before the Virgin and Child*, from the Book of Hours of Catherine of Cleves, ca. 1440, MS. 945, fol. 1v. New York, The Pierpont Morgan Library

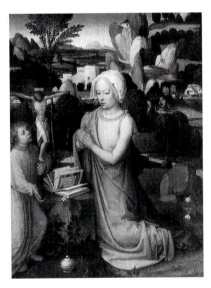

Fig. 38. Attributed to Adriaen Ysenbrandt (active 1510–51), *Mary Magdalene in a landscape*, panel. London, The National Gallery

RELIGIOUS TOURISM

In the spring of 1465, the famous Benedictine church of the Virgin Mary in the Swiss town of Einsiedeln burned to the ground. It had attracted hordes of pilgrims, because it offered many attractions for the pious tourist, among them a statue of the Virgin that could work miracles. Indeed, the church itself was a miracle. Legend had it that just before Conrad, bishop of Constance (died ca. 975), came to consecrate the church in 948, Christ and the angels appeared and performed the liturgical rites on his behalf. Another version of the story tells of a consecration by angels, and of a disembodied voice that called out three times: "Stop, brother, for God's hand has already consecrated the church". An added appeal for pilgrims was that a visit to the church gained a major indulgence, which Bishop Conrad had obtained from Leo VIII (pope 963–65) when he visited Rome in the entourage of Emperor Otto I (912–73). Just one special attraction was usually enough to galvanize believers, but the combination of these three made Einsiedeln one of the most popular destinations for pilgrims.

Indulgences were granted by the Church for the remission of a period of time that one would otherwise have to spend in Purgatory undergoing temporal punishment before being admitted to Heaven. Initially they could be gained by performing an act of some kind, which compensated in whole or in part for the debt of punishment. For instance, one could go on a journey to a holy place, or give money to a good cause. The most important change to the system in the Middle Ages was that indulgences gradually came to be associated not just with punishment or penitence but with guilt. That, of course, could only be done if guilt could be quantified. This led to a massive increase in the number of indulgences, and above all to a staggering inflation of the entire system. In the thirteenth century, for example, reciting a hymn like the *Ave facies praeclara* before an image of Christ earned a partial indulgence of ten days' remission of temporal punishment, but in the fifteenth century saying the *Salve sancta facies* (see p. 43) was worth 10,000 days' remission. It was no longer a matter of regulating people's existence on earth; the Church now had a way of guaranteeing life after death, in God's company, for oneself and the people one held dear. The Church owed this enormous credit to the martyrs, for after all they had not died for Christ in vain, had they? The Dutch translation of the *Salve sancta facies* discussed above tells us something about the popularity of this prayer, but it was stimulated by the efficacy accorded to this and other prayers by higher authority, and this was expressed in terms of indulgences.

The abuse of indulgences was more a question of hard cash than prayer. The end of the fifteenth century saw the rise of dealers who made fortunes selling indulgences. The Church's spiritual credit was redeemed for cash that lined the pockets of people such as Johann Tetzel (ca. 1465–1519), who aroused the ire of Martin Luther. Because of the bad reputation that indulgences have had since the Reformation, there is little if any awareness of the crucial rôle they played in medieval life. But for indulgences, many churches and hospitals would never have been built, there would have been far less travel, and it would probably not have been possible to mount any crusades. There would also have been much less prayer. Nor should it be surprising to learn that a great deal of art owes its existence to indulgences.

To return to Einsiedeln. After the church burned down, the Benedictines launched a campaign to finance immediate rebuilding. A key element of their fund-raising drive was the indulgence granted by Leo VIII, the quincentenary of which could be turned into an occasion for celebration. The mere age of the indulgence vouched for its efficacy, even if its meaning had changed drastically in the intervening five centuries. For their rebuilding programme the Benedictines acquired an important privilege: a visit to their shrine would be rewarded with a full, plenary indulgence after prayer and an 'act of perfect contrition'. This was the most attractive of all indulgences. But the Benedictines did not stop there. They wanted greater publicity for the legend of the consecration of their church, so they commissioned a workshop in Basle to make a booklet of woodcuts, known as a block-book (*fig. 39*). They also issued medals and pilgrims' badges, and completely overhauled the tourist infrastructure of Einsiedeln. In the end, according to a pilgrim from Constance writing in 1466, the year in which the new church was handed over to the monks, no fewer than 130,000 pilgrims made the journey to Einsiedeln. During the fortnight that the festivities lasted there were four hundred priests at work in the town, but our eye-witness complained that the church was far too full, and that despite the legion of clerics there was no opportunity to have one's confession heard.

The feast also led to a commission for perhaps the most beautiful devotional print of the fifteenth century. It was executed by Master E.S., who, with the Master of the Amsterdam Cabinet (see p. 30), was the most important graphic artist of the period

Fig. 39. Anonymous, Basle, before 1466, *Christ consecrating the church at Einsiedeln*, woodcut from the block-book *Dis ist der erst aneuang . . .,* A.DB. 5, fol. 49r. Einsiedeln, Stiftsbibliothek

PLATE 25a
Master E.S. (active Upper Rhine
ca. 1450–1467)
The Large *Virgin of Einsiedeln*, 1466
Engraving, hand-coloured; 206 × 123 mm

Berlin, Staatliche Museen zu Berlin, Preußischer
Kulturbesitz, Kupferstichkabinett, inv. no. 339–1

(PLATE 25a). What is so interesting is that Master E.S. did not depict the legend, as the woodcutter of the block-book had done, but devised a composition in which the narrative is subordinated to the devotional element. The Virgin bears not the slightest resemblance to the miracle-working Black Virgin of Einsiedeln, nor did Master E.S. even base the setting on a real building. In fact, he probably never even visited the town. In Constance he was familiar with a mural of 1445 over the tomb of a Bishop Otto in the Minster. It was this illusionistic, two-storey structure that he used for his gathering of the inhabitants of both Heaven and earth.

The Virgin is enthroned on the altar, flanked by St Benedict on the left and an angel on the right. Both are carrying candlesticks with lighted candles as a mark of honour. Standing and kneeling around the altar are pilgrims, recognisable by their headgear and staffs. On the balcony, behind a balustrade and beneath a triumphal canopy, is Heaven in all its panoply and glory. Not only is Christ present, but the full Trinity of Father, Son and Holy Ghost, and there are hosts of angels. One angel is displaying the orb of Christ's omnipotence, while another holds a pail of holy water so that Christ can bless the building with His aspergillum. Bishop Conrad is nowhere to be seen. It was evidently felt that his presence would be too distracting in this ambience of adoration and heavenly pomp. In the centre of the scene is the papal coat of arms, which stressed the authenticity of the indulgence. Running around the top of the arch are the words *"Dis ist die engelwichi zu unser lieben frouwen zu den einsidlen aue gracia plenna"* (This is the angelic consecration of [the church of] our dear Lady of Einsiedeln; hail, full of grace). So in addition to the title of the scene, Master E.S. names the prayer with which the pilgrims venerated the Virgin in order to obtain full remission of guilt and punishment. Probably the lettering on the tablet hanging outside the chapel on the right of the chapel is meant to suggest prayers and the text of the indulgence.

Who bought a print of this kind, which would only have been issued in a limited edition? Rich pilgrims, undoubtedly. But that also made them collectors. Perhaps there were collectors who never went on pilgrimages, and did not even say a Hail Mary before this depiction, but merely wanted to own a superb print by the finest engraver of the day. Be that as it may, the master also made a smaller print for those of more slender means (PLATE 25b). This reduces the scene to its essentials: the Trinity, the Virgin, St Benedict and the angel, as well as the papal coat of arms and the date of that special year, 1466. Master E.S. made an even smaller version for those who only wanted a card to keep in their prayer-books (PLATE 25c). The interesting point here is that there is no longer any reference to the miraculous consecration of the original church. It is simply a prayer-card. At the top, though, there is still the papal coat of arms, which shows just how important ecclesiastical authority was when it came to a large supply of Madonnas to be venerated in association with the most generous of indulgences.

Further reading:
Von Andrian-Werburg 1992; Belting 1990; Bynum 1982 and 1987; Challoner 1945; Freuler 1987; Gilbert 1984; Harbison 1985 and 1991; Hausherr 1975; Hood 1986 and Hood 1990; Kermer 1967; Kroos 1986; Little 1979; Van der Meer 1970; Van Os 1969; Purtle 1982; Radler 1990; Schuppisser 1986; Wentzel 1960; Wieck 1988

Quotations:
Van Os 1969, pp. 82–83; Radler 1990, p. 32
(× 2); Challoner 1945, pp. 175–76; Schuppisser
1986, p. 141

PLATE **25b**
Master E.S.
The Small *Virgin of Einsiedeln*, 1466

Engraving, hand-coloured; 133 × 87 mm

Berlin, Staatliche Museen zu Berlin, Preußischer
Kulturbesitz, Kupferstichkabinett, inv. no. 340–1

PLATE **25c**
Master E.S.
The Smallest *Virgin of Einsiedeln*,
1466

Engraving, hand-coloured; 97 × 65 mm
Inscription: 1466 (left, above the arch)

Berlin, Staatliche Museen zu Berlin, Preußischer
Kulturbesitz, Kupferstichkabinett, inv. no. 383–1

DEVOTIONAL THEMES

The same stories were constantly being depicted anew within the culture of prayer. In Late Medieval art, however, the focus narrowed to a few specific themes and motifs. For example, the motif of Christ carrying the cross was isolated from the larger scene of the Carrying of the Cross, and from the Lamentation came the devotional theme of the Pietà, in which the sorrowing Virgin is shown with the dead Christ on her lap. This fascinating process of the evolution of images has given rise to a great deal of discussion and confusion in art historical circles, so a brief digression is in order. Images distilled from a larger context have been called *Andachtsbilder*, literally 'devotional images'. The trouble with that concept is that it suggests it was private devotion that led to the creation of those specific themes, and that this form of spirituality had an emotional range different from that of the institutionalised Church liturgy. In fact, many of the themes that have been associated exclusively with private devotional practice were also depicted on altarpieces, and often at an earlier date. Images in churches could evoke just the same emotional, individual reactions – they could induce visions and work miracles, they consoled, and could shed tears with you.

In the Late Middle Ages, Christian spirituality expanded beyond the confines of churches and monasteries, but even in the outside world it remained largely directed towards the Church's intermediacy in salvation, and in particular towards the sacrament of the Eucharist. The best idea of the social and personal significance of the Late Medieval culture of prayer is provided by works of art the size of which makes it almost certain that they were used in the private domain as an accompaniment to prayer. That culture, though, cannot be seen in isolation from the ecclesiastical structures, as has been done so often in the past, both explicitly and by implication. The 'emotional repertoire' for Late Medieval spirituality was largely complete by about 1300, with Bernard of Clairvaux and Francis of Assisi setting the tone. It is true that there were variations in the repertoire, but the tone remained the same. Consequently, the development of a specific devotional theme in the visual arts cannot be explained by assuming that religious feelings had become more individual and more intense – a view one often encounters in art historical literature. The same emotions were expressed in prayers before a simple *Man of Sorrows* of ca. 1300 as before a highly dramatic interpretation of the same subject from the end of the fifteenth century.

With all this new imagery, it is often forgotten that the traditional *Madonna* and *Crucifixion* can be seen as devotional themes extracted from a narrative. Despite all the innovations in the stock of images, these two remained the most popular. Many of the small Late Medieval paintings of the Virgin and Child were augmented with secondary figures, with the result that the old theme began telling a new story. This is exemplified by a charming little painting of the Cologne School (PLATE 26). The shape of the triptych undoubtedly derived from Italian art (see PLATE 22), but all its other features place it firmly within the tradition of painting in Cologne. They include the bodiless figures, whose existence is determined solely by the undulating movement of their robes. The rich, full tonality lends weight to these mild-mannered forms. Even Jesus's tormentors in the scene of the *Mocking of Christ* cannot ruffle the mood of serenity. No other school produced such sensitive Virgins and such appealing, playful

PLATE **26**
Master of St Veronica (active in
Cologne ca. 1395–1415)
Triptych, ca. 1410

Open, centre: *The Virgin and Child in a mandorla
of angels, surrounded by Sts John the Evangelist,
Barbara, Christine, Catherine, Mary Magdalene and
John the Baptist; God the Father above*; left: *The
Flagellation* and *The Crucifixion*; right: *The
Resurrection* and *The Ascension*
Closed: *The Carrying of the Cross*
Panel; centre 70 × 32.5 cm, wings 70 × 16 cm
Kreuzlingen, Heinz Kisters collection

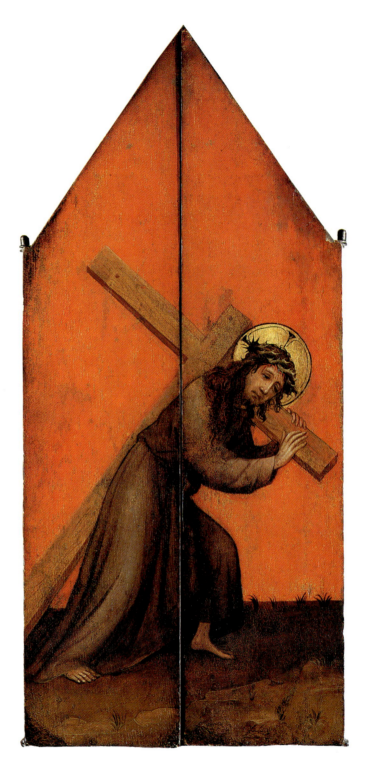

infants, and nowhere is the Virgin's relationship with her Child so tender as in Cologne painting.

The Virgin is traditionally recognisable as the Queen of Heaven from the crown on her head. This Cologne artist, however, presents the motif of the Virgin as Regina Coeli as a vision. Her radiance forms a great golden oval, surrounded by angels and revealed by God. Whoever prayed before this triptych – possibly even holding prayer-beads similar to those the Virgin wears around her neck – was confronted not only with the Virgin and Christ, but also with an image of heavenly bliss in this gold background. This is the first enrichment of the old theme. But there is more: in this triptych, Heaven touches earth. Theologians eagerly linked *humus*, the Latin word for earth, with *humilitas*. God's word found fertile ground in the Virgin. The faithful prayed to her that they, too, might be a well prepared breeding-ground in which the seed of God's grace could flower. "Mary, thou art the earth and the flowers", was a prayer said by one Dominican nun living at the time when this triptych was made.

Earth, fertile soil, growth and flowering were all common metaphors for the Virgin and for Christ's Incarnation in the Late Medieval practice of prayer. The fact that God's presence on earth in the person of Jesus became a reality time and again in a ritual manner at the sacrifice of the Mass is expressed in this triptych by the attributes of the two saints seated on the ground on either side of the Virgin. On the left is John the Evangelist with a chalice, and on the right John the Baptist with the Lamb of God, which is to be sacrificed. Between them they underscore the close relationship between private devotion and Church liturgy.

The Virgin's most striking attendants on the fertile earth are the four elegant ladies in the foreground. They are the four holy noblewomen who, particularly in Cologne art, often appear as the Virgin's close friends. On the left is St Barbara with her tower, and beside her St Christine with the millstone with which she was martyred. Across from her sits Princess Catherine with her wheel and sword (see PLATE 10b), who is looking at Mary Magdalene holding the jar of ointment with which she anointed the dead Christ. These figures also identify the setting in which the triptych was used. The fertile earth, the delightful garden, the *hortus conclusus*, were metaphors not only for the Virgin but also for a convent. This painting was undoubtedly intended for the cell of a well-born nun in one of Cologne's convents – a world in which images had always played an important part (see PLATE 16).

The left wing has two scenes from Christ's Passion and death, and on the right wing we see His triumph over death at the Resurrection and His apotheosis at the

Ascension. In the literature on this triptych these scenes are invariably associated with the Seven Sorrows and Seven Joys of the Virgin. Those sevenfold emotions comprised a system of scenes from the life of Jesus that had been developed in connection with the devotion of the rosary (see p. 154). That is too far-fetched an interpretation in this context. In the first place there are four scenes, not fourteen, and secondly their inclusion here is easily explained as a visual formulation of the actions of the Child on Mary's lap in his rôle as Saviour. Additions of many different kinds to the traditional theme of the Virgin and Child served to stimulate the religious imagination.

It is unusual for the decoration on the backs of the wings to play an important thematic rôle in the visual programme of a triptych like this, but it does so in this case. When the triptych is closed one is presented with a moving depiction of Christ carrying the cross, painted on a layer of red which was usually the support for gold leaf. Here the central motif has been isolated from the theme of the Carrying of the Cross, which was of crucial importance for Late Medieval devotion. Christ had Himself extended an invitation to follow Him when He said: "If any man will come after Me, let him deny himself, and take up his cross, and follow Me" (Matthew 16,24; Luke 9,23). In the Late Middle Ages that call became a starting-point for a way of life in the service of God. Having been isolated from the narrative, the image of the cross-bearing Christ acquires a validity unconnected with time or place. This Jesus walks through eternity before those who behold him. "Why do you hesitate to take up your cross; it is the only path to eternal life", asked Geert Grote, the spiritual father of the Modern Devotion (see pp. 168f.), a movement which had a great impact on life in Cologne. Anyone using the triptych began with the Carrying of the Cross, thus taking a step along the road to salvation. Inside, he or she then saw the Virgin and Child set against a background of heavenly bliss. So the very act of opening this triptych took on a religious significance comparable in some respects to the effect of opening a *Vierge ouvrante* (see PLATE 16).

To expand the scene with the Virgin and Child in order to give it a more domestic touch was one of the commonest ways of bridging the gap between the viewer and protagonists, and it was here that Joseph came into his own. Originally he was included so that his advanced age, doubts and generally dim-witted air would stress the virginal nature of Christ's birth. But around 1400, when the culture of prayer had become part of urban life, he was given a new rôle. He, Mary and Jesus formed a 'Holy Family'. Theologians and artists now placed Joseph the carpenter in a different context. Jesus's life with His parents became the model for the lay family, the cornerstone of society. Moreover, such scenes also enabled celibates, who had withdrawn from the world, to participate spiritually in family life — that of the Holy Family.

PLATE 27
Master of the Amsterdam Cabinet (active Upper Rhine ca. 1470–1500)
The Holy Family by the rose-bush, ca. 1490

Drypoint (unique impression); 142 × 115 mm

Amsterdam, Rijksmuseum, Rijksprentenkabinet, inv. no. RP-P-OB–889

One of the most delightful and surprising depictions of the Holy Family is an etching by the Master of the Amsterdam Cabinet (Housebook Master), which survives in only a single impression (PLATE 27). The family is outdoors, in an enclosed garden. In fifteenth-century Rhineland art, the Virgin and Child are often depicted in this *hortus conclusus*, a 'garden close-locked' that symbolizes Mary's virginity, sometimes with a rose hedgerow, another of the Virgin's symbols. Almost every landscape detail in this etching is a Marian symbol that features in one or more hymns to her. There is the church in the background, of course, but there is also a tower, the *turris Davidica*, and on the left the gateway to Heaven, the *porta coeli*. The harbour in the background may be a reference to Mary as a safe haven, the apple tree beside the roses may allude to Original Sin and to the redemptive rôles of Mary as the new Eve and Christ as the new Adam.

All of these motifs can be read symbolically, and probably were by some of the artist's contemporaries. However, there is an enormous difference between this and earlier scenes incorporating symbols. Garden, bench, gateway, tower, harbour and church are no longer isolated motifs, but together form a natural setting for this scene of family domesticity. The viewer can recognise their world as his own. That this naturalness was deliberate is particularly clear from Joseph's involvement with Jesus. He has been given a rôle halfway between simpleton and paterfamilias. He is no longer a marginalised, ineffective doubter, but a playful father interacting with his son (see PLATE 1). He is impishly distracting Jesus's attention by playing a game with the love apples from the Song of Songs. Jesus has lost His usual rôle as the Saviour communicating with the viewer, or as His mother's child. The landscape and the addition of Joseph are above all an attempt to create a suitable setting for an intimate scene of family life, one in which the believer devoutly saying his prayers can feel involved.

One genuinely new Marian theme was the Madonna dell'Umiltà, or Madonna of Humility. That title has come down to us more or less by accident, thanks to a number of scenes of the Virgin bearing the inscription *"Maria dell'Umiltà"* or some such designation. Here the Virgin is seated not on a throne but on a cushion on the ground. It is assumed that the inscriptions referred to the Virgin's humble position, and that all Virgins seated on the ground, with or without a cushion, were regarded at the time as humble Virgins. The first images of the Madonna dell'Umiltà, datable around 1300, appeared simultaneously on altarpieces, murals and small panels for private devotion. Frescos with the Madonna dell'Umiltà were the object of special veneration in northern Italy. In Siena, at the end of the fourteenth century, images of the Madonna dell'Umiltà for private devotion were produced *en masse* by Andrea di Bartolo's workshop. It is known, for instance, that the Dominicans who dedicated the tertiaries' convent in Venice gave the nuns Madonnas of this type executed by Andrea (see *fig. 27* on p. 74).

As far as is known, the Florentine monk Lorenzo Monaco painted only one *Madonna dell'Umiltà* for private devotion. It displays all the refinement of his art (PLATE 12a and opposite). This panel originally formed a diptych with the *St Jerome* in the Rijksmuseum (PLATE 12b). The gold of the *Madonna* is far more worn than that of *St Jerome*. The red layer of bole can be seen beneath the beautifully ornamented gold ground, as can the white layer of gesso to which the bole was applied. This clearly reveals the extent to which the red substrate determined the intensity of the effect of the gold background. Small though they may be, as a diptych these little panels form an impressive and rare monument to Italian painting for private devotion. St Jerome has removed the thorn from the lion's paw, illustrating the monastic virtue of chastity, while the Virgin displays her humility by seating herself on the ground.

Lorenzo's *Madonna dell'Umiltà* leads one to consider the crucial importance of humility within the culture of prayer. The medieval doctrine of the virtues taught that humility was the root of all the others. The message that preachers constantly drummed into their audiences was that prayer without humility was pointless. It was the only possible response to God's mercy. In the Late Middle Ages, however, this ceaseless emphasis on humility as a fundamental attitude often led to excessive displays of *humilitas*, especially in urban communities. Manifestations of humility, in other words, could also be prompted by a questionable sense of superiority. That is not to deny, however, that in the act of communing with God it retained a special significance as a precondition for prayer. At the Annunciation, Mary had demonstrated that she was the supreme embodiment of *humilitas*, because she had made herself and her entire existence subject to God's will. Not only did the faithful follow the angel in addressing her with the words "Hail Mary", but they also wanted to echo her response: "Behold the handmaid of the Lord".

It is believed that Lorenzo's diptych of St Jerome and the Virgin was used as a visual aid by a learned monk in the monastery of Santa Maria degli Angeli in Florence, where Don Lorenzo also lived and for which he made many works of art. The reason is that the veneration of St Jerome was mainly propagated by scholars. Here, though, he does not appear in the guise of an intellectual; learning, symbolized by the books in his study, is merely an attribute. The motif of the removal of the thorn from the flesh is the key element of the scene. It illustrates chastity, as its pair does humility, recalling St Jerome's incessant appeals to Roman matrons to lead ascetic lives. On this evidence it is more likely that the diptych belonged to a nun or a female tertiary.

The Virgin and Child image was completely renewed with the addition of St Anne, Mary's mother, and scenes of *St Anne with the Virgin and Child* spread throughout Europe. Italian painters such as Masaccio (1401–1428) and Leonardo da Vinci (1452–1519) relished the challenge of creating a convincing composition from the grouping of these three figures. But it was above all in the Low Countries, Germany, Sweden and northern France that the veneration of St Anne evolved into a true mother cult that penetrated to all corners of society and became the vehicle for deep human desires and feelings.

PLATE 28

Master of Cornelis Croesinck
(active in Holland ca. 1490–95)
St Anne with the Virgin and Child,
fols. 25v.–26r. from a prayer-book,
ca. 1490

Vellum; 162 × 121 mm; 20th-century binding

The Hague, Koninklijke Bibliotheek,
Ms. 135 E 19

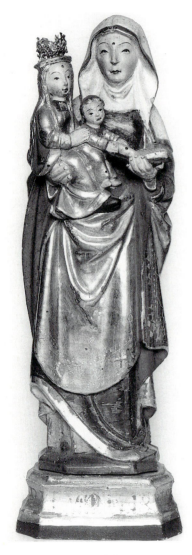

Fig. 40. Anonymous, Mechelen, ca. 1510–20,
St Anne with the Virgin and Child, walnut. Utrecht,
Rijksmuseum Het Catharijneconvent

*God gruet u edel rose angelier bloem, vol bistu der
ghenaden, o heilighe vrouwe ende moeder sinte anna
du helpste menighen mensch uut siinre noot, daerom
so staet my bi o waerde vrouwe ende helpt my doer
die bliscap die gii hadt doe u die engel gods
openbaerde ende seide tot u. dat gii een moeder wesen
soudt der waerdigher moeder gods In dier
gedenckenisse en in dier eren o waerde vrouwe so
verlost mi van alle bangicheit, drucke en rouwe. amen
Pater noster. Ave maria gracia ple.*

The veneration of St Anne has no Scriptural basis, indeed she is not even mentioned in the Gospels. She and Joachim, the father, make their first appearance in the apocryphal Book of St James, and are the subject of a long passage in the thirteenth-century *Golden Legend* by Jacobus de Voragine. The reason for this particular interest in Mary's parents was the growing veneration of the Virgin herself, in which the fixation on the physical side of Jesus's ancestry played a crucial rôle. The virgin birth of Christ implied that Mary was holy, which in turn meant that there must have been something exceptional about her own birth. Precisely what it was sparked off a quarrel among theologians that lasted until the nineteenth century. Dominicans believed that Mary was cleansed of Original Sin after her conception. This they called sanctification. Franciscans, on the other hand, argued that Mary had been sanctified before the world was even created, and that she must therefore have been conceived immaculately. This was the view that Pope Pius IX elevated to dogma in 1854.

Theological speculation was not, of course, the deciding factor in the spread of St Anne's veneration at the end of the Middle Ages, nor in the great popularity of stories about Mary's lineage. They provided no more and no less than a framework that met a desire for a cult of motherhood, for a religious stylisation of family life. This dynastic approach was reflected in the interest in the Holy Family's genealogical tree. St Anne gave succour in the hour of need. Many a person said a quick prayer to this 'Great Mother', who was also the Saviour's grandmother. "Help me, Anne, with your threesome", or "Help me, Jesus, Mary and Anne", and even "Help me, Anne, with your kin", which was designed to mobilise the whole family. There are many surviving statuary groups of *St Anne with the Virgin and Child* from Germany and the Low Countries (fig. 40).

One of the most moving testimonies to the veneration of St Anne is a small prayer-book from the northern Netherlands that must be dated ca. 1490 (PLATE 28). It consists mainly of spiritual exercises centred on Christ's life and Passion, but in the section entitled "*Ghetiden*" (Hours) there are "*VII devote groetenissen tot sint annen ghemaect op VII bloemen*" (Seven devout salutations to St Anne, fashioned on seven flowers). The introduction tells of a nun who had a vision of St Anne wearing a hat and carrying beautiful flowers in which prayers to the holy mother, Anne, were written in gold letters. Each prayer is woven around the theme of a particular type of flower. The prayer accompanying the first miniature runs as follows: "God greet you, noble pink gillyflower, thou art full of grace, O holy woman and mother, St Anne, you help many a person in their hour of need. So stand by me, O worthy woman, and help me with the joy you felt when the angel of God revealed himself to you, and announced that you would be the mother of the worthy Mother of God. In that memory, and in that honour, O goodly woman, deliver me from all fear, oppression and sorrow. Amen, Our Father, Hail Mary, full of grace."*

All the prayers to St Anne in this manuscript correspond to a series of prayers in a work that circulated widely at the end of the fifteenth century, *Die historie, die ghetiden ende die exempelen der heyligher vrouwen, sint Anna* (The history, hours and examples of the holy woman, St Anne), which is attributed to Jan van Denemarken (active mid-15th century) of Vinkeveen, south of Amsterdam. Jan was a passionate advocate of St

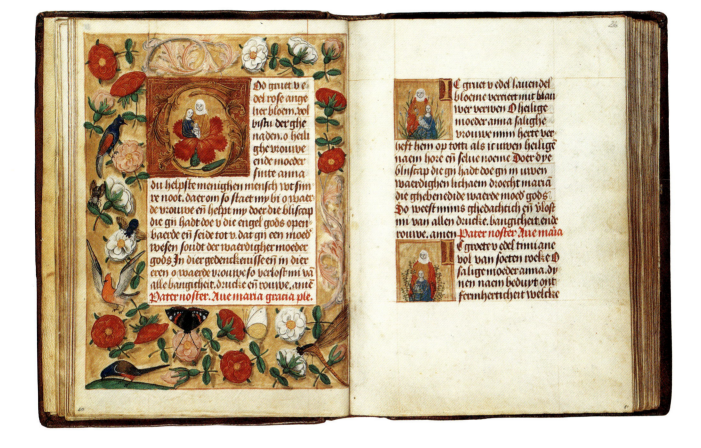

Fig. 41. Anonymous, *The Virgin adoring the Child*, from the Book of Hours of Gian Galeazzo Visconti, fol. 24r. The Hague, Koninklijke Bibliotheek

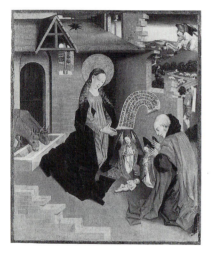

Fig. 42. Johann Koerbecke (ca. 1400/10–1491), *The Virgin adoring the Child*, ca. 1470–80, panel. Munich, Bayerische Staatsgemäldesammlungen, Alte Pinakothek

**O du vesen des wesens O du lich des lichtes O du overschoen ewighe/ schoenheit O ynghedruckede ewighe soticheit O du hoghe bant der godliker/ mynne unde hebbest gelaten de glorie dyns vaders unde du quamest neder yn/ dit darl der unsalicheit up dattu uns van de ewigen doet werlosen/ woldest O myn her unde myn god unde myn alre sotest soen.*

Anne, and also wrote lives of Joachim and Joseph. Just how far imagination could be unleashed on Mary's lineage is shown by his story of Emerantia, the mother of St Anne. Emerantia was unwilling to marry, because she knew that Christ was to be born of a virgin. Accompanied by monks from Mount Carmel, she prayed for advice for three days. On the third day she and her companions discovered that they had all experienced the same vision, of a tree with a beautiful flower on one of its branches, and on that flower a succulent fruit. A voice explained the meaning of the vision: the tree was the marriage that Emerantia had to enter into, for the branch was the daughter named Anne who would be born of that union, the flower was the Virgin Mary, and the fruit Jesus Christ. With this glorious prospect before her, Emerantia decided to marry after all, but most decidedly not for "carnal gratification". Thus it was that stories, prayers and visions blossomed from the veneration of Christ's grandmother.

On one of the most beautiful pages of the Book of Hours of Gian Galeazzo Visconti (see p. 16), Mary kneels before the radiant, nude Christ Child in the initial D that opens the psalmist's well known prayer, *Deus in adiutorium meum intende* (fig. 41). This type of Nativity, with Mary adoring the Child she has just brought into the world, became one of the most ubiquitous prayer-cards ever, and could in principle accompany any prayer addressed to Jesus. In a scene on a Westphalian altarpiece of ca. 1470/80 from the Cistercian monastery of Marienfeld, the Virgin is again seen kneeling before her Child (fig. 42). Now, though, the words of her prayer are also depicted, much like a modern comic-strip: "O being of beings, O light of lights, O you most beautiful, eternal beauty, O ingrained eternal sweetness, O you, my high vessel of divine love, for me hast Thou left the glory of Thy Father and come down to this vale of tears, that You might redeem eternity, O my Lord and my God and my most sweet son".*

These words were inscribed on the painting so that they could be repeated by the worshippers. The faithful were given the opportunity of having the Christ Child born in their own hearts. In those days that was experienced far more realistically than we can imagine. Like Mary, who became anxious and searched for Jesus high and low when he was disputing with the Doctors in the Temple, believers could also lose Christ and find him again. Empathizing with Mary, you could share her feelings of guilt, and wonder whether you were taking proper care of him. This is how the author of the *Meditationes* describes Mary's relationship with her son, his purpose being to ensure that the nun for whom he was writing would treat her Christ Child in the same way.

As an accompaniment to the spiritual intercourse with Jesus, wooden *Christ Children* were produced in large numbers from the mid-fourteenth century onwards (fig. 43). Christ is now shown upright, inviting adoration. In the book with prayers to St Anne (see p. 96) there is a miniature beside the prayer "on the sweet name of Jesus" in which Jesus is sitting up (fig. 44). Most of these images show a rather stiff little baby, because it was the divine Redeemer who was being worshipped in the Child. Nuns and beguines took great spiritual pleasure in clothing their Child, and some of those costumes have been preserved. One of them still adorns a *Christ Child* from Mechelen, which is now in the museum in Schwerin (fig. 45). Here eternal beauty is expressed by

a very sumptuous display indeed. Interestingly, there is also a reference to the Cross, for on the belt there is an inscription mentioning a relic of the True Cross that is incorporated in this "sweet" Child.

Here more than anywhere else, with these numerous wooden statuettes of the infant Jesus, one realises that what is now regarded as art was in those days nothing more than an aid to devotion. They were props in an intimate theatre of spirituality. The most thrilling moment of all was when a wooden Jesus briefly forgot that it was a statuette and came to life. On Christmas night in 1223, Francis of Assisi made preparations for a very special celebration. He filled a crib with straw, placed a Christ Child in it, and brought in an ox and an ass. He knelt before the crib and prayed intensely. His heart overflowed with joy, and his rapturous tears besprinkled the crib. Mass was then celebrated, and Francis sang the Gospel. One of his loyal followers

Fig. 44. Anonymous, *The Christ Child giving the blessing*, from a North Netherlandish prayer-book, MS. 135 E 19, fol. 127v. The Hague, Koninklijke Bibliotheek

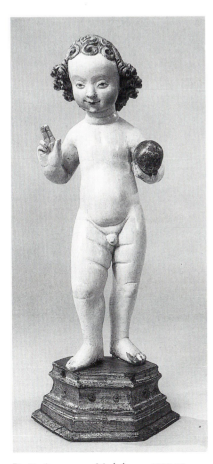

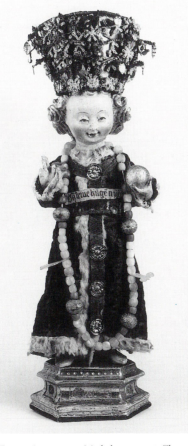

Fig. 43. Anonymous, Mechelen, ca. 1500–15, *The Christ Child giving the blessing*, walnut. Amsterdam, Rijksmuseum

Fig. 45. Anonymous, Mechelen, ca. 1500, *The Christ Child giving the blessing*, oak. Schwerin, Staatliches Museum Schwerin

PLATE 29
Gregor Erhart (Ulm ca. 1465 –
Augsburg 1540)
*The Christ Child with the terrestrial
globe*, ca. 1500
Limewood, polychromed; height 56.5 cm

Hamburg, Museum für Kunst und Gewerbe,
Campe-Stiftung, inv. no. 1953.35

later related that as a result of the intensity of Francis's prayer, the Christ Child came
to life when the saint took it in his arms (*fig. 46*). Thus it was that the fondest dreams
of the faithful came to pass in the lives of saints.

In the Museum für Kunst und Gewerbe in Hamburg there is a nude *Christ Child* so
skilfully executed that it appears to have been brought to life (PLATE 29). It is life-size,
and its plasticity is amazingly convincing and lively, certainly for anyone familiar with
those stiff, baby Redeemers. The polychromy is remarkably well preserved. The traces
of gilding on the locks of hair are virtually the only indication that this naked little boy
came from Heaven. It is as if he is walking in the open air. He gives the blessing in
passing. A landscape is depicted on the globe, which is the attribute of his power. The
little boy was undoubtedly clothed originally. The Child gambolling on the Virgin's
lap in the large print by Master E.S. (see PLATE 25a) is about the only one that can
match this statuette for sprightliness. It is believed, and with good reason, that like the
Vierge ouvrante in the Metropolitan Museum (see PLATE 16), paradisian infants of this
kind were brought to the cell of a dying nun to give her a foretaste of heavenly
salvation, conferred liturgically with the last rites. In any event, it is known that this
particular infant came from a Cistercian convent at Heggbach in Swabia. The nuns
ordered their *Christ Child* from the best sculptor in the region, Gregor Erhart of
Augsburg.

On 29 July 1856, in a Cistercian convent in the little town of Essen on the Rhine,
Sister Scholastique died at the age of 87. Baptized Marie-Joseph Baudhuin, she came
from the abbey of Marche-les-Dames near Namur, which she and the other nuns
had been obliged to leave when the French Revolutionary armies arrived. Sister
Scholastique was the last surviving nun from Namur. A few years before her death she
presented the bishop of Namur with what was perhaps the most precious work of art
the abbey had ever possessed. It was a small silver crib with an infant Jesus, known as

Fig. 46. Puccio Capanna (active ca. 1530),
completed by Antonio Vite (active 1378–1407),
St Francis with the Christ Child, fresco. Pistoia, San
Francesco

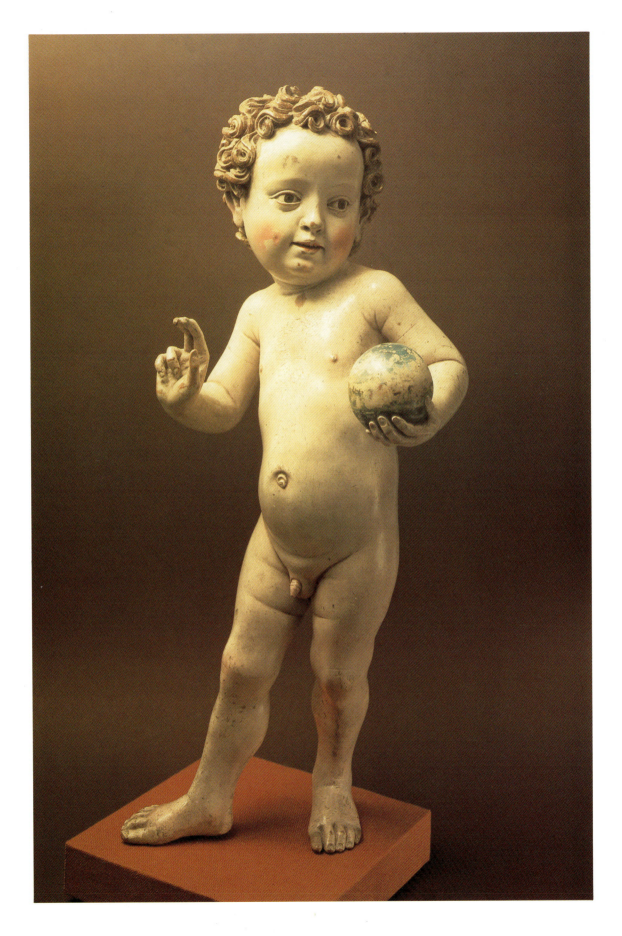

PLATE 30
Anonymous (Liège)
Jésueau, early 15th century
Silver gilt, embossed and cast; 12.6 × 12 × 8 cm

Namur, Musée des Arts Anciens
(Photograph more than life-size)

Fig. 47. Jésueau (PLATE 30), detail: one of the hallmarks on the coats of arms.

Fig. 48. Anonymous, woodcut from the block-book *Van die gheestelijker kintheyt Jesu*, Antwerp 1488, BMH il4, f. 20v.–21r. Utrecht, Rijksmuseum Het Catharijneconvent

**Men sal dit zuete kindeken ihesus nu opnemen ende heffen uut syn wiegelkyn. As hi selve seyt, men moet des menschen soen verheffen op dat alle dieghene die aen hem geloven niet en vergaen, mer hebben mogen dat eewige leven.*

a *Jésueau* (PLATE 30). She had bought it at an auction of the treasures of the parish church of Friedberg, near Frankfurt, where it had come to rest after the sale of the contents of the abbey of Marche-les-Dames. For the next thirty years she had kept it in her cell to assist her in her prayers.

The Namur cradle is the smallest, costliest and most complete of a group of cribs used for private devotion. Almost all of them are made of wood, not silver, and their precious nature was suggested by gilding, ornamentation and dress. Opulence enhanced the sanctity of the object. So, too, did bells. Bells adorned the sumptuous vestments of high priests, bishops and abbots, and were also sewn on to altar cloths. Gold and crystal reliquaries, too, were sometimes decorated with bells, so that they tinkled when borne in procession, emphasizing their preciousness.

This ornate bed stands on four pillars that imitate masonry. It has a much more solid base than many other such cribs, in which the Christ Child could be rocked to and fro. The robustness, though, is essential, for otherwise the entire structure would be smothered by the flamboyant decoration. On the sides, in low relief, are the two saints most beloved of nuns, Catherine and Barbara (see PLATES 10a and 10b). In the crib lies the minuscule infant who is also the Saviour. Attached to the head and foot of the bed are two lettered banners. Like the coats of arms and the numerals hanging as pendants between the bells, their meaning is not clear. It can be assumed that the shields identify the family of the distinguished lady who brought the crib with her when she entered the nunnery of Marche-les-Dames. The hallmarks on the shields suggest that she came from Liège, or at least bought the crib there (*fig. 47*).

It is known from inventories that cribs for private devotion were particularly common in the Southern Netherlands. They stood on sideboards in grand houses, often flanked by candlesticks. A dresser of this kind could take on the appearance of a domestic altar. It undoubtedly had a special function at Christmas, as did the larger cribs. It is also known that small cribs like the one at Namur might be given to a woman by her family when she entered a convent. There it assisted her in her private devotions in her cell, where she could cherish the Child on a spiritual plane. After her death it might be transferred to one of the chapels in the church. In a Brussels convent at the end of the nineteenth century it was still customary for a portable crib to be installed before the altar at Christmas, with a candle on either side. Each nun entering the church knelt by the crib and rocked the Christ Child before saying her prayers. Such cribs could also be used as reliquaries, becoming part of the church treasury.

One of the most poignant documents of spiritual communion with the Christ Child is a woodcut in a block-book entitled *Van die gheestelijker kintheyt Jesu* (On the spiritual childhood of Jesus), which was published in Antwerp in 1488 (*fig. 48*). The book deals with the spiritual exercises that are necessary to prepare for Christ's birth in one's soul. In the illustrations two female figures representing *meditatio* and *oratio* look after the Child. The text begins as follows: "One now gathers up this sweet little child Jesus and lifts Him from His crib. As He Himself said, one must lift up the Son of Man so that all those who believe in Him do not perish, but may have eternal life."* It is hard to imagine a better description of how to cherish the Christ Child in one's soul.

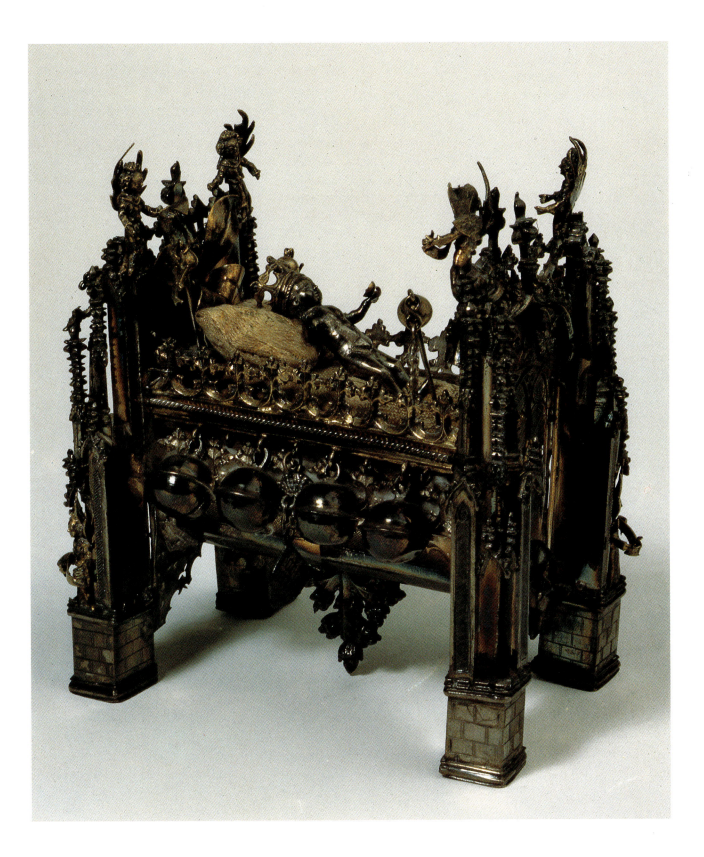

PLATE **31**
Anonymous (Middle Rhine)
The Lorch *Pietà*, ca. 1420–30
Alabaster; height 39 cm, base 51 cm

Wiesbaden, Museum Wiesbaden, Sammlung
Nassauischer Altertümer, inv. no. 27/35

It is clear from the devotional themes of the Child and the crib that people felt a great need to isolate from a narrative the motifs that stimulated prayer. With the Christ Child by Himself, either standing on a base or lying in a crib, the nun no longer need feel the distance in time and space that separated her from God's arrival on earth. The historical setting disappears, and with it the physical distance. It was now a purely personal matter between her and Jesus. Elements of the Nativity story would naturally arise in her prayers, but the subjective relationship between believer and Saviour was more important than the objective structure of the historical account of the coming of Christ. It was from this need that the devotional themes of Christ's suffering evolved. By far the most important of them are the Pietà and the Man of Sorrows.

Most Pietàs were large, and intended for a public rôle in devotion, but they were often found in the private domain as a theme for prayer. In the Landesmuseum in Wiesbaden there is a small alabaster *Pietà* (PLATE 31). The Virgin holds the body of the dead Christ on her lap, and leans over Him with a sorrowing expression. The ornamental rosettes on the superb openwork base of the sculpture are an allusion to the devotion of the rosary (see p. 154).

Just how intensely people could identify with an image of this kind is shown by a quotation from the work of the German mystic Heinrich Suso (ca. 1295–1366), who played a key rôle in the development of private devotion. With her dead son in her arms, Mary says: "I took my tender Child on my lap and looked at Him, but He was dead; I looked at Him again and again, there was neither awareness nor voice. Behold, my heart then died again, and could have shattered into a thousand pieces from those mortal wounds it received. It gave many inner bottomless sighs; the eyes shed many heartbroken, bitter tears, my mien became utterly miserable."*

Suso then addresses her with the following words: "Alas, pure tender lady, I now beg you to offer me your tender Child, as it appeared when dead, placing it on the lap of my soul so that, according to my ability, I may be vouchsafed in a spiritual manner and in meditation that which befell you in a physical manner."*

Ich nam min zartes kint uf min schoze und sah in an, – do waz er tot; ich lugt in aber und aber an, do entvas da weder sin noch stimme. Sich, do erstarb min herze aber und mochti von dien totwunden, so es enphieng, in tusent stuk sin zersprungen. Do lies es mengen inneklichen grundlosen súfzen; dú ogen rerten mengen ellenden bitterlichen trehen, ich gewan ein gar trurklich gestalt.

Owe, reinú zartú frowe, nu beger ich, daz du mir din zartes kint in der totlichen angesiht bietest uf die schoze miner sele, daz mir nach minem vermugenne geistlich und in betrahtunge werde, daz dir do wart liplich.

In German a Pietà is generally called a *Vesperbild*, and the Virgin is often referred to as the *Schmerzenmutter* or 'Mother of Sorrows'. It is that aspect, above all, that is evoked by Suso's devotion. The narrative scenes of the Deposition, Lamentation and Entombment contributed to the genesis of this theme at the beginning of the fourteenth century. Often, too, the Pietà was regarded as a shocking variant of the image of the Virgin and Child. In the German regions, in particular, the Mother of Sorrows was a much loved devotional theme. Although several different types can be distinguished, it is difficult to trace a clear line of development. The emotional charge was present from the outset, and admitted of only a few variants. It is a very different matter with the Man of Sorrows.

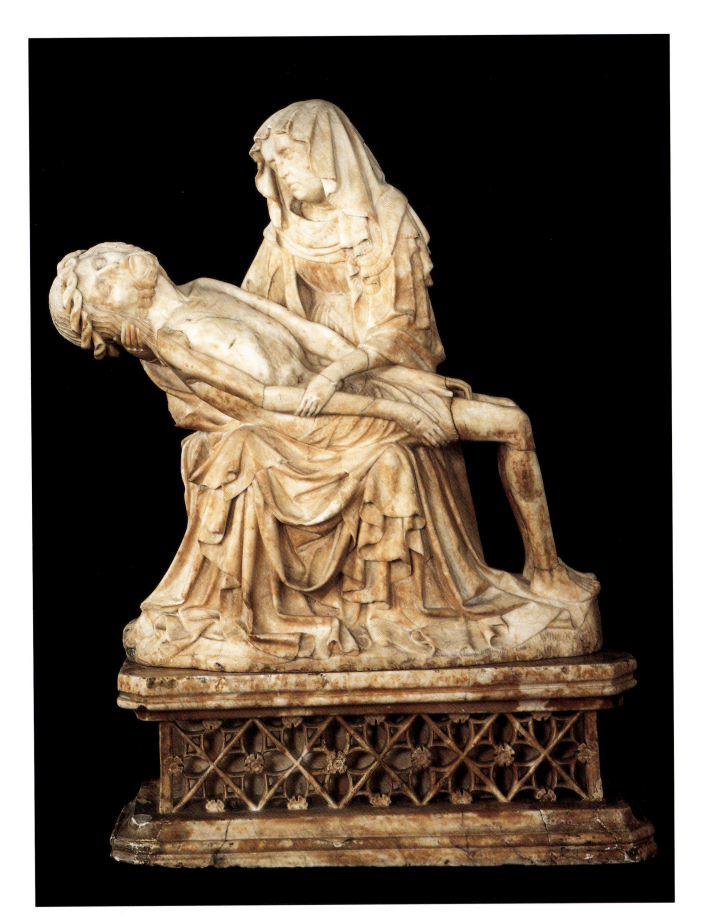

PLATE 32
Anonymous (Venice?)
Triptych, ca. 1300

Open: centre *Man of Sorrows*; left *The Virgin*;
right *St John the Evangelist*
Closed: *Two Dominicans, a bird and Christ
enthroned* (back of the left panel)
Panel; wings 20.1 × 16.5 cm

Dordrecht, Museum Mr Simon van Gijn, on loan
from a private collection

Fig. 50. Anonymous, Constantinople, 12th
century, gold frame of an icon. Jerusalem,
Treasury of the Church of the Holy Sepulchre

Fig. 49. Triptych (PLATE 32), before restoration

Around twenty years ago it was discovered that hidden beneath a hideous nineteenth-century triptych of Christ wearing the crown of thorns, accompanied by the Virgin and St John (*fig. 49*), was one of the earliest depictions of the Man of Sorrows, datable around 1300 (PLATE 32). Here it is not wounds, the crown of thorns or a sorrowful expression that identify the subject as Christ's Passion. His head is merely inclined slightly to the side, and his eyes are closed. That is enough to arouse the compassion of the Virgin and St John, who share His suffering. The eyes appear to be closed in sleep rather than in death. The word sleep is often used in the liturgy to make it clear that although Christ's body died, that death activated God. Death and salvation are evoked by speaking of the sleep of death. The crucified Saviour did not have to be propped upright like the Christ Child on the ground. He hung on the Cross. The Crucifixion scene, though, condensed His suffering into a single event. The shared Passion and compassion which liturgical texts and prayers dwell on at such length also related to many other moments in Christ's suffering: the scourging, crowning with thorns, descent from the cross and entombment. Those successive stages in the story of the Passion are often referred to in one and the same text. The Man of Sorrows was the image that encapsulated Christ's sacrifice for mankind, as well as providing an opportunity to express all the emotions aroused by that sacrifice.

There are only a few known examples of this simplest form of the Man of Sorrows, and all of them are Byzantine. The most important remnant we have is the gold frame of an icon that must have been made in Constantinople in the twelfth century. Today it is in the treasury of the Church of the Holy Sepulchre in Jerusalem (*fig. 50*). In the ornate gold surround is the silhouette of this earliest type of the Man of Sorrows. The remarkably costly surround tells us that this was an icon that was treasured in Constantinople. It was the holy face of the suffering Christ – a cult image that was venerated in a prominent shrine and was possibly carried in processions. It is not only a rare, early example of this image, but unique in that the context of shared suffering has been preserved: it is the only early triptych of its kind to have survived intact. The others consist of separate panels that, on iconographical grounds and on the evidence of traces of the original attachments, are believed to have belonged to triptychs.

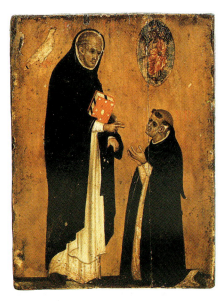

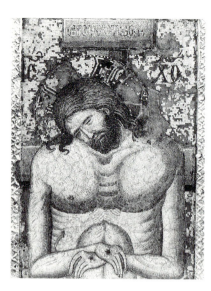

Fig. 51. Anonymous, Constantinople, ca. 1300, mosaic icon. Rome, Santa Croce in Gerusalemme

Detail of *Fig. 52*

Precisely because it is a unique triptych, it is worth examining how such objects were used in private devotion. It was closed by folding the wing with the Virgin, the Mother of Sorrows or *Mater Dolorosa*, over the *Man of Sorrows*. The *Virgin* came to rest within a lip to the right of the central panel. There is a similar lip on the left of the panel with *St John the Evangelist*, and it is because of these two projections that the right-hand panel can be folded over the other two. The scene on the outside of the half-closed triptych is equally exceptional. On the red layer of bole is a portrait of the first owner of this work, a Dominican friar, kneeling before his prior, who is blessing him. Above them and to the left is a bird, and at upper right a *Christ in Majesty*.

The Dominican clearly commissioned an artist to paint a copy of a highly venerated Byzantine icon to assist him in his private devotions. A small triptych of this kind could easily be taken on one's travels, and it is possible that the blessing the friar is receiving was associated with a departure on a journey. In any event, the Dominicans had an important foundation in Constantinople, as did the Franciscans, despite the fact that the city was the stronghold of the Eastern Church. It is impossible to say for certain whether the painter of the triptych came from Constantinople or Venice, where haloes were decorated with similar delicacy.

Another early representation of the Man of Sorrows displays the words *"Misericordia domini"*, so this is plainly a case of God's compassion for mankind. Gérard de Frachet, one of the first historians of the Dominicans, active at the end of the thirteenth century, wrote about the function of images in the cells of Dominican friars. According to him, they had images of the Virgin and her crucified Son in their cells so that they could look at them when reading, praying or sleeping, and be looked at by them in turn, with eyes of compassion.

A more usual form of the Man of Sorrows is a half-length figure of the suffering Christ in front of the Cross with his arms folded on his breast. The most prestigious image of this type is a mosaic icon from Constantinople (*fig. 51*). Mosaic icons are extremely rare, and were among the most precious works produced by the artists of Constantinople. This one dates from the same period as the triptych with the *Man of Sorrows*, and in view of its size must also have been an aid to private devotion. This single devotional theme refers both to the Crucifixion, symbolized by the Cross, and to the Entombment, at which the arms were folded over the breast. The inscription at the top of the Cross, "Βασιλεὺς τῆς δόξης" (The King of Honour), makes it abundantly clear that the dead body of Christ alludes to the glory of God. This theological nicety eventually disappeared from images of the Man of Sorrows in the west. The desire to share in Christ's suffering was too great. In the east, however, this simple type of the Man of Sorrows remained unchanged for centuries, as is confirmed by a remarkably informative visual document – an early sixteenth-century icon by Emanuele Zanfurnari depicting the burial of the saintly hermit Ephraem (ca. 306–373) (*fig. 52*). Lying on his breast is an icon of the Man of Sorrows which he evidently kept by him during his life of asceticism. Behind Ephraem are scenes from his life, with Simeon Stylites on his pillar in the middle. The numerous caves are adorned with images used during private devotions.

Fig. 52. Emanuele Zanfurnari (active ca. 1500),
The burial of the hermit Ephraem, panel. Rome,
Pinacoteca Vaticana

PLATE 33
Israhel van Meckenem
(Meckenheim? ca. 1440/45 –
Bocholt 1503)
Vera icon, ca. 1490
Engraving; 168 × 112 mm

Berlin, Staatlichen Museen zu Berlin, Preußischer
Kulturbesitz, Kupferstichkabinett, inv. no. 943–1

Fig. 53. Anonymous, Emilia, ca. 1293–1300, *The Man of Sorrows*, Ms. Plut. xxv.3, fol. 183v. Florence, Biblioteca Medicea Laurenziana

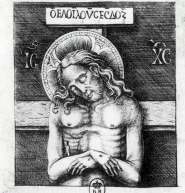

Fig. 54. Israhel van Meckenem, *Vera icon*, engraving, ca. 1495. Paris, Bibliothèque Nationale

A Franciscan prayer-book made in Genoa around 1300 identifies the prayers that were said in the west before the Byzantine image of the Man of Sorrows (*fig. 53*). It is associated with some very emotional prayers: "O how intensely Thou embraced me, good Jesu, when the blood went forth from Thy heart, the water from Thy side, and the soul from Thy body. Most sweet youth, what hast Thou done that Thou shouldst suffer so? Surely I, too, am the cause of Thy sorrow."

It can be inferred from the miniature of a monk in a white habit in the initial O that these prayers were attributed to Bernard of Clairvaux. Time and again he proves to have set the tone for subsequent centuries. More than that, one sometimes has the impression that he actually created the emotions that were showered on Christ and the Virgin in the fourteenth and fifteenth centuries.

The second type of the Man of Sorrows, standing before the Cross with His arms folded on His breast, was a resounding success in Late Medieval art, due to the transfer of the mosaic icon from Constantinople to Rome around 1380, where it found a new home in the church of Santa Croce in Gerusalemme. In the fifteenth century, when the Carthusians of Santa Croce decided to publicise their church in order to attract more pilgrims, they made this precious icon the centrepiece of their campaign. They chose the same course as the monks of Einsiedeln around the same time (see pp. 82–84). The Carthusians approached Israhel van Meckenem, the best known printmaker of the day, to make an engraving of the icon, together with a smaller version for those of more modest means (PLATE 33 and *fig. 54*).

Van Meckenem's task was a little different from that of Master E.S. (see PLATES 25a-c), as shown by the inscription below the print, which reads: "This image was made after the model and likeness of the well known first image of the Pietà, which is preserved in the Church of the Holy Cross in the city of Rome, which the holy Pope Gregory the Great ordered to be painted according to a vision that he had had and that had been shown to him from above".* Now the Madonna by Master E.S. was not even a version or variant of the Madonna in Einsiedeln, but Van Meckenem's *Man of Sorrows* is expressly presented as a reproduction, *"ad instar et similitudinem"*, of the Byzantine icon in Santa Croce. That was entirely due to the Carthusians' assertion that this *"ymago pietatis"* was a portrait, and therefore exceptional. It was based on a vision vouchsafed to none other than Pope Gregory the Great (ca. 540–604) when he was saying Mass. Van Meckenem was also asked to make a print of that event. In it, the *"ymago pietatis"* appears amidst the motifs of Christ's Passion. It is also stated that those saying prayers in front of that image would obtain an indulgence of 20,000

Hec ymago contrefacta est ad instar et similitudinem illius prime ymaginis pietatis custodite in ecclesia sancte crucis in urbe romana, quam fecerat depingi sanctissimus gregorius papa magnus post habitam ac sibi ostensam desuper visionem.

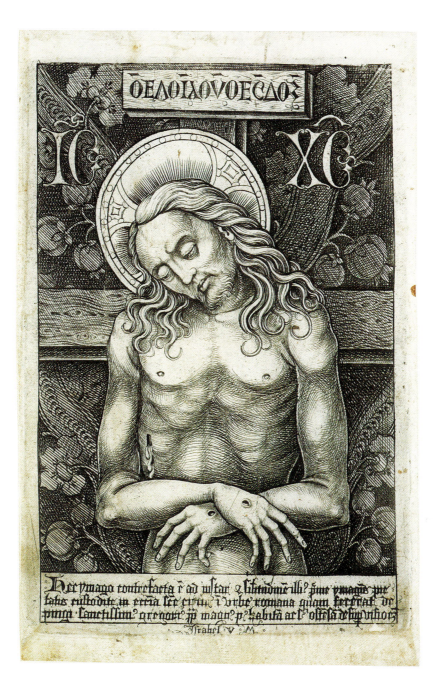

PLATE 34
**Anonymous (Northern
Netherlands)**
The Mass of St Gregory, ca. 1460

Woodcut, hand-coloured; 252 × 181 mm

Nuremberg, Germanisches Nationalmuseum,
inv. no. H.13 Kapsel 6

**Soe wie ons heren wapenen aen siet/ Daer hi mz
dogede sijn v'driet/ Ende iamm'lyc waert getorment/
Vanden ioden ombekent/ Ende dan sprect ov' sine
knien/ Drie pr nr en ·iij· aue marien Ende rouwe heeft
van sinen sonden/ ouer waer willic dat orconden/
Dat die ·xiiijm· iaer aflaets heeft/ Die hem die paus
gregorius geeft/ Ende noch ·ij· pause dats waerhede/
Die daer gauen aflaet mede/ Ende xl bisscopen des
gelike/ Dit mach verdienen arm ende rike/ Nv
verdient al oetmoedelike)*

years (*fig. 55*). Judging by the text on another impression of the print, indulgence inflation took on alarming proportions in the second half of the fifteenth century, for now the same effort of prayer was rewarded with an indulgence of 45,000 years.

By the time it came into the possession of the Carthusians, the icon in Santa Croce probably already had the reputation of being a *vera icon* (see p. 40–42), for that was the very reason why Byzantine icons were introduced in the west as cult images. Anything that came from Constantinople had an aura of authenticity. By linking the icon with the story of Gregory's vision, the Carthusians instantly aged it by 700 years, giving it even greater legitimacy. Moreover, this *imago pietatis* was stamped with the very highest ecclesiastical authority, that of the first of the Church Fathers, Pope Gregory himself. A final and important point was that it acquired a liturgical dimension through its direct relationship with the sacrifice of the Mass. It is no wonder, then, that as a result of this alluring visual promotion the Santa Croce *Man of Sorrows* began to play a key rôle in painting from the end of the fifteenth century, thanks partly to Van Meckenem's prints. The scene of St Gregory's vision also made the Santa Croce *imago* widely known in the art of the Low Countries. In the St Anne prayer-book (see p. 96), beside the calendar for January, there is a full-page miniature of it that testifies to its appeal (*fig. 56*). Kneeling before the scene are the two donors, who are sharing in Pope Gregory's vision of the Man of Sorrows. This saved them the trip to Rome. The main reason for the widespread popularity of the scene was the trade in indulgences. One Netherlandish indulgence print does not even mention the fact that there was an *imago pietatis* in Santa Croce (PLATE 34). It is clear from Gregory's position within that print, and from the inscription, that the main point was that the indulgence was granted by Gregory himself. "Verily, anyone who sees and reflects on Our Lord's weapons (the weapons by which He suffered and with which He was lamentably tortured by the ignorant Jews), and then kneeling says three Our Fathers and three Hail Marys and repents his sins, will earn an indulgence of 14,000 years, granted by Pope Gregory and by two other popes (this is the truth), who also grant an indulgence, as well as forty bishops. This can be earned by both poor and rich. Earn it now, humbly."*

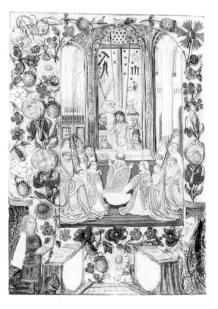

Fig. 55. Israhel van Meckenem, *The Mass of St
Gregory*, engraving, ca. 1480–85. Washington,
National Gallery of Art

Fig. 56. Anonymous, *The Mass of St Gregory*,
from a North Netherlandish prayer-book, MS.
135 E 19, fol. 2v. The Hague, Koninklijke
Bibliotheek

Soe wie ons here wapenen aen siet Daer hi in dogede sin
vdriet Eñ iammilijc waert getorment Vanden vode onbekent
Eñ dan spreet oð sine knien Drie pr vð eñ · iij · aue marien
Eñ rouwe heest van sinen souden Dñ waer wilte dat
oeronden Dat die · xlij · iaer aflaets heeft Die hem die paus
gregorius gheeft Eñ noch · ij · paus das waerliede Die daer
gauen aflaet mede Eñ Al bisscopen des gelike Dit mach
verdieuen arm eñ rike stu verdient al oetmoedelike

PLATE 35
Anonymous (Lower Rhine/ Westphalia)
Devotional booklet, ca. 1330–50

Outside back cover: *The Coronation of the Virgin with a kneeling monk*; outside front cover: *St Lawrence with a bishop and kneeling monk*; inside front cover: *The Last Supper*; fol. 1r.: *The Arrest of Christ*; fol. 5v.: *The Mocking of Christ*; fol. 6r.: *The Instruments of the Passion*; fol. 6v. and inside back cover: *The Instruments of the Passion*

Ivory, carved (cover), painted (six leaves in all); 10.5 × 6 cm

London, Victoria and Albert Museum, inv. no. 11–1872

The "weapons" are the *arma Christi*, the instruments of the Passion with which the battle for salvation was won. These formed a distinct devotional theme that was often combined with the Man of Sorrows from as early as the mid-fourteenth century. There is an unusual depiction of it in an ivory devotional booklet made in Westphalia or thereabouts in the mid-fourteenth century (PLATE 35). In the relief that serves as the cover, a monk kneels before St Lawrence, who must have been the name-saint of the person who ordered the ivory. Beside him is an unidentified bishop. Heavenly glory is portrayed on the reverse with a *Coronation of the Virgin*. Here too, the owner kneels to demonstrate that he can earn Heaven through prayer.

Turning the ivory pages one hears the advice of the author of the *Meditationes*: let every scene of Christ's Passion be an occasion for prayer. Immerse yourself in what Christ must have felt, endure all those sorrows and tortures. At the *Last Supper* there is the sorrow at Judas's deceit. This is followed by the *Kiss of Judas* and the *Arrest of Christ*. His innocence is apparent before Pontius Pilate and Herod, but He is found guilty nonetheless. There then follow the *Flagellation, Pontius Pilate washing his hands, The Carrying of the Cross* and the *Crucifixion*. After experiencing the scenes of the Passion in his soul, the monk can also relive the *Resurrection*, and can address his prayers to the *vera icon*. Finally, he can focus his gratitude for Christ's suffering, and his compassion with what his Lord had endured, on the *arma Christi*, a Passion rebus that may not be easy for us to decipher.

Christ is first shown with one of his tormentors, and above is a hand that struck Him. Opposite is the crown of thorns, the wound in Christ's side, the bucket of vinegar and the staff with the sponge that was offered to Christ to drink from on the cross. The next page shows the cloth with which He was blindfolded when being mocked, the nails and hammer used to fasten Him to the cross, and the pincers for removing the nails after His death. Below this the maker of the booklet allowed his imagination to roam by dreaming up some peculiar instruments of torture. The series of circles are probably 29 of the thirty pieces of silver for which Judas betrayed Christ. Even more unusual are the footsteps with the drops of blood, which enable the 'reader' to accompany Christ on the journey to Golgotha. Finally, there is a page with a stick, the scourge, the ladder, Christ's cloak for which the soldiers cast lots, the spear, and a bird's-eye view of the tomb.

These and similar motifs originated well before the fourteenth century. The instruments of the Passion appear in sixth-century mosaics in Ravenna, but there they have a very different connotation. Prior to 1300 they were regarded as the weapons with which Christ, by suffering, achieved his paradoxical victory. The *arma Christi* belong to the victor, the risen Christ, not to the suffering Jesus. They are the attributes of the *Majestas Domini*. There could hardly be more conclusive evidence of the new function of old images than the change in meaning of the instruments of the Passion. In the Late Middle Ages, what were originally symbols of triumph became stimuli for compassion. Artists invented more and more of these instruments. Variants are seen in the woodcut with the vision of St Gregory (see PLATE 34), where they include the scoffing, the lantern used at Christ's arrest, and the cock that crowed after Peter's denial.

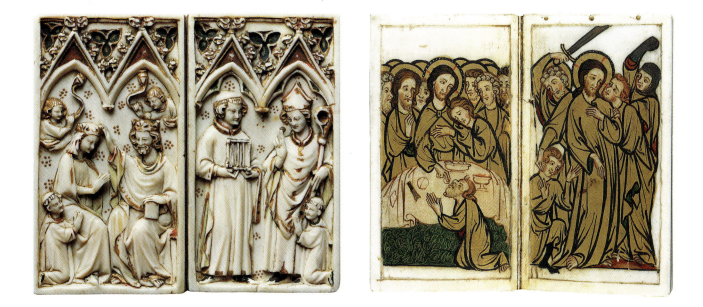

11·72

PLATE 36
Master of the Magdalene Legend
(active in Brussels and Mechelen
ca. 1475–1530)
Diptych, 1523

Left: *The Virgin and Child*
Right, front: *Willem van Bibaut*; back: *Arma Christi*
Panel; wings 25 × 14.5 cm

Amsterdam, private collection

In a Flemish diptych of 1523 attributed to the Master of the Magdalene Legend, the *arma Christi* appear in combination with a Madonna and a portrait of the monk who owned the work (PLATE 36). The opened diptych reveals the Carthusian abbot, Willem van Bibaut (ca. 1484–1535), praying to a Madonna suckling the Christ Child. In addition to general prayers like the *Ave Maria*, Willem undoubtedly would have associated this image specifically with prayers inspired by the *lactatio* (see p. 52). The *arma Christi* are depicted on the back of the abbot's portrait, and were visible when the diptych was closed. This work thus turns the crib and the cross, the Incarnation and the Passion, into themes for prayer.

The Man of Sorrows with the *arma Christi* is the main subject of a small triptych in the Boymans-van Beuningen Museum in Rotterdam that is regarded as one of the most important documents from the very earliest stage of Netherlandish painting (PLATE 37). It is dated around 1415, and was bought by the collector D.G. van Beuningen in 1938 at the sale of part of the Duke of Norfolk's collection, which is why it is known as the Norfolk triptych. At that time it was still believed to be a work of the French school, but it can be deduced from the combination of saints that it must have come from the bishopric of Liège. Four holy bishops flank the Man of Sorrows, and the names of three of them can be read in the inscriptions: Servatius, Lambert and Martin. Above them is a scene of Christ and the Virgin, crowned and enthroned in heavenly glory and flanked by the apostles James the Less, Peter, Paul and Andrew. The three identified bishops all have a clear association specifically with Maastricht, which was part of the see of Liège.

On the wings are some of the most distinguished members of the Christian pantheon. Attention is drawn to the four bishops by placing the four Fathers of the Church beside them: on the left are Sts Jerome and Gregory, on the right Sts Ambrose and Augustine. At top left is a gathering of the most important virgin martyrs, Dorothy, Agnes, Barbara and Catherine, together with Mary Magdalene. Their counterparts on the other wing are four male ascetics, Sts Anthony Abbot, Benedict, Leonard and Giles. In the pinnacles are the two archdeacons and first Christian martyrs, Lawrence on the left and Stephen on the right. This select company is expanded on the backs of the wings with the four Evangelists and John the Baptist on the left, and on the right the apostle James the Less with the holy bishops Denis and Hubert. St Vincent stands in the middle, and ample room has been left beside him for the archangel Michael to do battle with evil on Judgment Day.

What makes this pantheon so remarkable is that a number of saints of more local significance, such as Servatius, Lawrence, Martin, Leonard, Giles, Denis and Hubert, have been elevated to the very highest circles of sainthood. None of them were venerated exclusively in one place, but it cannot be an accident that all are associated with the bishopric of Liège, and with Maastricht in particular. One of them was a bishop of both cities, the principal churches were dedicated to the others, and the relics of most were preserved in Maastricht.

The question is why such a large and distinguished company was mustered like this. In the Liège region, such an arrangement of saints was customary only on reliquaries.

Obiit Gratia nopoli anno 1575.

Guilielmus bibaucius primas tot̄,
Ordinis Cartusientium ⁊ 1525.

PLATE **37**

Anonymous (Southern Netherlands, bishopric of Liège?)

The Norfolk triptych, ca. 1415–20

Left wing *St Lawrence, Sts Mary Magdalene, Dorothy, Agnes, Barbara and Catherine, the Church Fathers Jerome and Gregory*; right wing *St Stephen, Sts Anthony Abbot, Benedict, Leonard and Giles, the church fathers Augustine and Ambrose.*

Rotterdam, Museum Boymans-van Beuningen, inv. no. 2466

(Photograph taken during restoration)

PLATE **37**
**Anonymous (Southern
Netherlands, bishopric of Liège?)**
The Norfolk triptych, ca. 1415–20

Closed: top *The Annunciation*; middle *The
Adoration of the Magi with a kneeling figure*; below
left *Four Evangelists and St John the Baptist*; below
right *The apostle James the Greater, the saintly
bishops Denis and Hubert, St Vincent and archangel
Michael battling evil*
Panel; centre 33 × 32 cm, wings 33 × 13 cm

Rotterdam, Museum Boymans-van Beuningen,
inv. no. 2466

(Photograph taken during restoration)

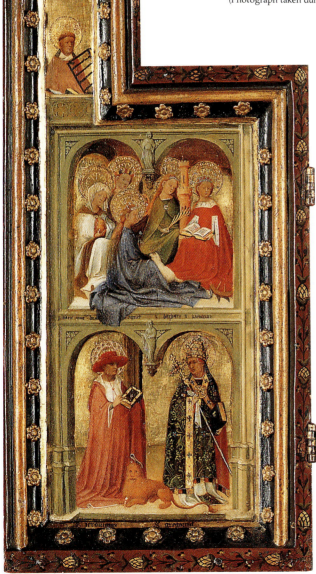

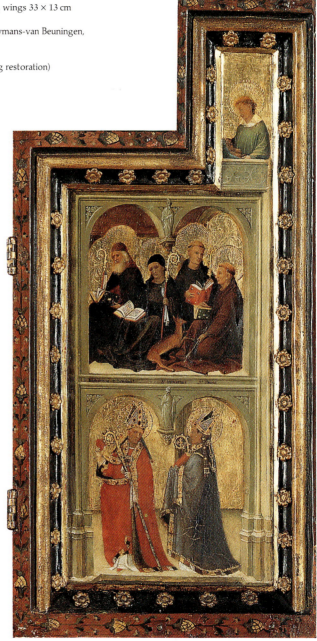

PLATE 37

Anonymous (Southern Netherlands, bishopric of Liège?)
The Norfolk triptych, ca. 1415–20

Open, centre: at the top *The apostles James the Less and Peter, Christ and the Virgin enthroned, the apostles Paul and Andrew*; below *The saintly bishops Servatius and Lambert, the Man of Sorrows, the saintly bishop Martin and an unknown bishop*

Rotterdam, Museum Boymans-van Beuningen, inv. no. 2466

(Photograph taken during restoration)

Fig. 57. The Norfolk triptych (PLATE 37), detail: centre panel before restoration.

The idea of a triptych reliquary is also suggested by the framing of the figures. A significant part of the workmanship is designed to create the illusion that this is not a painted object. In many respects it imitates precious metalwork. However, the abundance of ornate frames and painted architecture would appear to nullify the devotional purpose of the central image, as do the many saints. In the midst of all this embellishment, the *Man of Sorrows* has been reduced to a tiny figure almost swamped by His entourage. Such a design was not uncommon for triptych reliquaries, which for that matter could also be used for private devotion.

In order to discover the original function of the Norfolk triptych it is important to analyse the central scene carefully. The painted architectonic surround lends even more grandeur to the two scenes, and this applies especially to the four Prophets in their niches above the throne of the Virgin and Christ. The emphatic articulation casts the conceptual significance of the original image of the Man of Sorrows in a new form. The mutilated body alludes to God's majesty. The artist, or his patron, had probably seen the mosaic icon that had recently arrived in Rome (see *fig. 51* on p. 108), for there is no other way to account for the quasi-Greek lettering at the top of the cross. The image itself, however, leaves no doubt about the meaning of the inscription; this is the "Βασιλεὺς τῆς δόξης", the King of Honour.

The most striking feature of the Man of Sorrows is the asymmetric silhouette. This Christ is a close-up of Jesus as shown in Depositions from the Cross. The addition of two angels to support Him and present Him to the onlooker makes this depiction far more dynamic than its Byzantine cousins. In the fourteenth century, the presentation of Christ's body by one or two angels was employed when there was a direct relationship between the Man of Sorrows and the Eucharist, for there, too, Christ's body was proffered to the faithful, this time ritually. However, the angels are even more common in the context of the veneration of relics, and considering the prominence given to the *arma Christi*, that is probably what is involved here. Christ is actually depicted behind the open tomb, draped over the front of which is the cloak for which the soldiers cast lots, along with other pieces of fabric, including His burial shroud. The instruments of mockery and flagellation help introduce the *imago pietatis*. Everything points to the Norfolk triptych having served in a practice of prayer centred around the veneration of the Passion relics belonging to the bishopric of Liège, and in particular to the city of Maastricht.

One more fact has recently come to light that confirms this. At the beginning of 1993 the Boymans-van Beuningen Museum decided, as a very rare exception, to loan the triptych out. First, though, it was necessary to treat a crack running down the centre of the *Man of Sorrows* (*fig. 57*). During the examination prior to this delicate piece of conservation it was discovered that a plug of coniferous wood had been inserted into the oak panel. The different rates of shrinkage and expansion of the two types of wood had set up stresses that had caused the panel to crack. Coniferous wood is such an unusual support, especially in northern Europe, that it could only have been inserted in oak for a particular reason. The *arma Christi* refer to relics of the Passion, but the triptych itself contains a relic. This little block of wood in that particular spot can be none other than a relic of the True Cross, the most important instrument of the Passion, which was made of cedar.

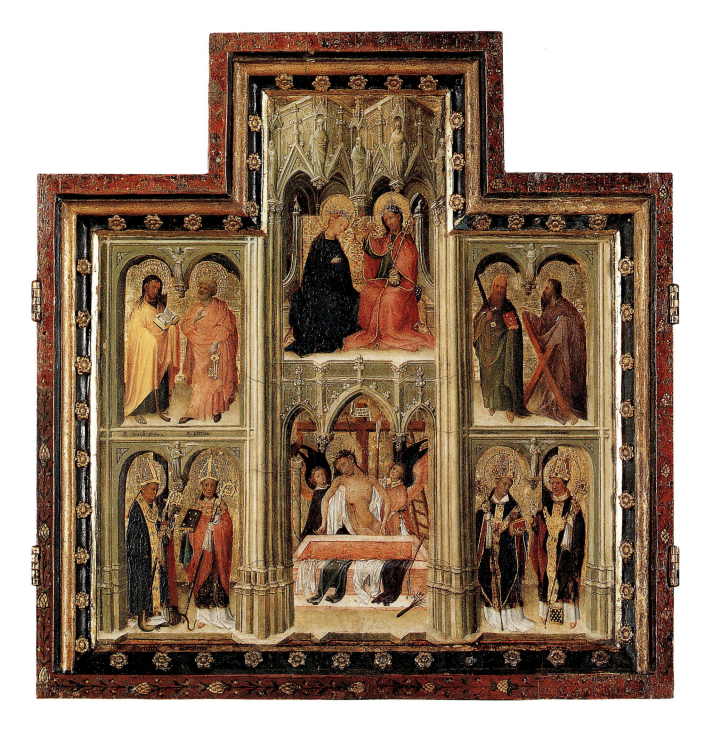

PLATE 38
Anonymous (Paris)
Reliquary, ca. 1400–10

Front, open: left *The Virgin mourning and an angel with the Cross*; centre *The Man of Sorrows with an angel*; right *St John mourning and an angel with the lance*; above *The Coronation of the Virgin*
Front, closed: left *John the Baptist*; right *St Catharine*
Back: below *The Death of the Virgin*; middle *Vera icon*; above *The Assumption of the Virgin*
Gold and enamel, opened 12 × 12.7 × 2.5 cm
Amsterdam, Rijksmuseum, inv. no. RBK 17045

This special feature of the Norfolk triptych also throws a light on the scene with the *Adoration of the Magi*. On the right, a figure in contemporary dress is proffering a golden vessel – very probably a monstrance containing a relic. It stands to reason that this is the donor, who has had himself depicted in the row of Magi. Although much research still has to be done before we know precisely what this object is, it is clear that the form and iconographic programme of the Norfolk triptych can only be understood by positing a direct connection with triptych reliquaries. From around 1400 it had become accepted that the value of a 'true' relic could be transferred to its representation.

The painter of the Norfolk triptych was undoubtedly familiar with the combination of heavenly glory and the Man of Sorrows in an architectonic setting. The existence of such combined scenes is known from documents, but they were usually made of far costlier materials. The only surviving example is in the Rijksmuseum (PLATE 38). It is a minuscule masterpiece of casting, enamelling and chasing. In the centre the *Man of Sorrows* is held up to our gaze by an angel. The harmony of movement, colour and contour between the two figures lends great power and penetration to the presence of this *imago pietatis* in its golden niche, quite apart from the decorative refinement and superb craftsmanship. Above the *Man of Sorrows* is the *Coronation of the Virgin*, the figures of which are cast in gold and flanked by two kneeling angels against a three-part screen with foliate motifs, which are chased in the gold. On the wings are the Virgin and John the Evangelist, chased and with enamel inlay, partaking in the Passion at one remove. Above them hover angels with the chief instruments of the Passion.

This little triptych was obviously a reliquary, for when seen from the back it has the form of a shallow, vertical box with wings. On the back is an engraved *vera icon* with the *Death of the Virgin* below it and the *Assumption* above. The reliquary probably contained a fragment of Christ's head – a lock of hair, perhaps, or part of a tooth, and possibly an equally minute relic of the Virgin as well. When the wings are closed, the front of the box shows the figures of John the Baptist and Catherine of Alexandria, chased in the gold and inlaid with translucent enamel, against a dark blue enamel ground.

This triptych is one of a group of extremely costly pieces that were executed around 1400 in Paris workshops for French kings and dukes. It has been identified with a documented reliquary from the former abbey of Chocques in the Pas de Calais. These precious objects had a wide cultural influence, so it is very possible that the painter of the Norfolk triptych, or his patron, had some such reliquary in mind when he designed the central scene of the painted triptych reliquary.

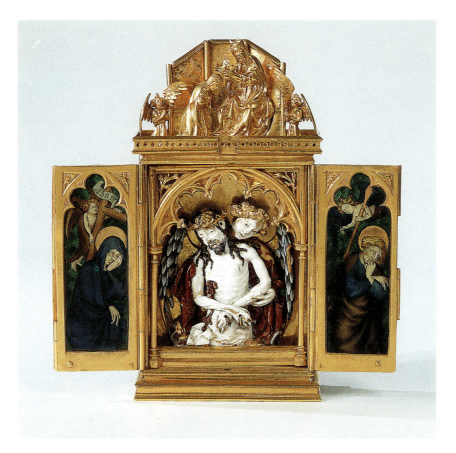

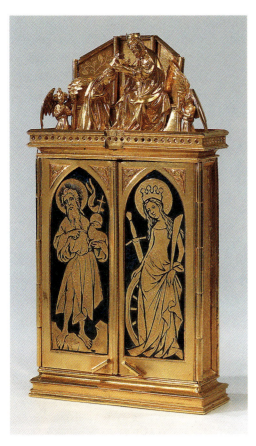

PLATE **39**

Hans Multscher (Reichenhofen
ca. 1400 – Ulm 1467)
The Holy Trinity, ca. 1430–35
Alabaster; 28.5 × 16.3 × 9.8 cm

Frankfurt, Liebieghaus-Museum alter Plastik,
inv. no. St.P. 401

Back of PLATE 39

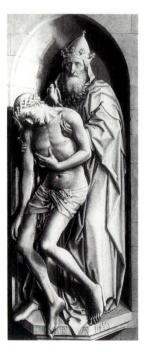

Fig. 58. Robert Campin (1378/79–1444), *Mercy-seat Trinity*, ca. 1427–32, panel. Frankfurt, Städelsches Kunstinstitut

So far we have only considered additions to the original theme of the Man of Sorrows. In the fifteenth century, artists used their ingenuity to integrate the motif with other subjects, such as the Trinity. The so called Mercy-seat Trinity was evolved in order to portray an abstract concept (see PLATE 16 and *fig. 15* on p. 55). Such a very static, frontal depiction of a theological notion hardly seems amenable to a personal response. Replacing the Christ on the cross with the Man of Sorrows gave the Father and Son an equivalence that made emotional expressiveness possible. The finest example of this is an alabaster *Mercy-seat Trinity* made around 1430 by the South German sculptor Hans Multscher (PLATE 39).

God the Father is standing, giving the blessing with His right hand, two fingers of which are missing. He is blessing us, and the substance of that blessing is the sacrifice of His Son. Christ's body is presented by an angel. Between Father and Son is the dove of the Holy Ghost, through whom this sacrifice can inspire faith. Hans Multscher had undoubtedly seen painted images of the Mercy-seat Trinity on altarpieces (*fig. 58*), but in his alabaster sculpture, which is so small that it must have been intended to accompany prayer, there is a touching relationship between Father and Son. The group is from Schloss Sandizell, near Ingolstadt, and may have been given to the Count of Sandizell by Louis the Bearded, Duke of Bavaria (1368–1447). Louis was the brother of the Queen of France, and a member of the French court from ca. 1402 to 1415. It may have been there that he saw the depictions of the Man of Sorrows that gave him the idea for this commission.

God looks down with compassion at the dead body of Christ, which Multscher has rendered with expressive plasticity. A common feature of the extant examples of the standing Man of Sorrows from Germany executed at the beginning of the fourteenth century is their stiffness, which makes little if any appeal to the beholder. By contrast, this utterly limp body with its dangling head is very compelling indeed. Multscher resolved the paradox of the upright corpse by introducing an angel to support it. Interestingly, we know which prayers were addressed to this emotive *Trinity*, for on the back are texts engraved in the fifteenth and sixteenth centuries that clarify the function of the sculpture. They include *Herrgott las mich nit* (Lord God, do not abandon me) and *Maria hillff mir* (Mary, come to my aid).

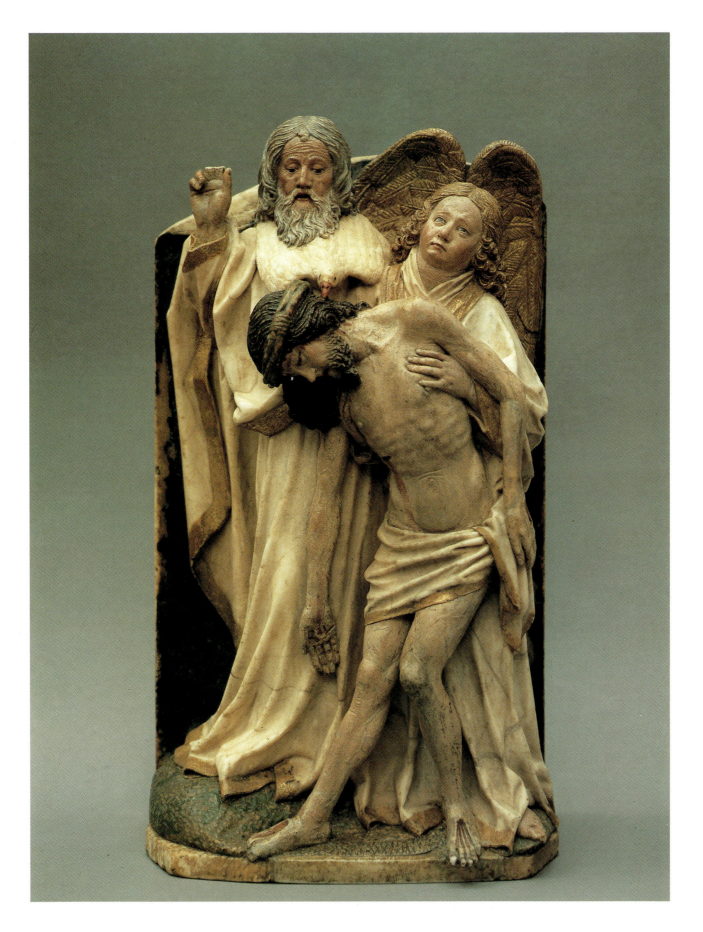

PLATE 40

Master of the Presentation in the Temple (active in Wiener-Neustadt? ca. 1420–40)
Christ at the foot of the Cross,
ca. 1425

Panel; 25 × 34 cm

Berlin, Staatliche Museen zu Berlin Preußischer Kulturbesitz, Gemäldegalerie, inv. no. 1837

Individual artistic improvisation on the stories and themes of Christ's Passion also led to several other moving depictions. In the Staatliche Museen in Berlin there is a small, iconographically unique panel executed by an Austrian painter around 1420 (PLATE 40). It can be regarded as a variation on the devotional theme of *Christ on the stone* (fig. 59), which, like the Man of Sorrows, was a comprehensive image of Christ's suffering. This, however, is a very personal interpretation of the story. Night has fallen. The last witnesses of the Crucifixion have returned to the city, and only the Virgin and St John remain, slumped in grief. The instruments of the Passion lean against the Cross, their work done. The open tomb awaits on the left. Christ has been taken down from the Cross, and His body rests against it. His trials are over; all has been consummated. The artist feels that the moment has come when the viewer can claim Christ for himself in his prayers. The Virgin and St John exemplify the mood in which this forlorn Man of Sorrows wishes to be approached. It was once thought that this little painting came from a series of scenes below a large altarpiece. Examination of the wood, however, shows that this could not have been the case, and the scene itself is such that nothing could have preceded this inner lamentation, or followed it.

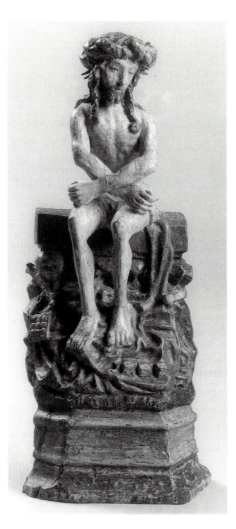

Fig. 59. Anonymous, Southern Netherlands, ca. 1495–1504, *Christ on the stone*, wood. Utrecht, Rijksmuseum Het Catharijneconvent

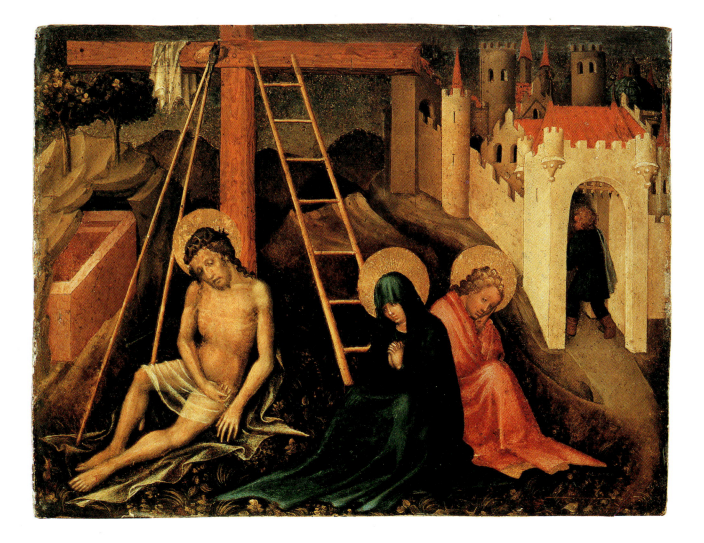

PLATE **41**
Geertgen tot Sint Jans (active in Haarlem, second half of the 15th century)
The Man of Sorrows
Panel; 26.2 × 25.2 cm

Utrecht, Rijksmuseum Het Catharijneconvent, inv. no. ABM s 63

Artists' improvisations also led to the creation of new scenes, some melancholy, some infused with the highest drama. The most poignant example is a small panel by the Haarlem painter Geertgen tot Sint Jans, now in the Catharijneconvent in Utrecht (PLATE 41). Here Geertgen has transformed a devotional theme into a spiritual event. He does so primarily by breaching the rigid frontality of the composition. The Cross and the grave in diagonal perspective give this Man of Sorrows an unprecedented dynamism. The structure is subordinated to the depiction of the drama of Christ's suffering. The cross and the grave establish the basic framework, but it is the movement of Christ's body that gives the scene its expressiveness.

Anyone familiar with earlier representations of the Man of Sorrows will find it almost shocking to see how the *arma Christi*, which had usually been depicted as nothing more than a fairly haphazard collection of instruments used during the Passion, can be used to heighten the drama of the scene. Geertgen does this by showing angels in various poses and engaged on different tasks. Given the basic structure of the composition, all the other emotive figures seem to have been added in no discernible order. As a result, the Virgin, Mary Magdalene, St John and the angels express their own, individual emotions in isolation. It appears to be a chaotic maelstrom of emotions, but it is not, and that is what gives this small painting its remarkable expressive force. The key is Christ, who despite all the emotion in the picture, addresses the viewer with His gaze, His body and the gesture of His right arm.

Of all the writings that describe the bloody drama of the Passion, the popular Dutch devotional booklet *Fasciculus mirre* remains in the mind. The author urges the reader to meditate on all the blood that was shed for man's salvation. The meditations practised by Geert Grote's brothers of the Common Life involved steeping oneself in the Passion while indulging in powerful fantasies of bloodletting. With his soul the mystic wanted to penetrate the open wounds to reach the Lord's heart, there to become one with Him. With Geertgen's scene in our mind's eye, we read: "O behold here with your inner eyes the Lord of Lords, the King of Kings, so wounded, so bloodied, so mutilated. Purple is painted but twice, Jesu's body more than that. It was painted at His flagellation, at His crowning and on His cross. O Father in eternity, look at Him, is this really Your Child, so sorely wounded, so mutilated, so abandoned, so rejected, and so derided by His own people?"*

The painting by Geertgen tot Sint Jans brings one development to a close. While the text attributed to Bernard of Clairvaux accompanying the *Man of Sorrows* of ca. 1300 (see *fig. 53*) expresses powerful emotions which are only partly visualised in the tranquil *imago pietatis*, Geertgen's *Man of Sorrows* fully answers the believer's desire to abandon himself to the drama of Christ's Passion, to which so many Late Medieval meditations were addressed. In this small masterpiece, word and image are at one.

Further reading:

Belting 1981; Berliner 1955; Bertelli 1967; Brandenbarg 1990; Bynum 1982 and 1987; Caron 1984; Claussen 1978; Gaborit-Chopin 1990; Kirschbaum/Braunfels 1968–76; Marrow 1979; Van Os 1969; Van Os 1978; Panofsky 1927; Preysing 1981; Ringbom 1984; Schiller 1966–80; Surmann 1991; Uden 1992; Vetter 1963

Och siet hier doch mit uwen inweyndighen ogen den heer des heren, den coninck der coninghen, soe doorwont, so bebloet, so mismaect. Purper en wort niet dan twewerf geverwet, mer dat lichaem Ihesu is meer geverwet. Dat is geverwet in sijn geesselinge, in sijn croninge ende in sijn cruce. O vader inder ewicheit, siet doch of dit u kynt is, die dus deerlick doerwont is, dus mismaect is, dus verlaten is, dus verworpen is, ende dus van sijn eygen volck bespot wort.

Quotation:
Marrow 1979, pp. 50–51

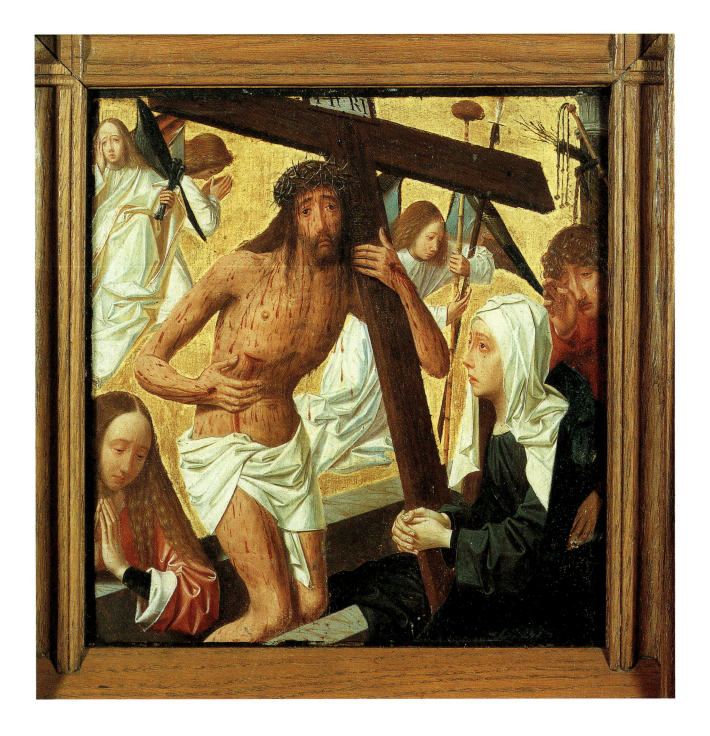

Fig. 60. Attributed to Defendente Ferrari (ca. 1490–ca. 1535), *Scenes from the life of Sts Crispin and Crispinian,* before 1508, panel. Turin, Museo Civico

MANTEGNA'S BERLIN *VIRGIN AND CHILD*

The story of devotional art opens around 1300, when images to accompany prayer began appearing throughout Europe. But when did it come to a close? When was there such a definitive break that one can say that what followed was utterly different? Frankly, it is impossible to detect such a break, certainly not for European art as a whole. This is partly because a separate, indigenous culture of prayer began evolving in Italy in the fifteenth century in which different artistic norms and values were formulated earlier than anywhere else in Europe. One consequence was that old devotional themes were viewed in a new light, as artistic challenges, and their depiction was measured against independent aesthetic criteria that were legitimised in part by referring back to the art of antiquity.

Another culture of prayer made its appearance, or rather a new note was sounded here and there. Bernard of Clairvaux and Francis of Assisi had set the tone by unleashing powerful emotions and intense empathy. The supreme goal was to lose one's own identity so that one could go to the side of the baby Jesus, imitate Christ, and feel at one with Him during His Passion, with the stigmata as the high point of a life of prayer. Humanists, in particular, objected to the lack of refinement and detachment that characterized this experience of religion, indeed were a precondition for it. That was not because they were worldly scholars, as is often assumed. Their strictures were prompted above all by the different attitude which the new cultural élites adopted towards traditional religious scenes. Their criticism raised the issue of the relevance of the traditional culture of prayer. Devotional behaviour of the kind discussed here in connection with Late Medieval works of art is still current today, but it has acquired a very different social significance. It is certainly no longer normative for cultural life. The sixteenth-century painter and writer Giorgio Vasari (1511–1574) considered that much of the art used for prayer was suitable solely for old women, who did not know any better. This disdain gradually spread to all corners of society.

In the course of the fifteenth century, devotional scenes acquired a different, more neutral position in the private sphere, and here, too, Italy took the lead. In the Museo Civico in Turin there is a painting of ca. 1500 attributed to Defendente Ferrari which shows the birth of the saintly twins Crispin and Crispinian (*fig. 60*). On the wall of the lying-in room is a *Virgin and Child*. There are quite a few extant pictures showing devotional scenes in bedrooms, and they make it clear that such small paintings on a wall had a different function from diptychs or triptychs, which were opened when one wanted to pray, like a Book of Hours (*fig. 61*). These were closer to hand, on a lectern or on a sideboard, which could be turned into a house-altar. A *Virgin and Child* on the wall was more remote. It sanctified the room as a whole, as well as serving if necessary as a focal point for prayer. It had become one of the norms for interior decoration. A second-rate *Madonna* would have been out of place in a sumptuous room. Of course, works of art also hung on walls in the fourteenth and fifteenth centuries. In monastic cells, for instance, there were Madonnas and crucifixes aplenty, as there are today. In hermits' caves, images to accompany private devotion dangled from the roof (see *fig. 52* on p. 109). There, however, they were part of the uninterrupted daily routine of prayer. Opening and closing objects with shutters in a lay household implies a specific

Fig. 61. Joos van Cleve (active 1507–40/41), *The Annunciation*, ca. 1525, panel. New York, The Metropolitan Museum of Art, Michael Friedsam Collection

PLATE **42**
Andrea Mantegna (Isola di
Cartura ca. 1430/31 – Mantua
1506)
The Virgin with the sleeping Child,
ca. 1465–70
Canvas; 43 × 32 cm

Berlin, Staatliche Museen zu Berlin, Preußischer
Kulturbesitz, Gemäldegalerie, inv. no. S.5

Fig. 62. Donatello (ca. 1386–1466), the Chellini
Madonna, in or before 1456, bronze. London,
Victoria and Albert Museum

activity associated with prayer. Small paintings on a wall have a permanent presence in a room, making it inevitable that different aesthetic criteria should come into play. If you hang three more paintings beside the one in Defendente's picture, you already have quite a respectable art collection.

One of the most beautiful 'paintings on a wall' for private devotion is Andrea Mantegna's *Virgin and Child* of ca. 1465/70 in the Staatliche Museen in Berlin (PLATE 42). Mantegna was the greatest Early Renaissance painter of northern Italy. As an authority on antiquity, and mixing as he did with princes, he regarded each commission as a new artistic challenge. Whatever he painted – classical triumphs, Madonnas, saints, mythological tales – the result was always something entirely and unmistakably his own. That conscious, erudite communion with the past in order to achieve new creations is one of the most remarkable aspects of his career. That is also the case with his *Virgin and Child*, which for this reason has been included in this discussion of Late Medieval devotional art.

The innovative nature of the work is immediately apparent from the technique employed. It is not on panel, but canvas, and the medium used was not egg or oil, but glue. Mantegna painted directly on to the canvas, with no intermediate ground. Painting with glue as the medium on an unprepared canvas was a practice used in Flanders, but not in Italy. So even with the technique Mantegna was proclaiming his originality. He wanted to be different, exceptional, although that desire should not be associated with romantic notions of artistry. Mantegna broke with accepted craft practice because he served patrons who sought exceptional artists partly in order to enhance their social status. The romantic genius stands alone, but the Renaissance artist stood out from the run-of-the-mill craftsman because he rubbed shoulders with men of letters, philosophers and musicians at the courts of the rulers of the city-states of Italy.

Renaissance artists who wanted to display their exceptional qualities often did so by a radical individualisation of stereotypes, in this case the Virgin. She does not follow the fixed type, nor does she present her Child in accordance with the rules developed in Byzantine art. There was a programme for the Virgin cheek to cheek with the Child, the so called *eleousa* Madonna, but Mantegna leaves it so far behind that it becomes almost irrelevant. The spatial conception gives both figures a new presence. The rectangular format is turned into a window at which Mary displays her baby, but without making a point of presenting it to the viewer. Her relationship with Jesus brings them very close to us. The Mother of God is an ordinary girl who has no need of a halo to idealise her. She gazes pensively straight ahead, caressing her sleeping Child.

Mantegna undoubtedly had Florentine models in mind when he painted this Madonna. The great sculptor Donatello, in particular, who had produced major works in Padua, showed the Virgin as a woman of flesh and blood (*fig. 62*). The inward-looking expression on Mary's face, however, is entirely Mantegna's. The effect of spatial proximity was something that many artists sought to achieve. One remarkable example of this is a *Madonna* from Ferrara of approximately the same date, who is

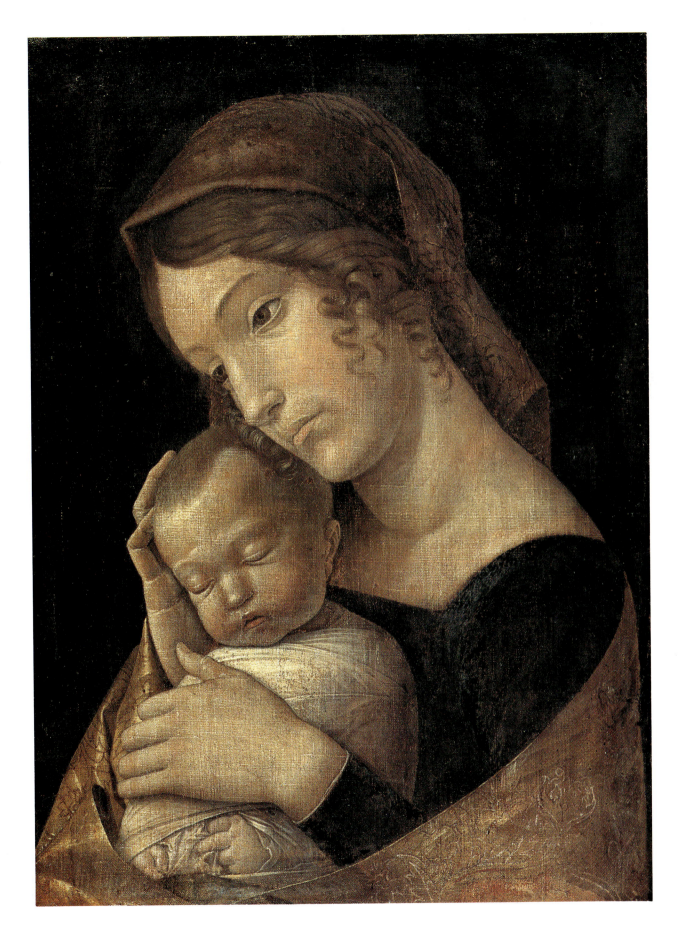

Fig. 63. Anonymous, Ferrara, ca. 1470, *The Virgin and Child*, panel. Edinburgh, National Galleries of Scotland

made visible in the here and now because the window has been torn open (*fig. 63*). Mantegna did not need to indulge in such tricks in order to create the illusion of immanence.

The childlike nature of Mantegna's Jesus is emphasized by His swaddling clothes. The purpose of the ancient custom of swaddling was to prevent a baby scratching its eyes and to ensure that its legs grew straight. Moreover, a swaddled child could come to no harm if its mother had to leave it for a while. Depictions of swaddled children are found in Rome as early as the first and second centuries. In the visual context of Mantegna's painting, the swaddling clothes turn Jesus into an ordinary baby, just as the Virgin is an ordinary woman. A great artist had to be capable of bringing art very close to reality. That, above all, was the task that artists like Mantegna set themselves.

The Christ Child is not infrequently depicted with closed eyes in fifteenth-century North Italian art. Several such scenes have explanatory inscriptions based on the Song of Solomon 5,2, to the effect that the Child may be asleep but its heart is awake. Its sleep can also be seen as a prefiguration of Christ's death. The fifteenth-century Dominican reformer Giovanni Dominici (1355/56–1419), on the other hand, believed that the maternal and childlike nature of a Madonna with a sleeping Christ would hold a special appeal for children. Generally, though, there was a rather different intention: Jesus's sleep prompts the viewer to ask the virgin to wake him, so that He can start on His work of saving the soul of the man or woman who is praying. When an artist like Mantegna employed a motif like this it was undoubtedly to exploit the expressive potential of a child sleeping soundly while its mother ponders the future with a melancholy expression.

The significance of one particular motif that has an important bearing on the composition has so far never been discussed in the art historical literature. It is the brocade cloth enveloping both Mary and Jesus. It is clearly not part of the Virgin's dress, but an adjunct to the scene. In order to understand where this motif comes from it is necessary to make a digression into the history of devotional customs in Padua. In the cathedral there is a faithful seventeenth-century copy of a late thirteenth-century *Madonna* (*fig. 64*). It is rightly believed that this earliest depiction of the Virgin with the swaddled Child must have been an important source of inspiration for Mantegna's picture. Copies of it were being made as early as the fourteenth century. At the end of the fifteenth century it was given a costly silver frame bearing the following inscription: HIC DEUS EST ET HOMO QUEM VIRGO PUERPERA PROMO (Here is God and man, whom I, the virgin and mother, bring forth). Judging by the inscription, this unique scene was intended to portray the Virgin appearing to the faithful with the express purpose of presenting her baby as the Saviour; that would also account for the illusionistic architecture. The swaddled baby bears a striking resemblance to wooden figures of the Christ Child that were laid in a crib by the high altar at Christmas-time. They also often played the leading rôle in annual liturgical plays.

The script of one of those mystery plays staged in Padua at Christmas has come down to us, and it turns out that this image is the protagonist. The play begins when the bells are rung for Matins. The bishop stands in the choir. The *Madonna* has been placed near the altar, covered with a richly decorated, costly cloth. The text states that this stands for the crib. Behind it are two canons who play the part of midwives. The cantors represent shepherds. The midwives sing, "Who are you seeking in the manger?" to which the shepherds reply, "Christ the Lord and Saviour". The midwives then uncover the painting, and sing, "Here is the baby". The shepherds kneel before the picture, then turn to the faithful with the words, "Christ is born to us. Approach". They then turn back to the painting, kneel, and sing, "Let us adore".

This mystery play is moving testimony to the Late Medieval desire that the Saviour should make himself visible. There are no other surviving scenes of the Virgin and Child that were manifestly painted for a special occasion of this nature. In the fifteenth century, humanists in many Italian cities deliberately encouraged the veneration of old depictions of the Virgin and her Child. New frames were made for prized Madonnas, Renaissance architects built churches and chapels to house them, and scholars composed the most splendid legends telling of the special part that they had played in the city's history.

Fig. 64. Anonymous, Padua, 1647 (?), copy after a late 13th-century *Virgin and Child*, panel. Padua, Cathedral

With his *Virgin and Child*, Mantegna brought the veneration of the famous Padua *Madonna* into the home. By an artifice he removes the costly cloth, revealing Mary displaying her sleeping baby wrapped in swaddling bands. Art exposes Salvation. The essential feature is still the proximity of the sacred, but the ingenuity of the artist has taken on a different dimension. From craftsmanlike fabricator he has manifestly become a creator.

Further reading:
Goffen 1975; Hueck 1967; Van Os 1971; London/New York 1992

'GATHERED UP, FOLDED SHUT AND PACKED AWAY': TWO RECONSTRUCTIONS

Reference has already been made to a number of paintings that originally belonged to composite works, the constituent parts of which were later dispersed. Francesco Vannuccio's *Madonna* in The Hague once formed a diptych with the artist's *Crucifixion* in Philadelphia (PLATES 21a and 21b), as did Lorenzo Monaco's *St Jerome* in the Rijksmuseum with the *Madonna dell'Umiltà* in Copenhagen (PLATES 12a and 12b). It is only possible to ascertain the precise meaning of such scenes when they are viewed in their original context, which necessitates reconstructing the ensemble. This is especially true of the two works discussed here. The first is a four-part polyptych by an anonymous master working at the end of the fourteenth century, the four panels of which are now divided between the Mayer van den Bergh Museum in Antwerp and the Walters Art Gallery in Baltimore. Together with the Norfolk triptych (PLATE 37), it is the most important document of Netherlandish painting around 1400 to survive. The second is a touchingly beautiful diptych attributed to Geertgen tot Sint Jans, of which the *Glorification of the Virgin* is in the Boymans-van Beuningen Museum in Rotterdam, and the *Crucifixion* in the National Galleries of Scotland in Edinburgh.

What both ensembles have in common is that they reveal their original, devotional function only when viewed in their reconstructed form. The first is a series of narrative scenes, while the second consists of two images that serve as the visualisation of a single prayer. Both works have been analysed as reassembled ensembles by two specialists: the former by Hans Nieuwdorp, curator of the Museum Mayer van den Bergh, and the Geertgen diptych by Bernhard Ridderbos of Groningen University.

Hans Nieuwdorp

Among the paintings in the catalogue published in 1904 to mark the opening of the Mayer van den Bergh Museum in Antwerp were two small panels ascribed to Melchior Broederlam (PLATES 43b and 43d and f). Although that attribution can no longer be sustained, it does tell us that in 1904 scholars recognised that these were two rare and very early examples of Netherlandish painting, for at that time Broederlam (active 1381–1409) was one of the few late fourteenth-century painters known by name and work.

A second reason for the attribution to Broederlam was the panels' place of origin, namely Dijon, and more specifically the Carthusian monastery of Champmol near that city, the famous foundation of Duke Philip the Bold of Burgundy (1364–1404). (Between 1392 and 1399, Melchior Broederlam had worked on the duke's commission, painting the wings (see *fig. 65*) for a retable carved by Jakob de Baerze of Dendermonde; wings and retable are now in the museum at Dijon). The provenance of the two Champmol panels was recorded by Carlo Micheli, from whose collection they and other works were purchased by Fritz Mayer van den Bergh in Paris in 1898. Micheli had acquired the paintings in 1843 at the sale of the Bartholomey collection in Dijon.

One of the panels is painted on both sides, and it was originally thought that the pair formed a diptych because they were hinged together and could be folded shut. This did, however, seem an odd construction, partly because there was no apparent correlation between the scenes. They depict the *Nativity* (PLATE 43a) and the *Resurrection* (PLATE 43d), with a *St Christopher* (PLATE 43f) on the back of the latter. The reverse of the *Nativity* is unfinished and undecorated.

In 1939 two very similar panels were acquired by the Walters Art Gallery in Baltimore, and became the subject of thorough art historical study (PLATES 43a and e and 43c). They, too, formed a diptych, one panel of which was painted on both sides. Even without this resemblance there was not the slightest doubt that these works were in the same style, even by the same hand, as those in Antwerp. Moreover, the correspondence in size and use of colour suggested that all four panels belonged together. They were not two diptychs, but a polyptych.

The reconstruction of the ensemble demonstrates beyond any doubt that the four panels indeed belonged to a polyptych in which they were displayed one beside the other. The outermost ones served as shutters when the ensemble was closed. The four panels had apparently become separated and were randomly rearranged in pairs in the nineteenth century by someone who had no knowledge of their original structure. The reconstruction reveals both a thematic coherence and an artistic unity and harmony which are not apparent from the panels' rearrangement as two diptychs. Before discussing the polyptych as a whole the individual paintings will therefore be described in their logical order.

Fig. 65. Melchior Broederlam (active 1381–1409), *The Annunciation* and *The Visitation*, wing of the retable of Jakob de Baerze (active ca. 1390). Dijon, Musée des Beaux-Arts

PLATE **43**
Anonymous (Gelderland?)
The Antwerp-Baltimore polyptych, ca. 1400

The Annunciation, The Nativity, The Crucifixion, The Resurrection, The Baptism of Christ and St Christopher
Panel; wings 38 × 26.5 cm (a/e and c), 37.6 × 26.2 cm (b and d/f)

Baltimore, The Walters Art Gallery, inv. nos. 37.1683 A-C
Antwerp, Museum Mayer van den Bergh, cat. 1, no. 374

PLATE **43a**
The Annunciation

PLATE **43b**
The Nativity

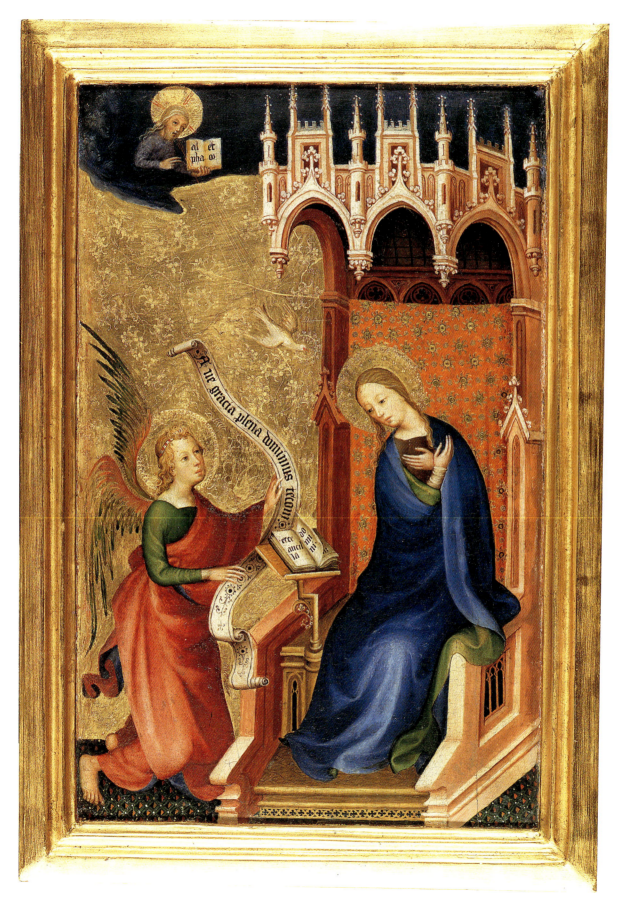

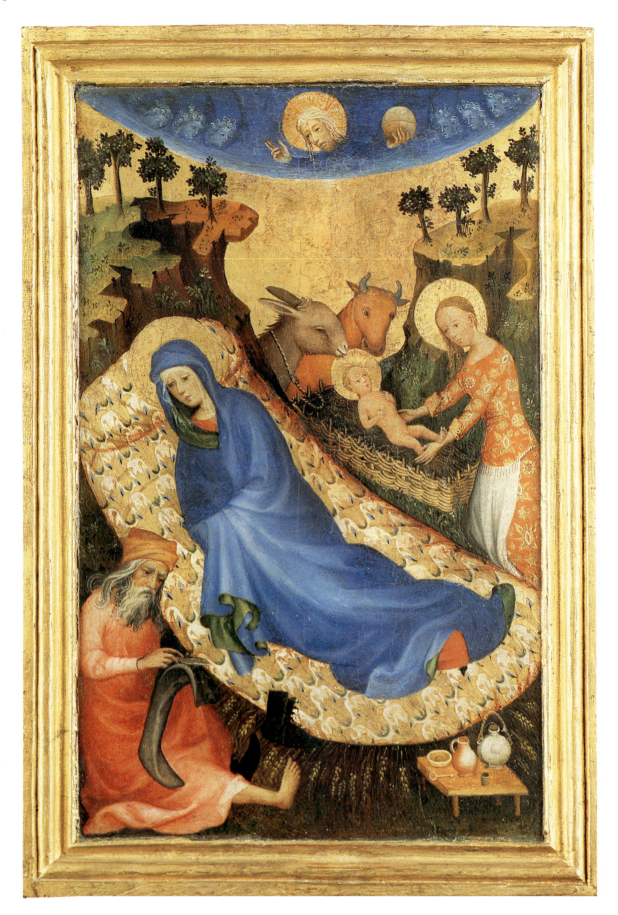

The first scene of the opened polyptych is the *Annunciation* (PLATE 43a). The Virgin is seated on a monumental throne with a tall back supporting a large, architectural canopy. Its wealth of ornament gives it the look of a Gothic edifice in white marble, much like a tower. It may in fact be an allusion to the ivory tower that was one of the titles given to the Virgin in reference to her Immaculate Conception. Be that as it may, this detail is part of the traditional repertoire for scenes of this type, as evidenced by numerous miniatures in illuminated manuscripts of the period.

Mary has her arms crossed over her breast, and is inclining her head towards the angel who brings God's message. His words are inscribed on the banderole in the angel's hand: *"Ave gracia plena dominus tecom"*, the opening words of the Hail Mary. Gabriel is identified as an archangel by his coloured wings, the diadem on his brow and his halo. Between these two figures, on a lectern ingeniously attached to the throne, is an open prayer-book with Mary's reply: *"Ecce ancilla domini"* (Behold the handmaid of the Lord), indicating her submission to the word of God.

God the Father is seen in Heaven – the blue zone extending across the top of the panel. The bust-length figure holds an open book, and points to the words *"Alpha et Ω"* (I am the beginning and the ending). This scene illustrates the beginning of the story, for the message to Mary marks the start of salvation, the arrival of God's Son on earth. The same figure displaying the same text reappears in the *Resurrection* panel, which brings the story to an end.

In contrast to the *Annunciation*, which adheres to the traditional elements and standard composition of the story, the *Nativity* displays great originality (PLATE 43b). The Virgin is resting on a richly brocaded cloth strewn with a stylised motif of ears of corn, mirroring the bed of corn on which the rug is spread. Behind her, the naked baby Jesus is being laid in a crib by a midwife, who is wearing a magnificent brocade gown over which she has tied a simple pinafore. The ox and the ass bend their heads over the Child, warming Him with their breath. The Virgin, however, is looking in the other direction, at Joseph, who is seated on the ground in the lower left corner. He has taken off one of his stockings and is cutting it into pieces with a knife. This is certainly an unusual motif, but is not entirely unknown in Netherlandish and German folksongs and painting. Joseph's stockings were preserved in Cologne Cathedral, where they were venerated as relics by the numerous pilgrims who came to the city. His action serves not only to underline the impoverished circumstances under which the Son of God came into the world, but also illustrates the popular view of Joseph, forced into a submissive, nurturing and thus unmanly rôle. His figure is contrasted with the grandeur of the Incarnation, in which Mary is the central figure and the embodiment of the greatest mystery of all.

Strikingly, the Nativity is set not in a cave or stable, but in a landscape denoted by cliffs riven with clefts and studded with trees. Above the gold background behind these crags is an azure segment of Heaven from which God, surrounded by seraphim, looks down and gives His blessing.

The simplicity of the *Crucifixion* (PLATE 43c) is in marked contrast to the other scenes, which are predominantly narrative and anecdotal. The execution on Calvary has been reduced to its essence. The figure of the crucified Christ claims sole attention. The only human witnesses are the Virgin and St John. They flank the Cross and give vent to their grief with restrained gestures. Four miniature angels catch the blood flowing from Christ's wound. They are so small that they almost disappear in the decoration of the gold background.

Contrasting with these traditional motifs is the unexpectedly dramatic impact of the figure of Christ. This is not the dead Christ, but the Saviour at the height of his suffering, crying out in despair to His Father in the arc of Heaven at the top: ELOY ELOY LAMA SABATANI (My God, My God, why hast Thou forsaken Me?). This taut composition convincingly captures a sense of inner turmoil unparallelled in comparable scenes from the period. It was not until the sixteenth century that this type of the crucified Christ *ad vivum*, rather than the dead or dying Christ, became a common iconography. So here, around 1400, we are confronted with a rare depiction of tragedy and emotion which seems to reflect the artist's own deep involvement in the story.

The series of scenes on the inside of the polyptych closes with the *Resurrection* (PLATE 43d). The triumphant Christ steps energetically from the horizontal sarcophagus, the cover of which has been pushed aside by angels. He holds the banner of the Resurrection, the sign of his victory over death. At the top, in Heaven, choirs of angels sing the texts inscribed on the banderoles at left and right: "*Sanctus, Sanctus, Sanctus*" (Holy, Holy, Holy) and "*Gloria in excelsis deo et in terra*" (Glory to God in the highest and on earth).

The most striking elements in this panel are the three guards asleep in the foreground. Two of them are wearing doublets and surcoats with the most sumptuous, colourful floral designs. This once again demonstrates the artist's love and great knowledge of luxurious fabrics, such as the costly silks that were being imported from Italy at the time. Did the painter actually visualise soldiers from Christ's day as men wearing such exotic garb, or could he simply not resist the feast for the eye offered by these decorative patterns? In any event, this fairy-tale finery, or at least the superb fabrics, appears to refer to a reality that made a great impression on the artist, and fed his imagination.

On the back of the panel with the *Annunciation* is a scene that was designed to be visible on the outside of the polyptych. It shows the *Baptism of Christ* (PLATE 43e) – a subject that is difficult to relate to this series. It does not immediately tie in with the four scenes depicting the Incarnation and the Passion. It has been suggested that it is a reference to baptism under the Old Law, with St Christopher wading through the water on the other outside panel representing baptism according to the rites of the New Law. Such an interpretation, however, assumes a very large degree of artistic

PLATE **43c**
Anonymous (Gelderland?)
The Antwerp-Baltimore polyptych,
The Crucifixion

PLATE **43d**
Anonymous (Gelderland?)
The Antwerp-Baltimore polyptych,
The Resurrection　　**141**

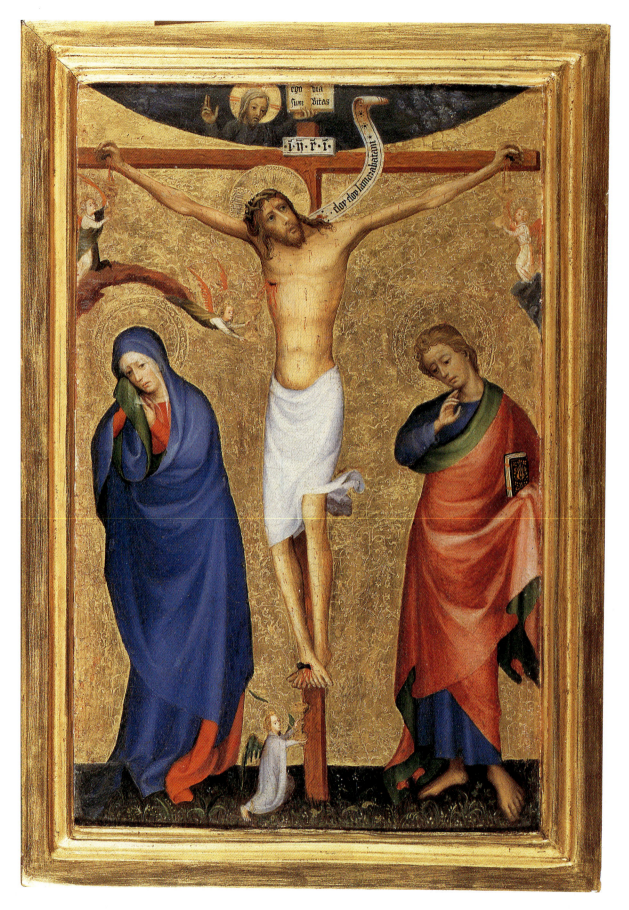

licence on the part of the artist or his patron. The presence of water in both scenes is insufficient evidence for such a far-fetched theory, particularly when the strict theological interrelationship of the four inner panels testifies to a carefully considered religious conception. The reason for including this scene should be sought rather in the importance that was attached to John the Baptist. Like its pendant, *St Christopher*, this is a depiction of a saint. The Baptist is shown in a key scene from his life, carrying out the task for which he was named. In that sense, the figure of Christ whom he is baptizing, the traditional angel holding Christ's cloak, and the entire landscape with the River Jordan, in which fish are swimming, should be construed as the saint's attributes.

The choice of John the Baptist could not have been accidental. He was the first and most important saint in the history of Christianity, and had a widespread cult. Even more interesting from our point of view is that he was also the chosen patron saint of Duke Philip the Bold. He appears repeatedly in works of art which Philip commissioned for churches and chapels, particularly those which also feature the duke as patron or donor. In these cases the duke is not accompanied by his name-saint, the apostle Philip, as was customary, but by the Baptist, who serves as the patron of his dynasty. The analogous is true, incidentally, of the duchess, Margaret of Flanders (1359–1405), who is always attended by St Catherine.

A famous example of the importance of these two saints for the ducal couple is the portal of the monastery church of Champmol. There the Netherlandish sculptor Claus Sluter (ca.1340/50–1405/06) depicted the duke with the Baptist and the duchess with St Catherine in life-size figures that can be counted among the finest achievements of European sculpture (*fig. 66*). A direct connection with Philip the Bold probably accounts for the Baptist's presence on the Antwerp-Baltimore polyptych.

St Christopher (PLATE 43f) is on the back of the panel with the *Resurrection*. An extremely popular saint in the Middle Ages (see p.30), he was an amalgam composed from folk tales and legends. The *Golden Legend* gave him an air of authenticity and contributed greatly to his popularity. The Greek name Christophoros means 'Christ-

Fig. 66. Claus Sluter (ca. 1340/50–1405/06), *Philip the Bold with John the Baptist* and *Margaret of Flanders with St Catharine*. Champmol-les-Dijon, monastery church

bearing', and the legends accordingly characterized him as a giant who carried the Christ Child on his back. His cult was particularly strong in the Late Middle Ages. Every church had a life-size image of him, often by the entrance, so that he was visible from a distance, and sometimes even from outside the church. The sight of him was supposed to protect one from sudden or 'bad' death. To the devout medieval soul that meant a death without confession and forgiveness of sins, thus condemnation to Hell or a long spell in Purgatory in the after-life, which was the worst fate that could befall anyone. Travellers and pilgrims were particularly prone to this kind of death, so a daily obeisance to an image of St Christopher was of vital importance to them. St Christopher came thereby to be the principal patron of travellers, and remarkably enough he has become so again in the twentieth century, especially among motorists. His presence on this small retable might indicate that the object itself was taken on the owner's travels and used each day.

To summarise, it turns out that when the polyptych is opened it encapsulates the four great truths of the Christian faith: God's Son is made man, is born of the Virgin Mary, died for us on the cross, and rose from the dead on the third day. That this Incarnation and sacrifice on the cross were part of a divine plan of salvation is emphasized by the inclusion of God the Father in every scene against a blue heaven that links the four panels in a wonderful and effective symmetry. A series like this is of course anything but rare. The synthetic nature of the content makes it amenable to every form of religious use – in public on an altar, or in the seclusion of an oratory for private prayer. Its small size, however, points to the latter use. It is a veritable gem, made to be seen from close to, and easy to lift with two hands.

Gathered up, folded shut and packed away – the outer panel with St Christopher indicates that this a portable altarpiece. The original owner has already been named in the discussion of the *John the Baptist* scene. We can assume that this work of art belonged to Philip the Bold, Duke of Burgundy. This is suggested not only by the choice of the duke's patron saint; there are other clues as well. The tradition attached to the panels in Antwerp and Baltimore is that they came from the Carthusian monastery of Champmol near Dijon, which was founded by Philip and was the site he chose for his tomb. The duke was also a passionate lover of painting, and attracted many artists, preferably Netherlandish, to his court. He also bought panel paintings avidly, and when he died left numerous polyptychs of various origins and shapes.

Indeed, Philip owned another famous four-panel polyptych that was also a travelling altarpiece, and had almost the same form as the one discussed here. It was the Passion polyptych by Simone Martini, the great Sienese painter, the constituent panels of which are now spread between museums in Paris, Berlin and Antwerp. On the outside of that polyptych is the *Annunciation*, and on the inside four scenes from Christ's Passion (see *fig. 33* on p. 78). So, although it may not be precisely the same as our polyptych, its form and function are closely related. It is not inconceivable that the painter of the Antwerp-Baltimore polyptych modelled his work on that by Simone Martini, at least in function, for both are travelling altarpieces or portable retables.

PLATE **43e**
Anonymous (Gelderland?)
The Antwerp-Baltimore polyptych,
The Baptism of Christ

PLATE **43f**
Anonymous (Gelderland?)
The Antwerp-Baltimore polyptych,
St Christopher

Fig. 67. The Antwerp-Baltimore polyptych (PLATE 43), reconstruction, folded flat

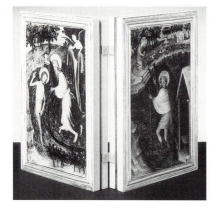

Fig. 68. The Antwerp-Baltimore polyptych (PLATE 43), reconstruction, closed

How were such polyptychs actually used? The four panels were attached to each other by hinges. When closed for packing away they lay one on top of the other (*fig. 67*). When erected for use there were two possible views, closed and open, as was customary with retables. In the closed arrangement, the backs of the two outermost panels cover the two middle panels (*fig. 68*), and when the ensemble was unfolded the inside of the entire series was visible (*fig. 69*). The open arrangement is the 'active' mode, for use during prayer. The closed arrangement is 'passive', and was the way the retable was seen when not being used for private devotion. The scenes of *St John the Baptist* and *St Christopher* then had the secondary function of identifying the owner and displaying the saint whose protection was invoked, without prayers necessarily being said or there being any specific devotional intent.

The hinged arrangement was eminently practical, for it made it possible to open and erect the altarpiece in a single action, as one would do with a folding screen. It could also be folded down to its smallest unit, so that it took up as little space as possible and was also well protected – two essential requirements, both then and now, for something that is regularly taken in one's luggage. This method of assembly and use has been satisfactorily demonstrated by a reconstruction (*figs. 67–69*). The polyptych probably travelled in a pouch, which would explain why the outer panels at the top and bottom of the folded altarpiece are still in such good condition. Unfortunately it is no longer possible to make a physical reconstruction with the panels themselves, for at some stage the frames of the pair in Baltimore were repaired and renewed.

Around 1400, a travelling altarpiece was a costly yet indispensable possession for someone as powerful as the Duke of Burgundy, first and foremost because travel itself was so important. Medieval man was not deterred by distance. Pilgrimages to Rome or Santiago, or even to Jerusalem, were great but far from rare undertakings. The real difference between our day and the Middle Ages is not so much the distance or the mode of transport as the length of time involved, and the reasons for making a journey.

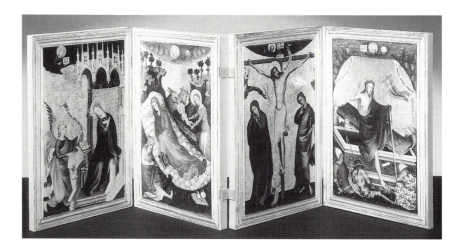

Fig. 69. The Antwerp-Baltimore polyptych (PLATE 43), reconstruction, open

The medieval traveller to distant places knew he would be away for months, if not years. That stands to reason, given the slowness of travel in those days, which, if it could not be by boat, was necessarily by foot or by horse. Travellers also had to take the weather and the seasons into account, for they could affect the state of the roads very considerably.

People travelled for political, religious or economic reasons. Of particular interest to us is the administrators' need for communications. The medieval ruler was by definition a traveller, and the larger his realm the more often he had to move from one place to the next, generally taking his court with him. His presence was his authority. Some Late Medieval princes had highly sophisticated systems of administration and communications, and in this respect Philip the Bold was an exemplary and progressive ruler of his vast and far-flung possessions. Nevertheless, he still spent much of the year on the road between Dijon, Paris and Flanders, and that constant mobility fully reflected his prominent position on the political stage.

With an itinerant administrative system of this kind, a ruler had to have numerous residences. Philip owned more than forty castles in Burgundy alone. They provided a base, some better than others, for the duke and his large retinue of soldiers, court and officials for several days at a time, but were only partly furnished. The luxury and comfort with which a ruler surrounded himself travelled with him – a large wardrobe, and objects and utensils of every kind, including a polyptych such as the one in discussion.

Costly tableware, and everything needed for banquets, tournaments and hunting made up much of the court baggage, and often filled several wagons. The objects for day-to-day use included everything that the clergy needed to celebrate Mass. Daily attendance at Mass was common, especially for the ruler and the higher echelons of society, and it is not unusual to find them going twice or more in a day. Philip the Bold was a very devout man, and undoubtedly set time aside each day for more personal forms of prayer and devotion. Many of his castles had a private chapel where he could hear Mass or to which he could withdraw to pray. For the same reason, the private chambers of people of his rank also had a prie-dieu.

Prayer was an integral part of daily life, both at home and when journeying. Travel itself, which was not without its dangers, was a traditional reason for prayer, and especially for devotions to the saint whose protection was invoked by travellers, St Christopher. The duke, travelling with his large retinue, was undoubtedly less at risk than most, but even so a prayer to St Christopher was one of the customs that no traveller would have neglected. Conversely, the veneration of St Christopher was so intimately bound up with travel and travellers that his image would instantly have been associated with a journey.

Although the 1904 attribution of the panels to Melchior Broederlam is no longer acceptable, it accurately defined the circle in which the work was executed, for Broederlam was court painter to the counts of Flanders and the dukes of Burgundy. He lived in Ypres, but his commissions regularly took him to Paris and Dijon, and he also spent some years in the castle at Hesdin. He was undoubtedly very familiar with the art being produced at the courts of Bourges, Paris, and above all Dijon, and it is in this milieu that the Antwerp-Baltimore polyptych must be situated.

Numerous other artists, in addition to Broederlam, were working for these courts, and many of them came from the Low Countries. However, it has not yet been possible to link the polyptych with an artist whose name and work are known. The painter remains anonymous. Perhaps he is one of the many names that are known solely from the ducal archives. It is also possible that the polyptych was painted in the Low Countries as a gift for the duke. Whatever the answer, it dates from the very earliest period of Netherlandish painting, a period in which art was associated predominantly with the powerful ducal courts in France. Philip the Bold, Jean de Berri (1340–1416) and the royal court in Paris regularly exchanged works of art, and even artists. At the end of the fourteenth century the most respected artists were usually painters and sculptors from the north. Another key figure in the development of the innovative style of the day was Jan Maelwel (or Jean Malouel; ca. 1370–1416), to whom this polyptych has also been attributed, although this is no more than a tentative hypothesis. In reality, there is no other known painting that displays the distinctive hand of the creator of this polyptych.

There are, however, indications that its artist, like Maelwel, came from the Low Countries, and more specifically from the Gelderland region. The unusual motif of Joseph's stockings in the *Nativity* scene indicates a familiarity with an iconography that was firmly rooted in popular devotion in that part of the world. The celestial arcs on the insides of all four panels are a compositional device which is characteristic of North Netherlandish book illumination, and therefore suggest that the artist was trained in those circles. At the same time, though, he had a good knowledge of the French and even Italian art of his day. He was one of the most representative and original practitioners of the International Style favoured at various courts around 1400.

Bernhard Ridderbos

One of the treasures in the collection of the Boymans-van Beuningen Museum is a small panel with the *Glorification of the Virgin* (PLATE 44b), attributed to Geertgen tot Sint Jans (see also PLATE 41). Even without knowing anything about the subject, one is fascinated by the spectacular lighting effect and the scores of angels swarming around the Mother of God. The full import of the painting, however, only becomes apparent when it is seen in conjunction with its former pendant, a small *Crucifixion* panel in the National Gallery in Edinburgh. The latter is not generally regarded as an autograph Geertgen. But whether the master and a pupil executed one panel each, or whether both are shop products, is irrelevant to a deeper understanding of their joint devotional function. They were probably painted in the 1480s.

The two panels were recorded as pendants in the nineteenth century, when they belonged to a cardinal. They have the same shape and dimensions, and traces of hinging indicate that they formed a diptych, with the *Virgin* to the right of the *Crucifixion*. Diptychs with a *Virgin* and Child and a *Crucifixion* were very common at the end of the Middle Ages (see PLATE 21). One, of 1453, has remained intact, and shows the *Crucifixion* and the same image of the Virgin as in the Rotterdam panel – a so called *Maria in Sole* (fig. 70).

PLATE **44**

Attributed to Geertgen tot Sint Jans (active in Haarlem, second half of the 15th century)
Diptych, ca. 1480?

Left (a): *Christ on the cross with Passion scenes*
Right (b): *The Glorification of the Virgin*
Panel, wings 26.8 × 20.5 cm

(a) Edinburgh, National Gallery of Scotland, inv. no. 1253
(b) Rotterdam, Museum Boymans van Beuningen, inv. no. 2450

Fig. 70. Master of Hallein (active 1st half 15th century), diptych, ca. 1453. Nuremberg, Germanisches Nationalmuseum

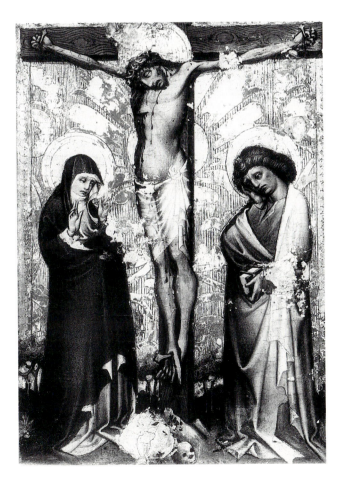

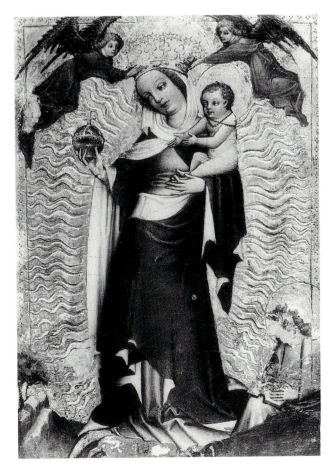

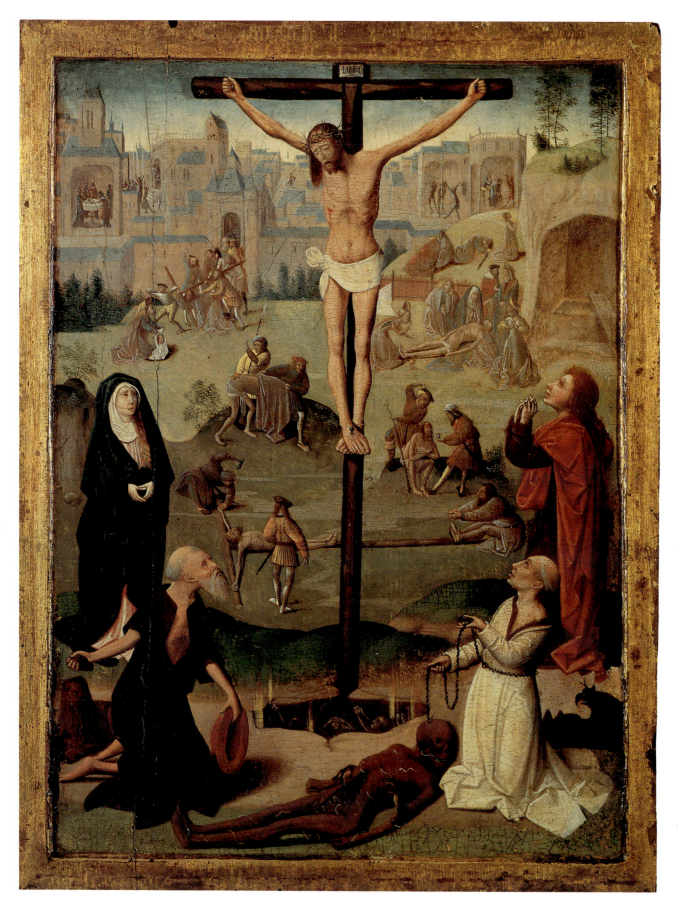

PLATE **44b**

This iconography derives from the last book of the Bible, the Revelation of St John (12,1), where the author describes a vision of a woman "clothed with the sun, and a moon under her feet, and upon her head a crown of twelve stars". She gives birth to a child and is attacked by a dragon which is dispatched by angels. The 'Woman of the Apocalypse' was traditionally identified with the Virgin Mary, and in art she was given the attributes listed by St John. In the Rotterdam panel she is bathed in light, with the twelve stars above her crown, which is held by two angels, and beneath her the sickle moon and the vanquished dragon.

This kind of half-length *Maria in Sole* served mainly as an accompaniment to a prayer, such as the *Ave sanctissima*, to which an indulgence was attached (see PLATE 34). In the case of the Rotterdam-Edinburgh triptych, however, a different prayer was said. This is clear from the fact that beneath her crown the Virgin wears a 'chaplet of roses' – groups of five white roses separated by one red rose. The roses, like the beads of a rosary, stand for the Hail Marys and Our Fathers that make up the devotion of the rosary. The allusions to the rosary are underscored by the two angels, at the same level as the faces of the Virgin and Child in the central of the three rings of angels, both of whom hold rosaries in their outstretched hands.

The devotion of the rosary originated in the second half of the fifteenth century, and was enthusiastically propagated by the Dominicans, who even claimed that it was invented by their founder, St Dominic. The greatest champion of the rosary was the Dominican Alanus de Rupe (1428–1475). One of his pupils, and another great advocate of the rosary, was Jacobus Weyts, prior of the friary in Haarlem, the town where Geertgen tot Sint Jans worked. In 1478 the Haarlem Dominicans founded the first confraternity of the rosary in the Low Countries. Such organizations were set up in order to involve lay people in special devotions. In 1479 Pope Sixtus IV granted an indulgence to all who said the rosary. It can be seen that the indulgence as well as the devotion of the rosary promulgated by the Dominicans are visualised in the diptych formed by the Rotterdam panel together with the *Crucifixion*.

Standing on either side of the Cross, as usual, are the Virgin and John the Evangelist. On the ground beside John is a dragon from which, according to legend, the heathens obtained poison in a vain attempt to kill the saint. The Crucifixion is not depicted as a historical event with all the onlookers described in the Bible. Christ's suffering is presented as a timeless event which the believer of many centuries later relives in his devotions. The feelings of grief the beholder is meant to experience are demonstrated by the Virgin and St John, with their anguished expressions and clasped hands. However, there are two other figures with whom one can also identify. Kneeling in the foreground on the left is St Jerome, a Father of the Church, and on the right St Dominic. Both are chastising themselves in order to expiate their sins.

Jerome himself described a period in his life when he cast himself in spirit at Jesus's feet while beating himself on the chest with a stone. By the end of the Middle Ages he had become one of the favourite saints for all who did penance in their private devotions. Here he is shown holding his cardinal's hat as a sign of his ecclesiastical dignity. He is gazing up at Christ and striking himself on the breast with a stone. Lying behind him is the tamed lion which according to legend was his constant companion (see p.36).

154

Fig. 71. Copy after Geertgen tot Sint Jans, *From the Legend of the rosary of St Dominic,* panel. Leipzig, Museum der bildenden Künste

St Dominic is whipping himself with a rope that is tied around his waist. Drops of blood are visible on his bared shoulder. Dominic's penance was closely associated with the devotion of the rosary, as shown by a copy after a lost painting attributed to Geertgen tot Sint Jans illustrating the legend of the institution of the rosary (*fig. 71*). There Dominic is kneeling in the background before a crucifix, flagellating himself. He is rewarded in the left foreground with a vision of the Virgin and Child with angels. Mary is wearing a crown and a chaplet of roses, and hands the saint a rosary. In the right foreground he is seen promulgating its cult.

The strange motifs in the centre foreground of the Edinburgh *Crucifixion* make it clear that the purpose of the penance and the devotion of the rosary propagated by the diptych was to obtain indulgences. At the foot of the Cross lies a decomposing corpse which is being devoured by little monsters and has worms crawling in it. We are confronted with a *memento mori,* a warning to be mindful of death. The menace of death is further illustrated by the despairing figures surrounded by flames in a pit directly beneath the Cross. This represents Purgatory, where the souls of the faithful are cleansed of sin before ascending to heavenly bliss. By doing penance during one's life, and practising one's devotions, one could reduce the time one had to spend in Purgatory. It was also possible to shorten the stay of those already there. Indulgences, which played a very pragmatic rôle in this process, could be gained by performing particular devotions, such as going on pilgrimage and repeating certain prayers over and over again. "*Sprecht all den rozenkrantz gemein / den die im Fegfeuer leiden pein*" (Say the rosary all together, for those in Purgatory are suffering pain), went a German rhyme from the first quarter of the sixteenth century.

There can be no doubt that the person who commissioned this diptych wished to have the most evocative visual accompaniment to his or her devotions of the rosary; by Geertgen's day there was already an indulgence attached to saying the rosary. This particular devotion evidently involved penitential meditation on Christ's Passion by

the patron or patroness, who may also have had a special veneration for St Jerome. The rosary already provided for this kind of meditation, for its central section comprises the Sorrowful Mysteries, five key events of the Passion which are depicted behind the Cross in the Edinburgh panel, beginning with the Agony in the Garden and ending with the Entombment. These narrative scenes therefore also had a devotional function, entirely in line with Alanus de Rupe's advice to use not a book but an image when contemplating the mysteries of the rosary.

The theme of the Passion is illustrated in the panel with the *Glorification of the Virgin* by the objects borne by some of the angels. The three at the top of the central ring hold banners bearing the word "*Sanctus*", two display rosaries, and the others carry the *arma Christi*: the cross, the lance that pierced Christ's side, the crown of thorns, the hammer and nails that fastened Him to the cross, the sponge on a cane that was dipped in vinegar for Him to drink, and the column at which He was scourged. They are seen in this order if one follows the central ring anti-clockwise from centre left, and are borne as the symbols of Christ's victory by the angels venerating the Virgin and Child.

The artist gives a remarkable expression of that veneration in the figures of musician angels in the outermost ring and at the four corners, who have instruments of every kind. Oddly, too, the Christ Child is joining in the performance with a bell in each hand. There is possibly a symbolic connotation here. According to an anonymous, Early Christian writer who was wrongly identified as Dionysius the Areopagite in the Middle Ages, and is now known as Pseudo-Dionysius, God is the cause of *consonantia*, harmonic consonance, and of *claritas*, clarity. This pronouncement, which was given wider currency in Dominican circles through the work of Thomas Aquinas (1225–1274), may help explain the two most striking features of the Rotterdam panel: the remarkable lighting effect, and the host of angels making music with Christ. The light clothing the *Maria in Sole* is the light of Christ, who is the cause of the harmony of the spheres. The Child is looking to the left, and its gaze is met by an angel who is also swinging two bells, thus giving the impression that the music that Christ is making has been taken up by the musician angels.

This interpretation adds an intellectual, theological dimension to the scene, one that fits in well with the nature of the Dominican order, and makes it less likely that the diptych was ordered by a layman. The patron could have been one of the Haarlem Dominicans who were the moving spirits behind the devotion of the rosary that flourished in that city.

IMAGE AND IMAGINATION IN THE MEDIEVAL CULTURE OF PRAYER: A HISTORICAL PERSPECTIVE

Eugène Honée

THE MAIN FUNCTIONS OF IMAGERY

In order to appreciate how images were regarded and used in the period when they were made it is necessary to have an understanding of contemporary attitudes to the visual arts. This is equally true of the Middle Ages, which was a time of burgeoning theories about art – so much so that it is actually possible to distil a complete visual theology from the works of Thomas Aquinas (1225–1274) and Johannes Bonaventure (1221–1274). But if one examines the views of these great thinkers more closely one is struck by the fact that they all fall within the confines of a strictly defined framework. Their thoughts are based on a few fundamental pronouncements made in the past by Church councils or great popes. Ecclesiastical rulings were never so weighty as in the Middle Ages, and they influenced not only the thinking of theologians but also the way in which artists treated sacred objects and images. They also shaped the minds of the public for whom those objects were made.

Theoretical discussions about images were almost invariably conducted against the background of the Old Testament commandment, "Thou shalt not bow down to them [graven images]" (Exodus 20,5). Even before the Middle Ages, a general consensus had evolved about the meaning to be attached to these words in the era after Christ's coming. Popes and Church councils had resisted a blind acceptance of the Old Testament prohibition, and had put forward various arguments in favour of making and venerating sacred images. Those pronouncements spawned commentary after commentary, and formed the basis for learned discussions about images. In this historical review those same pronouncements can be used to give a brief idea of the functions that were attributed to images in medieval times.

In one of his many letters, Pope Gregory the Great (ca. 540–604) justified the use of images by citing the necessity of employing visual means to explain the faith to those who could not read. Images, he said, are the books of the unlettered, "for what the Scripture teaches those who read, this same the image shows to those who cannot read but see".[1] This is a classic formulation of the first and, according to many medieval authors, primary function of images. They were a fitting aid for religious instruction.

In Gregory's day, the images that were made for didactic purposes were mainly found in churches. Almost invariably they offered the faithful, most of whom were illiterate, a *historia* to decipher and learn from, such as an episode in the story of salvation, or turning-points and miracles from the lives of saints. In other words, the didactic images took the form of narratives. Generally, several scenes were depicted one beside the other, in the church portals and on the walls and altars. Together they formed a single cohesive, visual story, and for that reason had to be viewed by the church-goers in a set order. Artists and the public were particularly fond of scenes illustrating Christ's work of salvation. These were portrayed in more or less standardised programmes. There were also cycles with the lives of the Virgin and the saints. In the Late Middle Ages one also finds narrative scenes in Books of Hours and prayer-books, and in the so called *biblia pauperum*, the 'bibles of the poor'. These were illustrated books for the poor in spirit, namely the laity, depicting the stories in the Bible, and were used as an aid in religious instruction and sermons.

In addition to their didactic purpose, many images were designed as objects of veneration. Some of them demanded a respectful attitude. They were blessed and thurified, burning candles were placed before them, and worshippers knelt to venerate them. This use of images caused quite a controversy, primarily in the Greek Christendom of eastern Europe, engaging supporters and opponents in heated arguments. Church doctrine on this point was laid down at the Second Nicene Council in 787. This conclave of bishops decided that the crucifix and other images of Christ, as well as depictions of saints, could be displayed and venerated in churches and homes. The Council members gave a famous dogmatic justification for their standpoint, namely that "the honour shown to the image is transferred to the prototype, and whoever honours an image honours the person represented by it".[2]

Although theological in tone, this decree does identify the most important feature that distinguishes a cultic image from a narrative scene. It does not tell a story but depicts a figure. It is an *imago*, a likeness of Christ or a saint. The sacred icons are the supreme cultic image. In the West European Church, the Council's decision initially aroused considerable opposition, particularly from theologians, who considered that it ran counter to the standpoint adopted by Gregory the Great. In time they came to accept the decree, but stressed one aspect of it that has not yet been mentioned.

157

The Council of Nicaea spoke not only of veneration, but of remembrance. Portrait-like images awaken the memory (*memoria*) of Christ, the holy martyrs or confessors they depict. Great emphasis was later placed on this aspect in the west. Medieval theologians explained that images of saints, in particular, served not so much for adoration as for instruction, like the *historiae*. Illustrations of saints could prompt the faithful to recall and imitate the virtues of their venerated predecessors.

Popular piety was certainly influenced but not necessarily governed by the views of theologians. In any event, the veneration of images took on extreme forms at the end of the Middle Ages, in the Latin west as well as in the east, and was condemned by numerous theologians. But it was in vain that they stressed the difference between the saint and his or her image. Religious practice and piety were dominated by a tendency to confuse the image with the reality to which it referred. This is shown very clearly by the pilgrimages to what were known as 'miraculous images', in which the saint was considered to be present just as he was in his grave or in the relics taken from it, to which the faithful addressed their entreaties for a miracle.

The functions discussed above can be summarised in three words: instruction, veneration and remembrance. For the sake of completeness, a fourth should be added at the head of the list, namely adornment. This was the basic function that preceded the other three. All images mentioned in authoritative Church documents served primarily for the embellishment of the house of God. Whether they consisted of individual objects or were incorporated in sacred vessels, the walls of a church or liturgical vestments, images were made primarily for a sacral space, and part of their purpose was to define that space and give it lustre. However, there were exceptions to this rule. Not every image was made to be installed in a church or sacred building. Some were designed to be used by individual believers. They were destined for a private rather than a public setting. This led to a new classification of images. It overlapped the earlier one in that the image made for an individual served equally for instruction, veneration and remembrance.

Very few pronouncements by popes and councils on images for private use predate the Middle Ages. The attention of the Church authorities was firmly fixed on public worship and the practical, public value of images. The private sphere was completely ignored in the early days of Christianity. The only remark of any consequence occurs in a letter inserted in the correspondence of Pope Gregory the Great in the eighth century. The actual date of the letter is not of any great importance; the main point is that it was later invariably attributed to Gregory himself. This could be described as a happy anachronism, for the comments in the letter were very favourable, and in the Middle Ages Gregory was deemed to be the supreme authority on the subject of images.

Gregory's supposed letter was addressed to a hermit called Secundinus, who had asked the pope to send him an image of "Our Saviour". The writer of the letter complied with Secundinus's pious request, and sent him no fewer than three gifts: a crucifix, with which Secundinus could keep the devil at bay, and two small panels, one showing the Saviour and the Mother of God, the other Sts Peter and Paul. The writer had every sympathy for the reason for the hermit's request. His brief discussion is in line with Gregory's well known views on images, but now adapted to the particular case of an individual believer. Just as images serve to instruct the public at large, so they assist Secundinus in his devout

meditation on the mysteries of Salvation. We are eager to have an image of the Saviour to look at daily, the writer explains, because it stimulates the active recollection (*recordatio*) of the Son of God, and this in turn fires us with love (*amor*) for him.[3]

Later in the letter there is mention of more reactions from the heart which can ensue from the act of beholding an image, and its logical consequence, active remembrance. Like the written word (*scriptura*), the writer says, an image (*pictura*) can also help us to achieve recollection (*memoria*) of the Son of God, but we can call Him to mind in different ways: as a new-born babe, as a man undergoing suffering, or enthroned on the right hand of the Father. One's feelings will vary from one case to the next. The author of the letter gives two examples. If we think of the Lord's Resurrection, our heart is filled with joy; if we meditate on His Passion, our heart melts with tenderness. [4]

The theorists of the High Middle Ages used these observations by Pseudo-Gregory as the basis for more wide-ranging reflections. Durandus of Mende (ca. 1230/37–1296), for example, wondered if an image did not, in a sense, have more value than the word. He believed that it did, giving as his reason *"plus movet"* – it stirs the spirit more strongly.[5] Thomas Aquinas felt the same, and singled out various reasons for the introduction of images, saying among other things that they were suitable "for awakening feelings of piety". In his opinion, those feelings were more easily aroused "by seeing images than by hearing words".[6] *"Ad excitandum devotionis affectum"*, to awaken feelings of piety: these words of St Thomas Aquinas could be used to characterize Secundinus's request and Pseudo-Gregory's response. In the correspondence between them it was, after all, a question of devotional images.

IMAGES FOR PRIVATE DEVOTION IN THE MIDDLE AGES

It would be a mistake to regard images for private devotion as a separate genre from the narrative or representative scenes mentioned above. In fact, all sorts of images were used for private devotion in the Middle Ages. The term 'devotional image' is therefore used here in a functional sense, and not as a designation of formal features or visual motifs. It refers to images that played a part in private piety. Within this domain of personal spirituality, images were used to venerate and invoke Christ and His saints, as well as to meditate on the most important mysteries of faith or events from the story of salvation. The private function of devotional images is readily apparent from Secundinus's request. It is significant that his plea reached Pseudo-Gregory from the desert, and that it came from a believer who lived in a part of the world where there were no churches and no liturgical services.

Although little is known about the use of devotional images in the first millennium of the Christian era, they certainly were used, even if only on a limited scale. It was not until the latter half of the Middle Ages that their use was actively encouraged. This was first done on a large scale in monasteries and convents in the thirteenth century, and it spread to the lay world soon afterwards. Those chiefly responsible for this development were the Dominicans and Franciscans, which is hardly surprising given that the mendicants, of all the conventual orders, had the closest ties with the lay community. From their foundation in the early thirteenth century they had deliberately built their friaries in the middle of the towns. In this urban environment they had devoted themselves unstintingly to pastoral care, and in doing so had unexpectedly sated the hunger of many city-dwellers for a personal experience of faith. The mendicant foundations were also a breeding-ground for innovation, and in the course of the thirteenth century they helped shape a new spirituality. It was this experience of faith that provided one of the most important backdrops to the persistent use of devotional images.

An early record of the use of this sort of image by monastics is found in a history of the first Dominicans written around 1260. The author relates that "in their cells they [the friars] had images of her [the Virgin] and her crucified Son before their eyes, so that they could look upon them when reading, praying and sleeping, and could be looked upon by them in

Fig. 72. Anonymous, 15th century, *Eternal wisdom*, Ms. 710, fol. 89r. Einsiedeln, Stiftsbibliothek

Fig. 73. Jean le Tavernier, *Philip the Good at Mass*, 1457, Ms. 9092, fol. 9r. Brussels, Koninklijke Bibliotheek Albert I

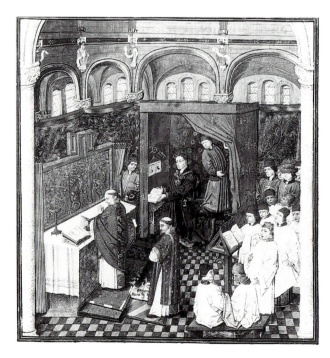

turn, with eyes of compassion".[7] This is very probably a reference to small panel-paintings hanging on the walls of the friars' cells, and contrasts sharply with the rules that had applied in earlier monastic communities. For example, the sixth-century rule of Caesarius of Arles prohibited "the hanging of painted panels", and stated that "paintings may not be displayed in the corridors or cells of the monastery".[8] As the mendicant orders evolved, they came to attach growing importance to images as aids to devotion. This emerges, for example, from the biography of a famous member of the Dominican order, the German mystic Heinrich Seuse, or Suso (ca. 1295–1366). It is said that at Constance, from the very start of his life as a religious, he was in the habit of retiring to a secluded place, a private chapel, where he practised his religiosity "*nach bildreicher Weise*", in other words by looking at images. Also, and again at a very early date, he had an image made on parchment of the "Eternal Wisdom who has Heaven and earth in her power, and who excels all creatures in sweet beauty and form".[9] The biographer reports that Suso later took this depiction with him when he went to Cologne to study at the order's Studium Generale. There he installed it in the window embrasure of his cell, so that he could regularly look at it "with love and desire". And when he returned to Constance a few years later, the parchment was given a permanent place in the same private chapel he had used previously.

One would naturally like to know what sort of image it was that so fascinated Suso. It would be wrong to think of it as an abstract or schematic figure. Suso conceived of "Eternal Wisdom" as a person. On the one hand he regarded it as his bride, for whom he carried out courtly tasks in the manner of the troubadours, but at the same time he equated it with Christ. We do not know the precise appearance of this "Eternal Wisdom" that accompanied him everywhere, but some of the manuscripts of his works are illuminated with miniatures which are believed to be based on the mystic's own instructions. Some of the miniatures depict the "Eternal Wisdom", and in every case it is the well known image of Christ as *Salvator mundi* (fig. 72).

As already noted, the practice of gazing on devotional images in private followed by the new religious was soon being imitated in the outside world. Take, for example, a passage in a work on the miracles of St Francis, which must have been written in the mid-thirteenth century. It mentions an unusual custom which had become all the rage in Rome.

Pious noblewomen began fitting out a room in their palaces as "quarters where one can pray well". They also installed a portrait of the saint for whom they had a special veneration. This particular case concerned a woman who had chosen St Francis to intercede for her in Heaven, and had a painted representation of him in her private chapel. The author relates that she often retired to her "secluded room" to invoke St Francis "in silence".[10]

The members of the laity who could afford the luxury of a private chapel were usually kings, princes and other rulers. When they went on a journey, all the chapel furnishings were packed up and taken with them, to be installed in a room temporarily set aside for the purpose. In a mid-fifteenth-century miniature preserved in Brussels (*fig. 73*), Duke Philip the Good of Burgundy is shown in a tent which has been specially erected for him beside the high altar in a church, where Mass is being celebrated. There is a choir to add lustre to the service, which is also being attended by ordinary church-goers. The duke is not following the service very closely, but is employing it more as an opportunity to immerse himself in a Book of Hours or prayer-book that has been set before him. He is also using another well known attribute of private devotion, the prie-dieu. His has been placed in such a way that he can look not only at the altar but also at a diptych hanging on the wall of the tent. This shows the Madonna on the left, and on the right a kneeling figure, probably the duke himself in an ideal pose.

The miniaturist has here united the two worlds of private devotion and Church liturgy. The public liturgy also has a number of standard properties, some of which are shown in the miniature. There is the missal on the altar, with liturgical directions for the priest, the antiphonary or hymnal for the choir, and of course the altarpiece, which the congregation could look at during the service. This particular one is a triptych with scenes from the Passion: the Carrying of the Cross, the Crucifixion and the Descent from the Cross.

PRIVATE PRAYER AND THE INDIVIDUAL EXPERIENCE OF FAITH

The use of devotional images presupposes an individual experience of faith. This manifested itself first and foremost in monasteries and convents, whence it found its way to the lay world due to active propaganda on the part of conventuals. The development of a private religiosity in the monastic foundations was closely related to the structure of the life of prayer they practised. In addition to the *opus dei*, which comprised both the communal choral prayer and the celebration of the Eucharist, monks and nuns had immersed themselves in private prayer from time immemorial. It was subject to various rules, and had been given a great deal of thought. Its theory began to take shape in the early days of the Church, and reached its first pinnacle with two Cistercian writers, Bernard of Clairvaux (1090–1153) and William of St-Thierry (ca. 1085-ca. 1148/49). They placed individual prayer and the associated practice of meditation in a broader context, which was governed by the personal striving for perfection.

The tracts of both authors have a mystical slant, and describe the ascent of the individual believer to God. A metaphor they preferred even more was that of the return, of the road to be travelled by the soul before it is reunited with its Creator. The distance to this Origin is determined by sin. The individual who wishes to strive for perfection must practise self-denial and prayer in order to rise above the daily reality to which he is so inordinately attached. This will restore the soul's original resemblance to God, so that it can be united with him. A feature of the theology of the great Cistercians is its shift to the subjective experience of faith. Great emphasis is placed on 'innerness', and on the existential experience of the divine that takes place there. In many cases that experience takes the form of a dialogue between the individual soul and its Creator.

The mystic tradition that began with the Cistercians continued in the thirteenth century with the mendicant orders, changing its character in the process. The main influence was St Francis, who wrote no mystical works himself but whose life itself indicated a new way forward. The special feature of the mysticism practised by Francis was that it included service to one's fellow men. Whereas the followers of St Bernard withdrew into the solitude of their abbeys in order to shield their eyes from the glittering delights of the world, St Francis wished to remain in that

world for the benefit of his fellow creatures. This intention is very clearly expressed in *The Spiritual Marriage of St Francis with Dame Poverty*. In this book, Dame Poverty asks the brothers where their monastery is, whereupon "the brethren took her to a hilltop and showed her all the world that could be seen from there, saying: 'This, mistress, is our monastery'".[11]

The service to one's fellow man that St Francis exemplified by his life was given shape by the mendicant orders as an active apostolate among the laity. This brought about a great change in the position which that group had occupied in the Church up until then. In the first half of the Middle Ages the laity played hardly any rôle in the life of the Church. The illiterate faithful were overshadowed by the clergy. Nor did they play a very active part in the ecclesiastical life of prayer. Praying was a task for priests and monks, which they carried out on behalf of the laity in exchange for generous alms-giving. In the second half of the Middle Ages, the relationship between clergy and laity changed and again it was due chiefly to the mendicants. They devised two important ways of bringing faith to the masses: the sermon and the theatre. The sermons were delivered in the vernacular, and the friars used all sorts of techniques, such as gestures, fictitious dialogues and exclamations, to initiate the faithful in the mysteries of faith. The theatre accompanied the sermon, and evolved from the liturgy. At first it consisted of para-liturgical plays performed at Christmas, Easter and Whitsun which enabled the faithful to visualise the mysteries associated with those feasts.

Lay people were also taught how to pray. This was done primarily in the tertiary orders and confraternities, two new types of organization which were also invented by the mendicants. Both were communities of lay people who undertook to carry out the ideals of the Franciscans and Dominicans in the outside world. Tertiaries were governed by the rule of the order to which they were attached, and their task was to embody its essence in their way of life. In many cases, new rules were drawn up for them that included several periods of prayer which they were required to observe each day. In the Late Middle Ages, in addition to numerous tertiaries, every town had one or more confraternities. These were created for the special veneration of a saint, or of the Holy Sacrament – the body and blood of Christ. One of their tasks was to strengthen the faith of their members. Many para-liturgical forms of prayer became

popular in these communities, a good example being the Italian *laudi*, which were initially canons in praise of Christ, the Virgin Mary and the saints. As time passed these developed into fully fledged theatrical performances, in which the brothers played out the birth and sufferings of Our Lord as moving statues.

In a learning process that lasted for centuries, ordinary believers were trained in spiritual values that had evolved in the claustral world of the monastics. Two activities deserve special mention: personal prayer and meditation. It was by no means self-evident that large numbers of lay people should have taken up these exercises. All that had been asked of the laity in the early Middle Ages was that they learn the Twelve Articles of Faith and the Our Father by heart. The Hail Mary was later added. Church reformers often argued, unsuccessfully, that this minimum of compulsory prayers should be increased. Alcuin (ca. 735–804), an English scholar at the court of Charlemagne, suggested in one of his letters to the emperor that the laity, like conventuals, should be obliged to say a prayer out loud seven times a week.[12] He was thinking, in other words, of a lay breviary, of a kind that was introduced only in the Late Middle Ages.

From around 1300, the Book of Hours gradually came into vogue in royal and aristocratic circles, and among the urban patriciate. This was a lay prayer-book, the text of which followed the canonical hours of the day. The services and personal prayers it contained were usually illuminated with miniatures, which were all the more important in that the user usually only half understood the words of the prayers, most of which were in Latin. It was partly due to these illustrations that the prayer of the pious layman could develop into meditation. The Book of Hours was therefore usually read in the peace and quiet of a private chapel or the inner chamber of a patrician's house. In order to aid concentration, use was made of a prie-dieu, installed in such a separate room. This small pew became one of the leading aids for the private devotions of high-ranking laymen.

In addition to illuminated prayer-books, the private quarters of a nobleman's castle or a prominent citizen's house were often adorned with small paintings or diptychs. Many of these art-works would also accompany the owner on his travels. They were made in such a way that the owner could put them on display wherever he was – hang them on a wall, or even wear them around his neck. A good example of a

devotional image worn as a body ornament is a pendant in the form of a minuscule triptych, the shutters of which could be opened and closed (*fig. 74*). The central panel depicted Christ as the Man of Sorrows, with two angels placing the crown of thorns on his head (compare also PLATE 38).

As the demand for devotional images grew, so their production was simplified. The first stage in this process can be illustrated by the well known discovery in 1957 of some hundred fifteenth- and sixteenth-century images in the convent of Wienhausen near Celle. They were found beneath the floor of the choir, and consisted mainly of small pieces of parchment cut from larger sheets and then pasted on to wooden tablets. A piece of string or cord passed through a hole made in the top of the tablet enabled it to be hung on the wall (*fig. 75*). Eventually the people producing this kind of representation began using various ingenious techniques for duplication, such as the woodcut and the copper engraving. Finally, after the introduction of book printing, loose-leaf devotional prints and prayer-cards were made, which could be inserted anywhere in a missal or prayer-book.

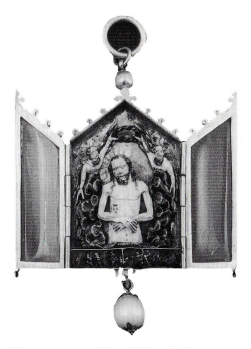

Fig. 74. Anonymous, Paris, ca. 1400, pendant, gold and rock crystal. Munich, Schatzkammer der Residenz

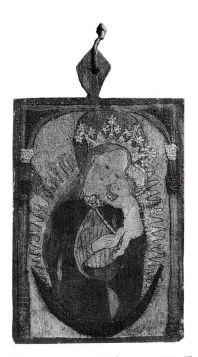

Fig. 75. Anonymous, Wienhausen, ca. 1500, *The Glorification of the Virgin*, parchment on wood. Wienhausen near Celle, convent

THE VENERATION OF CHRIST AS MAN

The prayer and meditation in which lay people were trained
by the mendicants were directed not only towards saints, but
above all towards Christ. It should be realised, however, that
the way in which the Saviour was presented to the people
differed markedly from the image of Christ that had taken
root in the early Middle Ages. In religious life and art it was
always Christ's divine nature that had been stressed. He was
seen as the ruler whose authority extended throughout the
entire cosmos, or the judge who would appear in glory on
the Last Day to pass His verdict on the living and the dead.
The Redeemer's human nature was by no means disavowed,
but it was not an immediate object of veneration. It was only
in the later Middle Ages that Christ's image was transformed,
reflecting a general change in the experience of faith. The
twelfth-century mystical theologians, led by Bernard of
Clairvaux, are considered to have laid the foundations for this
new development. At the beginning of the thirteenth
century, Francis of Assisi gave it a fresh impulse, and it was
then rephrased in a classic manner within the Franciscan order
by Johannes Bonaventure.

For St Bernard it was not so much God's omnipotence that
was revealed in Christ as his goodness. God has turned to us
in Christ, and has assumed our nature in order to win us for
Himself. The visible God made man shows us the way to the
invisible God. This line of reasoning gave the mystery of the
divine Incarnation a central rôle in the mystical theology of
Bernard of Clairvaux and William of St-Thierry. Taking their
cue from the Song of Songs, both Cistercians describe the
soul's mystical union with God in terms of a "spiritual
marriage", in which Christ is the bridegroom and the soul
giving itself to Him in love is the bride.

Under the influence of St Bernard and like-minded spirits, the
human nature of the Lord became more and more the focus
of the experience of faith. His life on earth became the
principal object of pious meditation. For the first time in the
history of spirituality, Christ was now also accorded an
anima, a human soul, the stirrings of which were accessible to
the faithful. At around the time St Bernard was writing his
mystical tracts, Christian armies recaptured large areas of the
Holy Land. This removed the places where Jesus had lived
from the realm of fantasy. The Crusades helped arouse
interest in the finer details of Christ's life, and it was not long
before these were being explored in manuals on meditation,

and being recommended for pious contemplation. A classic
example of such a manual is the *Meditationes Vitae Christi* (see
also p. 12f). Its author is unknown, but contemporaries
attributed the work to St Bonaventure. This book, which
dates from the last quarter of the thirteenth century, sheds a
revealing light on the new way of experiencing faith.

The author, let us call him Pseudo-Bonaventure, opens with a
prologue in which he marks out a path and unfolds a
programme for all those seeking to attain Christian
perfection. He explains that the basis and beginning of all
perfection consists in contemplating the life of Jesus. Pious
meditation on that life must be constantly repeated, and
carried out in accordance with a specific system, namely the
one he himself demonstrates in his manual. After a while, he
explains, the person of Christ will draw near to us. A
familiarity grows up between him and us, a bond (*confidentia*)
is created, and we become inflamed with love (*amor*).[13]

It is argued later in the prologue that the love that flows
from meditation automatically changes into a desire to
imitate Christ's way of life. *Meditatio*, in other words, leads to
imitatio. The author illustrates this transition with the life of
St Francis, and evokes the image of it as follows: "Do you
believe that the Blessed Francis would have attained such
abundance of virtue . . . if not by familiar conversation and
contemplation of his Lord Jesus? With such ardour did he
change himself that he became almost His image."[14] Here
Pseudo-Bonaventure was referring to the miraculous
stigmatization that took place at the end of St Francis's life,
during his solitary sojourn on Mount Alverna. Christ
appeared to the saint in the form of a crucified seraph, and
impressed on Francis's body the five wounds He had received
on the cross. For Pseudo-Bonaventure, this miracle was a
logical extension of the meditation and imitation that Francis
had practised all his life. In his eyes, it completed the
identification of the saint with his model, for it brought about
Francis's transformation into the one he loved.[15]

MEDITATION AND IMAGINATION

The *Meditationes Vitae Christi* greatly influenced the style and manner of Late Medieval meditation. Its most prominent feature is the constant appeal it makes to the imagination. Pseudo-Bonaventure had referred in his prologue to the importance of employing one's senses and fantasy when contemplating Jesus's life. He urges the reader to call the various stages of that life to mind as tangibly as possible. The believer must make himself a witness, with his ears as well as his eyes, and act as if he himself is present at all the narrative events. [16] The *Meditationes* can help in this by graphically recapitulating what happened and what was said. The author takes the reader by the hand and leads him from one event to the next, describing in his own words what took place, inviting the reader each time to act as an involved spectator by absorbing what is said and done.

This method automatically leads to both considerable abridgements and expansions of the Gospel story. The author was aware of this, for he explains that there are things in the Gospels which do not lend themselves to vivid meditation. Conversely, not all the elements of Jesus's life which are open to meditation are literally recorded in the New Testament. "In order to make them more vivid", he will tell them in fact "as they might have occurred". [17] The result is a richly tapestried biography of Christ in which the plain story related in the Gospels is embroidered with numerous "scenes taken from the imagination". [18]

It is the last part of the *Meditationes*, a continuous evocation of the Passion and death of Christ, that made the greatest impact on contemporaries and later generations. In order to bring the reader as close to the drama as possible, the author employed the literary device of describing Jesus's last days as seen through the eyes of the Virgin Mary, Mary Magdalene and John, his most beloved disciple. The indignation and despair of this involved group of onlookers are dealt with at such length as to make it appear that they are the central focus of the story. The narration of the events is constantly interrupted by long monologues or dialogues in which these bystanders give vent to their feelings. The author magnifies them and their emotions in order to awaken similar feelings in the reader, in whom he wants to engender the greatest possible immersion in Our Lord's sufferings.

One wonders, finally, why Pseudo-Bonaventure found it so important to advocate such an extreme concentration of the senses and the mind on Christ's suffering. He himself supplies no answer, but it emerges from later tracts based on the *Meditationes* that the affective contemplation of the Passion is the best way for the individual believer to bring the salvation that Christ wrought for all mankind within his reach. The northern Netherlandish writer Gerard Zerbold of Zutphen (1367–1398), for instance, later expressed himself in this sense. He explains in one of his tracts that, while meditating, we should relate the Passion to ourselves. "For He suffered for your personal redemption. Therefore apply all that you read of Christ's doings to yourself, as if they were done for you alone, and always imagine that Christ is saying to you: 'I did this that you might follow Me'." [19]

The *Meditationes Vitae Christi* spread rapidly throughout Europe, and was translated into almost every language spoken there. Not surprisingly, the various editions were also illuminated. With its constant appeal to the senses, it spontaneously invites a pictorial depiction of the matters it discusses. In addition, it inspired many artists to retell in visual form the mysteries of Christ's life in small-format, autonomous series for use in private devotion.

In the world of medieval mysticism, *meditatio* and the related practice of prayer were consistently described in the broader context of the soul's ascent to God. One could say that they were regarded as stages on the road to salvation laid down for the individual, as rungs on a ladder which he climbs, ascending to the pinnacle of *contemplatio*, the pure contemplation of God. All kinds of theoretical discussions on meditation and prayer invariably raise the question of the function served by images, in the sense of scenes conjured up before the mind's eye. They were considered indispensable aids to prayer and meditation, and were put on a par with words. Only on the highest rung of the 'ladder to Paradise', at the moment when one beheld the face of God, was it possible to transcend the boundaries of sensory existence. Only then was the knowledge of God stripped of both word and image.

Back in the twelfth century, Bernard of Clairvaux's friend and fellow Cistercian, William of St-Thierry, had evolved such a theory, explaining that during private prayer and meditation those who were still on a low rung of perfection "must make a [firm] image of the humanity of Our Lord, of His birth, His Passion and His Resurrection".[20] This authority also believed that even those who had climbed a long way up the ladder to Paradise, or 'monks' ladder', still had to pray in the prescribed manner now and then. His explanation was that it was impossible in the sublunary world entirely to transcend sensory perception, and to think of Christ "fully in accordance with His divinity".[21]

From the middle of the thirteenth century there was a remarkable upsurge of mystical piety. In the words of André Vauchez, there was a complete "invasion of mysticism" in piety and thought throughout Europe around this time. In some circles it had an intellectual and speculative character, but others glorified feelings and experience. Leading representatives of the first current were Meister Eckhart (ca. 1260–1328) and Johannes Tauler (ca. 1300–1361) in the Rhineland, and Jan van Ruusbroec (1293–1381) in the Netherlands. It is the second movement, based on an experience of faith inflected by the senses and the heart, that concerns us here. Remarkably enough, this was professed mainly by pious women. At first this tendency is found chiefly in Italy, with Margaret of Cortona (1249–1297), Clare of Montefalco (died 1308) and Angela of Foligno (1248–

1309). In the course of the fourteenth century the movement spread throughout Europe, where the mystical experience was glorified in German and Swiss Dominican nunneries, and by great saints like Bridget of Sweden (1303–1373), Catharine of Siena (1347?–1380), Dorothy of Montau (1347–1394) and the anchoress Julian (or Juliana) of Norwich (died ca. 1416/20). One common thread uniting all these women is that their meditation was never a question of contemplation without images. Quite the reverse, it led to visions and transports of ecstasy in which those venerated in the images manifested themselves in apparitions.

The conceptual universe of fourteenth-century German Dominican nuns is known to us from local chronicles of convent life and biographies. A great deal of information is also contained in the revelations vouchsafed to many of the nuns, which were later written down. All these sources teem with stories about the gift of tears with which some of the sisters were blessed, and there are reports of them hearing voices, even levitating. Above all, though, they tell of the visions granted them at night in their dreams, or in the daytime while praying before images.

The biographies of the sisters of the Töss convent near Winterthur tells of an image of Christ, referred to as an "*Antlut*" (countenance), which hung by the entrance to the convent chapter. Sister Anna was in the habit of praying before this image whenever she saw it. She repeated the prayer attached to it, which began with the words "*Salve summe deitatis*" (Hail, God most high). When she came to the line "*Te saluto milies*" (I greet You a thousand times) she would make a deep bow and speak with the deepest conviction. One day, the story goes, the image began to speak to her while she was reciting this passage ("*Da redete das Antlitz unseres Herren mit ihr*"), and showered her with comforting words. [22]

Margaretha Ebner (ca. 1291–1351), who lived in the Medingen convent near Dillingen, recorded in her *Revelations* that one night she was blessed with a vision of the Christ Child. She saw Him playing in the crib, merry and boisterous. When she asked why she had been woken she was told, "I do not want to let you sleep, you must take Me unto you".[23] Margaretha took the Child on her lap, whereupon He embraced her and began to kiss her. This episode can only be seen in its proper light when we learn that Margaretha had

"a crib with a Christ Child" (see PLATE 30, p. 103). That devotional image, which is mentioned twice in her correspondence, was given to her by her friend and confessor, Heinrich of Nördlingen (died ca. 1356).

The English mystic Dame Julian of Norwich received sixteen revelations in her thirty-first year, which she later noted down in her *Book of Showings*. Most of them centred around the "bodily sight" of the suffering Christ. In her youth, Julian had prayed that one day she, too, would be granted such an experience. At the time, incidentally, she had also begged for another gift from Heaven, namely "bodily sickness". This second request was associated with and based on a desire to participate physically in Christ's Passion. In fact, Julian had forgotten her two youthful wishes when she fell ill at the age of thirty-one, so ill that she was given the Last Sacrament. But at the very moment when the priest held up a crucifix to her, the mortal danger passed. There was a spontaneous cure, accompanied by a lengthy period of ecstasy. In five successive hours she received fifteen of the sixteen 'showings'. According to eye-witnesses, her gaze was fastened throughout on the crucifix that the priest had brought with him. Julian now experienced a "bodily sight" (*visio corporalis*) of the suffering Christ, which she later described in her revelations. The text consists of a string of realistic images in which the separate episodes of the Passion, such as the Crowning with Thorns, the Flagellation and the Death on the Cross, are described in minute detail. In her eighth revelation we are presented with the face of the Man of Sorrows: "I saw the swete face as it were drye and blodeles with pale dyeng and deede pale [pale dying and dead pale], langhuryng and than turned more deede in to blew, and after in browne blew, as the flessch turned more dede. For his passion shewde me most propyrly in his blessyd face, and namely in hys lyppes. Therin saw I these iiij colours."[24]

One final example will illustrate the importance that mystics attached to the imagination and images. It concerns the stigmatization of St Francis (see PLATE 19), or rather the imitation to which this extreme form of mystical union gave rise among visionary saints in Italy. The idea that a human being can identify physically with Christ increasingly took hold a century after St Francis's death. What is so striking about it is the importance of images in contemporary reports of such cases. For example, it is said of Clare of Montefalco and Angela of Foligno that they more than once experienced the feeling of being nailed to the cross with Christ, and that this usually happened while they were immersed in spiritual exercises before an image of the Cross. One eyewitness says that Clare of Montefalco eventually felt that "she bore a Cross in her heart".[25] The same source relates that her fellow nuns accordingly opened her body after her death, and found there the 'arms' of Our Lord's Passion: the cross, the crown of thorns and the sponge with vinegar.

These two mystics were evidently intent on self-sanctification through contemplation, which should ideally lead to physical identification with Christ. Here the image served as a medium or instrumental cause: it mediated the desired mystical union. This connection is graphically depicted in an altarpiece by Andrea di Bartolo showing St Catherine of Siena and four other female Dominicans in a colonnade. On the predella the saint is seen in four attitudes of prayer, marking the successive stages of her stigmatization. The tension mounts from the outer scenes towards the centre, with Catherine's initial contemplation unattended by images developing to a sight of the crucifix on the altar which finally, in the central scene, comes alive and impresses the marks of the wounds on her body (see *fig. 76*).

Fig. 76. Andrea di Bartolo (active 1389–1428),
St Catherine of Siena praying, ca. 1393–94,
predella panel. Venice, Gallerie dell'Accademia

MODERN DEVOTION (THE BROTHERS OF THE COMMON LIFE)

The mystical tradition enjoyed its greatest flowering in the fourteenth century, and then gradually lost its force. The copious literature to which it gave rise was admittedly passed on to subsequent generations, but by then there was a different attitude to religion. In the last hundred years of the Middle Ages, asceticism prevailed over mysticism. The transition can be observed very clearly in the religious revival of which the foundations were laid by the Dutchman Geert Grote (1340–1384), but which came to its full fruition only in the fifteenth century as the 'devotio moderna'. Geert Grote had two main objectives. In the first place he attacked the moral decay he observed among the clergy – conventuals as well as priests. He called on them to stop flouting their vows of celibacy and poverty, and to observe them by leading a strict, ascetic life. Secondly, Grote was greatly concerned about ordinary believers, and devoted himself to an active apostolate among them.

His first ideal, the reform of the clergy, inspired Grote's followers to set up new communities with the twin objectives of self-purification and the apostolate, involving the care of souls and preaching. The members of these communities became known as the brethren of the Common Life, or Devotionalists. A third institution soon sprang from the fraternities and sororities they founded, the convents of 'Modern Devotion'. For many of the spiritual followers of Geert Grote, a period spent with the brothers or sisters was merely a preliminary to a full monastic life. By taking that step they exchanged evangelism for life-long, binding promises. The first monastery founded by the movement was at Windesheim near Zwolle, and before long it was drawing devotees in large numbers. It became the focus of a whole network of monasteries known as the Windesheim congregation. All the convents joining this association vowed to follow the original rule in the same, very strict manner.

Grote's second ideal was pastoral. His life was dominated by a drive for apostolicism. His interest in the spiritual welfare of the ordinary layman resulted among other things in the translation from the Latin of important writings of the past. Apart from mystical works, these were mainly prayers for the daily use of priests and monastics, the so called 'hours'. It was due to Geert Grote that the Book of Hours became one of the most popular books in the Low Countries in the course of the fifteenth century. His translation of the Hours spread beyond the circle of the Devotionalists, becoming one of the favourite books of Dutch townspeople. The followers of the great master continued this practice, and translated more and more Latin literature into the vernacular, mainly prayer-books and meditational tracts. And no less important, these writings were copied and illuminated in the fraternities.

Copying was indeed one of the brothers' main activities, alongside prayer and meditation. It was regarded not only as an important form of asceticism, but also served a manifold practical purpose. In the first place, it met the movement's own need for liturgical texts and books for prayer and meditation. Secondly, it enriched the libraries which the brothers had set up in all their foundations, primarily to assist them in their teaching of local schoolchildren, but also for the use of ordinary people. Finally, copying helped support the brothers and the students lodging with them, for the production of books was partly commissioned by outsiders, and as such was a source of income.

In order to meet the growing demand for books, most of the fraternities had a scriptorium, as did the monasteries. The manuscripts were usually executed in a restrained, sober style, but decoration could be added if the customer wished. The illumination was done either by the Devotionalists themselves or was contracted out to professional miniaturists. The fact that the brethren of the Common Life not only copied but also illuminated writings to be used for private devotion raises the question of the rôle they accorded religious images in their spiritual life.

An important place was reserved for personal prayer and meditation in the daily routine of the brothers, sisters and conventuals. Remarkably enough, in the early years of the movement there were no lengthy contemplative exercises governed by a fixed programme or method. Meditation took the form of brief moments of reflection, preferably at the beginning and end of each day. The guide was generally a *rapiarium* – an individual's own anthology of favourite quotations and excerpts for reading. There was also a vogue for written meditations by mystics of the past and by the movement's own spiritual leaders. The latter included the edifying tracts of Thomas à Kempis (1379/80–1471), which are known under the collective title *On the Imitation of Christ*.

In one passage, Thomas à Kempis urges his readers always to summon up an "image" of Christ in their souls, and not just at set times of the day. They must identify with him to such an extent that "they can no longer avert the eyes of their spirit from this image".[26] As in the case of the fourteenth-century Dominican nunneries in Germany, collections of biographies have survived documenting the various fraternities and sororities, and they tell how some members of the communities put Thomas à Kempis's injunction into practice. It is said of one sister in Deventer that whenever she crossed the courtyard of the Meester Geerts House, or went anywhere else, she did so devoutly and introspectively, "as if Our Lord had gone before her, carrying His cross".[27] And according to his brethren, Johannes Kessel, the cook of the Florens House in Deventer, "always had the life of Our Lord and His holy Passion ... in his heart", such that he was often found in a very odd pose at his work, "kneeling down, stirring the pot and saying his prayers".[28]

When meditation was practised with the aid of a text, the Devotionalists could of course rely on their own powers of imagination. As an aid they would then use the illustrations in their meditation books. The rôle they attached to imagination and the image can be illustrated by a woodcut with an inscription in an early edition of the *Imitation of Christ*. It is on the title-page, and shows Christ the Saviour, with the handwritten inscription *"Ansien doet gedencken"* (The act of beholding stimulates thought) (*fig. 77*). In other words, the soul reflects on what the eye sees. The purpose of the "thought" or meditation is indicated by a quotation from the Gospel of St John, which is given to the left of Christ in Latin and to the right in Middle Dutch: *"Die mi navolcht, en wandert niet in duysternisse"* (He that followeth Me shall not walk in darkness; John 8,12). The print as a whole depicts the entire spirituality of the brethren of the Common Life much like an emblem. The purpose of life on earth is to imitate Christ by renouncing the world and practising virtue. In order to achieve this it is necessary to consider Christ's life in one's soul – a life marked by self-denial and suffering. This loving remembrance rests in turn on 'the act of beholding', in the dual sense of looking and imagining – using one's eyes and observing with the eyes of the soul.

Thomas à Kempis also wrote many prayers, one of which is addressed to Christ's limbs. Graphic prayers are said first to the feet, then to the legs, whence the eyes of the soul are raised to the loins, the side and the Lord's back. By way of

Fig. 77. Anonymous, *Christ as Salvator Mundi*, woodcut on the title-page of Thomas à Kempis's *Over de Navolging van Christus*, Antwerp 1505, BMH pi30, f. 4r. Utrecht, Rijksmuseum Het Catharijneconvent

the hands, neck, mouth, face, ears and eyes one finally ascends to the head. All the parts of the body are kissed in one's thoughts, and applied to one's own life. At the feet, for example, the believer asks for forgiveness of "my misdeeds, by commission or omission". The individual supplications close with a Hail Mary.[29] There can be no doubt that when he wrote this prayer Thomas à Kempis was basing himself on a visual image, and wanted his readers to summon up a similar one. What he describes while praying is a crucified Christ, for he writes of feet "both pierced by the hammering of a nail", of hands "wide outstretched" and "pierced with coarse iron nails". The prayer as a whole recalls Geert Grote instructing his followers, "for ever to reflect on the Passion of Christ, and thus construct Christ's cross [anew]".[30] It is as if Thomas à Kempis, in his prayer, is erecting the Cross for us again. To put it another way, he gradually builds up an image of the crucified Christ in words.

CREATING IMAGES IN THE MIND

The Modern Devotion in the Netherlands was contemporaneous with other reformist movements elsewhere in Europe. From the last quarter of the fourteenth century, almost all the monastic orders embarked on a common endeavour which can be summarised as 'observance'. The goal of all monastic reformers was the conscientious observance of a rule. The mendicants, in particular, had gone into a drastic decline in the course of the fourteenth century. The supporters of the observance ideal analysed the reasons for this, and tried to reverse it. Here and there their work to restore monastic discipline was successful, and in those cases the friars regained the esteem in which they had been held by the laity in the early years of their existence.

Before long, broad sectors of the population were adopting the new forms of spirituality that the conventuals had developed in their process of self-reform. Well known examples of this are the rosary and the veneration of the Holy Name of Jesus. The former consisted of the multiple repetition of the Hail Mary while meditating on Christ's life, death and resurrection. This para-liturgical link between prayer and meditation arose in the fifteenth century in monastic circles and was then propagated among the laity by the friars, partly through the foundation of confraternities of the rosary. The prime mover behind the second practice, devotion to the Name of Jesus, was the preacher and monastic reformer, Bernardino of Siena (1380–1444), who visited all the cities of northern and central Italy, tirelessly serving as a missionary to the common people. Wherever he preached he displayed a panel in a prominent position bearing the letters IHS in gold, surrounded by the rays of the sun. By this means he propagated a piety directed towards Christ (see also *fig. 16* on p. 60).

New forms of prayer also began appearing in several Dominican tertiary nunneries in Alsace, in the south-west corner of the Holy Roman Empire. These were the same convents where a hundred years before, at the beginning of the fourteenth century, experiential mysticism had flourished. This predisposition towards a mystical piety had not lasted very long, and the convents soon evolved into houses caring for women from noble families and the urban patriciate. Their readiness to adapt had contributed to a slackening of conventual discipline, and even to outright abuses. At the end of the fourteenth century, though, a number of these

convents took up the observance ideal, chief among them Unterlinden in Colmar and St Nikolaus in Undis and St Agnes in Strasbourg. These and some other houses in Alsace introduced stringent reforms. As a result, the Dominican tertiaries in this region took on a second lease of life essentially different from that of a century earlier, but no less influential for all that.

The spirituality of these reformed Dominican nuns displays many parallels with that of the brethren of the Common Life. One shared feature was a deep attachment to para-liturgical spiritual exercises, although these were far more exuberant among the nuns. Moreover, many of the prayers were not strictly personal but communal, and were recited by the whole community. Finally, the sisters set great store by the multiple repetition of Our Fathers and Hail Marys. These two prayers formed the basis for almost all the exercises, but their repetition was considered to have a symbolic significance.

This repetition of set prayers can best be explained in the light of the legend of 'the monk and the rosary', which became extremely popular in the fifteenth century, and was used to explain the origin of the rosary. It tells of a youth who was in the habit of weaving a garland of roses for the Virgin Mary, with which he then adorned her image. When he entered a monastery he realised that he would be unable to continue this chivalrous service, whereupon an old monk advised him to say fifty Hail Marys each day to replace the floral tribute. The legend relates how the Virgin appeared to the young monk while he was praying, and at every Hail Mary plucked a rose from his mouth and wove the flowers into a garland herself.[31]

The story draws much of its point from the young man's practice of garlanding an image of the Virgin. The custom of decorating and dressing images was unknown in the early Church, but had become accepted practice in the Middle Ages. It was associated with the idea that an image not only represented the person of the saint, but in a sense was that person. The legend of the monk and the rosary documents a further stage in the development of this realistic attitude towards images. The garlanding of saints is now suddenly carried out in and through the act of prayer. The roses of the legend were in no sense a metaphor or symbol. It was more a question of the monk's Hail Marys materialising in heaven, where they were turned into a garland for the Virgin.

As recently demonstrated by Thomas Lentes, the exercises introduced by the Dominican nuns of Alsace represent an even later evolutionary stage of the use of images. One of them involved a garland made for St Barbara.[32] It consisted of flowers of different varieties and colours which had to be paid for with prayers. A periwinkle cost thirty Our Fathers, a daisy a hundred Hail Marys, and so on. The garland woven from prayers has several layers of symbolic meaning. The individual flowers can be related to various virtues practised by St Barbara that are worthy of imitation. The prayers, recited in a prescribed rhythm, feed the imagination and help those saying them to summon up the saint's virtues and deeds before the mind's eye. The nun evokes them one by one, or preferably visualises them as images, and combines those images together in a colourful bouquet, a still life of a garland of flowers.

The function of this and similar exercises was twofold. First and foremost they assisted in self-purification. The sisters recalled the meritorious actions of the saints in order to follow their example. The imagination, in other words, like the 'beholding' of the brethren of the Common Life, had to lead to *imitatio*, in this case of the saints. Secondly, with the aid of their floral garlands the nuns hoped to obtain the assistance and intercession of the saints. In return for her garland, St Barbara was expected to intercede when the nun appeared before God's judgment seat. In one of the prayers, for instance, she was implored to hold out the garland to the nun at that crucial moment, thus shielding her sins from God's countenance. Another speaks of the sweet scent of the flowers with which Barbara, at the appointed time, must drive away the stench of the sins which the nun has committed.

As already mentioned, the entire community was involved in some of these prayers – an unusual practice which can be illustrated by one example. In the convent of St Nikolaus in Undis in Strasbourg, a prayer was said that centred around the Virgin, as did the rosary. Here, however, the first among all the saints was clad not with a floral garland but with her own cloak. This exercise has to be seen in the light of the widespread veneration of the Virgin's cloak at the time. It originated in the thirteenth century, when the Latin west, as a result of the Crusades, had learned of the existence of a mantle relic that was preserved in Byzantium. Hence there evolved an autonomous iconographic image which was depicted on such objects as the banners of confraternities and in the chapels where they gathered (*fig. 78*), and is known as

Fig. 78. Anonymous, Bamberg, ca. 1500, *The Madonna della Misericordia in a rosary*, woodcut. Bamberg, Staatsbibliothek

the Madonna della Misericordia. The Virgin was shown with her cloak spread wide open, beneath which the confraternity or the whole of Christendom could seek protection. The texts of prayers were often inscribed on such scenes. They referred to the Virgin's cloak, and in many cases the authors also intended them to be recited before images of the Madonna della Misericordia. One prayer of supplication that became very well known opens with the words "*Sub tuum praesidium confugimus*" (We fly to your protection).

The Virgin's cloak, like her garland of flowers, could also be made from the prayers of those venerating her. Exercises began to circulate in the Late Middle Ages defining precisely how many Hail Marys the cloak cost. This custom was based on the idea that the protective force emanating from the Virgin's cloak was sustained, in part, by the prayers of the faithful. The Dominican nuns of St Nikolaus in Undis interpreted this custom in a particular way. They developed an exercise in which the cloak was made by all of them together. The order of service for the dead laid down the exact details of their communal prayer. It was to be recited whenever a member of the community died, and oddly enough it related not to the dead nun but to the next one to die. With a view to her death the sisters had to say a specific number of prayers, namely 90,000 Hail Marys. The order of service has the following to say about this prescribed number of prayers. "This is the cloak of the worthy Mother of God,

171

for the first sister who shall come to die. May Mary protect her beneath her maternal cloak from all her enemies when her life ends. The Hail Marys must be divided among the sisters."[33] A record in the convent archives shows that this was strictly observed. It was made on the death of one of the sacristans, and lists the division of all the prayers to be said.[34] There were 26 nuns in the convent at the time, which provided the divisor for the prayers needed to weave the Virgin's cloak.

What the above examples tell us is that prayers to the saints were not just said before images, but were transformed into images themselves. This produced another sort of image from that made by hand, but no one doubted its verity. St Barbara's garland and the Virgin's cloak belonged to a higher reality than man-made images. They were gifts, and could be employed when communing with the saints, both to honour them and to invoke their assistance.

CONCLUSION

The terms 'scene for private devotion' and 'devotional image' should preferably be used in a functional sense. They refer not just to images that reflect a particular mood or are an ideal expression of it. Even images that lack these formal features but which played a part in personal exercises involving prayer or meditation can be described as devotional images. In other words, the terms do not refer to a mood, devotional or otherwise, but to a purpose, the purpose which images served in the devotion or piety of the individual.

In the Late Middle Ages, images were increasingly used for private devotion, first among monastics, and then by lay people as well. This development should be seen primarily in the light of a growing desire for a personal domain of faith. In that respect one can also speak of the emergence of a para-liturgical piety, although that term should not be interpreted in a negative sense. It was not a piety that evolved in defiance of liturgical services, but within and alongside them.

The spread of the devotional image cannot be understood without appreciating the nature of the spirituality that evolved in the Late Middle Ages. Religious literature placed more and more emphasis on the proximity of the saints and the human nature of the Saviour. Christ and the saints entered more deeply into the conceptual world of the faithful. In that process, exercises involving prayer and meditation evolved in which a constant appeal was made to the imagination. The more widespread those exercises, the greater the demand for images in which their content was depicted in an exemplary form.

Finally, we have taken a brief look at three different environments which set great store by devotional images. For the practitioners of an experiential mysticism, they served as a medium that enabled the beholder to bring the inhabitants of Heaven close to him. In the ascetic world of the Brethren of the Common Life the image was no more than a tool. It was an aid for exercising the inner eye, which focusses on Christ's life on earth and desires to imitate Him. For the sisters of the reformed Dominican convents, finally, imaginal reality was constantly being augmented by images formed internally, which were considered to be richer and more powerful than 'real' images. With their aid it even seemed possible to transcend visible reality and gain admission to Heaven.

Further reading:

Andriessen/Bange/Weiler 1985; Angenendt 1994; Boespflug/Lossky 1987; Caron 1984; Dinzelbacher 1986; Dinzelbacher/Bauer 1985 and 1988; Duby 1966; Van Dijk 1990; Elm 1985; Feld 1990; Van Geest 1993; Gerrits 1986; Goossens 1952; Van Herwaarden 1984; Hinz 1981; Honée 1991; Krüger 1990; Langer 1987; Lentes 1993; Mollat du Jourdin/Vauchez 1990; Nyberg 1985; Post 1968; Rapp 1963 and 1985; Ringbom 1984; Ruh 1964 and 1993; Schöne *et al.* 1957; Spamer 1930; Stock 1990; Vauchez 1981 and 1987; Vavra 1985; Verdeyen 1990; Weiler 1984 and 1992; Freiburg 1978; Utrecht 1984 and 1993; Ziegler 1992

NOTES

1. Gregorius Magnus, *Registrum epistolarum*, xi, 1, in *S. Gregorii Magni Registrum Epistolarum*, ed. D. Norbert, 2 vols (Corpus Christianorum, Ser. lat. 140/140A), Turnhout 1982, I, p. 874: "*Nam quod legentibus scriptura, hoc idiotis praestat pictura cernentibus, quia in ipsa ignorantes vident quod sequi debeant, in ipsa legunt qui literas nesciunt; unde praecipue gentibus pro lectione pictura est*".

2. *Conciliorum Oecumenicorum Decreta*, Bologna 1973, p. 136: "*Imaginis enim honor ad primitivum (prototypon) transit; et qui adorat imaginem, adorat in ea depicti subsistentiam*".

3. *Registrum Epistolarum, cit.* (note 1), II, p. 1110v.: "[...] *illum in corde tota intentione quaeris, cuius imaginem prae oculis habere desideras, ut visio corporalis cotidiana reddat exertum et, dum picturam vides, ad illum animo inardescas, cuius imaginem videre desideras [...]. Scimus quia tu imaginem Salvatoris nostri [...] petis, ut [...] ob recordationem filii Dei in eius amore recalescas, cuius te imaginem videre desideras*".

4. *Ibid.*: "*Et nos [...] illum adoramus, quem per imaginem aut natum aut passum vel in throno sedentem recordamur. Et dum nos ipsa pictura quasi scriptura ad memoriam filium Dei reducimus, animum nostrum aut de resurrectione laetificat aut de passione emulcat*".

5. Durandus van Mende, *Rationale divinorum officiorum*, vol. 1, pt. 3 (edn. Naples 1859, p. 23).

6. Thomas Aquinatis, *Super IV Libros Sententiarum*, Lib. 3, dist. 9, q. 1, art. 2, in *Opera Omnia*, ed. S.E. Fretté, Paris 1871–80, IX, p. 155: "[...] *ad excitandum devotionis affectum, qui ex visis efficacius incitatur quam ex auditis*".

7. Gerardus de Frachet, *Vitae Patrum*, cap. 4, *Monumenta Ordinis Fratrum Praedicatorum Historica*, ed. B.M. Reichert, I, Rome 1847, p. 149 "*In cellis habebant eius [sc. Mariae] et Filii crucifixi imaginem ante oculos suos, ut legentes et orantes et dormientes ipsas respicerent et ab ipsis respicerentur, oculis pietatis*".

8. Caesarius van Arles, *Regula Virginum*, cap. 45; ed. A. de Vogüé and J. Courreau, *Césaire d'Arles, Œuvres monastiques*, 2 vols, I: *Œuvres pour les moniales* (Sources Chrétiennes, CCCXLV), Paris 1988, p. 230f: "[...] *nec tabulae pictae adfigi, nec in parietibus vel cameris ulla pictura fieri debet*".

9. *Das Leben des seligen Heinrich Seuse*, ch. 35; ed. K. Bihlmeyer, *Heinrich Seuse. Deutsche Schriften*, Frankfurt 1961 (Stuttgart 1907), p. 103.

10. Fr. Thomas de Celano, *Tractatus de Miraculis B. Francisci* (Analecta Franciscana, X), Florence/Quaracchi 1926–41, p. 275f: "*Moris est [...] romanarum nobilium matronarum [...] in propriis domibus seorsum habere camerulas aut diversorium aliquod orationibus aptum, in quo aliquam depictam habent iconam et illius sancti imaginem quem specialiter venerantur. Quaedam igitur domina [...] sanctum Franciscum in suum elegerat advocatum. Cuius imaginem depictam habebat in secreto cubiculo, ubi Patrem in abscondito exorabat*".

11. *Sacrum Commercium S. Francisci cum Domina Paupertate*, cap. 63, ed. PP. Collegii S. Bonaventurae, Florence/Quaracchi 1929, p. 73: "*Adducentes eam in quodam colle ostenderunt ei totum orbem quem respicere poterant, dicentes: Hoc est claustrum nostrum, domina*".

12. For this letter see *Monumenta Germaniae Historica*, epist. ii, Munich 1978 (Berlin 1895), pp. 462–64.

13. Pseudo-Bonaventure, *Meditationes Vitae Christi*; ed. A. Peltier, *S. Bonaventurae Opera Omnia*, 20 vols., xii, Paris 1868, pp. 509–630, esp. p. 510: "*Ex frequenti enim et assueta meditatione vitae ipsius adducitur anima in quandam familiaritatem, confidentiam et amorem ipsius, ita quod alia vilipendit et contemnit*". The English translation is from *Meditationes*, p. 2.

14. *Ibid.*: "*Unde credis quod beatus Franciscus ad tantam virtutum copiam [...] pervenit, nisi ex familiari conversatione et meditatione [vitae] Domini sui Jesu? Propterea sic ardenter afficiebatur ad ipsam, ut quasi sua pictura fieret*"; *Meditationes*, p. 3.

15. *Ibid*: "[...] *fuit in eum transformatus totaliter*".

16. *Ibid.*, p. 511: *"Ita te praesentem exhibeas his quae per Dominum Jesum dicta et facta narrantur, ac si tuis auribus audires et oculis ea videres".*

17. *Ibid.*: *"Non autem credas, quod omnia quae ipsum dixisse, vel fecisse constat, meditari possimus, vel quod omnia scripta sint: ego vere ad majorem impressionem ea sic, ac si ita fuissent, narrabo"; Meditationes*, p. 5.

18. *Ibid.*: *"imaginariae repraesentationes".*

19. Ed. M. de la Bigne, *De Spiritualibus Ascensionibus* (Maxima Bibliotheca Veterum Patrum et Antiquorum Scriptorum Ecclesiasticorum, XXVI), Lyons 1677, p. 273B: *"Nam passus est propter tuam [. . .] redemptionem [. . .]. Igitur omnia que legis Christum fecisse, attrahe tibi quasi propter te solum facta, et cogita semper quasi Christus dicat tibi: hoc feci, ut sequaris me [. . .]".*

20. Ed. J. Déchanet, *Lettre aux frères du Mont-Dieu* (Sources Chrétiennes, CCXXIII), Paris 1975, pp. 282–85: *"Homini [animali] oranti vel meditanti melius ac tutius [. . .] proponitur imago dominicae humanitatis, nativitatis ejus, passionis et resurrectionis; ut infirmus animus, qui novit cogitare nisi corpora et corporalia, habeat aliquid cui se afficiat".*

21. *Ibid.*, p. 284: *"Eum [Christum Ihesum] secundum Deum plene cogitare".*

22. Ed. F. Vetter, *Das Leben der Schwester von Töss beschrieben von Elsbet Stagel* (Deutsche Texte des Mittelalters, VI), Berlin 1906, p. 46f.

23. P. Strauch, *Margaretha Ebner und Heinrich von Nördlingen. Ein Beitrag zur Geschichte der deutschen Mystik*, Amsterdam 1966 (Freiburg i.B. 1882), p. 90: *"Ich wil dich nit lan schlaffen, du muost mich zuo dir nemen".*

24. E. Colledge and J. Walsh, *A Book of Showings to the Anchoress Julian of Norwich*, Toronto 1978, pp. 357–58.

25. Proceedings of the canonization procedure, quoted from Vauchez 1981, p. 516f.

26. Ed. M.J. Pohl, Thomas à Kempis, *Opera Omnia*, 7 vols. , Freiburg i.B. 1901–22, V, p. 310: *"Oculos mentis ab eius imaginatione numquam avertere".*

27. Ed. D. de Man, *Hier beginnen sommige stichtige punten van onsen oelden susteren. Naar het te Arnhem berustende handschrift uitgegeven*, The Hague 1919, p. 45: *"[. . .] alsof onse lieve Here voer oer hadde gegaen, dragende sijn cruce".*

28. D. A. Brinkerink, 'Biografieën van beroemde mannen uit de Deventer kring', *Archief voor de geschiedenis van het Aartsbisdom Utrecht* xxix (1903), p. 24: *"[. . .] staende op sijnen knyen ruerende den pot ende also sprekende sijn gebeden".*

29. For the Latin text see Pohl, *op. cit.* (note 26), V, pp. 204–08, and for the Middle Dutch text the references in M. Meertens, *De godsvrucht in de Nederlanden naar handschriften van gebedenboeken der XVe eeuw* (Historische Bibliotheek van godsdienstwetenschappen), 4 vols. , Mechelen 1930–34, II, p. 57f.; VI, pp. 45, 103 and 235.

30. Ed. W. Mulder, *Gerardi Magni Epistolae* (Tekstuitgaven van Ons Geestelijk Erf, III), Antwerp 1933, p. 240: *"Hec ergo crux Christi in ruminacione passionis iugiter fabricanda est".*

31. H.-G. Richert, *Marienlegenden aus dem alten Passional*, Tübingen 1965, pp. 115–30.

32. This exercise has survived in manuscript form: Berlin, SBPK, Ms. germ. oct. 54, fols. 335r.–39v., and is described in Lentes 1993, pp. 125–27.

33. The order of service survives as a manuscript: Frankfurt a.M., St.UB., Ms. germ. octo 28, fol. 129r.; here quoted from Lentes 1993, 140f.

34. Strasbourg, A.M., II 39/17, quoted in Lentes 1993, p. 140.

CATALOGUE

Norbert Middelkoop

The number of each entry corresponds to the number in the exhibition and to the appropriate colour plate. The page references are to the discussion of the works of art in the main text in the book.

1
Anonymous (France/Meuse Valley)
Diptych, mid-14th century

Bottom: *The Nativity* and *The Adoration of the Magi*
Top: *The Crucifixion* and *The Last Judgment*
Ivory; wings 20.3 × 9.5 cm
Inscriptions: Quatuor eburnae/ Imagines dicuntur/ opera seculi 800^mi (back of left wing); verus Possessor/ Albergatus Ehlen/ Prior Cartusie/ Trevirensis. 1781· (back of right wing)
Literature: Koechlin 1924, no. 783; Baarsen 1992 (last quarter of the 14th century)
Provenance: in 1781 in the collection of Albergatus Ehlen in Trier; Trier, convent of the Welsche Nuns; Liège, Mgr. Schoolmeesters collection, 1905; France, private collection; Brasschaat, W. Neutelings collection, 1981; donated to the Rijksmuseum, 1992

Amsterdam, Rijksmuseum, inv. no. BK 1992–28

Pp. 10–13, 25
Establishing the date and place of manufacture of medieval ivories is a tricky business. Parallels with monumental sculpture can be taken only so far. Although Paris is still regarded as the main centre of ivory-carving in the Late Middle Ages, it is now assumed that there must have been other centres as well.

Richard Randall has suggested that this particular diptych may be of Mosan origin (verbal communication, September 1993). He has drawn attention to two iconographic details: the exceptional depiction of celestial Jerusalem at Christ's feet in the *Last Judgment*, and the kneeling king in the *Adoration of the Magi*, who has inserted his left arm through the crown (see also *fig. 29* on p. 75).

2
Jean le Tavernier (active in Oudenaarde ca. 1434–69)
The Adoration of the Magi, fol. 143v. from the Book of Hours of Philip of Burgundy, 1454

Jean Miélot (copyist), Jean le Tavernier and workshop (grisailles)
Vellum; 341 fols.; 268 × 187 mm; Latin and French; late 15th-century binding
153 grisailles, 12 marginal scenes, decorated initials (see also *figs. 2, 3, 13, 15* and *35*)
Literature: Byvanck 1924, pp. 55–59, no. 21, pls. 24–26; The Hague 1980–81, no. 45; Brandhorst/Broekhuisen-Kruijer 1985, no. 411
Provenance: made for Duke Philip the Good of Burgundy; Mons, De Montfort collection, 18th century; Gérard collection; purchased in 1818; in the Koninklijke Bibliotheek since 1832

The Hague, Koninklijke Bibliotheek, Ms. 76 F 2

Pp. 14, 16–18
This Southern Netherlandish book of hours was made for Philip the Good, Duke of Burgundy (1396–1467). The duke's likeness appears several times, as does his motto, "*Aultre naray*" (I shall have no other). The book contains many hours and prayers in Latin and French, the majority of which were copied by Jean Miélot, the duke's secretary. The numerous grisailles in the book can be attributed on stylistic evidence to Jean le Tavernier and a workshop assistant. Tavernier and Miélot worked regularly together for the court. In 1434

Tavernier is recorded in Tournai, and between 1453 and 1469 in Bruges. The manuscript is dated 1454 on the basis of a surviving payment order to the artist, who was then living in Oudenaarde. That document, however, speaks of a Book of Hours with 230 grisailles and two coloured illustrations, so it seems that the book was originally larger.

3
Master of the Modena Book of Hours (active in Lombardy ca. 1390–1400)
The Annunciation and *The Visitation*, fols. 13v.–14r. from the Book of Hours of Gian Galeazzo Visconti, also known as the Book of Hours of Isabella of Castile, Milan ca. 1400, completed in Spain ca. 1500

Vellum; 159 fols.; 89 × 67 mm; Latin; 18th-century binding
2 full-page miniatures, 36 historiated initials, 2 marginal scenes, decorated initials, border decoration (see *fig. 41*)
Literature: Byvanck 1924, pp. 36–41, no. 14; The Hague 1980–81, no. 55; Brandhorst/Broekhuisen-Kruijer 1985, no. 464
Provenance: made for Gian Galeazzo Visconti; possibly in the possession of Isabella of Castile ca. 1500; still in Madrid in 1574; in 1750 bought by Prince Willem IV from the J.H. van Wassenaer van Obdam collection; Stadholders' collection

The Hague, Koninklijke Bibliotheek, Ms. 76 F 6

P. 16
The Master of the Modena Book of Hours, to whom the majority of the illuminations in this manuscript are attributed, was one of the leading miniaturists active around 1400 in Lombardy. He must have been a member of the court of Duke Gian Galeazzo Visconti in Milan (1351–1402). Eight works are attributed to him.

The miniatures of the *Annunciation* and the *Visitation* are the most detailed in the book. The remainder consist of highly original border decorations. Although the text is complete, the illumination is unfinished. It was only around 1500, when the book may have been in the possession of Isabella of Castile (1451–1504), that the remaining decoration was inserted around the text. The manuscript contains the calendar of the diocese of Milan, the Office of the Virgin, the Office of the Passion, the Mass for the Dead, the Seven Penitential Psalms and the Litany.

4
Anonymous (Southern Netherlands)
Retable with *The Annunciation*, ca. 1480–90

Oak and walnut, polychromed; centre 41.5 × 23.5 × 9.5 cm, wings 41.5 × 11.1 cm
Literature: De Coo 1969, p. 185
Provenance: acquired by F. Mayer van den Bergh before 1902

Antwerp, Museum Mayer van den Bergh, cat. 2, no. 2227

P. 18
Most Late Medieval retables consist of a cabinet containing a sculpted group of figures, and shutters displaying narrative scenes. The shutters do not so much protect the central group as brace it. Monumental retables could contain relics, and were made for the altars in churches. Antwerp, in particular, produced and exported retables on a large scale.

In this particular *Annunciation*, the shutters are painted with an ornamental floral motif, so that the viewer's eye goes automatically to the compact *Annunciation* group. The original polychromy and gilding are very well preserved, although all but one of the wings of the angels are missing, as are the angel Gabriel's right hand, part of the open tracery at top left, and the figure of God the Father in the centre, which may have been attached to it. The relief pearl shape used for the eyeballs is unusual, as is the combination of two types of wood – oak for the cabinet and walnut for the main group.

5

Bernardo Daddi (active in Florence ca. 1312–48)

Triptych, 1338

Centre: *The Crucifixion* and *Christ Logos*
Left wing: *The Nativity* and *The Crucifixion of St Peter* (top)
Right wing: *The Madonna enthroned* and *The miracle of St Nicholas* (top)
Panel; centre 90 × 43.5 cm, wings 63.5 × 19 cm
Inscription: ANNO·DNI·MCCC·XXXVIII·FLORENTIA·PER (on the frame below the central panel; reinforced)
Literature: Brigstocke 1978, pp. 36–38; Offner/Boskovits 1989, pp. 52–53; Offner/Boskovits 1990, pp. 77–83, pl. XXXIV
Provenance: in 1854 at Stanstead Hall (Essex), W. Fuller Maitland collection; bought ca. 1907 by R. Langton Douglas; in 1917 in Munich with J. Böhler; acquired in 1938 from the Spanish Art Gallery, London, Cowan Smith bequest

Edinburgh, National Galleries of Scotland, inv. no. 1904

Pp. 22–24
Bernardo Daddi di Simone was active in Florence in the first half of the 14th century. He very probably trained with Giotto (ca. 1266/67–1337), assimilating the influence of his monumental style of painting, as well as that of Sienese art (see cat. 20–22). His work displays a pronounced narrative tendency. He must have had a large workshop, judging by the extensive œuvre that is attributed to him. He was responsible for a number of fresco cycles, but his true *forte* was small altarpieces, several dozen of which survive. The central panels usually have a *Madonna enthroned* or a *Crucifixion*.

Offner attributed the *Crucifixion* triptych in Edinburgh to an immediate follower of Daddi, but Boskovits has recently assigned it to the master himself. Only a few of these relatively large triptychs have survived in good condition. Not only could they be damaged, but in many cases the wings were removed or bits sawn off. Apart from a vertical split in the central panel and a few minor areas of damage, this triptych is in exceptionally fine condition.

6

Anonymous (France)

Diptych, ca. 1260–70

Top: *The Coronation of the Virgin* and *The Last Judgment*
Bottom: *The Ladder to Heaven* and *The Raising of the dead and the Jaws of Hell*
Ivory; wings 12.4 × 7 cm
Literature: Cologne 1960, no. 23 (ca. 1330); Cologne 1968, no. D 10; Little 1979, pp. 64–65
Provenance: acquired in 1970 from the E. Köfler-Truniger collection, Lucerne

New York, The Metropolitan Museum of Art, The Cloisters Collection, inv. no. 1970.324.7a-b

Pp. 25–26
This diptych only emerged after the Second World War in a private collection in Lucerne, which is why it does not appear in Koechlin's standard work of 1924. The ivory, with the rare combination of the *Coronation of the Virgin* and a *Last Judgment*, is very deeply carved, so much so that some of the figures are partially freed from the background. Great care was taken to attune the composition of the four scenes to the architectural surrounds. The early dating of the work is based on stylistic similarities to the stone sculpture on the portals of Notre-Dame in Paris (Porte Rouge, ca. 1260) and Rheims Cathedral (façade, ca. 1250).

7

Attributed to Hans Paur (documented in Nuremberg 1445–72)

The Martyrdom of St Sebastian, ca. 1472

Woodcut, hand-coloured; 255 × 182 mm
Inscription, below: O du saliger Sebastian wie groß ist dein glaub Bit für mich/ deinen diener unsern herren ihm x̅r̅m̅ das ich vor dem ubel/ geprechen der

pestilencz behüet werde Bit für uns du hailiger/ Sebastian das wir der glübde unnsers herren wirdig werden// Almechtiger ewiger got der du durch das verdinen und gebet/ des hailigen martteres sant Sebastians vor dem gemein̅e/ geprechen der pestilencz den menschen gnadiglich behuten vist/ verleih allen den die pitten oder dits gebet pey in tragen oder an/dechtiglichen sprechen ...es dieselben vor dem gepresten behutt wer/den und durch getrawen des selbigen hailigen uns vor aller be/trubnuss und engsten leibs und der sele erlegit werden Amen.
Literature: Heitz 1918, vol. 2, p. 7, no. 19; Schreiber, 1927, vol. 3, pp. 181–82, no. 1679
Provenance: unknown

Munich, Staatliche Graphische Sammlung, inv. no. 118258

Pp. 28–30
This woodcut is attributed to the Nuremberg map-maker Hans Paur. There is also a slightly different version, the only early impression of which is in the Guildhall Library in London (Heitz no. 18, Schreiber no. 1678). It is not clear which version of the two is the earliest.

8

Master of the Amsterdam Cabinet (active Upper Rhine ca. 1470–1500)

St Sebastian with archers, ca. 1475–80

Drypoint (unique impression); 129 × 192 mm
Literature: Lehrs 1932, vol. 8, pp. 119–20, no. 43; Amsterdam/Frankfurt 1985, no. 42
Provenance: Leiden, Baron P.C. van Leyden collection; Koninklijke Bibliotheek, The Hague, 1807

Amsterdam, Rijksmuseum, Rijksprentenkabinet, inv. no. RP-P-OB–904

P. 30
Despite all the research generated by his œuvre, the identity of the Master of the Amsterdam Cabinet (also known as the Housebook Master) is still not known. He is named after his drypoint prints, most of which are preserved in the Rijksprentenkabinet in Amsterdam, or as the Housebook Master after an illustrated manuscript with drawings of profane subjects now in a private collection. The master worked in the Rhineland region, probably for aristocratic patrons, such as the rulers of Heidelberg or Mainz. His work sometimes displays remarkable similarities to that of contemporaries such as the engraver Martin Schongauer (active 1465–91).
St Sebastian with archers is assigned to the master's middle period. St Sebastian is usually depicted as a beautiful, nude young man bound to a tree, his body riddled with arrows. One striking feature of this drypoint print, apart from the absence of any arrows in the saint's body, is that the background has been left bare.

9

Anonymous (Lake Constance region?)

St Christopher with the Christ Child, ca. 1430–40

Woodcut (unique impression), hand-coloured; 283 × 201 mm
Literature: Schreiber 1927, vol. 3, p. 64, no. 1350a; Musper 1976, p. 17
Provenance: in 1907 in Munich, Antiquariat Jacques Rosenthal

Berlin, Staatliche Museen zu Berlin, Preußischer Kulturbesitz, Kupferstichkabinett, inv. no. 120–1908

P. 32

10a
Master of the Amsterdam Cabinet (active Upper Rhine ca. 1470–1500)
St Barbara, ca. 1485–90

Drypoint (unique impression); 120 × 40 mm
Literature: Lehrs 1932, vol. 8, pp. 120–21, no. 44; Amsterdam/Frankfurt 1985, no. 46
Provenance: Leiden, Baron P.C. van Leyden collection; Koninklijke Bibliotheek, The Hague, 1807

Amsterdam, Rijksmuseum, Rijksprentenkabinet, inv. no. RP-P-OB-907

10b
Master of the Amsterdam Cabinet
St Catherine, ca. 1485–90

Drypoint (unique impression); 119 × 38 mm
Literature: Lehrs 1932, vol. 8, pp. 122–23, no. 47; Amsterdam/Frankfurt 1985, no. 47
Provenance: Leiden, Baron P.C. van Leyden collection; Koninklijke Bibliotheek, The Hague, 1807

Amsterdam, Rijksmuseum, Rijksprentenkabinet, inv. no. RP-P-OB-908

Pp. 32–34; see also cat. 8.

Both impressions are of superb quality, and belong to the master's late work. It is unclear why the saints have been placed in niches. It is possible that the prints were made after or as models for sculptures.

11
Anonymous (Bavaria)
St Dorothy, ca. 1410–25

Woodcut (unique impression), hand-coloured; 271 × 197 mm
Inscription: S. Dorothea (at top)
Literature: Heitz 1912, vol. 3, p. 22, no. 7; Schreiber 1927, vol. 3, no. 1395; Vienna 1962, no. 305; Munich 1970, no. 7; Musper 1976, p. 14
Provenance: monastery of St Zeno, near Reichenhall; Munich, Bayerische Staatsbibliothek (Clm. 16455); transferred in 1884

Munich, Staatliche Graphische Sammlung, inv. no. 171506

P. 34
This *St Dorothy* comes from a manuscript of 1410 from the monastery of St Zeno near Reichenhall, together with a woodcut of *St Sebastian* (Heitz no. 8, Schreiber no. 1677). The woodcut was probably slightly damaged when it was removed from the volume in the 19th century. In the course of a later restoration the original colours emerged from beneath an old overpaint.

12
Lorenzo Monaco (Siena ca. 1372 – Florence 1424)
Diptych, ca. 1420

Left (a): *Madonna of Humility*
Right (b): *St Jerome*
Panel; wings 22.8 × 17.8 cm (a), 23 × 18 cm (b)
Literature: Groningen/Utrecht/Florence 1974, no. 34b (ca. 1408); Ridderbos 1984, pp. 15–39; Vos/Van Os 1989, pp. 165–69, no. 13; Eisenberg 1989, pp. 44–45, 80–81, 91–92
Provenance: (a) B. Thorvaldsen collection; bequeathed to the Danish State in 1844; in the museum since its opening in 1848; (b) in 1872 in the Costabili collection in Ferrara, auctioned 1885; in 1901 in the R. von Kaufmann collection in Berlin; Amsterdam, O. Lanz collection, 1917; The Hague, Stichting Nederlands Kunstbezit; The Hague, Dienst voor 's-Rijks verspreide Kunstvoorwerpen; transferred in 1960

(a) Copenhagen, Thorvaldsens Museum, inv. no. B 1
(b) Amsterdam, Rijksmuseum, inv. no. SK A 3976

Pp. 34, 94; see also cat. 15
Around 1400 the Sienese Lorenzo Monaco had one of the most flourishing workshops in Florence. He produced book illustrations and altarpieces, some for his own monastery. Lorenzo's œuvre displays an evolution from the Florentine late Trecento manner to the more flowing style of painting generally known as International Gothic.

13
Dieric Bouts (Haarlem ca. 1410/20 – Louvain 1475)
Christus Salvator Mundi, ca. 1450

Panel; 36 × 27 cm
Literature: Friedländer 1940; Hannema 1949, p. 19, no. 8; Van Regteren Altena 1953, p. 229; Brussels/Delft 1957–58, no. 21; Friedländer 1967–76, vol. 3 (1968), p. 76, Add.no. 119; Utrecht 1984, no. 113; Rotterdam 1994; Giltaij 1994
Provenance: Amsterdam, J. Goudstikker Gallery; Vierhouten, D.G. van Beuningen collection, 1939; acquired in 1958 with the D.G. van Beuningen collection

Rotterdam, Museum Boymans-van Beuningen, inv. no. 2442

P. 40
Dieric Bouts was born in Haarlem but was mainly active in Louvain, where he settled around 1445. Bouts's style is marked by a high degree of realism and figures that display little emotion. He was influenced by Rogier van der Weyden (ca. 1399/1400–1464), whose pupil he may have been. His sons Dieric the Younger (ca. 1488–ca. 1490/91) and Albrecht (died 1549) were also painters.

There are at least eight related versions of this portrait of Christ. The Rotterdam work is regarded as the earliest in the series. The blue background may not be original; it is possible that the rayed nimbus typical of portraits of Christ has been overpainted. The broad, unpainted border around the scene would appear to suggest that the panel was originally furnished with a special frame.

14
Hans Memling (Seligenstadt am Main ca. 1435/40 – Bruges 1494)
Diptych, ca. 1470–75

Left (a): *St John the Baptist*; on the back *A skull in a niche*
Right (b): *St Veronica with the sudarium*; on the back *The chalice of John the Evangelist*
Panel; wings 31.6 × 24.4 cm (a), 31.2 × 24.4 cm (b)
Inscription: (a) H.V.D.GOES 1472 (at lower right, not original)
Literature: Panofsky 1953, p. 498, note 329; Kermer 1967, vol. 1, pp. 184–87, vol. 2, pp. 139–41, no. 139; Friedländer 1967–76, vol. 6 (1971), p. 52, nos. 44 and 46; Hand/Wolff 1986, pp. 193–201; Belting 1990, pp. 478–80
Provenance: possibly in the Bembo collection in Venice at the beginning of the sixteenth century; (a) acquired by Maximilian I in 1819 or 1820; Schleißheim, Schloß-Galerie, 1825; transferred in 1836; (b) San Donato, Demidoff collection, sale Paris, 3.3.1870, no. 204; private collection, Italy; on the Berlin art market before 1930; Lugano, H. Thyssen-Bornemisza collection; New York, M. Knoedler & Co., 1950–51; New York, Kress Foundation

(a) Munich, Bayerische Staatsgemäldesammlungen, Alte Pinakothek, inv. no. 652; not exhibited
(b) Washington, National Gallery of Art, Samuel H. Kress collection, inv. no. 1952.5.46 (1125)

P. 43
Hans Memling, who came from the Middle Rhine region, worked for most of his life in Bruges, where he registered as a citizen in 1465. He may have

trained with Rogier van der Weyden (ca. 1399/1400–1464) in Brussels, given the similarities in their styles. Memling was the leading Bruges painter at the end of the 15th century, and many works are attributed to him.

Nowadays it is widely believed that *Veronica* and *John the Baptist* originally formed a diptych. Memling repeated this combination in the Floreins triptych of 1479 in the Hospital of St John in Bruges. The attributes of these two saints epitomize Christ's role as the Saviour. The connection with the subjects on the backs of the panels is more difficult to fathom. The unusual choice of the *Chalice of John the Evangelist* may be connected with the name of the first owner of the diptych. The *Skull in a niche* with the inscription *"morieris"* (Thou shalt die) should be construed in a general cautionary sense.

15

Attributed to Lorenzo Monaco (Siena ca. 1372 – Florence 1424)

Madonna, ca. 1395

Panel; 36 × 29 cm
Inscription: questa vergine la recò un fratello d'una Nostra Monacha di contan … [dopo?] cadde in mare e sette 3 giorni sotta la qua e poi venne a galla miracolosamente e si posse nella ..stra chiesa dalla Mre Priore e qui [si?] vuole stare rivolta la usò … levare la notte l'a perse qui tornato. (on the back)
Literature: Groningen/Utrecht/Florence 1974, no. 38; Eisenberg 1989, p. 174; Vos/Van Os 1989, pp. 170–73, no. 14
Provenance: at the beginning of this century still in Florence, Certosa di Galluzzo; later in Florence according to an old inscription on a photograph, Montughi, "fr. Faldi fr. Girolamo"; Amsterdam, O. Lanz collection, 1934; The Hague, Stichting Nederlands Kunstbezit, 1953; The Hague, Dienst voor 's-Rijks Verspreide Kunstvoorwerpen; transferred in 1960

Amsterdam, Rijksmuseum, inv. no. SK A 4004

P. 48; see also cat. 12
This *Madonna* has been attributed to a number of artists since it was discovered in 1903 in the Carthusian monastery of Galluzzo near Florence. When the Dutch State acquired it from the Lanz collection in 1950 it was going under the name of Lorenzo Monaco, although Niccolò di Pietro Gerini (active 1368–ca. 1415/16) and Lorenzo's pupil Matteo Torelli (active at the beginning of the 15th century) are also mentioned as its authors. There are no convincing grounds for attributing the panel to any of these three, although it must have been painted in Lorenzo's immediate circle. Eisenberg, on the other hand, points to the stylistic similarities with the San Gaggio altarpiece in the Accademia in Florence, which is also attributed to Lorenzo. In his view, it displays the influence of Nardo di Cione (active ca. 1343/46–ca. 1365/66).

16

Anonymous (Cologne)

Vierge ouvrante, ca. 1300

Oak, polychromed and painted; height 36.8 cm
Open: *Mercy-seat Trinity* (incomplete); left wing: *The Annunciation, The Nativity* and *The Adoration of the Magi*; right wing: *The Visitation, The Presentation in the Temple* and *The Announcement to the shepherds*
Closed: *Madonna lactans*
Literature: Kroos 1986, p. 60; Radler 1990, pp. 77–80, 271–75, no. 16; Von Andrian-Werburg 1992, pp. 24–31
Provenance: Lyons, art market; Aix-en-Provence, private collection, 1876; Paris, M. Bing collection; bought by J. Pierpont Morgan; donated to the museum in 1917

New York, The Metropolitan Museum of Art, inv. no. 17.190.185

Pp. 52, 55
The New York *Vierge ouvrante* is the smallest of the examples known. When closed it shows a *Madonna lactans*, the Virgin suckling the Christ Child. According to Radler, the style of execution reflects some influence of French ivory-carving. The vegetation on which the Virgin's throne stands refers to the Tree of Jesse, which traces Christ's descent from King David.

The *Mercy-seat Trinity* inside the *Vierge ouvrante* shows God the Father enthroned, displaying the cross. This has the irregular shape of the *lignum vitae*, or Tree of Life, from which the family of the faithful originated. The figure of the crucified Christ and the dove of the Holy Ghost are missing. In their flat and decorative execution, the scenes of Christ's early childhood on the insides of the wings recall trends in book illumination, and provide the basis for the reasonably precise attribution and dating.

17

Master IAM van Zwoll (active in Zwolle ca. 1470–1500)

The Lactation of St Bernard, ca. 1480–85

Engraving; 320 × 241 mm
Literature: Lehrs 1930, vol. 7, pp. 203–04, no. 15; Filedt Kok 1990, pp. 348–49, 352
Provenance: Leiden, Baron P.C. van Leyden collection; Koninklijke Bibliotheek, The Hague, 1807

Amsterdam, Rijksmuseum, Rijksprentenkabinet, inv. no. RP-P-OB–1093

P. 52
The anonymous master IAM van Zwoll is regarded as the only important 15th-century engraver active in the northern Netherlands. Judging by the signature, he must have worked in the town of Zwolle. The frequent appearance of the monogram IAM or IM has been associated with the documented painter Johan van der Mynnesten, who was active in Zwolle between 1462 and 1504. Filedt Kok has suggested that some of the 26 works attributed to the master are the result of collaboration between this painter and the engraver, who in some cases signed with the monogram IA.

The master's interest in architectonic space is very apparent in the *Lactation of St Bernard*. There are two known impressions of this print. The one in Amsterdam is of excellent quality, but has been trimmed all round. There is a later, complete impression in the Ashmolean Museum, Oxford (329 × 261 mm), with the inscription "Zwoll" (Zwolle).

18

Anonymous (Upper Rhine)

Christ and St John, ca. 1330–40

Walnut, polychromed; height 34.5 cm
Literature: Wentzel 1960; Hausherr 1975, pp. 79–103; Beck 1980, pp. 144, 147
Provenance: Adelhausen convent near Freiburg im Breisgau; acquired in 1950

Frankfurt, Liebieghaus-Museum alter Plastik, inv. no. 1447

P. 58
There are some 25 known groups of *Christ and St John*. All date from the 14th century and come from south-west Germany. This specimen, one of the smallest, is from the Dominican convent of Adelhausen, near Freiburg im Breisgau. Much of the original polychromy is still intact.

19

Master Caspar (active in Regensburg ca. 1470–1480)

The Stigmatization of St Francis, ca. 1470–80

Woodcut, hand-coloured; 385 × 252 mm
Inscription, below: Heiliger und wirdiger vatter sandt franciscus ein diener iĥu xp̄i Und ein trost aller der/ menschen die dir hie dienen und dich an ruffen und dich eren mit peiten und vastn/ feyern almůsen geben Und ander gutte werck Ich pitt dich das du got fur mich pittest/ der dich begobet hat mit den heiligen funff wunden Als er dir erschein gyb mir willige ar/mit keuscheit gehorsamkeit rew und leit meiner sundn uñ das ewig leben Amen// Caspar.
Literature: Heitz 1910, vol. 21, p. 19, no. 33 (ca. 1480); Schreiber 1927, vol. 3, no. 1423a

Provenance: the incunable containing this print is from the Franciscan friary at Ingolstadt

Munich, Bayerische Staatsbibliothek, Rar. 327

P. 62
The word "Caspar" in the lower right corner of this woodcut is known from a few other woodcuts, and may refer to the artist who made this print. Schreiber places this master, who is otherwise unknown, in Regensburg.

The large, coloured woodcut is on the inside of the back cover of an incunable from the Franciscan friary of Ingolstadt. In the same volume, pasted on the inside of the front cover, is a print of *Christ in the wine-press* (Heitz no. 16, Schreiber no. 841a). The incunable is a breviary printed at Basle in 1493. Both prayer-prints must have been inserted by a later owner, who may have been one of the friars.

20

Ambrogio Lorenzetti (active in Siena ca. 1319–48)
The Small *Maestà*, ca. 1335–40

The Virgin enthroned with the Christ Child, six angels flanking the throne at the back; on the left St Elizabeth of Hungary, on the right St Catherine of Alexandria; kneeling on the left St Nicholas(?); in the left foreground Pope Clement I; on the right St Martin(?); in the right foreground Pope Gregory I
Panel; 50.5 × 34.5 cm
Literature: Rowley 1958, pp. 66–69; Moran/Seymour 1967, pp. 28–39; D'Argenio 1985, pp. 150–52; Torriti 1990, pp. 76–78
Provenance: possibly the central panel of a triptych which in 1735 was in the Monteoliveto monastery near Porta Tufi in Siena; listed in the museum inventory in 1816

Siena, Pinacoteca Nazionale, inv. no. 65

P. 66
Ambrogio Lorenzetti, his brother Pietro (active 1306?–1345) and Simone Martini (ca. 1284–1344) were the trio of great Sienese painters after Duccio (ca. 1255–ca. 1318/19). Ambrogio may have spent some years in Florence. He received many commissions in Siena, the best known being for the frescos in the Palazzo Pubblico.

Traces of hinging suggest that this panel, which is cropped at the top, was originally the central part of a triptych. Moran and Seymour have postulated that small panels with scenes from the lives of Sts Nicholas and Martin (Paris, Louvre, and New Haven, Yale University Art Museum) may have formed the wings. The differences in style between the panels make this hypothesis unconvincing.

21

Francesco Vannuccio (Siena ca. 1315/16 – ca. 1388)
Diptych, ca. 1380

Left (a): *Virgin enthroned with the Christ Child, Sts Lawrence and Andrew*
Right (b): *Christ on the Cross with the Virgin and St John*
Panel; wings 34.5 × 23.5 cm (a), 43 × 30.5 cm (b, incl. frame)
Inscription: (b) hoc·hopus·nelmille·/ccc· … (on the frame)
Literature: Offner 1932, p. 95; Groningen/Utrecht 1969, no. 7(a); Vos/Van Os 1989, no. 10(a); Van Os *et al.* 1989, pp. 56–62, no. 12
Provenance: (a) probably acquired in Italy by Baron van Westreenen van Tiellandt after 1845; (b) Durand-Ruel collection (?); listed in the Johnson collection in 1907

(a) The Hague, Rijksmuseum Meermanno-Westreenianum, inv. no. 806/60
(b) Philadelphia, Philadelphia Museum of Art, The John G. Johnson collection, inv. no. 94

P. 69
Francesco Vannuccio was active in Siena between 1360 and 1390. The œuvre attributed to him displays the influence of Simone Martini (ca. 1284–1344), but his style is more ornamental. It is not known when the two panels of this diptych were separated. The *Crucifixion* is still in its original frame, but the date on it is only partly legible.

22

Workshop of Sassetta (Siena 1392 – Siena ca. 1450–51)
Triptych, ca. 1430

Centre: *The Virgin enthroned with the Christ Child, two angels flanking the throne at the back; on the left probably St Catherine of Alexandria; on the right St Lucy; God the Father above*
Left: *St Ansanus, with the angel Gabriel of the Annunciation above*
Right: *St Lawrence, with the Virgin of the Annunciation above*
Panel; 61 × 52.5 cm
Literature: Groningen/Utrecht 1969, no. 26; Bellosi/Angelini 1986, vol. 1, pp. 43–47; Vos/Van Os 1989, no. 23; Van Os *et al.* 1989, pp. 126–31, no. 36
Provenance: probably acquired in Italy by Baron van Westreenen van Tiellandt after 1845

The Hague, Rijksmuseum Meermanno-Westreenianum, inv. no. 808/61

P. 72
Stefano di Giovanni, called Sassetta, was the most important Sienese painter of the first half of the 15th century. His workshop was extremely productive, and regularly had several painters working on a single commission.

There are four other surviving paintings similar to this one, all of them from Sassetta's shop, and all with virtually the same disposition of the figures. The two saints on the wings of the Hague triptych are attributed to the Osservanza Master, who was a pupil of Sassetta's. The *Annunciation* and the central section are by another hand. Traces of an attachment below the central panel show that the triptych originally stood on a base.

23

Anonymous (Paris)
Tabernacle, ca. 1300

Centre: *The Virgin and Child*
Left: *The Annunciation* and *The Adoration of the Magi*
Right: *The Nativity* and *The Presentation in the Temple*
Ivory; 16.8 × 15.1 cm open
Literature: Koechlin 1924, no. 153 (beginning of the second quarter of the 14th century); Bloch 1969, pp. 14–15, no. 10
Provenance: acquired for the Königliche Kunstkammer in 1835

Berlin, Staatliche Museen zu Berlin, Preußischer Kulturbesitz, Skulpturensammlung, inv. no. 627

P. 76

24

Master of Catherine of Cleves (active in Utrecht ca. 1430–60)
The Madonna with donors and
The Nativity, from the Book of Hours of the Van Lochorst family, fols. 13v.–14r. ca. 1460

Illuminations by the Master of Catharine of Cleves and Lieven van Lathem, ca. 1460
Vellum; 187 fols.; 185 × 125 mm; Middle Dutch; 15th-century binding
3 full-page miniatures, 6 historiated initials, decorated initials, border decoration (see also *fig.* 12)
Literature: Boon 1964, pp. 241–54; Boeren 1979, pp. 198–200; Ekkart 1979, pp. 22–26; Utrecht/New York 1989–90, no. 50
Provenance: made for Willem van Lochorst?; Derich van Sevichveld?; in 1803 in the possession of Sara Ploos van Amstel; acquired from the firm of Rosenberg & Stiebel, New York, in 1964

The Hague, Rijksmuseum Meermanno-Westreenianum, Ms. 10 F 50

Pp. 78–81
The Master of Catherine of Cleves, who worked in Utrecht, takes his name from the Book of Hours which he made for Catherine of Cleves. It is now in New York, in two parts. The Hague Book of Hours is a late work in the master's œuvre. In addition to the Master of Catherine of Cleves, Lieven van Latham (active 1454 – after 1462) was responsible for much of the fantastic border decoration. The manuscript originally contained six full-page miniatures, three of which were later removed.

This Book of Hours contains the calendar of the diocese of Utrecht, the Hours of the Virgin, the Seven Penitential Psalms and the Litany, the Hours of the Eternal Wisdom, the Hours of the Holy Cross, the Hours of the Holy Ghost, the Vigil of Nine Lessons, the Last Words of Our Lord, and a prayer. The patron was probably a member of the Van Lochorst family. Another Book of Hours which the master made for another member of the family is preserved in Münster.

25a
Master E.S. (active Upper Rhine ca. 1450–67)
The Large *Virgin of Einsiedeln*, 1466

Engraving, hand-coloured; 206 × 123 mm
Inscriptions: 1466 (left of the arch); E (right of the arch); Dis ist die engelwichi zu unser lieben frouwen zu den einsidlen aue grcia plenna (around the arch)
Literature: Lehrs 1910, vol. 2, pp. 146–51, no. 81; Schuppisser 1986; Munich/Berlin 1986–87, no. 32
Provenance: von Quandt collection, 1860

Berlin, Staatliche Museen zu Berlin, Preußischer Kulturbesitz, Kupferstichkabinett, inv. no. 339–1

25b
Master E.S.
The Small *Virgin of Einsiedeln*, 1466

Engraving, hand-coloured; 133 × 87 mm
Inscription: 1466 (right of the arch)
Literature: Lehrs 1910, vol. 2, pp. 133–35, no. 72; Schuppisser 1986; Munich/Berlin 1986–87, no. 31
Provenance: von Nagler collection

Berlin, Staatliche Museen zu Berlin, Preußischer Kulturbesitz, Kupferstichkabinett, inv. no. 340–1

25c
Master E.S.
The Smallest *Madonna of Einsiedeln*, 1466

Engraving, hand-coloured; 97 × 65 mm
Inscription: 1466 (left, above the arch)
Literature: Lehrs 1910, vol. 2, pp. 128–29, no. 68; Schuppisser 1986; Munich/Berlin 1986–87, no. 30
Provenance: Hartmann Schedel collection?; von Nagler collection

Berlin, Staatliche Museen zu Berlin, Preußischer Kulturbesitz, Kupferstichkabinett, inv. no. 383–1

P. 84
The master from the Upper Rhine region who signed with the initials E.S. was the most important German printmaker of the third quarter of the 15th century. He was probably also a goldsmith, since some of his engravings are designs for goldsmith's work, and also because he regularly used a goldsmith's punch when making his prints. Master E.S. was the first printmaker to use cross-hatching in his work, which gives the scenes something of a sculptural look. His most important works are the Madonnas which he made in 1466 as a superior form of prayer-card for the Benedictines of Einsiedeln, a place of pilgrimage. The subtle colouring of the Smallest *Madonna* is possibly the work of the collector Hartmann Schedel, who may have been its first owner.

26
Master of St Veronica (active in Cologne ca. 1395–1415)
Triptych, ca. 1410

Open, centre: *The Virgin and Child in a mandorla of angels, surrounded by Sts John the Evangelist, Barbara, Christine, Catherine, Mary Magdalene and John the Baptist; God the Father above*; left: *The Flagellation* and *The Crucifixion*; right: *The Resurrection* and *The Ascension*.
Closed: *The Carrying of the Cross*
Panel; centre 70 × 32.5 cm, wings 70 × 16 cm
Literature: Cologne 1973, no. 19; Zehnder 1981, no. 6; Cologne 1993–94, no. 34
Provenance: unknown

Kreuzlingen, Heinz Kisters collection

Pp. 87–91
The Master of St Veronica is named after an image of the saint in the Alte Pinakothek in Munich. He is regarded as the most important painter in Cologne before Stefan Lochner (1400?–1451?), who was influenced by him. His work is distinguished by soft contours and subtle colour combinations. The central panel of this triptych is widely considered to be autograph; the wings may have been made in the master's shop.

27
Master of the Amsterdam Cabinet (active Upper Rhine ca. 1470–1500)
The Holy Family by the rose-bush, ca. 1490

Drypoint (unique impression); 142 × 115 mm
Literature: Lehrs 1932, vol. 8, pp. 105–06, no. 27; Amsterdam/Frankfurt 1985, no. 28
Provenance: Leiden, Baron P.C. van Leyden collection; Koninklijke Bibliotheek, The Hague, 1807

Amsterdam, Rijksmuseum, Rijksprentenkabinet, inv. no. RP-P-OB–889

P. 92; see also cat. 8 and 10

28
Master of Cornelis Croesinck (active in Holland, ca. 1490–95)
St Anne with the Virgin and Child, fols. 25v.–26r. from a prayer-book, ca. 1490

Vellum; 140 fols.; 162 × 121 mm; Dutch; 20th-century binding
11 large and 15 small miniatures, decorated and historiated initials, 11 marginal scenes, border decoration (see also *figs. 44* and *56* on pp. 99 and 112)
Literature: The Hague 1980–81, no. 77; Brandhorst/Broekhuisen-Kruijer 1985, no. 308; Utrecht/New York 1989–90, no. 102; Uden 1992, no. 5
Provenance: Ulco Proost collection; acquired from Antiquariaat Beyers, Utrecht, in 1967

The Hague, Koninklijke Bibliotheek, Ms. 135 E 19

P. 96
The Master of Cornelis Croesinck, to whom the miniatures in this Book of Hours are attributed, is named after a Book of Hours which he made around 1494 for Cornelis Croesinck (died 1519?) of The Hague, which is now in New York. The miniaturist is numbered among the 'Black Eyes Masters', so called after the distinctive black-rimmed eyes of their figures. In addition to the calendar of the diocese of Utrecht, the book contains prayers to St Anne, the Virgin and Christ, prayers centring around the Passion, the Resurrection and the Assumption of the Virgin, as well as the Penitential Psalms and the Litany. The prayers are divided over the days of the week.

The border decoration of floral motifs on coloured grounds points to a strong influence from the South Netherlands, since border ornamentation in the north was generally painted on plain parchment. One notable feature is that the miniatures are an integral part of the pages and were not added later, which was the usual practice.

29
Gregor Erhart (Ulm ca. 1465 – Augsburg 1540)
The Christ Child with the terrestrial globe, ca. 1500

Limewood, polychromed; height 56.5 cm
Literature: Feulner 1933; Otto 1943, pp. 35, 87; Baxandall 1980, p. 293; Hilger 1991, pp. 20–21
Provenance: Heggbach (Swabia), convent; art market; Munich, private collection; acquired in 1953

Hamburg, Museum für Kunst und Gewerbe Campe-Stiftung, inv. no. 1953.35

P. 100
Gregor Erhart, who was born in Ulm, was one of the leading South German sculptors of his day. His work displays the influence of Hans Multscher (see cat. 39) and Tilman Riemenschneider (ca. 1460–1531). He was initially associated with the Master of the Blaubeurer Altar, on which altarpiece he probably collaborated.

This *Christ Child* giving the blessing is from the Cistercian nunnery at Heggbach, Swabia, and dates from after Erhart's move to Augsburg in 1494. The polychromy has been slightly abraded by the dress and a buckle at the breast.

30
Anonymous (Liège)
Jésueau, early 15th century

Silver gilt, embossed and cast; 12.6 × 12 × 8 cm
Inscriptions: JUSQUA/ LE FIN; EN BŌNE/ ESPOIR; ELLE MOY/ QFORT; TOT LES/ DECLIN (on coats of arms)
Literature: Niffle-Anciaux 1889; *idem* 1911; Colman 1966, vol. 1, pp. 158–60, 244 no. 610; vol. 2, figs. 224–25; Huy 1990, no. 108; Brussels 1994, no. 96
Provenance: Namur, Marche-les-Dames Abbey; Friedberg (Hessen), parish church; Essen a.R., Sister Scholastique (Marie-Joseph Baudhuin); Mgr. Deheselle, Bishop of Namur, ca. 1850; Société Archéologique de Namur

Namur, Musée des Arts Anciens

P. 102
A *Jésueau*, or *Repos de Jésus*, is a miniature crib containing a figure of the infant Christ. The earliest known examples date from after 1300. Cribs of this kind became extremely popular in the 15th century, but after that the genre virtually disappeared.

The Namur crib is the only surviving specimen executed in precious metals; most of the others are of wood. It is also exceptional in that the Christ Child has been preserved. He is crowned, and holds a terrestrial globe.

31
Anonymous (Middle Rhine)
The Lorch *Pietà*, ca. 1420–30

Alabaster; height 39 cm, base 51 cm
Literature: Swarzenski 1921, pp. 170, 175, 179, 180, 205 no. 3; Krönig 1962, p. 161; Legner 1969, pp. 134–35; Frankfurt 1975–76, no. 64
Provenance: Lorch a.R., Martinskirche; private collection

Wiesbaden, Museum Wiesbaden, Sammlung Nassauischer Altertümer, inv. no. 27/35

P. 104
Numerous Pietàs have survived, especially in German sculpture, where they are also known as *Vesperbilder*. The emphasis is on the Virgin's *pietà* or *pitié*, her compassion.

The Lorch *Pietà* is one of a small group of works which Swarzenski attributed to the so called Rimini Master, who acquired his name from a famous alabaster *Crucifixion* group in the Liebieghaus in Frankfurt, which came from Santa Maria delle Grazie in Rimini. This attribution is no longer generally accepted. This alabaster *Pietà* could very well have been made in Lorch itself.

32
Anonymous (Venice?)
Triptych, ca. 1300

Open: centre *Man of Sorrows*; left *The Virgin*; right *St John the Evangelist*
Closed: *Two Dominicans, a bird and Christ enthroned* (back of the left panel)
Panel; wings 20.1 × 16.5 cm
Inscriptions: LS.IESUCRV (centre panel, not original); Y XC (back of the left panel, flanking the figure of Christ)
Literature: Van Os 1978, pp. 65–75 (reprinted in Van Os 1992, pp. 144–266); Vos/Van Os 1989, pp. 77, 116–19, no. 1
Provenance: Paris, art market, ca. 1930–40; Netherlands, private collection; on loan to the museum since 1971

Dordrecht, Museum Mr Simon van Gijn, on loan from a private collection

P. 106
It is not clear where this triptych was executed. The austere *maniera greca* (Byzantine style) used to depict the two Dominicans seems to point to an East European origin. However, it could also come from Venice, since the style and decoration are also reminiscent of the group of works attributed to the Maestro dell'Incoronazione (early 14th century) and his pupil, Paolo Veneziano (active 1347 – ca. 1362).

33
Israhel van Meckenem (Meckenheim? ca. 1440/45 – Bocholt 1503)
Vera icon, ca. 1490

Engraving; 168 × 112 mm
Inscriptions: ŌEΛOÏΛOV̄OC̄ΔOξ (top); IC and XC (either side of the nimbus); Hec ymago contrefacta ē ad instar·' silīitudinē illi' p̄me ymagīs pie/tatis custodite in eccīa sc̄e cruc' ī urbe romana quam fecerat de/pingi sanctissim' gregori' p̄p magn' p' habita ac s' ostēsā desup visioēz (below the image); Israhel V.M. (at the very bottom)
Literature: Lehrs 1934, vol. 9, pp. 177–78, no. 167; Bertelli 1967; Hollstein 1954f, vol. 24 (1986), p. 75, no. 167; Belting 1990, pp. 477–78
Provenance: Von Nagler collection

Berlin, Staatliche Museen zu Berlin, Preußischer Kulturbesitz, Kupferstichkabinett, inv. no. 943–1

P. 110
Israhel van Meckenem worked as a goldsmith between 1465 and 1503, and after 1475 was mainly based in Bocholt. He also made many engravings after works by other artists, such as the Master of the Amsterdam Cabinet (see cat. 8, 10 and 27) and Master E.S. (see cat. 25). The latter was probably his teacher. Van Meckenem was extremely prolific, producing more than 620 engravings, the bulk of which are copies. His own work is far freer and more original.

34

Anonymous (Northern Netherlands)
The Mass of St Gregory, ca. 1460

Woodcut, hand-coloured; 252 × 181 mm
Inscription: Soe wie ons herē wapenen aen siet Daer hi mz dogede syn/ v'driet
Eñ iamm'lyc waert getorment Vanden iodē ombekēt/ Eñ dan sprect ov' sine
knien Drie p̄r n̄r eñ ·iij· aue marien/ Eñ rouwe heeft van sinen sonden Du waer
willic dat/ orconden Dat die ·xiīīj· iaer aflaets heeft Die hem die paus/
gregorius geeft Eñ noch ·ij· pause dats waerhede Die daer/ gauen aflaet mede
Eñ xl bisscopen des gelike Dit mach/ verdienen arm eñ rike Nv verdient al
oetmoedelike.
Literature: Schreiber 1927, vol. 3, no. 1462; Musper 1976, p. 33
Provenance: unknown

Nuremberg, Germanisches Nationalmuseum, inv. no. H.13 Kapsel 6

P. 112
A vision of the dead Christ appeared to St Gregory during Mass. The saint is
kneeling to the left of the altar, and two cardinals are proffering the papal tiara.
Behind Christ is the cross, with the crown of thorns and his robe on the cross-
beam. On the left, on top of the flagellation, is the cock that crowed when the
apostle Peter, shown at top right, denied knowing Christ. The other heads may
be of the traitor Judas, a mocker, Pontius Pilate, governor of Judea, King Herod
and St Veronica (see cat. 14). Her attribute, the cloth with the impression of
Christ face, is also included. On the right is the empty tomb, with three jars of
ointment standing on it.

The two popes mentioned in the inscription (see p. 000 for a translation) in
connection with the augmentation of Pope Gregory's indulgence are Nicholas
V (pope 1447–1455) and Calixtus III (pope 1455–1458). The print was
probably executed not long afterwards, around 1460.

35

Anonymous (Lower Rhine/Westphalia)
Devotional booklet, ca. 1330–50

Outside front cover: *St Lawrence with a bishop and kneeling monk*; inside front
cover: *The Last Supper*; fol. 1r.: *The Arrest of Christ*; fol. 1v.: *Christ before Pilate*;
fol. 2r.: *Christ before Herod*; fol. 2v.: *The Flagellation*; fol. 3r.: *Pilate washing his
hands*; fol. 3v.: *The Carrying of the Cross*; fol. 4r.: *The Crucifixion*; fol. 4v.: *The
Resurrection*; fol. 5r.: *Vera icon*; fol. 5v.: *The Mocking of Christ*; fol. 6r. *The
Instruments of the Passion*; fol. 6v. and inside back cover: *The Instruments of the
Passion*; outside back cover: *The Coronation of the Virgin with a kneeling monk*
Ivory, carved (cover), painted (six leaves); 10.5 × 6 cm
Literature: Köchlin 1924, no. 526; Wentzel 1962
Provenance: acquired in 1872

London, Victoria and Albert Museum, inv. no. 11–1872

P. 114
The combination of two techniques in this devotional booklet, a carved ivory
binding and painted scenes in the book itself, has led to speculation about its
date and place of origin. The style of the cover was deemed to indicate a
French origin, while the Passion scenes bear a resemblance to painting from the
Lower Rhine and Westphalia. It has also been suggested that the cover is older
than the painted scenes.

Nowadays it is assumed that the cover and paintings could well have been
executed at the same time and place. French ivories had spread throughout
Europe, where they were copied. The cover could equally well come from
Germany, and may be an imitation of a French model. The holes at the top of
each leaf may have served as attachments for silk hangings covering and
protecting the scenes.

36

Master of the Magdalene Legend (active in Brussels and Mechelen ca. 1475–1530)
Diptych, 1523

Left: *The Virgin and Child*
Right, front: *Willem van Bibaut*; back: *Arma Christi*
Panel; wings 25 × 14.5 cm
Inscriptions: (left) Obiit Gratia nopoli anno 1575 (on the frame); (right)
Guilielmus bibaucius primas tots/ Ordinis Cartusientium 1523 (on the frame)
Literature: Friedländer 1967–76, vol. 12, pp. 13–17
Provenance: Brussels, Comte d'Outremont collection; Amsterdam, H. Wetzlar
collection; sale Amsterdam (Sotheby/Mak van Waay) 9.6.1977, no. 60; London
Brod Gallery, 1977

Amsterdam, private collection

P. 116
The Master of the Magdalene Legend is named after a large altarpiece of
ca. 1515/20, the six panels of which are now spread over five collections. The
artist was a sound but not very innovative painter who received commissions
from the very highest circles. From around 1490 he must have worked for the
Burgundian/Habsburg court in Brussels and Mechelen, given the many
portraits of Philip the Handsome (1478–1506), his family and numerous
courtiers that are attributed to the artist. Those portraits were copied
extensively, possibly in the master's own workshop. Friedländer has suggested
that the master could be identical with the painter Pieter van Coninxloo, who
is mentioned in documents and worked for the court.

Characteristic of the master is the gold background with dark spots, which can
also be seen in this devotional triptych of 1523. It was probably executed in
Grenoble, referred to on the frame as "*Gratia nopoli*", two years after the
appointment of Willem Bibaut (ca. 1484–1535) as abbot of the Carthusian
order. It is not clear why the inscription states that Bibaut died in 1575.

37

Anonymous (Southern Netherlands, bishopric of Liège?)
The Norfolk triptych, ca. 1415–20

Open, centre: at the top *The apostles James the Less and Peter, Christ and the
Virgin enthroned, the apostles Paul and Andrew*; below *The saintly bishops Servatius
and Lambert, the Man of Sorrows, the saintly bishop Martin and an unknown
bishop*; left wing *St Lawrence, Sts Mary Magdalene, Dorothy, Agnes, Barbara and
Catherine, the Church Fathers Jerome and Gregory*; right wing *St Stephen, Sts
Anthony Abbot, Benedict, Leonard and Giles, the Church Fathers Augustine and
Ambrose.*
Closed: top *The Annunciation*; middle *The Adoration of the Magi with a kneeling
figure*; below left *Four Evangelists and St John the Baptist*; below right *The apostle
James the Greater, the saintly bishops Denis and Hubert, St Vincent and archangel
Michael battling evil*
Panel; centre 33 × 32 cm, wings 33 × 13 cm
Inscriptions: unintelligible inscription in Greek letters (against the Cross behind
the Man of Sorrows, central scene); ave gca plena (beside the angel Gabriel,
back of the right wing, at the top); ecce agnus dei · c (or e?) · g ·(?) (beside John
the Evangelist, back of the left wing, below); most of the saints have their
names on banderoles (back of the left side wing) or on the framing
Literature: Gudlaugsson 1946; Hannema 1949, pp. 32–33; Van Regteren Altena
1953, pp. 226–28; Marrow 1979, p. 175, note 739; Rotterdam 1994
Provenance: London, A.J.B. Beresford-Hope collection; sale Christie's, London
15.5.1886, no. 302; Duke of Norfolk's collection; sale Christie's, London
11.2.1938, no. 85; Amsterdam, J. Goudstikker Gallery; Vierhouten, D.G. van
Beuningen collection, 1938; acquired in 1958

Rotterdam, Museum Boymans-van Beuningen, inv. no. 2466

Pp. 116, 118–22
During the recent restoration of this triptych the overpaint was removed from
the frame. Anne van Grevenstein, who carried out the restoration, has

suggested that the presence of a plug of pinewood could indicate that the triptych was intended also to serve as a reliquary.

To the right of the person kneeling on the outside of the right wing is a mark that looks like a letter, which may be a key to the identity of the supposed donor. In the past it was thought that the letters on John the Evangelist's banner, "·c·g" or "e·g·", followed by a third letter, were a signature. However, it is still not known who painted this triptych. In view of the detailed handling of the scenes, Giltaij (in Rotterdam 1994) has suggested that the artist should be sought among book illuminators.

38
Anonymous (Paris)
Reliquary, ca. 1400–10

Front, open: left *The Virgin mourning and an angel with the Cross*; centre *The Man of Sorrows with an angel*; right *St John mourning and an angel with the lance*; above *The Coronation of the Virgin*
Front, closed: left *John the Baptist*; right *St Catharine*
Back: below *The Death of the Virgin*; middle *Vera icon*; above *The Assumption of the Virgin*
Gold and enamel, opened 12 × 12.7 × 2.5 cm
Literature: Panofsky 1927, p. 277; Müller/Steingraber 1954, pp. 47–48, 72; Lestocquoy 1962; Vienna 1962, no. 466; Gaborit-Chopin 1990, pp. 115–16, 118 note 35 and 38
Provenance: Chocques Abbey?; probably in the T.D. Gibson-Carmichael collection, ca. 1900; Berlin, mentioned in the E. Gutmann collection, 1906 and 1913; Amsterdam, F. Manheimer collection; acquired in 1952

Amsterdam, Rijksmuseum, inv. no. RBK 17045

P. 122
This reliquary, also known as the Chocques triptych, is one of the few surviving testimonies to the high standard of French goldsmith's work around 1400. The triptych, which was probably made in Paris, was reputedly donated to Chocques Abbey (near Béthune, Pas de Calais) by Duchess Mathilde Mahaut of Arras. A duchess of that name died in 1329, but that was before this reliquary could have been made.

In 1962 Lestocquoy identified this triptych in the Rijksmuseum on the basis of a detailed description in the catalogue of an exhibition at Arras in 1896. Among other details given in the catalogue it is stated the triptych originally had a covering of gold-coloured material, and a leather pouch, stamped and engraved with decorative motifs around Christ's monogram.

39
Hans Multscher (Reichenhofen ca. 1400 – Ulm 1467)
The Holy Trinity, ca. 1430–35

Alabaster; 28.5 × 16.3 × 9.8 cm
Inscriptions: maria hilff mir MV Sanizell, hergot las mich nit, glick ist mein freyd unglick ist mein leyd, hilf mir anna sant dritt; IHS (back)
Literature: Tripps 1969, pp. 47, 257 no. 8; Beck/Bückling 1988; Jopek 1988, pp. 59–60, 115–17 no. 11; Leutkirch 1993, pp. 35–37
Provenance: Oberbayern, Schloß Sandizell, until after 1920; private collection; acquired in 1983

Frankfurt, Liebieghaus-Museum alter Plastik, inv. no. St.P. 401

P. 124
Hans Multscher is regarded as the most important South German sculptor of his age. It is thought that he visited the Netherlands, for this would explain the marked realism of his work, and the similarity in this respect to Jan van Eyck (ca. 1390–1441) and Robert Campin (ca. 1378/79–1444). Multscher worked for most of his life in Ulm. He had a large workshop, to which both sculptors and painters were attached. His best known works include a *Man of Sorrows* (1429) and the Karg retable (1433), on and in Ulm Minster, and a retable of the Virgin in Sterzing (1458).

Despite its remarkably good state of preservation, this alabaster sculpture has not survived entirely unscathed. There are two fingers missing from the hand which God has raised in blessing, and at some stage the base was repaired. The scuff marks on the bottom of the base indicate how this *Trinity* was used. It was regularly removed from its setting or small cupboard for private prayer. The inscriptions were meant to assist the worshipper in his or her devotions.

40
Master of the Presentation in the Temple (active in Wiener-Neustadt?, ca. 1420–1440)
Christ at the foot of the Cross, ca. 1425

Panel; 25 × 34 cm
Literature: Vienna 1962, no. 82
Provenance: Berlin, art market; acquired in 1918

Berlin, Staatliche Museen zu Berlin, Preußischer Kulturbesitz, Gemäldegalerie, inv. no. 1837

P. 126
The Meister der Darbringung owes his name to two panel paintings of *Presentation in the Temple*, now in Vienna and Wiener-Neustadt. The artist is thought to have worked in the latter town. On the basis of the Berlin *Christ at the foot of the Cross* it has been suggested that he was a pupil of the Master of the Vienna Adoration (active ca. 1415–30). The attribution to the Master of Presentation in the Temple was abandoned at the exhibition *Europäische Kunst um 1400* (Vienna 1962), where the work was described as "anonymous, Austria".

41
Geertgen tot Sint Jans (active in Haarlem, second half of the 15th century)
The Man of Sorrows

Panel; 26.2 × 25.2 cm
Literature: Panofsky 1953, p. 326; Friedländer 1967–76, vol. 5 (1969), pp. 23, 74–75, no. 7; Hoogewerff 1936–47, vol. 2 (1937), pp. 179–86; Châtelet 1980, pp. 114–15, 221, no. 76
Provenance: Utrecht, Sint Willibrorduskerk; Utrecht, Aartsbisschoppelijk Museum

Utrecht, Rijksmuseum Het Catharijneconvent, inv. no. ABM s 63

P. 128
Geertgen tot Sint Jans owes his sobriquet (at St John's) to his sojourn with the Knights Hospitallers at the Commandery of St John in Haarlem. Very little is known of his life. In his *Schilder-boeck* of 1604, the biographer Karel van Mander says that he studied with the Haarlem painter Albert van Ouwater (ca. 1451–ca. 1475), and that he died at the age of 28. Following Friedländer, his dates are usually placed between 1460/65 and 1490/95. Châtelet, though, locates him considerably earlier in the century, saying that he was active between 1465 and 1475, and that he died before 1480.

Geertgen's principal work was a large *Crucifixion* triptych for the Knights Hospitallers in the Church of St Bavo in Haarlem. All that remains of that work are the two painted sides of one of the wings (Vienna, Kunsthistorisches Museum). A modest number of works are attributed to Geertgen on the basis of stylistic similarities with that wing. The Utrecht *Man of Sorrows* is unanimously accepted as an autograph, late work.

Recent investigation has revealed that the panel has been sawn down slightly on all sides, although without reducing the painted surface. The gold background is probably of a later date. Vestiges of hinges and a small nail hole suggest that this *Man of Sorrows* once served as a door, possibly on a portable tabernacle.

42
Andrea Mantegna (Isola di Cartura ca. 1430/31 –
Mantua 1506)
The Virgin with the sleeping Child, ca. 1465–70

Canvas; 43 × 32 cm
Inscription: AVE MARIA:GRACIA (on the frame, possibly not original)
Literature: Lightbown 1986, p. 424; London/New York 1992, no. 41
Provenance: Vicenza, conte Della Porta collection; London, art market; James
Simon collection, ca. 1897

Berlin, Staatliche Museen zu Berlin, Preußischer Kulturbesitz, Gemäldegalerie,
inv. no. S.5

P. 132

Until 1448, Andrea Mantegna trained with Francesco Squarcione (1397–1468)
in Padua, where he assimilated the influence of such figures as Antonio
Vivarini (active 1440–ca. 1476/84), Andrea del Castagno (1421–1457 ?),
Donatello (ca. 1386–1466) and Jacopo Bellini (ca. 1400–ca. 1470/71), and
married Bellini's daughter. From 1459 he was in Mantua as court painter to
Lodovico Gonzaga (died 1478) and his successors. For them he painted such
works as the frescos in the Camera degli Sposi of the Palazzo Ducale
(completed 1474), and the cycle with the *Triumphs of Caesar* now at Hampton
Court (ca. 1486–94). He visited Florence and Pisa, and worked in Rome from
1488 to 1490.

The Berlin *Madonna* is widely accepted as an authentic Mantegna, although
there is great disagreement over its dating. Some authors, believing they can
detect the influence of Donatello, date it to the 1450s. Others place it in the
period after Mantegna's Tuscan journey of 1466, citing similarities to the
Camera degli Sposi frescos. Lightbown regards it as a late work, and dates it
around 1490/95.

43
Anonymous (Gelderland?)
The Antwerp-Baltimore polyptych, ca. 1400

Open: *The Annunciation* (a), *The Nativity* (b), *The Crucifixion* (c), *The Resurrection*
(d)
Panel; wings 38 × 26.5 cm (a and c), 37.6 × 26.2 cm (b and d)
Closed: *Baptism of Christ* (e) and *St Christopher* (f)
Inscriptions: al/pha// et Ω, Ave gracia plena dominus tecom, ecce/ ancil/la//
do/mi/ni *Annunciation*; ego/ sum// via/ vitas, ·i·n·r·i·, eloy eloy lamasabatani
Crucifixion; al/pha// et Ω ·, ·gloria in excelsis deo et in terra,
·Sanctus·Sanctus·Sanctus· *Resurrection*
Literature: Panofsky 1953, vol. 1, pp. 93–95, 97, 127, 394–95n.; 447n.; De Coo
1958 and 1960; Vienna 1962, no. 12; De Coo 1978, pp. 123–29; Châtelet
1981, pp. 21–24, 190–91, no. 5; Nieuwdorp/Guislian-Witterman/Kockaert
1984-85; Zafran 1988, pp. 86–91, no. 34
Provenance: Champmol, Charteuse, until 1772–74(?); presented by Louis XV to
C.A. de la Roche-Aymon, Champigny-les-Vitraux; C.G. de la Roche-Aymon
collection (provenance uncertain up to this point); Niort, Cuvillier collection,
ca. 1904; Paris, A. Seligman, Rey & Co.; Baltimore, H. Walters collection, 1919;
acquired in 1939 (a, c, e); Dijon, Bartholomey collection; auctioned Paris
23.1.1843; Paris, C. Micheli collection; purchased by F. Mayer van den Bergh
in 1898 (b, d, f)

(a/e, c) Baltimore, The Walter's Art Gallery, inv. nos. 37.1683 A-C
(b, d/f) Antwerp, Museum Mayer van den Bergh, cat. 1, no. 374

Pp. 137–48

44
Attributed to Geertgen tot Sint Jans (active in
Haarlem, second half of the 15th century)
Diptych, ca. 1480?

Left (a): *Christ on the cross with Passion scenes*
Right (b): *The Glorification of the Virgin*
Panel, wings 26.8 × 20.5 cm
Literature: Hoogland 1888; Kronenburg 1905, vol. 3; Friedländer 1949,
pp. 186–88; Panofsky 1953, pp. 494–95, note 324; Snyder 1957, pp. 131–32;
Sulzberger/van Regteren Altena 1959; Ringbom 1962; Engelbrecht 1963; Van
Os 1964; Lemmens 1966; Kermer 1967, vol. 2, pp. 142–46, no. 140A;
Winternitz 1967; Friedländer 1967–76, vol. 5 (1969), pp. 91–92,
Add.nos. 139–40 ((a) not by Geertgen); Châtelet 1981, pp. 134–38, 226–77,
nos. 99A/B
Provenance: Cardinal Fesch collection; auctioned Rome, March–April 1845,
no. 264 (a and b); England, private collection (a); New York, V. Spark
collection; New York, Wildenstein; Vierhouten, D.G. van Beuningen collection,
1952; acquired in 1961 (b)

(a) Edinburgh, National Galleries of Scotland, inv. no. 1253
(b) Rotterdam, Museum Boymans-van Beuningen, inv. no. 2450

P. 151; see also cat. 41
When it was discovered, the *Glorification of the Virgin* was generally hailed as a
work by Geertgen, but doubt was cast on that attribution in 1959 when
Sulzberger and Van Regteren Altena demonstrated that it originally formed a
diptych with the Edinburgh *Crucifixion*.

BIBLIOGRAPHY

Amsterdam/Frankfurt 1985
J.P. Filedt Kok, exhibition catalogue *Livelier than Life. The Master of the Masterdam Cabinet or the Housebook Master ca. 1470–1500*, Amsterdam (Rijksmuseum, Rijksprentenkabinet)/ Frankfurt a.M. (Städtische Galerie im Städelsche Kunstinstitut) 1985 (Dutch edition *'s Levens felheid. De Meester van het Amsterdamse Kabinet of de Hausbuch-meester ca. 1470– 1500*)

Andriessen/Bange/Weiler 1985
Edd. J. Andriessen, P. Bange and A.G. Weiler, *Geert Grote en Moderne Devotie. Voordrachten gehouden tijdens het Geert Grote congres, Nijmegen 27–29 september 1984* (Middeleeuwse Studies dl. 1), Nijmegen 1985

Von Andrian-Werburg 1992
J. von Andrian-Werburg, '800 Jahre deutscher Orden. Ausstellung des Germanischen Nationalmuseums 1990. Ergänzungen und Korrekturen', *Anzeiger des Germanischen Nationalmuseums*, Nuremberg 1992

Angenendt 1994
A. Angenendt, *Heilige und Reliquien. Die Geschichte ihres Kultes vom frühen Christentum bis zur Gegenwart*, Munich 1994

Baarsen 1992
Ed. R. Baarsen, 'Keuze uit recente schenkingen en legaten', *Bulletin Rijksmuseum* XL, 1992, pp. 297–98

Baxandall 1980
M. Baxandall, *The Limewood Sculptors of Germany*, New Haven/London 1980

Beck 1980
H. Beck, *Liebieghaus-Museum alter Plastik, Führer durch die Sammlungen: Bildwerke des Mittelalters I*, Frankfurt a.M. 1980

Beck/Bückling 1988
H. Beck and M. Bückling, *Hans Multscher. Das Frankfurter Trinitätsrelief. Ein Zeugnis spekulativer Künstlerindividualität*, Frankfurt a.M. 1988

Bellosi/Angelini 1986
L. Bellosi and A. Angelini, *Monte dei Paschi di Siena, Collezione Chigi Saracini*, 3 vols. , Siena 1986

Belting 1981
H. Belting, *Das Bild und sein Publikum im Mittelalter. Form und Funktion früher Bildtafeln der Passion*, Berlin 1981

Belting 1990
H. Belting, *Bild und Kult. Eine Geschichte des Bildes vor dem Zeitalter der Kunst*, Munich 1990

Belting/Blume 1989
Edd. H. Belting and D. Blume, *Malerei und Stadtkultur in der Dantezeit. Die Argumentation der Bilder*, Munich 1989

Berliner 1955
R. Berliner, 'Arma Christi', *Münchner Jahrbuch der bildenden Künste* VI, 1955, pp. 35–116

Bertelli 1967
C. Bertelli, 'The "Image of Pity" in Santa Croce in Gerusalemme', in *Essays in the history of art presented to Rudolph Wittkower*, edd. D. Fraser, H. Hibbard and M.J. Lewine, London 1967, pp. 40–55

Bloch 1969
P. Bloch, *Madonnenbilder. Vierzig Denkmäler der Skulpturenabteilung* (Bilderhefte der Staatliche Museen Preußischer Kulturbesitz Band 14), Berlin 1969

Boeren 1979
P.C. Boeren, *Catalogus handschriften Rijksmuseum Meermanno-Westreenianum*, The Hague 1979

Boespflug/Lossky 1987
F. Boespflug and N. Lossky, *Nicée II 787–1987. Douze siècles d'images religieuses*, Paris 1987

Boon 1964
K.G. Boon, 'Nieuwe gegevens over de meester van Katharina van Kleef en zijn atelier', *Bulletin van de Koninklijke Nederlandsche Oudheidkundige Bond* XVII, 1964, pp. 241–54

Brandenbarg 1990
T. Brandenbarg, *Heilig familieleven. Verspreiding en waardering van de Historie van Sint-Anna in de stedelijke cultuur in de Nederlanden en het Rijnland aan het begin van de moderne tijd (15de/16de eeuw)*, Nijmegen 1990

Brandhorst/Broekhuisen-Kruijer 1985
J.P.J. Brandhorst and K.H. Broekhuisen-Kruijer, *De verluchte handschriften en incunabelen van de Koninklijke Bibliotheek*, The Hague 1985

Brigstocke 1978
H. Brigstocke, *Italian and Spanish Painting in the National Gallery of Scotland*, Glasgow 1978

Brussels/Delft 1957–58
Dieric Bouts, exhibition catalogue, Brussels (Paleis voor Schone Kunsten)/Delft (Museum Het Prinsenhof) 1957–58

Brussels 1994
Ed. P. Vandenbroeck, exhibition catalogue *Hooglied. De beeldwereld van religieuze vrouwen in de Zuidelijke Nederlanden, vanaf de 13de eeuw*, Brussels (Paleis voor Schone Kunsten) 1994

Bynum 1982
C. Walker Bynum, *Jesus as Mother. Studies on the spirituality of the High Middle Ages* (Publications of the Center for Medieval and Renaissance Studies UCLA vol. 16), Berkeley/Los Angeles 1982

Bynum 1987
C. Walker Bynum, *Holy Feast and Holy Fast. The religious significance of food to medieval women*, Berkeley/Los Angeles/London 1987

Byvanck 1924
A.W. Byvanck, *Les principaux manuscrits à peintures de la Bibliothèque Royale des Pays-Bas et du Musée Meermanno-Westreenianum à La Haye*, Paris 1924

Caron 1984
M.L. Caron, 'Ansien doet gedencken. De religieuze voorstellingswereld van de Moderne Devotie', in Utrecht 1984, pp. 25–43

Cauchies 1989
Ed. J.-M. Cauchies, *La dévotion moderne dans les pays bourguignons et rhénans dès origines à la fin du XVIe siècle*, Rencontres de Colmar-Strasbourg (29 septembre au 2 octobre 1988) (Publications du Centre Européen d'études Bourguignonnes tome 29), Neuchatel 1989

Challoner 1945
B. Challoner, *The Garden of the Soul*, London 1945

Châtelet 1980
A. Châtelet, *Les primitifs hollandais. La peinture dans les Pays-Bas du Nord au XVᵉ siècle*, Fribourg 1980

Claussen 1978
P.C. Claussen, 'Goldschmiede des Mittelalters. Quellen zur Struktur ihrer Werkstatt am Beispiel der Schreine von Sainte-Geneviève in Paris, Westminster Abbey in London, St. Gertrud in Nivelles und St. John in Beverly', *Zeitschrift des deutschen Vereins für Kunstwissenschaft* XXXII, 1978, pp. 46–86

Colman 1966
P. Colman, *L'orfèvrerie religieuse liégeoise du XVe siècle à la révolution*, Liège 1966

Cologne 1960
Ed. H. Schnitzler, exhibition catalogue *Große Kunst des Mittelalters aus Privatbesitz*, Cologne (Schnütgen-Museum) 1960

Cologne 1968
Ed. H. May, exhibition catalogue *Weltkunst aus Privatbesitz*, Cologne (Kunsthalle) 1968

Cologne 1973
Ed. R. Wallrath, exhibition catalogue *Vor Stefan Lochner. Die Kölner Maler von 1300 bis 1430*, Cologne (Wallraf-Richartz-Museum) 1974

Cologne 1993–94
Ed. F.G. Zehnder, exhibtion catalogue *Stefan Lochner – Meister zu Köln. Herkunft – Werke – Wirkung*, Cologne (Wallraf-Richartz-Museum) 1993–94

De Coo 1958
J. de Coo, 'De unieke voorstelling van de "Jozefs-kousen" in het veelluik Antwerpen-Baltimore van ca. 1400', *Oud Holland* LXX, 1958, pp. 186–98

De Coo 1960
J. de Coo, 'De voorstelling met de "Jozefskousen" in het veelluik Antwerpen-Baltimore toch niet uniek', *Oud Holland* LXXII, 1960, pp. 222–28

De Coo 1969
J. de Coo, *Museum Mayer van den Bergh, catalogus 2: beeldhouwkunst, plaketten, antiek*, Antwerp 1969

De Coo 1978
J. de Coo, *Museum Mayer van den Bergh, catalogus 1: schilderijen, verluchte handschriften, tekeningen*, Antwerp 1978

Dinzelbacher 1986
Ed. P. Dinzelbacher, *Wörterbuch der Mystik*, Stuttgart 1986

Dinzelbacher/Bauer 1985
Edd. P. Dinzelbacher and D.R. Bauer, *Frauenmystik im Mittelalter*, Ostfildern 1985

Dinzelbacher/Bauer 1988
Edd. P. Dinzelbacher and D.R. Bauer, *Religiöse Frauenbewegung und mystische Frömmigkeit im Mittelalter*, Bonn 1988

Dobschütz 1899
E. von Dobschütz, *Christusbilder. Untersuchungen zur christlichen Legende* (Texte und Untersuchungen zur Geschichte der altchristlichen Literatur Band 18), Leipzig 1899

Dresen 1989
G. Dresen, 'Vrouwen bezeten van liefde. Van minnemystiek naar lijdenslust in de late middeleeuwen', *Ongeregeld zenuwleven. Historische opvattingen over de relatie tussen vrouwen en waanzin*, Utrecht 1989

Duby 1966
G. Duby, *Fondements d'un nouvel humanisme*, Geneva 1966

Dülberg
A. Dülberg, *Privatporträts. Geschichte und Ikonologie einer Gattung im 15. und 16. Jahrhundert*, Berlin 1990 (diss. Cologne 1985)

Van Dijk 1990
R. van Dijk, 'Het Getijdenboek van Geert Grote: terugblik en vooruitzicht', *Ons Geestelijk Erf* LXIV, 1990, pp. 156–94

Eisenberg 1989
M. Eisenberg, *Lorenzo Monaco*, Princeton 1989

Ekkart 1979
R.E.O. Ekkart, '15e eeuws Noordnederlands getijdenboek van de Meester van Catharina van Kleef', *Bijvoorbeeld* XI, 1979, pp. 22–26

Elm 1984
K. Elm, 'Die Bruderschaft vom gemeinsamen Leben. Eine geistliche Lebensform zwischen Kloster und Welt, Mittelalter und Neuzeit', in Andriessen/Bange/Weiler 1985, pp. 421–34

Engelbrecht 1963
J.H.A. Engelbrecht, ' "Het glorievolle rozenkransgeheim van Maria's kroning in de hemel" door Geertgen tot Sint Jans', in *Album discipulorum aangeboden aan Prof. Dr J.G. van Gelder*, Utrecht 1963, pp. 31–44

Feld 1990
H. Feld, *Der Ikonoklasmus des Westens* (Studies in the History of Christian Thought vol. 41), Leiden 1990

Feulner 1933
A. Feulner, 'Ein Christuskind des Blaubeurer Meisters', *Pantheon* XII, 1933, pp. 382–84

Filedt Kok 1990
J.P. Filedt Kok, 'Master IAM of Zwoll. The personality of a designer and engraver', in *Festschrift to Erik Fischer. European drawings from six centuries*, Copenhagen 1990, pp. 341–56

Frankfurt 1975–76
Edd. H. Beck, W. Beeh and H. Bredekamp, exhibition catalogue *Kunst um 1400 am Mittelrhein. Ein Teil der Wirklichkeit*, Frankfurt (Liebieghaus-Museum alter Plastik) 1975–76

Freiburg 1978
Ed. H.H. Hofstätter, exhibition catalogue *Mystik am Oberrhein und in benachbarten Gebieten*, Freiburg i.B. (Augustinermuseum) 1978

Freuler 1987
G. Freuler, 'Andrea di Bartolo, Fra Tommaso d'Antonio Caffarini, and Sienese Dominicans in Venice', *Art Bulletin* LXIX, 1987, pp. 570–86

Friedländer 1940
M.J. Friedländer, 'De kersttentoonstelling in Museum Boymans te Rotterdam', *Maandblad voor beeldende kunsten* XVII, 1940, p. 37

Friedländer 1949
M.J. Friedländer, 'Zu Geertgen tot Sint Jans', *Maandblad voor beeldende kunsten* XXV, 1949, pp. 186–88

Friedländer 1967–76
M.J. Friedländer, *Early Netherlandish Painting*, 14 vols., Leiden/Brussels 1967–76 (*Die altniederländische Malerei*, Berlin/Leiden 1924–37)

Gaborit-Chopin 1990
D. Gaborit-Chopin, 'Une "Pitié Nostre Seigneur" d'ivoire', in edd. H. Krohm and Ch. Theuerkauff, *Festschrift für Peter Bloch zum 11. Juli 1990*, Mainz 1990, pp. 111–19

Van Geest 1993
P. van Geest, 'De sermones van Thomas a Kempis. Een terreinverkenning', *Trajecta* II, 1993, pp. 305–26

Gerrits 1986
G.H. Gerrits, *Inter timorem et spem. A study of the theological thought of Gerard Zerbolt of Zutphen (1367–1398)* (Studies in Medieval and Reformation Thought vol. 37), Leiden 1986

Gilbert 1984
C.E. Gilbert, 'Tuscan observants and painters in Venice, ca. 1400', in *Interpretazioni veneziane. Studi di storia dell'arte in onore di Michelangelo Muraro*, Venice 1984, pp. 109–20

Goffen 1975
R. Goffen, 'Icon and vision. Giovanni Bellini's half-lenght Madonnas', *Art Bulletin* LVII, 1975, pp. 487–518

Goossens 1952
L.A.M. Goossens, *De meditatie in de eerste tijd van de moderne devotie*, Haarlem 1952

Graesse 1890
Ed. Th. Graesse, *Jacobi a Voragine, Legenda aurea vulgo historia lombardica dicta*, Bratislaw 1890

Groningen/Utrecht 1969
Edd. H.K. Gerson and H.W. van Os, exhibition catalogue *Sienese paintings in Holland*, Groningen (Groninger Museum)/Utrecht (Aartsbisschoppelijk Museum) 1969

Groningen/Utrecht/Florence 1974
H.W. van Os and M. Prakken, exhibition catalogue *The Florentine paintings in Holland*, Groningen (Groninger Museum)/Utrecht (Aartsbisschoppelijk Museum)/Florence (Nederlands Interuniversitair Kunsthistorisch Instituut) 1974

Gudlaugsson 1946
S. Gudlaugsson, 'Aanvullingen omtrent de Norfolk-triptiek', *Kunsthistorische mededeelingen van het Rijksbureau voor Kunsthistorische Documentatie* I, 1946, pp. 17–22

The Hague 1980–81
A.S. Korteweg and C.A. Chavannes-Mazel, exhibition catalogue *Schatten van de Koninklijke Bibliotheek. Acht eeuwen verluchte handschriften*, The Hague (Koninklijke Bibliotheek) 1980–81

Hand 1992
J.O. Hand, ' "Salve sancta facies". Some thoughts on the iconography of the "Head of Christ" by Petrus Christus', *The Metropolitan Museum Journal* XXVII, 1992, pp. 7–18

Hand/Wolff 1986
J.O. Hand and M. Wolff, *Early Netherlandish Painting* (The Collections of the National Gallery of Art), Washington 1986

Hannema 1949
D. Hannema, *Catalogue of the D.G. van Beuningen collection*, Rotterdam 1949

Harbison 1985
C. Harbison, 'Visions and meditations in early Flemish painting', *Simiolus* XV, 1985, pp. 87–118

Harbison 1991
C. Harbison, *Jan van Eyck. The play of realism*, London 1991

Hausherr 1975
R. Hausherr, 'Über die Christus-Johannes-Gruppen. Zum Problem "Andachtsbilder" und deutsche Mystik', in *Beiträge zur Kunst des Mittelalters. Festschrift für Hans Wentzel zum 60. Geburtstag*, Berlin 1975

Heitz 1899–1942
Ed. P. Heitz, *Einblattdrücke des XV. Jahrhunderts*, 100 vols., Strasbourg 1899–1942

Van Herwaarden 1984
J. van Herwaarden, 'Gemeenschappen en kloosters van de Moderne Devotie', in Utrecht 1984, pp. 12–24

Hilger 1991
H.P. Hilger, *Das Jesuskind mit der Weintraube* (Bayerisches Nationalmuseum Bildführer Band 19), Munich 1991

Hinz 1981
P. Hinz, *Deus Homo. Das Christusbild von seinen Ursprüngen bis zur Gegenwart*, 2 vols., Berlin 1973–81, vol. 2: *Von der Romanik bis zum Ausgang der Renaissance*

Huy 1990
Exhibition catalogue *Filles de Cîteaux au pays mosan*, Huy (Collégiale Notre-Dame de Huy) 1990

Hollstein 1954ff.
F.W.M. Hollstein, *German engravings, etchings and woodcuts ca. 1400–1700*, 22 vols., Amsterdam/Blaricum/Roosendaal 1954ff.

Honée 1991
E. Honée, 'Vroomheid en kunst in de late Middeleeuwen. Over de opkomst van het devotiebeeld', *Millennium* V, 1991, pp. 14–31

Hood 1986
W. Hood, 'Saint Dominic's manners of praying. Gestures in Fra Angelico's cell frescoes at S. Marco', *Art Bulletin* LXVIII, 1986, pp. 195–206

Hood 1990
W. Hood, 'Fra Angelico at San Marco. Art and the liturgy of cloistered life', in edd. Th. Verdon and J. Henderson, *Christianity and the Renaissance. Image and religious imagination in the Quattrocento*, Syracuse (NY) 1990, pp. 108–31

Hoogewerff 1936–47
G.J. Hoogewerff, *De Noord-Nederlandsche schilderkunst*, 5 vols., The Hague 1936–47

Hoogland 1888
A.J.J. Hoogland, 'De Dominicanen te Haarlem', *Bijdragen voor de geschiedenis van het bisdom van Haarlem* XV, 1888, pp. 101–71

Hueck 1967
I. Hueck, 'Ein Madonnenbild im Dom von Padua – Rom und Byzanz', *Mitteilungen des kunsthistorischen Institutes in Florenz* XIII, 1967, pp. 1–30

Huizinga 1919
J. Huizinga, *The Waning of the Middle Ages* (Dutch edition *Herfsttij der middeleeuwen*, Haarlem 1919)

Jopek 1988
N. Jopek, *Studien zur deutschen Alabasterplastik des 15. Jahrhunderts* (Manuskripte zur Kunstwissenschaft in der Wernerschen Verlagsgesellschaft), Worms 1988

Kaftal 1952–85
G. Kaftal, *Saints in Italian art*, 4 vols., Florence 1952–85

Kermer 1967
W. Kermer, *Studien zum Diptychon in der sakralen Malerei von den anfängen bis zur Mitte des sechzehnten Jahrhunderts*, 2 vols., Tübingen 1967 (diss. 1966)

Kirschbaum/Braunfels 1968–76
Edd. E. Kirschbaum and W. Braunfels, *Lexikon der christlichen Ikonographie*, 8 vols. , Rome/Freiburg/Basle/Vienna 1968–76

Kleineidam 1950
E. Kleineidam, 'Die Nachfolge Christi nach Bernhard von Clairvaux', in edd. E. Kleineidam, O. Kuss and E. Puzik, *Amt und Sendung. Beiträge zu seelsorglichen und religiösen Fragen*, Freiburg i.B. 1950, pp. 432–60

Koechlin 1924
R. Koechlin, *Les ivoires gothiques français*, 2 vols. , Paris 1924

Krönig 1962
W. Krönig, 'Rheinische Vesperbilder aus Leder und ihr Umkreis', *Wallraf-Richartz-Jahrbuch* XXIV, 1962, pp. 97–192

Kronenburg 1905
J.A.F. Kronenburg, *Maria's heerlijkheid in Nederland. Geschiedkundige schets van de vereering der Heilige Maagd in ons vaderland, van de vroegste tijden tot op onze dagen*, 8 vols. , Amsterdam 1904–14

Kroos 1986
R. Kroos, ' "Gotes tabernakel". Zu Funktion und Interpretation von Schreinmadonnen', *Zeitschrift für Schweizerische Archäologie und Kunstgeschichte* XLIII (1986), pp. 58–64

Krüger 1990
K. Krüger, 'Bildandacht und Bergeinsamkeit. Der Eremit als Rollenspiel in der städtischen Gesellschaft', in Belting/Blume 1990, pp. 187–200

Langer 1987
O. Langer, *Mystische Erfahrung und spirituelle Theologie. Zu Meister Eckharts Auseinandersetzung mit der Frauenfrömmigkeit seiner Zeit*, Munich 1987

Legner 1969
A. Legner, 'Der Alabasteraltar aus Rimini', *Städel-Jahrbuch* N.F. II, 1969, pp. 101–68

Lehrs 1908–34
M. Lehrs, *Geschichte von und Katalog der Deutsche, Niederländische und Französische Kupferstiche im XV. Jahrhundert*, 10 vols. , Vienna 1908–34

Lemmens 1966
G. Th. M. Lemmens, 'Geertgen tot Sint Jans' "Kruisiging met de Heilige Dominicus" ', *Oud Holland* LXXXI, 1966, pp. 73–87

Lentes 1993
Th. Lentes, 'Die Gewänder der Heiligen. Ein Diskussionsbeitrag zum Verhältnis von Gebet, Bild und Imagination', in ed. G. Kerscher, *Hagiographie und Kunst. Der Heiligenkult in Schrift, Bild und Architektur*, Berlin 1993, pp. 120–51

Lestocquoy 1962
J. Lestocquoy, 'Un email parisien du Rijksmuseum d'Amsterdam', *Bulletin de la Société nationale des Antiquaires de France* 1962, pp. 175–79

Leutkirch 1993
M. Tripps *et al.*, exhibition catalogue *Hans Multscher – Meister der Spätgotik. Sein Werk, seine Schule, seine Zeit*, Leutkirch im Allgäu (Museum im Bock) 1993

Lightbown 1986
R. Lightbown, *Mantegna. With a complete catalogue of the paintings, drawings and prints*, Oxford 1986

Little 1979
C.T. Little, 'Ivoires et art gothique', *Revue de l'Art* XLVI, 1979, pp. 58–67

London/New York 1992
Ed. J. Martineau, exhibition catalogue *Andrea Mantegna*, London (Royal Academy of Arts)/New York (Metropolitan Museum of Art) 1992

Marrow 1979
J. Marrow, *Passion iconography in Northern European art of the late middle ages and early renaissance. A study of the transformation of sacred metaphor into descriptive narrative* (Ars Neerlandica. Studies in the history of art of the Low Countries published under the auspices of the Ministerie van Nederlandse Cultuur, Brussels, vol. 1), Kortrijk 1979

Meditationes
Edd. I. Ragusa and R.B. Green, *Meditations on the life of Christ. An illustrated manuscript of the fourteenth century* (Princeton monographs in art and archaeology vol. 35), Princeton 1961

Van der Meer 1970
F. van der Meer, *Lofzangen der Latijnse Kerk*, Utrecht/Antwerp 1970

Mollat du Jourdan/Vauchez
Edd. M. Mollat du Jourdin and A. Vauchez, *Un temps d'épreuves (1274–1449)* (Histoire du christianisme des origines à nos jours, tome 6), Paris 1990

Moran/Seymour 1967
G. Moran and C. Seymour, 'The Jarves St. Martin and the beggar', *Yale University Art Gallery Bulletin* XXXI, 1967, pp. 28–39

Müller/Steingraber 1954
Th. Müller and E. Steingraber, 'Die französische Goldemailplastik um 1400', *Münchner Jahrbuch der bildenden Kunst* V, 1954, pp. 29–79

Munich 1970
Exhibition catalogue *Die Frühzeit des Holzschnitts*, Munich (Staatliche Graphische Sammlung) 1970

Munich/Berlin 1986–87
H. Bevers, *Meister E.S. Ein oberrheinischer Kupferstecher der Spätgotik*, Munich (Staatliche Graphische Sammlung)/Berlin (Staatliche Museen Preußischer Kulturbesitz, Kupferstichkabinett) 1986–87

Musper 1976
H. Th. Musper, *Der Einblattholzschnitt und die Blockbücher des XV. Jahrhunderts*, Stuttgart 1976 (W.L. Schreiber, *Handbuch der Holz- und Metallschnitte des XV. Jahrhunderts*, Band 9)

Nieuwdorp/Guislian-Witterman/Kockaert 1984/85
H. Nieuwdorp, R. Guislian-Witterman and L. Kockaert, 'Het Pre-Eyckiaanse vierluik Antwerpen-Baltimore. Historisch en technologisch onderzoek', *Bulletin van het Koninklijk Instituut voor het Kunstpatrimonium* XX, 1984/85, pp. 70–98

Niffle-Anciaux 1889
E. Niffle-Anciaux, 'Les Repos de Jésus et les berceaux reliquaires', *Annales de la Société archéologique de Namur* XVIII, 1889, pp. 420–84

Niffle-Anciaux 1911
E. Niffle-Anciaux, ' "Repos de Jésus" alias "Jésueau" ', *Annales de la Société archéologique de Namur* XXX, 1911, pp. 194–202

Nyberg 1985
T. Nyberg, 'Birgitta von Schweden – die aktive Gottesschau', in Dinzelbacher/Bauer 1985, pp. 275–89

Offner 1932
R. Offner, 'The works and style of Francesco di Vannuccio', *Art in America* XX, 1932, pp. 89–114

Offner/Boskovits 1989
Edd. R. Offner and K. Steinweg, *A corpus of Florentine painting. The fourteenth century*, Part 3, vol. 3, *The works of Bernardo Daddi*, revised M. Boskovits and E. Neri Lusanna, Florence 1989 (New York 1930)

Offner/Boskovits 1990
R. Offner, *A corpus of Florentine painting. The fourteenth century*, Part 3, vol. 4, *Bernardo Daddi, his shop and following*, revised M. Boskovits, Florence 1990 (New York 1934)

Van Os 1964
H.W. van Os, 'Coronatio, Glorificatio en Maria in Sole', *Bulletin Museum Boymans-van Beuningen* XV, nr. 2–3, 1964, pp. 23–38

Van Os 1969
H.W. van Os, *Marias Demut und Verherrlichung in der sienesischen Malerei 1300–1450* (Kunsthistorische studiën van het Nederlands Historisch Instituut te Rome dl. 1), The Hague 1969

Van Os 1971
H.W. van Os, 'The Madonna and the Mystery Play', *Simiolus* V, 1971, pp. 5–19

Van Os 1978
H.W. van Os, 'The discovery of an early Man of Sorrows on a dominican triptych', *Journal of the Warburg and Courtauld Institutes* XLI, 1978, pp. 65–75

Van Os et al. 1989
Edd. H.W. van Os, J.R.J. van Asperen de Boer, C.E. de Jong-Janssen and C. Wiethoff, *The early Sienese paintings in Holland*, Florence/The Hague 1989

Van Os 1992
H.W. van Os, *Studies in Early Tuscan Painting*, London 1992

Van Os/Rinkleff-Reinders 1972
H.W. van Os and M. Rinkleff-Reinders, 'De reconstructie van Simone Martini's zogenaamde Polyptiek van de Passie', *Nederlands Kunsthistorisch Jaarboek* XXIII, 1972, pp. 13–26

Otto 1943
G. Otto, *Gregor Erhart* (Denkmäler Deutscher Kunst), Berlin 1943

Panofsky 1927
E. Panofsky, ' "Imago Pietatis", ein Beitrag zur Typengeschichte des "Schmerzensmannes" und der "Maria Mediatrix" ', in *Festschrift für Max J. Friedländer zum 60. Geburtstag*, Leipzig 1927, pp. 261–308

Panofsky 1953
E. Panofsky, *Early Netherlandish Painting*, 2 vols., Cambridge (MA) 1971 (1953)

Post 1968
R.R. Post, *The Modern Devotion. Confrontation with Reformation and Humanism* (Studies in Medieval and Reformation Thought vol. 3), Leiden 1968

Preysing 1981
M. Gräfin Preysing, 'Über Kleidung und Schmuck von Brabanter Christkindfiguren', in *Documenta textilia. Festschrift für Sigrid Muller-Christensen* (Forschungshefte Bayerisches Nationalmuseum München Band 7), Munich 1981, pp. 349–56

Purtle 1982
C.J. Purtle, *The Marian Paintings of Jan van Eyck*, Princeton 1982

187

Radler 1990
G. Radler, *Die Schreinmadonna "Vierge ouvrante" von den berhardinischen Anfängen bis zur Frauenmystik im Deutschordensland* (Frankfurter Fundamente der Kunstgeschichte Band 6), Frankfurt 1990

Randall 1993
R.H. Randall, *The Golden Age of ivory. Gothic carvings in North American collections*, New York 1993

Rapp 1963
F. Rapp, 'La prière dans les monastères des dominicaines observantes en Alsace au XVᵉ siècle', in *La mystique rhénane*, Paris 1963, pp. 207–18

Rapp 1985
F. Rapp, 'Zur Spiritualität in elsässischen Frauenkloster am Ende des Mittelalters', in Dinzelbacher/Bauer 1985, pp. 347–65

Van Regteren Altena 1953
J.Q. van Regteren Altena, review of Hannema 1949, *Oud Holland* 1953, pp. 225–31

Ridderbos 1984
B. Ridderbos, *Saint and symbol. Images of Saint Jerome in early Italian art*, Groningen 1984

Ringbom 1962
S. Ringbom, 'Maria in Sole and the Virgin of the Rosary', *Journal of the Warburg and Courtauld Institutes* xxv, 1962, 326–30

Ringbom 1984
S. Ringbom, *Icon to narrative. The rise of the dramatic close-up in fifteenth-century devotional painting* (Acta Academiae Aboensis ser. A, Humaniora, vol. 31, nr. 2), Doornspijk 1984 (Åbo 1965)

Roth 1967
E. Roth, *Die volkreiche Kalvarienberg* (Philologische Studien und Quellen Band 2), Berlin 1967

Rotterdam 1994
Edd. J. Giltaij and F. Lammertse, exhibition catalogue *Van Van Eyck tot Bruegel*, Rotterdam (Museum Boymans-van Beuningen) 1994

Rowley 1958
G. Rowley, *Ambrogio Lorenzetti*, Princeton 1958

Ruh 1964
K. Ruh, 'Zur Grundlegung einer Geschichte der franziskanischen Mystik', in ed. K. Ruh, *Altdeutsche und altniederländische Mystik* (Wege der Forschung Band 23), Darmstadt 1964, pp. 240–74

Ruh 1993
K. Ruh, *Geschichte der abendländischen Mystik*, Band 2: *Frauenmystik und Franziskanische Mystik der Frühzeit*, Munich 1993

Schiller 1966–80
G. Schiller, *Ikonographie der christlichen Kunst*, 5 vols., Gütersloh 1966–80

Schmitt et al. 1935f.
Ed. O. Schmitt, also E. Gall, L.H. Heydenreich, H.M. Frhr. von Erffa and K.-A. Wirth, *Reallexikon zur deutschen Kunstgeschichte*, Stuttgart/Munich 1935f.

Schöne et al. 1959
W. Schöne, J. Kollwitz and H. Freiherr v. Campenhausen, *Das Gottesbild im Abendland* (Glaube und Forschung Band 15), Witten/Berlin 1959 (1957)

Schreiber 1926–30
W.L. Schreiber, *Handbuch der Holz- und Metalschnitte des XV. Jahrhunderts*, 8 vols., Leipzig 1926–30

Schuppisser 1986
F.O. Schuppisser, 'Die Engelweihe der Gnadenkapelle von Einsiedeln in der frühen Druckgraphik', in *"Nobile claret opus". Festgabe für Frau Prof.Dr. Ellen Judith Beer zum 60. Geburtstag, Zeitschrift für Schweizerische Archäologie und Kunstgeschichte* XLIII, 1986, pp. 141–50

Snyder 1957
J.E. Snyder, *Geertgen tot Sint Jans and the Haarlem School of Painting*, Princeton (diss.) 1957

Spamer 1930
A. Spamer, *Das kleine Andachtsbild vom XIV. bis zum XX. Jahrhundert*, Munich 1930

Stock 1990
A. Stock, 'Bilderstreit als Kontroverse um das Heilige', in ed. A. Stock, *Wozu Bilder im Christentum? Beiträge zur theologischen Kunsttheorie* (Pietas liturgica vol. 6), St. Ottilien 1990, pp. 63–86

Sulzberger/Van Regteren Altena 1959
S. Sulzberger, 'La Glorification de la Vierge de Gérard de Saint Jean', met een postscriptum van J.Q. van Regteren Altena, *Oud Holland* LXXIV, 1959, pp. 169–73

Surmann 1991
U. Surmann, *Christus in der Rast*, Frankfurt 1991

Swarzenski 1921
G. Swarzenski, 'Deutsche Alabasterplastik des 15. Jahrhunderts', *Städel-Jahrbuch* I, 1921, pp. 167–213

Timmers 1947
J.J.M. Timmers, *Symboliek en ionographie der christelijke kunst*, Roermond/Maaseik 1947

Torriti 1990
P. Torriti, *La Pinacoteca Nazionale di Siena. I dipinti*, Genoa 1990

Toussaert 1963
J. Toussaert, *La sentiment réligieux en Flandre à la fin du moyen-age*, Paris 1963

Tripps 1969
M. Tripps, *Hans Multscher. Seine Ulmer Schaffenszeit 1427–1467*, Weißenhorn 1969

Uden 1986
Ed. L.C.B.M. van Liebergen, exhibition catalogue *Birgitta van Zweden 1303–1373. 600 jaar kunst en kultuur van haar kloosterorde*, Uden (Museum voor religieuze kunst) 1986

Uden 1992
T. Brandenbarg, W. Deeleman-van Tyen, L.C.B.M. van Liebergen and G. Jászai, exhibition catalogue *Heilige Anna, grote moeder. De cultus van de Heilige Moeder Anna en haar familie in de Nederlanden en aangrenzende streken*, Uden (Museum voor religieuze kunst) 1992

Utrecht 1984
Exhibition catalogue *Geert Grote en de Moderne Devotie*, Utrecht (Rijksmuseum Het Catharijneconvent) 1984

Utrecht/New York 1989–90
J.H. Marrow (intr.), H.L.M. Defoer, A.S. Korteweg and W.C.M. Wüstefeld (cat.), exhibition catalogue *The golden age of Dutch manuscript painting*, Utrecht (Rijksmuseum Het Catharijneconvent)/New York (The Pierpont Morgan Library) 1989–90

Utrecht 1993
Ed. W.C.M. Wüstefeld, exhibition catalogue *Middeleeuwse boeken van het Catharijneconvent*, Utrecht (Rijksmuseum Het Catharijneconvent) 1993

Vauchez 1981
A. Vauchez, *La sainteté en occident aux derniers siècles du Moyen Age d'après les procès de canonisation et les documents hagiographiques* (Bibliothèque des écoles francaises d'Athènes et de Rome tome 241), Rome 1981

Vauchez 1987
A. Vauchez, *Les laïcs au Moyen Age. Pratiques et expériences religieuses*, Paris 1987

Vavra 1985
E. Vavra, 'Bildmotiv und Frauenmystik – Funktion und Rezeption', in Dinzelbacher/Bauer 1985, pp. 201–30

Verdeyen 1990
P. Verdeyen, *La théologie mystique de Guillaume de Saint-Thierry*, Paris 1990

Vetter 1963
E.M. Vetter, 'Iconografia del "Varon de Dolores". Su significado y origen', *Archivo español de Arte* xxxvi, 1963, p. 197ff.

Vienna 1962
Exhibition catalogue *Europäische Kunst um 1400*, Vienna (Kunsthistorisches Museum) 1962

Vita Christi
Edd. A.-C. Bolard, L.-M. Rigollot and J. Carnandet, *Vita Jesu Christi e quatuor Evangeliis et scriptoribus orthodoxis concinnata*, Paris/Rome 1965

Vos/Van Os 1989
R. Vos and H.W. van Os, *Aan de oorsprong van de schilderkunst. Vroege Italiaanse schilderijen in Nederlands bezit*, The Hague 1989

Weale 1890
Th. Weale, 'De legende der H. Veronica', *Dietsche Warande. Tijdschrift voor kunst en geschiedenis* III, 1890, pp. 609–16

Weiler 1984
A.G. Weiler, *Getijden van de Eeuwige Wijsheid naar de vertaling van Geert Grote*, Baarn 1984

Weiler 1992
A.G. Weiler, 'De betekenis van de Moderne Devotie voor de Europese cultuur', *Trajecta* i, 1992, pp. 33–48

Wentzel 1960
H. Wentzel, *Christus-Johannes-Gruppen des XIV. Jahrhunderts* (Werkmonographien zur bildenden Kunst Band 51), Stuttgart 1960

Wentzel 1962
H. Wentzel, 'Ein Elfenbeinbüchlein zur Passionsandacht', *Wallraf-Richartz-Jahrbuch* xxiv, 1962, pp. 193–212

Wieck et al. 1988
R.S. Wieck, J. Plummer, L.R. Poos and V. Reinburg, *Time Sanctified. The Book of Hours in Medieval Art and Life*, New York 1988

Winternitz 1967
E. Winternitz, *Musical Instruments and their Symbolism in Western Art*, London 1967

Zafran 1988
E.M. Zafran, *Fifty Old Master Paintings from the Walters Art Gallery*, Baltimore 1988

Zehnder 1981
F.G. Zehnder, *Der Meister der Hl. Veronika*, Sankt Augustin 1981 (diss. Bonn 1973)

Ziegler 1992
J. Ziegler, *Sculpture of Compassion. The Pietà and the Beguines in the Southern Low Countries c.1300–1600* (Studies over Kunstgeschiedenis gepubliceerd door het Belgisch Instituut te Rome dl. 6), Brussels/Rome 1992

PHOTOGRAPHIC ACKNOWLEDGEMENTS

Copyright A.C.L., Brussels p. 78
Agent Foto, Turin p. 130
Bayerische Staatsbibliothek, Munich p. 63
Bayerische Staatsgemäldesammlungen, Alte Pinakothek, Munich pp. 44, 98 (below)
Bayerische Verwaltung der Staatlichen Schlösser, Gärten und Seen, Schloß Nymphenburg, Munich p. 163
Biblioteca Apostolica Vaticana, Rome p. 64 (middle and right)
Biblioteca Apostolica Vaticana, Rome p. 64 (middle and right)
Biblioteca Medicea Laurenziana, Florence p. 111 (above)
Bibliothèque Nationale, Paris pp. 12 (below), 110 (below)
Osvaldo Böhm s.n.c., Venice p. 167
© Ursula Edelmann, Frankfurt am Main p. 124 (above)
Foto Stijns, Dordrecht p. 106
Foto Studio Professionale C.N.B. & C., Bologna p. 76 (below)
Foto Testi, Siena p. 64 (left)
Fotografia Lensini Fabio, Siena p. 72
Fototeca Archivi Alinari, Rome pp. 108 (below), 109
Germanisches Nationalmuseum, Nuremberg pp. 113, 151
Anne Gold Photografie, Aachen p. 75 (below left)
Hirmer Fotoarchiv, München p. 106 (above)
Istituzione del S. Presepio p. 100 (below left)
© Inventaire général/SPADEM Michel Thierry, Dijon p. 144
Collectie Heinz Kisters/Foto: Atelier Beyer, Kreuzlingen, pp. 88, 89
Monastery of Wienhausen, Wienhausen p. 163 (below)
Koninklijk Instituut voor het Kunstpartrimonium, Brussels pp. 102 (foto: Robert Didier), 104 (above)
Koninklijke Bibliotheek, Den Haag pp. 14, 15, 17, 20, 46 (below left), 55, 80 (above), 97, 98 (above), 99 (right), 112 (right)
Kunsthistorische musea, Stad Antwerpen p. 148
Liebieghaus-Museum alter Plastik, Frankfurt pp 59, 124, 125
© The Metropolitan Museum of Art, New York pp. 27 (ca. 1982), 50 (ca. 1987), 51 (ca. 1987), 62, 65 (above), 131
Ministero della Pubblica Istruzione, Gabinetto Fotografico Nazionale, Rome p. 108 (middle)
Ministero per i Beni Culturali e Amientali, Soprintendenza per i Beni Artistici e Storici, Sienna pp. 60, 61, 67
Musée des Beaux Arts, Dijon p. 137
Musei Civici Padova, Gabinetto Fotografico, Padua p. 135
Musei Vaticani, Archivio Fotografico, Rome p. 21
Museum der Bildenden Künste, Leipzig p. 155
Museum Boymans-van Beuningen, Rotterdam pp. 118, 119, 120, 121, 124, 153
Courtesy, Museum of Fine Arts, Boston p. 24
Museum für Kunst und Gewerbe, Hamburg p. 101
Museum Mayer van den Bergh, Antwerpen pp. 19, 139, 143, 147
Museum Mr Simon van Gijn, Dordrecht pp. 7, 106, 107
Museum Wiesbaden, Wiesbaden p. 107
Narodni Galerie, Prague p. 75
The National Gallery, London pp. 42, 46 (below left), 81 (below)
© 1994 National Gallery of Art, Washington pp. 45, 74, 112b
National Galleries of Scotland, Edinburgh pp. 23, 134, 152
Patrimonio Nacional, Archivo Fotográfico, Madrid p. 65 (above)
Philadelphia Museum of Art, Philadelphia p. 71
The Pierpont Morgan Library, New York p. 81 (above)
Rheinisches Bildarchiv, Keulen p. 75 (below right)
Rijksmuseum Het Catharijneconvent, Utretcht pp. 96, 102 (below), 126 (below), 129, 169 (photo: Ruben de Heer)
Rijksmuseum Meermanno-Westreenianum, The Hague pp. 47, 70, 73, 79
© Rijksmuseum-Stichting, Amsterdam pp. 11, 23, 30, 31, 35, 39, 40 (above), 49, 53, 54, 93, 99 (above left), 160 (above)
Staatliche Graphische Sammlung, Munich pp. 29, 32
Staatliche Museen zu Berlin – Preußischer Kulturbesitz, Gemäldegalerie, Berlin pp. 40, 80 (below) (photo) Jörg P. Anders), 127, 133
Staatliche Museen Zu Berlin – Preußischer Kulturbesitz, Kupferstichkabinett, Berlin pp. 35, 85, 86, 111
Staatliche Museeen zu Berlin – Preußischer Kulturbesitz, Skulpturensammlung, Berlin p. 77
Staatliches Museum Schwerin, Schwerin p. 99 (below right)
Staatsbibliothek Bamberg, Bamberg p. 171
Stiftsbibliothek, Einsiedeln pp. 83, 160 (above)
Thorvaldsens Museum, Copenhagen pp. 38, 95
© The Board of Trustees of the Victoria and Albert Museum, London pp. 1, 76 (above), 115, 132
The Walters Art Gallery, Baltimore pp. 138, 142, 146

The publishers have made every possible effort to meet their copyright obligations. Should there, despite this, have been some oversight, the publishers would greatly appreciate those concerned contacting them.

LENDERS

Amsterdam, Rijksmuseum

Amsterdam, Print Room – Rijksmuseum Amsterdam

Amsterdam, private collection

Antwerp, Museum Mayer van den Bergh

Baltimore, The Walters Art Gallery

Berlin, Staatliche Museen zu Berlin – Preußischer Kulturbesitz,
 Kupferstichkabinett

Berlin, Staatliche Museen zu Berlin – Preußischer Kulturbesitz,
 Gemäldegalerie

Berlin, Staatliche Museen zu Berlin – Preußischer Kulturbesitz,
 Skulpturensammlung

Copenhagen, Thorvaldsens Museum

Dordrecht, Museum Mr Simon van Gijn
 (on loan from a private collection)

Edinburgh, The National Galleries of Scotland

Frankfurt, Liebieghaus-Museum Alter Plastik

The Hague, Koninklijke Bibliotheek

The Hague, Rijksmuseum Meermanno-Westreenianum

Hamburg, Museum für Kunst und Gewerbe
 Campe-Stiftung

Kreuzlingen, Heinz Kisters Collection

London, The Trustees of the Victoria and Albert Museum

Munich, Bayerische Staatsbibliothek

Munich, Staatliche Graphische Sammlung

Namur, Musée des Arts Anciens du Namurois
 (Société Archéologique de Namur)

New York, The Metropolitan Museum of Art

New York, The Metropolitan Museum of Art
 The Cloisters

Nuremberg, Germanisches Nationalmuseum

Philadelphia, Philadelphia Museum of Art,
 The John G. Johnson Collection

Rotterdam, Museum Boymans-van Beuningen

Siena, Pinacoteca Nazionale

Utrecht, Rijksmuseum Het Catharijneconvent

Washington, The National Gallery of Art
 Samuel H. Kress Collection

Wiesbaden, Museum Wiesbaden

INDEX

This is an index primarily of topics. The artists who figure significantly in the book can be traced through the catalogue.